WORLD OF WARCRAFT®

DAWN OF THE ASPECTS

RICHARD A. KNAAK

Prologue by Matt Burns

G

Gallery Books

New York London Toronto Sydney New Delhi

Gallery Books
A Division of Simon & Schuster, Inc.
1230 Avenue of the Americas
New York, NY 10020

This Gallery Books trade paperback edition November 2013

GALLERY BOOKS and colophon are registered trademarks of Simon & Schuster, Inc.

For information about special discounts for bulk purchases, please contact Simon & Schuster Special Sales at 1-866-506-1949 or business@simonandschuster.com.

The Simon & Schuster Speakers Bureau can bring authors to your live event. For more information or to book an event contact the Simon & Schuster Speakers Bureau at 1-866-248-3049 or visit our website at www.simonspeakers.com.

Manufactured in the United States of America

10 9 8 7 6 5 4 3 2 1

Library of Congress Cataloging-in-Publication Data is available.

ISBN 978-1-4767-6137-4

THE
NEXUS

COLDARRA

COLDARRA

NORTHREND

GALAKROND'S
REST

WYRMREST
TEMPLE

DRAGONBLIGHT

NORTHREND

PROLOGUE

CHARGE OF THE ASPECTS
by Matt Burns

I have murdered one of my own.

The thought hit Nozdormu the Timeless One the instant he saw the desiccated bronze dragon. Zirion had shriveled into a husk half his original size. Lesions covered his body from head to tail. Instead of blood, golden sand cascaded out of the wounds in unending streams upon which shimmered ghostly images of his life that had not yet come to pass. His future was bleeding out of him.

Nozdormu strode across one of the isolated peaks of Mount Hyjal to stand by Zirion's side, every moment of history rippling over the Timeless One's sun-colored scales. As he loomed over the dying dragon, a wave of helplessness flooded through him. An impenetrable veil had descended on the timeways, one that not even he, the Aspect of the bronze dragonflight and the Guardian of Time, could pierce. The past and future—things he had once seen with clarity—had become muddled.

"Where are the othersss?" Nozdormu craned his great neck toward Tick, who stood nearby. The loyal dragon had transported Zirion on her back from the bronze flight's lair in the Caverns of Time with all due speed, a feat possible only because of her passenger's withered state.

Tick's breaths were still labored from the ordeal. "He returned alone."

"How can that be?" Nozdormu growled in frustration. "Twelve I dispatched into the past. *Twelve!*"

He had tasked his agents with investigating the unsettling condition of the timeways, but now he couldn't shake the feeling that he had merely consigned them to their deaths. Upon returning to the present, the dragons were supposed to have met the Timeless One atop Hyjal precisely at midday. It was well past noon when Tick, whom he had not sent into the timeways, had arrived, bearing Zirion.

"What did you sssee, Zirion?" Nozdormu asked as he began weaving spells to reverse the sands of time escaping from the other dragon.

"I fear he has lost the strength to speak," Tick put in.

The Timeless One barely heard her. The impossible was happening: his magic was having no effect. His actions had been predicted and countered by equally powerful spellwork. There was only one being in existence who possessed the foresight and skill to best the bronze Aspect in the realm of time . . .

"When he first returned from the timeways," Tick continued hesitantly, "he recounted what he saw. No matter where he and the others attempted to journey in history, they always emerged at the same point in the future . . . the Hour of Twilight."

Nozdormu lowered his head and clenched his eyes shut. It was as he had feared. The strands of time had been gathered and pulled toward the apocalypse. In that gray and lifeless future, even the Timeless One would meet his end. That, at least, was what he believed. Ages ago, when the titan Aman'Thul had imbued him with his mastery over time, Nozdormu had also gained knowledge of his own demise.

"Who was responsible for hisss wounds?" The Timeless One

knew the answer, but he hoped more than anything that he was wrong . . . that what he had seen was an anomaly.

"It was the infinite dragonflight and its . . . leader." Tick averted her eyes from Nozdormu.

I have murdered one of my own. The damning words echoed in the Aspect's head.

He had once thought the infinite flight was merely a symptom of an errant timeline. Yet, as inconceivable as it seemed, he had learned that he and his bronze dragons would in the future abandon their sacred charge—protecting the integrity of time—and work to subvert it.

Nozdormu mulled over the events of the past weeks, struggling to control his anger. He had been trapped in the timeways until recently, when the mortal Thrall had reminded him of the First Lesson: that living in the moment was far more important than dwelling on the past or future. The bronze Aspect had emerged from his captivity with a newfound understanding of time . . . only to find himself now confronted by his darkest fears.

"Forgive me," Nozdormu whispered to Zirion, not knowing whether his beloved servant could still see or hear. The wounded bronze cocked his head in recognition. He gazed from side to side until his dull and cloudy eyes locked on Nozdormu.

"Forgive me," the Timeless One repeated. Zirion's mouth stretched wide, and his body quivered. It almost looked as if he were laughing, but Nozdormu quickly realized that the other dragon was sobbing.

As the last of Zirion's future bled out of him, he used whatever remained of his strength to push himself away from Nozdormu, his eyes filled with terror.

Mount Hyjal thrummed with the sounds of celebration.

After a series of delays, the Dragon Aspects Alexstrasza, Ysera, Nozdormu, and Kalecgos had combined their magics with those of

the shaman of the Earthen Ring and the druids of the Cenarion Circle to mend the ancient World Tree Nordrassil. More recently, word had arrived that Ragnaros—the elemental lord of fire, whose minions had sought to burn Nordrassil to ashes—had fallen at mortal hands.

Yet from where Ysera the Awakened stood in the Cenarion refuge at the base of the World Tree, the jubilation was a distant whisper. The Aspect of the green dragonflight heard only a tale of tragedy.

She was meeting with her fellow Aspects to discuss their next course of action against Deathwing, the maddened leader of the black dragonflight, who was responsible for shattering the world during the Cataclysm. Although Azeroth's defenders had recently triumphed in Hyjal and other regions, the tortured Aspect was even now scheming for ways to usher in the Hour of Twilight. So long as he drew breath, he would not stop until he had fulfilled his dark plans.

Instead of debating strategies, however, Nozdormu had recounted the death of Zirion and the infinite dragonflight's newest assault on the timeways. Wrinkles stretched across the Timeless One's otherwise smooth high elven face. He had, like his brethren, assumed his mortal form, a deed the Aspects performed whenever they were near the short-lived races that dwelled around Nordrassil.

"He wasss killed by my magic . . . by *me*," Nozdormu muttered. Ysera looked on, uneasy. Despite the Timeless One's horrific predicament, she couldn't help but notice how everything around her appeared distant. She floated between the waking world and the realm of dreams, anchored to neither.

"I must return to the meeting place." The bronze Aspect anxiously wrung his hands and fidgeted in impatience. "My other agents may yet arrive, but I do not know with certainty. I can only hope."

As Nozdormu turned to leave, Ysera frantically searched for words of comfort to offer him. He had clearly resigned himself to his fate. Aman'Thul had tasked him with upholding the purity of time no matter what harrowing events had taken or would eventually take place. On some level, the Timeless One's charge seemed wrong to Ysera, but she was not one to question his duties.

What do you say to a being who would do anything to protect the dragons of his flight, but now holds himself accountable for one of their deaths? she pondered. Her mind was a storm of fragmented thoughts. It was as if she were standing in a vast library ripped apart by a hurricane. Pages brimming with ideas and images whirled across her vision, but they were all parts of separate books.

Before the Awakened could grasp hold of anything meaningful, Nozdormu had left. An eerie silence followed. The night elves who normally inhabited the druidic haven were gracious enough to vacate it during the Aspects' meetings, but the absence of bustling life gave the place a cold and hollow feel.

"Whether or not the infinite flight is working in concert with Deathwing matters little," Alexstrasza the Life-Binder, Dragonqueen of her kind and Aspect of the red flight, finally said. "The reason we have all agreed to stay in Hyjal is to strategize about how best to deal with him. The timeways conundrum is just further evidence that we must act quickly. Kalecgos, has your flight continued its research?"

"We have." The Aspect of the blue flight cleared his throat and straightened his back. Kalec's amiable demeanor had become strangely formal of late. He was the youngest Aspect, recently chosen to lead his flight after its former leader, Malygos, had died. Ysera surmised that Kalec was trying to prove his worth to his fellow Aspects, when in truth they already saw him as their equal.

Kalec swept his hand through the air, and a series of luminescent runes winked into existence, each detailing experiments his flight

had conducted. The blues had scoured the ancient vaults of knowledge stored in their lair, the Nexus, for insight into Deathwing's weaknesses. Kalec's dragons were the stewards of magic, and if there was an answer hidden in the arcana, they would find it.

"We recovered portions of Deathwing's blood from the elemental realm of Deepholm, where he hid for many years. The samples were small, but they were large enough for our tests."

"And what of the results thus far?" Alexstrasza's voice was thick with anticipation. It was the most hopeful Ysera had seen her sister throughout these fruitless meetings.

"When we infuse the blood with arcane magic—an amount that would tear apart any other being—it only enrages the samples. The blood splits and boils, but ultimately it reforms."

"Not even arcane magic has an effect." The Life-Binder hunched her shoulders.

"But this is just the beginning of our tests," Kalec quickly added. "I believe we must have a tool at our side when we face Deathwing. Numbers, no matter how great, are of little help. We require a weapon . . . like none that has come before it. My flight will not rest until it solves this predicament."

"Thank you." Alexstrasza turned to Ysera. "Have you received any visions of note?"

"Not . . . as of yet," she replied, slightly ashamed. During these meetings, the Awakened often felt like nothing more than a fly on the wall. The titan Eonar had granted her dominion over nature and the lush primal forest realm known as the Emerald Dream. For millennia, she had lived there as Ysera the Dreamer. Just before the Cataclysm, she had been roused from the Dream. Ysera the Awakened, she was now called. Her eyes, so long closed, had opened, but she found herself wondering what she was supposed to see.

"Keep us apprised if anything comes to mind." The Life-Binder

smiled, but Ysera sensed her anxiety. "We will reconvene again on the morrow."

With that, the meeting ended just as it had begun: without answers.

The next morning, Ysera wandered through the scattered camps at the base of Nordrassil. The great World Tree towered over her, its canopy veiled in a layer of clouds. Here and there, Earthen Ring shaman and Cenarion Circle druids were peacefully meditating. After Nordrassil had been healed, Ysera had taught the druids how to meld their spirits with the tree's roots to help them extend into the soil. The shaman, meanwhile, worked to pacify the earth elementals, allowing the roots safe passage as they stretched into Azeroth's depths. The undertaking was an unprecedented union of the two dissimilar mortal groups. Yet as much as it emboldened Ysera, she knew that their noble efforts would be meaningless if Deathwing remained free to pursue his interests.

The Awakened continued up to a secluded ring of trees northeast of the World Tree. When she entered a clearing in the grove, Thrall was already waiting for her, deep in meditation. Ysera had profound respect for the orc shaman, likely more than he realized. Weeks ago, Deathwing and his allies had launched an assault on the green, red, blue, and bronze Aspects that would have destroyed them if not for Thrall's intervention. He had helped bring the dragon leaders together, and he had reminded them of their purpose in safeguarding Azeroth. The Aspects were more united now than they had been in more than ten thousand years.

"Thrall." The Awakened spoke softly. Nature stirred at her voice. The wind tugged at the orc's long black braids. The grass rustled beneath his simple robes. Yet the shaman did not open his eyes.

She was amazed by his level of focus, but she knew that it

had not come easily. During the first attempt to mend Nordrassil, Deathwing's servants had ambushed Thrall and sundered his mind, body, and spirit into the four elements—earth, air, fire, and water. Through the work of a mortal hero and Thrall's mate, Aggra, he had been saved. Ever since that time, Thrall had displayed a newfound connection with the earth that went beyond mere communication with the elements. He could feel Azeroth as if it were a part of *himself*, conjoining with the world in a miraculous way. Ysera believed that in the process of reforming his spirit, the essence of Azeroth had been taken into him.

"Thrall." Ysera gently placed her hand on the shaman's arm.

The orc finally broke out of his meditation and scrambled to his feet. "Lady Ysera, I have started without you. My apologies."

"I am here only to aid you when needed," the green Aspect assured him.

"If I may ask, how did the meeting go?"

"Progress was made," Ysera forced herself to say before changing the subject. "Shall we begin?"

"Yes." Thrall sat back down, and Ysera mirrored him. She had learned long ago that the best means of teaching was through demonstration. While Thrall's spirit melded with the earth, she would bind herself to Nordrassil's roots. The magics were different, but the principles of concentration were alike.

"Have you experienced the same troubles of late?" Ysera asked. Thrall had spoken of his failure to connect with the earth beyond Hyjal as if there were mental barriers blocking his spirit. The orc was determined to understand his new abilities, but he appeared hesitant to venture too far into Azeroth.

"I have." Thrall wrinkled his brow in frustration. "It is as if I were standing in the surf of a great ocean. The farther I wade into the deeps, the more distant I feel from the shore . . ."

"Thrall," Ysera said as she scooped up a handful of dirt and

placed it into the orc's left palm. "This is Azeroth. If your spirit can enter this soil, it can tread anywhere. Hyjal is not a magic anchor; it is the same earth that lies beneath the streets of Orgrimmar or the jungles of Stranglethorn. This world is one body."

"One body . . ." The orc regarded the soil and laughed heartily. "Oftentimes the most difficult problems are solved by the simplest answers . . . the things that are right before our eyes. My old tutor, Drek'Thar, once told me that many years ago. You have much in common with him. So wise and patient . . . No matter what obstacles I encounter, you always know how to overcome them."

Ysera willed herself to smile as the irony of Thrall's words hit her.

"This will be my anchor." The shaman clenched his hand around the dirt.

Thrall closed his eyes and breathed deep. Ysera did so as well and then spoke. "Quiet your thoughts. Detach your spirit from the flesh and feel the earth around us. Know that the rocks beneath you are the same as those beneath me. Know that if you can take one step, you can surely take another."

Ysera took her own instructions to heart as her spirit joined with one of the World Tree's colossal roots. Thrall believed that his burgeoning powers were never meant for him, that they were a fluke. In truth, they were quite the opposite. His purpose was clear, even if he didn't know it. All his years of dedication as a shaman had led to this extraordinary ability to join with the earth. The Awakened longed for a similar sense of fulfillment.

Her thoughts drifted to the meetings with the other Aspects. She focused on every detail, wondering if there was a simple answer hidden among the endless discussions. The Awakened's attention turned to Kalec. Something the young Aspect had mentioned itched in her mind.

"A weapon . . . like none that has come before it."

The words held power, a significance just beyond her understanding.

A weapon . . .

"*. . . like no other. It must be like no other.*" A familiar voice boomed in her head. It crashed over her like a tidal wave, sweeping away the millions of disjointed ideas circulating in her consciousness.

Ysera opened her eyes in shock, but she was no longer in Hyjal.

She floated through a dark and cavernous room that she recognized as the Chamber of the Aspects, the hallowed domain of the five dragonflights. Below her stood a gathering of dragons. Ysera—a past version of herself—was among them, along with Alexstrasza; Nozdormu's prime consort, Soridormi; the late blue Dragon Aspect, Malygos; and . . . *Deathwing.*

No . . . not the scarred and hideous creature of the present. It was Neltharion the Earth-Warder, the once-proud Aspect of the black dragonflight. Unbeknownst to his comrades, he had already been corrupted by the insidious Old Gods—unfathomably powerful beings of madness imprisoned in the earth by the titans—and had forsaken his charge to protect Azeroth.

Ysera discerned the time immediately. It was more than ten thousand years ago, amid the War of the Ancients. The demonic Burning Legion had invaded Azeroth, and the Aspects had gathered to undergo a ceremony that they hoped would spare the world from annihilation. They encircled a featureless golden disk hovering in the air.

It looked, at first glance, like an unassuming trinket. Yet it was the weapon that would shatter the unity of the dragonflights . . . the weapon that would murder countless blue dragons and drive Malygos into millennia of seclusion. The Dragon Soul.

Ysera watched in terror as the ritual concluded. Each of the Aspects—save Neltharion—had allowed a portion of his or her

essence to be sacrificed, thereby empowering the artifact. The dragons had performed the drastic act in the belief that the disk would be used to drive the Legion from Azeroth.

"It is done . . ." Neltharion declared. "All have given that which must be given. I now seal the Dragon Soul forever so that what has been attained will never be lost."

An ominous black glow enveloped the Earth-Warder and the artifact, a subtle hint of its true nature.

"Should that be?" Ysera's past self asked quietly.

"For it to be as it must, yes," Neltharion replied, barely hiding his defiance.

"It is a weapon like no other. It must be like no other," added Malygos.

The walls of the chamber fractured and then fell away like shards of glass after Malygos spoke, revealing the emerald-hued terrain of the clearing. Thrall remained fixed in his meditative state, oblivious to Ysera's vision. She scarcely glanced at the orc as she rose to her feet, trying to piece together what she had seen. *Is it wrong to think that the Dragon Soul could be the salvation of Azeroth after all the suffering and death it unleashed?*

The Awakened raced out of the grove in search of Kalec and Alexstrasza. *The other Aspects will think me mad when I propose using it to our own ends.* Despite her apprehension, one simple thought urged her forward: *Deathwing's tyranny must end how it began.*

The soil was not an object in Thrall's palm. It was, he realized, as much a part of him as his fingers were a part of his hand, unique in and of themselves but pieces of the greater whole.

The orc's spirit descended into the earth beneath him and then into the depths of Hyjal. He experienced every stone and grain of sand as if it were an extension of himself. The chaotic earth

elementals, whom he had for so long struggled to calm, embraced him—*welcomed* him—as one of their own.

The mountain was alive with activity. Shaman—Aggra among them—whispered to the earth in a harmonizing chorus that soothed Thrall's spirit just as it did the elements. Elsewhere, druids guided Nordrassil's roots ever deeper into Azeroth. The orc's essence moved alongside them, where jagged rocks and chunks of granite had crumbled to soft dirt so that the World Tree could nurture itself and in turn strengthen the earth. He drifted through the cycle of healing, invigorated.

Thrall's spirit reached the foothills of the mountain. This was the farthest he had dared to go before. His awareness of his physical body was as distant as it had been in his previous attempts. The orc focused on the faint sensation of soil in his hand, repeating Ysera's sage lesson. *This is Azeroth . . . This world is one body.*

Emboldened by the words, Thrall purged all reservations from his heart and plunged into Azeroth.

His essence raced headlong through the leagues and leagues of earth that unfurled around him. He moved through the sun-baked soil of Durotar and then to the muddy banks of the Swamp of Sorrows. All the lands, no matter how remote or distinct, were connected in a way that he had never comprehended.

Apart from the areas he knew, Thrall encountered other places and oddities in Azeroth of which he had been ignorant.

Somewhere in the Great Sea was a mysterious island shrouded in mists . . .

Beneath the Eastern Kingdoms, a presence stirred in the mountains of Khaz Modan. The spirit there was strong, but it was not an elemental. It was, strangely, like Thrall: a mortal who had transcended the bounds of flesh. The unknown being patrolled the ancient earth of the region as if it were keeping a silent vigil over the land. It spoke in a dwarven accent that echoed across Azeroth.

"For behold, we are earthen, o' the land, and its soul is ours, its pain is ours, its heartbeat is ours . . ."

Thrall also saw that the deep places of the world were riddled with molten lesions and other wounds.

What gave him the most pause was immense caverns, cold and unnatural, scattered throughout the globe. They were pockets of lifelessness that even the earth elementals were hesitant to approach.

One of the voids sat far below Mount Hyjal. Thrall directed his spirit toward the subterranean hollow. Unlike the rest of Azeroth, what lay inside the cavern was hidden from his sight. As he moved closer, a single voice surged out from within the chamber, bristling with unfathomable power.

"Shaman."

It thrummed along the orc's spirit as if Azeroth itself was speaking to him.

"Come."

Thrall was drawn toward the source, compelled to seek it out. His essence circled the outside of the chamber until he found an opening in the cavern's seemingly impenetrable walls. As he pushed his spirit into the void, rocks and soil entered with him. The debris coalesced into legs, a torso, arms, and a head; two multifaceted crystals served as his eyes. His new form resembled his true physical body save that it was made of earth.

"Who are you?" Thrall called out in a sharp clatter that sounded more like stones grinding together than a coherent language.

Pools of roiling magma offered the room's only illumination. The walls and floor were coated in a rough crystalline substance so black that it appeared to consume all light around it.

"Here," a reply came from the center of the subterranean hollow. *"Here lies the truth of this world."*

Thrall lumbered deeper into the chamber, enticed by the authority of the words. His connection with the rest of Azeroth

and his body on Hyjal grew thinner with each step he took. In the middle of the cavern stood a humanoid figure, its features shrouded in a strange, almost tangible darkness.

He plodded closer until two eyes opened on the statuesque being, burning the color of molten rock.

Thrall stumbled back as the shadows veiling the figure dissipated, revealing a grotesque human male. A massive piece of metal in the shape of a jaw was bolted to his ashen face. Jagged horns curled up from his shoulders, and his fingers ended in dagger-like claws. Veins of magma coursed across his chest.

The orc did not recognize the human, but he sensed his identity: *Deathwing* in his mortal guise.

"The arrogance of shaman never ceases to amaze me," the black Aspect rumbled, his voice like two immense boulders shattering against one another. "You seek to tame a power that by rights is not yours to command . . . a power beyond your comprehension."

Thrall bolted toward the wall where he had entered the cavern. Plates of black crystal ripped up from the floor and slammed over the exposed earth. The orc rammed his shoulder into the barrier, pleading with the elemental spirits to part before him. The vile substance did not heed his calls as the rest of Azeroth's earth elementals did.

"Intriguing, is it not?" Deathwing growled behind him. "The blood of the Old Gods does not answer to your whims, for they are not of this world. Only the chosen hold true sway over it."

Thrall whirled toward the Aspect, expecting an attack, but Deathwing had not advanced.

"I have been awaiting your arrival, watching your spirit stumble blindly through the slopes of Hyjal," Deathwing said. "I had presumed you lacked the courage to journey beyond the mountain, but your progress proves what I have suspected . . . The other

Aspects seek to grant you my powers. They wish to replace me with a mortal."

The meaning was lost on Thrall. Although he now possessed enhanced abilities, Ysera and her comrades had told him that he would never become an Aspect or, by extension, the Earth-Warder.

"They had no part in giving me these powers." Thrall edged along the cavern wall, groping for a crack or weak spot between the plates of Old God blood. "And the decision to use them was mine alone."

The chamber trembled at Deathwing's laughter. "So you have been led to believe. I have eyes in many places, shaman. I know that the other Aspects have stayed in Hyjal to scheme and that you are with them. Like cowards, they have lured you into this fate without your knowledge, intent on making my curse your own."

"What you were given was a gift, not a curse," Thrall said. He had learned much concerning the titans and the Aspects in recent times. Long ago, the titan Khaz'goroth had imbued Deathwing with dominion over the world's earthly expanses and charged him to protect them from any harm. However, this duty had made him susceptible to the influence of the Old Gods shackled within Azeroth. The trials and tribulations that had afflicted the Aspects throughout history, from Deathwing's betrayal to the impending Hour of Twilight, were all part of the Old Gods' grand scheme to scour life from the world.

"*A gift?*" Deathwing snarled. "You are as misguided as the other Aspects, too fool to recognize that the charges imposed upon us are nothing more than prisons."

"The titans gave you a purpose," Thrall retorted. His connection with Hyjal was more distant than ever. He sensed that the soil he held in his physical hand leagues away was running through his fingers.

"There is no purpose to what they do." Deathwing stomped toward Thrall, each step thundering through the chamber. "Azeroth was an experiment to the titans. A plaything. When they were done, they turned their backs on us all, indifferent to the broken world that they left behind."

"It is broken because of what you have done, because you forsook your gift!" Thrall roared.

"It is not a gift!" Deathwing's body quaked with rage.

Thrall noted that his words were having an effect. He continued goading the Aspect, hoping that he would reveal some kind of weakness. "The *gift* you did not have the strength to bear. The *gift*—"

"Silence!" Deathwing commanded. "If you insist on calling it a gift, so be it. Know then what it is to be me, to be given this gracious *gift* . . . to feel the fiery heart of this world as your own."

Pain flared deep within Thrall's earthen chest. The ceaseless flames that blazed in Azeroth's core churned inside his spirit. His stone skin hissed and steamed, glowing a dark and angry red.

"Know what it is to feel the weight of this dying world on your shoulders."

Thrall's legs trembled as every rock in Azeroth pressed down on him. His body splintered and cracked. It was beyond physical agony; his spirit was unraveling, suffocated by the unfathomable load.

"Does the gift taste as sweet as you thought it would?" Deathwing asked in amusement. "This is what the other Aspects wish: to chain you to this world as I have been. To damn you to a life of eternal torment."

Through the blinding pain, Thrall realized that he now possessed incredible strength. The weight of Azeroth was his to command. Was Deathwing so arrogant that he had given him this advantage?

The orc didn't question his intuition; this was the lapse in his foe's judgment that he had been awaiting. In one swift movement, Thrall

channeled the burden of Azeroth into his fist and lunged toward Deathwing. The power was intoxicating. He felt as if he could crack a mountain in two.

The black Aspect stood motionless as Thrall approached. An instant before his fist plowed into Deathwing's chest, the weight of Azeroth—and all of its might—was ripped away from the orc's grasp.

His hand slammed into the Aspect's human form, and Thrall's arm shattered into a thousand pieces up to the elbow. He sank to his knees and howled in agony as magma boiled out of the broken limb.

Far off in the distance, near his physical body in Hyjal, he sensed the earth tear asunder.

There were mortal magi, even members of the blue dragonflight, who held that the rules of arcane magic were absolute. Yet where they saw limits, Kalec saw only the potential for new discoveries. For him, magic was not a rigid system of cold logic. It was the lifeblood of the cosmos. It was boundless in its possibilities. It was the closest thing to beauty incarnate that he had ever known.

When Ysera had come to him, speaking excitedly of the Dragon Soul and the role it might play, he was immediately consumed with the puzzle of overcoming the impossible. Deathwing had not imparted his essence into the weapon as the other Aspects had, and the question of how it could be employed against him was a difficult one. Of equal concern was the belief that *any* dragon who used the artifact in its original state would be irrevocably damaged by its powers. The Dragon Soul had even torn apart Deathwing's body, forcing him to bolt his raging form together with metal plates.

Despite the challenges ahead, Kalec viewed the artifact as an opportunity to validate his place among the other Aspects, beings to whom he had always looked for inspiration. He had become the

Steward of Magic at a time when the blue, green, bronze, and red flights were threatened with extinction. The miraculous powers bestowed upon his late leader, Malygos, by the titan Norgannon were now his own. The blue dragons—the heart of the entire flight—had chosen him, had put their faith in *him*. He wouldn't let them down.

"The Dragon Soul cannot be turned against Deathwing, for it does not contain his essence," Alexstrasza said, although there was a hint of uncertainty in her voice. After Ysera had told Kalec of her discovery, the two Aspects had convened with the Life-Binder at their meeting place in the Cenarion refuge to discuss the plan's merits.

"True," the blue Aspect stammered. He felt the eyes of the other Aspects boring into him as if they were judging his every word. "We would need his essence. Unfortunately, the blood samples we acquired, while valuable in their own right, are devoid of this. But with enough arcane energy, it might be possible to alter the Dragon Soul's properties so that it *would* affect him . . . in theory, at least."

"In theory," the Life-Binder repeated.

Kalec winced inwardly. The artifact was, admittedly, a risk. Much of what he knew concerning how it worked had been gleaned from the writings of Kirin Tor magi, in particular the human Rhonin. He had handled the weapon himself and discerned some of its attributes, and his treatise on the subject was an invaluable source of information for Kalec. Still, very little was proven.

"We have no other option." Ysera stepped forward, much to Kalec's relief. "I know it pains you, but it feels right. It was this weapon that started everything . . . that broke us apart. This dark era in our lives must end how it began."

Alexstrasza cast her eyes down. Kalec saw the turmoil raging in them. In truth, he had been concerned about what the Life-Binder's reaction to the ploy would be. He was aware of the artifact's sordid history. At the end of the War of the Ancients, the blue, green,

bronze, and red Aspects had found and enchanted the weapon so that neither Deathwing nor any other dragon could wield it again. Millennia after that, it had fallen into the hands of the Dragonmaw orcs, who had then used it to enslave the Life-Binder and her brood. Many red dragons had been forced to act as mounts of war during that harrowing time.

"This is the answer we have been waiting for, Lady Alexstrasza," Kalec reassured her.

"I know . . ." The Life-Binder sounded forlorn. "I will depart to inform Nozdormu, then. Continue your research."

Everything hinged on the Timeless One. Even if Kalec found a means to alter the artifact, the Aspects would need to call upon Nozdormu's aid to retrieve it from the timeways. The Dragon Soul no longer existed in the present. Much of it had been destroyed more than a decade ago by Rhonin. Thereafter, the black dragon Sinestra had collected the weapon's remaining shards—by then largely devoid of their power—and used them to her own ends. Those last fragments of the Dragon Soul had eventually been obliterated as well. Bringing the artifact back was an impossible thing to ask of the Timeless One, yet Kalec, Ysera, and Alexstrasza knew it must be done.

After the Life-Binder left, Kalec returned to a small table in the Cenarion refuge. Scrying orbs, which he used to communicate with his agents in the Nexus, were scattered across its surface. He plucked one of the devices up and rotated it in his hand, mulling over the Dragon Soul's hurdles.

Ysera padded to Kalec's side and opened her mouth to speak when the earth wrenched, nearly knocking both of them to the ground. Screams began drifting in from the base of Nordrassil, where the Earthen Ring and Cenarion Circle were camped. The blue Aspect exchanged a wary glance with Ysera. Quakes had been

common since the Cataclysm, but this one had felt as if it originated right beneath their feet.

The earth heaved again, more violently than before.

"It cannot be . . ." Ysera's eyes widened as she braced herself against one of the druidic structure's wooden walls. There was a mix of fear and understanding in her voice that made Kalec uneasy.

"Is it Deathwing?" A sliver of dread crept up his spine. "Is he here?"

The green Aspect rushed out of the building without answering. Kalec followed on her heels as she raced toward Nordrassil's base.

Numerous fissures had opened around the World Tree. The shaman and druids there were pulling their comrades who had fallen into the chasms to safety. Ysera, however, did not stop. Much to Kalec's confusion, she continued past the World Tree and up through a line of trees encircling a tranquil clearing. Sitting at the center was Thrall, absorbed in meditation, from the looks of him. His mate, Aggra, was at his side, shaking the other orc's shoulders.

The brown-skinned female turned to Kalec and Ysera when the two Aspects entered the clearing.

"Something is wrong with Go'el," she said, using the orc's birth name. "I searched for him when the earthquakes began and found him like this. He will not wake from this state. What has happened?"

Ysera knelt by Thrall. The male orc looked as if he was in extreme agony, his face contorted in pain, but there were no visible injuries on his body. "It is him, then . . ." the green Aspect said.

The Awakened scrutinized Thrall's left hand. It was empty, from what Kalec could see. This gave the green Aspect pause. She quickly scooped up a handful of soil and placed it in the orc's palm.

"Is there a connection between Thrall and the earthquakes?" Kalec asked.

"He has communed with the earth in a manner that no other

shaman has before. The earth is a part of him, and he a part of it. Something has trapped his spirit. These fissures . . . these are his wounds."

"There must be a way to free him," Aggra pleaded.

"If his spirit has not traveled too far from Hyjal, there is a possibility." Ysera stood and beckoned to Aggra. "We must assemble the shaman and the druids. Much work lies ahead of us."

Thrall's mate hesitated. "I cannot leave him like this . . ."

"You must trust me if you wish to save him." Ysera's voice was barely a whisper, but it filled Kalec with an overwhelming sense of urgency.

Aggra must have experienced it too. Slowly, the orc joined the green Aspect.

"Lady Ysera, is there anything I can do?" Kalec felt woefully out of place. Thrall's predicament lay in the realm of the elements, a domain over which the blue Aspect had no power.

"Stay by his side and, whatever happens, ensure that there is always soil in his hand."

With that, Ysera and Aggra departed, the latter glancing back over her shoulder in worry.

It was not the answer Kalec had hoped for, but he complied. Briefly, he wondered if Ysera had given him this menial task because she did not think him worthy of something greater, but he knew that the Awakened was not one to judge others in that way. There was no hidden meaning in her words. He was needed here. That was all.

As he sat down next to Thrall, Kalec realized that perhaps he had been trying too hard to find a means for *himself* to defeat Deathwing, thus overlooking other, more viable solutions. If Thrall had truly managed to combine his essence with the earth, and vice versa, did it signify that this mortal held a portion of Azeroth within his spirit in the same fashion that Deathwing did?

The blue Aspect pulled a scrying orb from a pouch at his side. After a moment, the cloudy mist within the device faded away, revealing the face of Narygos, a member of his flight.

"Kalecgos." The other dragon bowed his head.

The blue Aspect returned the gesture before speaking. "There was a short-lived being who once wielded the Dragon Soul against the red dragonflight, correct?"

"The orc named Nekros Skullcrusher," Narygos replied. "A most despicable creature."

"Yes, yes. He was the one. How badly was he damaged by the artifact?"

"From what Rhonin documented on the subject, not at all," Narygos stated. "The Dragon Soul does not negatively affect short-lived races in the way it does our kind. It is quite unique in that respect, in fact."

"Thank you, my friend. That will be all." Kalec slipped the orb back into its pouch.

Thrall, a mortal who has tapped into the essence of the earth, the blue Aspect pondered. Not long ago, the orc had helped bind Earth to Kalec, Ysera, Nozdormu, and Alexstrasza, allowing them to combine their powers and stave off an attack by Deathwing's servants. At that time, the shaman had acted merely as a conduit to Azeroth. Now, however, he was much more than that. *He* was the answer . . . the fulcrum by which the Dragon Soul could be turned against its maker.

Kalecgos added soil to Thrall's palm and watched the orc's face twist in pain, fearing that the only hope the Aspects had for completing their venture was on the verge of being lost forever.

Deathwing raked Thrall's chest with a clawed hand, tearing another gash in the orc's earthen skin. The shaman's body was riddled with

molten gouges, but not one of his foe's attacks had been a killing blow.

The black Aspect longed to break Thrall's will, to mold him into an agent of the dragon's own design. That was the only explanation the orc could find for why his adversary had not yet destroyed him.

Deathwing had almost succeeded. Trapped within the cavern, Thrall's spirit had become numb to Azeroth save for its pain. If he had been in this situation mere weeks ago, when his doubts, fears, and anger still ruled his heart, he would have given in. He would have lost himself to this prison of isolation. Yet now he had never been surer of his purpose as a shaman.

"The titans believed that you had the strength to endure," Thrall said. His power was nothing compared to the Aspect's, and so the orc used the only weapons he could: his words. "They trusted you. Was it fear and doubt that caused you to fail and align with the very beings who seek to end all life on Azeroth?"

"Your loyalties are misplaced, shaman. If so inclined, the titans would exterminate your kind and the other lesser races without a second thought. The Old Gods know the futility of the titans' works. They have pledged to break the shackles of my charge. When that day comes, I will purge every remnant of the titans' presence and reign over this world from on high. Azeroth will be born anew."

Deathwing drove his knee into Thrall's chest, sending the orc crashing back into the cavern wall. The shaman was struggling to rise when he heard a series of voices reverberate through the earth outside the chamber. It was the Earthen Ring: Muln Earthfury, Nobundo, and . . . Aggra.

Through the spirits of the elementals, the shaman were searching for him. Thrall reached out for his physical body and, to his surprise, felt a fresh pile of cool, damp soil in his hand. His connection with

the leagues of earth between Hyjal and the cavern flared to life. The orc focused all of his concentration to mentally shout a reply to the elementals just outside the chamber.

Silence followed.

He was preparing to call out again when energy surged through him, and his earthen body began to heal. The shaman were also sealing the chasms in Hyjal, he realized. As they did, his wounds were mending. The orc sprang to his feet, reinvigorated.

"You didn't answer my question," Thrall said. "Was it fear and doubt that caused you to fail?"

Deathwing's eyes blazed crimson. He lunged forward and caught Thrall by the throat, hauling him into the air. The black Aspect drew one of his vicious claws across the orc's stomach.

"In a system flawed to its core, the only failure is blinding yourself to truth. However many wretched beings you and the other Aspects deceive with your erroneous cause is of no consequence. Victory will always prove elusive so long as you throw your lives away for a hopeless future."

Thrall's stone skin was melting where the black Aspect clenched his throat. Deathwing tightened his grip, his fingers sinking through the orc's neck. His connection with Hyjal wavered again.

"No . . ." the orc snarled as he thrashed against Deathwing's hold. "We will triumph . . . because we face our challenges . . . together. You failed . . . because you chose to . . . bear your burden . . . *alone!*"

The earth around the cavern began trembling in what Thrall attributed to a manifestation of Deathwing's anger. Yet rather than press his attack, the black Aspect suddenly cast him aside.

Deathwing thrust his hands out, roaring in fury. Massive boulders of the Old Gods' blood wrenched up from the cavern floor and moved to a high corner of the chamber, forming a thick barrier of the crystalline substance. It took a moment for Thrall to put the

pieces together and find the source of the tremors. The roots of Nordrassil were hurtling toward the chamber, burrowing through stone and soil at incredible speed.

The Earthen Ring—and the Cenarion Circle, it seemed—had found him.

Thrall charged forward and plowed into the Aspect, knocking him to the floor and interrupting his spellwork. Deathwing scrambled up, seething. His body pulsated, tendrils of lava slithering out from the cracks in his breastplate. The black dragon was beginning to move toward Thrall when one of Nordrassil's roots exploded through the cavern wall in a shower of crystal shards.

Deathwing planted his feet as the World Tree's root careened into him. For a short time, he held his ground against the living battering ram, its width greater than a kodo beast's girth. Three other roots followed soon after, bursting into the cavern and driving the black Aspect through the bottom of the chamber.

A fifth root slowly entered the hollow. It wrapped around Thrall's waist and pulled him out of the void. Once outside, the orc's connection with his physical body solidified. He felt the earth as it was, as it was meant to be, without the influence of the Old Gods. All of the pain and agony that he had experienced, the spirit-rending feelings that were Deathwing's entire existence, melted away.

Alexstrasza found the Timeless One waiting.

He stood motionless high atop the mountain. This far from the druidic and shamanic camps, the Life-Binder had assumed her draconic form. It was refreshing to stretch her wings again after spending so much time in her elven body. Once she had landed beside the scaled bronze Aspect, she told him of Ysera and Kalec's plan regarding the Dragon Soul and the part he would be required to play in it. The Life-Binder had surmised that Nozdormu would

reject her, and she wouldn't have questioned why. His mood, however, was much more subdued than she had expected.

"The Dragon Soul . . ." Nozdormu said. "There have been timesss when I considered going back and righting that day. Saving Malygos's flight . . . sparing all of usss from that terrible fate."

The Timeless One heaved a great sigh, never breaking his gaze from the horizon. "And if I were to commit such an act, I would be no different than the infinite dragonflight and . . . my future ssself."

"You would be more different than you can possibly imagine," Alexstrasza replied. "Eonar charged me with preserving life. When the topic of the Dragon Soul was broached, I asked myself how I could observe my duty while bringing the most destructive weapon ever forged back into existence."

"Yet you plan to do ssso," Nozdormu stated.

"Yes. Because to protect life, there are times when we must destroy that which seeks to end it . . ."

The Life-Binder had thought long about the Dragon Soul and the unthinkable suffering it had caused not only her and her flight, but also other living beings throughout history. Ultimately, she had come to a difficult realization: no cost was too great if it meant preserving the world.

"I cannot force you to do what you think is wrong," Alexstrasza said. "But ask yourself this: did Aman'Thul grant you dominion over time just so you could watch this world die?"

"This future inhabited by the infinite dragonflight, if I were to travel there . . ." Nozdormu trailed off. Apprehension and fear radiated from the Timeless One. The Life-Binder sensed that something about the apocalypse beyond the state of the timeways troubled the bronze Aspect. Yet she was already asking so much of Nozdormu; if he did not wish to voice his concerns, that was his choice.

Alexstrasza lowered her head to Nozdormu and spoke softly. "Unto each of you is given a gift . . ."

"Unto all of you isss given the duty." The Timeless One completed the ancient words without hesitation. They were the titans' last command to the Aspects, a reminder that while each of them was unique, their powers and knowledge were never meant to be separate. They were one.

"Time is your charge just as life is mine, but what is *our* duty?" Alexstrasza said.

"To preserve thisss world at . . . all costs. To prevent the Hour of Twilight," Nozdormu whispered.

The Timeless One was quiet after that. The Life-Binder followed his gaze into the sky, sorrow tugging at her heart. "Have any of your other agents returned?"

"No. None will. Yet I wait. I wasss once lost in time until Thrall aided me. Now I am lossst outside of it." To Alexstrasza's surprise, the bronze Aspect chuckled in pained amusement.

The Timeless One finally turned away from the horizon and looked to Alexstrasza. "For too long I have been rigid in my waysss. What you say is true. The time for waiting is past . . ."

The four Dragon Aspects and Thrall had gathered at the druidic haven at the foot of Nordrassil. An ethereal representation of the Dragon Soul hovered in the air among them. It gave Alexstrasza a chill to stand there. In a way, it reminded her of the ceremony that had been conducted millennia ago to empower the artifact.

Despite being an arcane facsimile summoned by Kalecgos, the weapon held power. Bathed in the pale violet light emitted by the Dragon Soul's image, the Aspects noticed that their shadows were flickering between their current mortal forms and their true draconic bodies.

"If we are to acquire the Dragon Soul, we mussst first journey to the future I have foreseen: the end of time itself," Nozdormu said. "By destroying the infinite dragonflight and its leader, who lord over the apocalypse, the timeways will be reopened, allowing usss to slip into the past and retrieve the Dragon Soul."

"How can history proceed if the artifact is suddenly plucked from the timeways?" Thrall asked. The orc had been standing silently among the Aspects. He had already done so much to help them. The Life-Binder wanted to grant him peace, but she needed him to risk his life once again for the safety of Azeroth.

"Time isss not as linear as some might think. My flight will halt the flow of history to negate the impact we make on the past. But we can hold together the integrity of the timewaysss only for so long. When our work isss done, we will return the Dragon Soul to its rightful place . . ."

"As to the matter of its rightful place," Kalecgos said, "there are many points in time when we could obtain the artifact. Its properties, however, were altered over the course of history. If our plan is to succeed, we must use the weapon in its purest form. Once Nozdormu has opened the timeways, we will take the Dragon Soul from the era in which it was created: the War of the Ancients."

"That leaves the wielder," Alexstrasza said, then beckoned toward Thrall.

"My friend." Kalecgos rested his hand on Thrall's shoulder. "From what I have discovered, the artifact was constructed in such a way that dragons who wield it are torn apart by its energies. It fills us with a pain that leads to madness. But short-lived beings, due to their very nature, can use it without bodily harm."

"There is great risk in what we ask of you, Thrall." Ysera's lilting voice wafted through the room. "After the Dragon Soul is brought to the present, you must transport it to Wyrmrest Temple. It is a place of great power connected to the Chamber of the Aspects, where

the artifact was originally imbued. The Dragon Soul will already be empowered, but we will infuse it with our essences again, making it more potent than it ever was . . . and potentially more unstable. Know that if Deathwing learns of our intent, he and his minions will surely converge on the temple to waylay you at all costs."

"I do not mean to question your wisdom," Thrall said humbly, "but other races throughout Azeroth have also suffered Deathwing's fury. We could muster an army of mortals the like of which has never been seen to crush the black Aspect. Would that not be a simpler course of action?"

"Even if every living mortal faced Deathwing, it would matter not," Alexstrasza said. "He has been twisted by the Old Gods' dark energies. No physical assault, however immense, can destroy him. He must be . . . *unmade*. His very essence must be unraveled, and the Dragon Soul alone has the power to do so."

"But only with you at our side," Kalec added. "The artifact was imbued with the essences of the four Aspects, but Deathwing never imparted his into it. If we are to use this weapon to defeat him, we must infuse it with the power of the Earth-Warder. You, Thrall, possess a portion, however small, of that exact thing: the essence of Azeroth itself."

"It is impossible for us to use the Dragon Soul on our own," Alexstrasza said to Thrall. "It falls to you . . . if you choose. This is more than I would have ever wished to ask of you, especially after you have already risked your life to help us."

"I am honored that you seek my aid," Thrall said. "I have but one request. The short-lived races vanquished Ragnaros, and before him the Lich King and countless other threats. Time and time again, we have been instrumental in safeguarding Azeroth. We are invested in it as much as you are. With all due respect, I believe that this plan, as noble as it is, can succeed only with their assistance."

There was no doubt that what Thrall said was right. Alexstrasza

had hoped to avoid dragging more mortals into this perilous endeavor. "If they are willing, they are welcome."

"There are always those who are willing." The orc smiled. "I will send out the call."

After Thrall departed, the Aspects lingered in silence.

"A question has plagued me," Kalec said. "If stopping the Hour of Twilight is *our* purpose, if this is what the titans created us to do, then what will become of us when it is done?"

A chill breeze stole through the Cenarion refuge as if to punctuate Kalec's words. The Aspects shifted, glancing sidelong at one another. They had all pondered this troubling mystery.

"Yesss . . . If we fulfill our duty, what worth do we have afterward?" Nozdormu brooded. "With the timeways defiled, even I cannot see what the future has in store for usss . . ."

"Will our actions result in loss . . . or attainment?" Ysera mused.

"The titans clearly had a plan for us," Kalec argued. "Magic, time, life, nature . . . they will forever exist. It is only logical that we were meant to safeguard them for eternity."

Alexstrasza looked on as Ysera, Kalec, and Nozdormu broke into a discussion, voicing their hopes and concerns. Their path forward was straight, but beyond the Hour of Twilight it was shrouded in a fog of uncertainty. The Life-Binder kept her own fears locked tight inside herself. She was the Dragonqueen, and if ever there was a time when her comrades needed her to guide them, it was at this moment.

"None of us knows for sure," Alexstrasza said, drawing the others' attention. "And if we did, would it matter? This is *why* we were charged by the titans. The wondrous gifts that they gave us are for us to use now."

The Life-Binder grasped the hands of the two Aspects nearest to her, Ysera and Kalecgos. They in turn did the same with Nozdormu.

Their magics intermingled, flowing through each of the dragons. The soothing energies calmed their nerves and filled them with a sense of unwavering determination.

"We will venture into the unknown as one," Alexstrasza said. "As we were always meant to be."

PART I

ONE
WYRMREST

His vague shadow passed over the immense structure below as he circled to land. Even though he had been here before, the scope and age of the stone temple and its surroundings still struck him hard. The temple rose several levels high, with each level built for a race obviously towering over humans and orcs. The rows of grooved columns that lined the outside from the circular base to the rounded top stood like an army of sentinels surveying every desolate direction of the chilling Dragon Wastes. Long fangs of ice draped the ancient edifice, and vicious cracks ran through many of the columns and curved archways, but despite the ravages of time and several fierce conflicts that had engulfed it, Wyrmrest stood defiant, eternal.

It was, to him, a welcome contrast to the horrific and seemingly endless transformations plaguing the world of Azeroth.

The others would already be here. He peered at the distant shrines to each of the great dragonflights—bronze, emerald, azure, ruby, and obsidian—surrounding Wyrmrest. They were shrines without purpose now, the dragonflights in disarray or decimated. Even Wyrmrest, though it might stand ten millennia more, risked being nothing but a relic of a time and hope long past.

The great blue dragon sighed and began his descent. As he did, his gaze briefly shifted far beyond the temple and the shrines to the north, where unsettling mounds dotted the icy landscape. He quickly looked away. Each mound was the frost-encrusted corpse of

a dragon; some of the mounds dated thousands upon thousands of years back. The Dragon Wastes were the graveyard of hundreds of his kind, whatever their color. It was a grim reminder that even the mightiest of creatures were not invulnerable.

The winged leviathan focused again on his destination. Wyrmrest seemed to swell before his eyes. By the time he neared one of the entrances at the base, the dragon was dwarfed by the temple. He alighted, and then, with one last glance around, stepped inside.

The interior did nothing to lessen the sense of enormity, the first chamber rising more than three times the dragon's height. Torches that still stayed lit despite the millennia gave some weak illumination. Ancient carvings loomed over him, many of them of indistinct figures with some resemblance to humans or elves, and yet were clearly not. Whether these were meant to represent the titans, the godlike beings who had brought order to the chaos and reshaped Azeroth to its current form, or had been carved with some other intent, the dragon did not know. This place had been built long before his time, indeed, long before the time of dragons in general.

No one knew the reason for its construction, but long ago it had become the meeting place for the greatest of his kind, the Aspects—guardians of not only all dragons, but all Azeroth. Here, over the millennia, the five champions had assembled to coordinate the actions of the dragonflights. Here, during the Nexus War—in which the Aspect of Magic had led the blue dragonflight in an attempt to purge Azeroth of all mortal spellcasters who did not bow to his utter control—the leaders of the three other dragonflights had created the Wyrmrest Accord, an annual gathering in which they discussed what courses of action to take in regard to the oft-precarious future of the world. Here, after the War of the Ancients—when demons had invaded Azeroth and ancient Kalimdor had been sundered—four of them, Malygos at that time still very much included, had

come to determine their next step to counter the treachery of one of their own. The last had become one of their predominant tasks, but even that long struggle paled against what had actually been their primary goal since the beginning: nothing less than preventing the Hour of Twilight, when all life on Azeroth would become extinct.

That extraordinary victory had at last been achieved . . . at the greatest of costs for the Aspects. Now, here, for the first time since this ancient edifice had been chosen as their meeting place, the four remaining former Aspects came not as the world's champions, but simply as themselves.

The dragon descended into a gorge carved into the ice, arriving at the lowest, half-buried portion of the temple. He listened, but heard no voices rising from within. It was possible that he had arrived before the others after all. He considered departing the temple and finding a nearby place to wait until one of the others turned up—for even after reassurance from the others, he still felt that as the youngest it was not his place to be first among them in any manner—but finally proceeded.

But as the scaled behemoth entered the lower level, he finally heard one of the others. Nozdormu. Trust the bronze dragon to still be the timeliest of them, even now. . . .

What the other male said, the blue dragon could not make out. However, the reply of the one with whom Nozdormu spoke came clear.

"We shall wait until we are all here," a soft yet commanding female voice answered. "Kalecgos deserves as much respect in that regard as any of us."

Hearing his name, the blue dragon surged forward. Not only was he not first, he had clearly kept the others waiting.

"I am here!" the blue roared. He entered a wide, circular chamber, the center of which contained a raised marble platform reachable

by steps at the northern and southern points of the compass. Each corner of the platform was also topped by a huge column.

Nozdormu turned his sharp gaze to the newcomer, the gargantuan bronze dragon flanked by two females equally imposing in size and majesty. The long, sleek emerald green dragon to the bronze's right stared unblinking at the blue with rainbow-colored orbs; Ysera, once She of the Dreaming, she for millennia of the ever-closed eyes, now never shut them even for an instant. She nodded to Kalecgos, but did not speak.

At Nozdormu's other side, a majestic crimson female took a few steps toward the blue. In size and girth, she outdid any of the three, but there was a gentleness about her that belied her fearsome appearance. A long crest stretched down from her back to her tail, and the blue dragon knew that if she stretched her wings, their expanse would be wide enough to obscure her two companions.

Three other dragons of slightly lesser size bowed their heads at his arrival. Each of the three stood positioned on the wide platform behind the former Aspect whose color they matched. These were among the most trusted, the most battle-tested of those who had served the champions. Kalecgos knew each well, from the swift and ready Chronormu—or Chromie, as she was referred to by those nearest her—to brave Merithra, daughter of Ysera. Of the three, though, he was probably most familiar with crimson Afrasastrasz, he who had once been commander of Wyrmrest's defenses during the struggle against the Twilight's Hammer, the fanatical cult that had tried to hasten the end of Azeroth.

The latter trio remained quiet and in the background. They were here to listen. Their presence reminded him once again that he, too, should have been accompanied.

The only problem was, there had no longer been anyone left in the Nexus to do that.

"There is no need to fear, Kalecgos," the lead red dragon calmly responded to his outburst, her voice melodic, calming. "We knew that you would be along shortly. Nozdormu merely expressed concern for you—did you not, Nozdormu?"

"As you sssay," the bronze replied vaguely. His voice bespoke age and wisdom even though, like the others, he appeared in the fullness of life.

"You are too kind." The blue bowed his long, crested head toward the elder dragons, then, to the crimson female, added, "*Kalec*, if you please, Alexstrasza."

Nozdormu snorted, but Alexstrasza nodded. "Kalec. Forgive me for forgetting your preferred—what do the younger races call it?—nickname. But I thought you only liked its use when in a humanoid form."

"Of late I've come to prefer it at *all* times." Kalec did not elaborate.

"Perhaps we should all have nicknames," Ysera interjected without a hint of sarcasm. "After all, it is their world now. Indeed, I find I spend more time of late in a humanoid form than I do in this, my birth one. Perhaps that would be the best and quickest way to close our era. . . ."

Her blunt words silenced the other three. After a moment clearly uncomfortable to all of them, Alexstrasza moved to take up a position at the very center of the wide dais. The other three followed suit, Nozdormu moving to the southern edge, Ysera to the east, and Kalec to the north. The west—Neltharion's place—had remained empty since his ancient betrayal.

The red dragon surveyed the others; then, gazing up for a moment, she declared, "Let this gathering of the Accord begin!"

Once, this pronouncement would have been accompanied by some magical spectacle, but such displays were a thing of the past.

Fearsome these four behemoths might still be, but guardians of Azeroth they were not. They had sacrificed their roles as Aspects in order to vanquish once and for all the monstrous black dragon Deathwing. Deathwing . . . he who had once been their comrade, Neltharion, and who, in his evil madness, had nearly succeeded in bringing about the Hour of Twilight.

It had been a worthy sacrifice, but Kalec was well aware that in its wake, it had left all four forever altered.

Kalec surreptitiously studied the elder three. He had come only lately into the role of Aspect of Magic, grudgingly accepting both it and rule over the blue dragonflight after the downfall of his predecessor and lord, Malygos. Malygos, also called the Spell-Weaver, had grown tired of what he considered the misuse of arcane magic by the lesser races, and had finally declared that such power was to be entrusted *only* to dragons and their allies. The Nexus War had swept across Azeroth and had ended only when, with the aid of Alexstrasza and a handful of her drakes, a band of heroes had entered the heart of his domain—the Nexus itself—and had regretfully put an end to both Malygos and his monstrous crusade. Seeking a new leader, the blue dragons had turned to the member of their flight who, through events, had proven to be the one whom they could trust most to lead: Kalec.

The blue waited, but no one spoke. Even Alexstrasza seemed uninterested in continuing beyond calling the Accord to order. The Life-Binder appeared to be waiting for one of the others to take control, something that neither Ysera nor Nozdormu showed the slightest inclination of doing.

But others did. Growing more visibly impatient than even Kalec felt, Chromie broke the silence. "If I may be permitted, there is a matter of concern. The timeways appear to be in flux! It may have to do with when the Dragon Soul was seized—"

Nozdormu cut her off. "The timeways are no longer our concern! They are beyond my ability to control. From here on, the younger races and the younger races alone will deal with both them and whatever paths to the future they lead to."

Chronormu obviously wanted to say more, but instead nodded. However, as she withdrew, Ysera's daughter dared speak up. "Perhaps I speak out of turn also, but there have been rumors that the Nightmare stirs in the Rift of Aln. It may be seeking a new puppet, another Nightmare Lord that will help it again reach from the Emerald Dream into the waking world. . . ."

"*We* have discussed this," Ysera pointedly reprimanded the other green. The former Aspect's expression momentarily changed. "I think we did . . . yes! We did! The rift and the corruption still touching the Emerald Dream will be dealt with by the druids . . . yes, the druids! The night elf Naralex has already led an effort that has seen the Nightmare sealed off. The druids will guard against the Nightmare more ably than we can now."

The speech was a far more focused, more concentrated one than those Kalec had heard from Ysera shortly after the green's loss of her Aspect role and its powers. Then, Ysera had seemed absentminded and unable to articulate her thoughts well. Since that time, however, her mind had clearly made strides in regaining much of what it had lost.

Merithra looked deflated. "As you say, Mother."

Once again, an uneasy silence reigned over the assembly. Afrasastrasz, wiser than the other two subordinates, looked disinclined to add his own voice. Kalec suddenly felt acutely aware of the lack of anyone at his own side.

It was as if time had stopped. No one even moved. Finally, well aware that it was his youth in part that stirred his impatience beyond his ability to command, Kalec blurted, "I would speak!"

With only the mildest visible curiosity, the other leviathans looked his way.

A sense of intimidation washed over Kalec, but he quickly recognized it as his own uncertainty, not any disdain on their part. His life, as tragic as much of it had been, was less than nothing compared to the combined suffering of these venerable beings. That he had been considered an equal even for a time still daunted him.

"Well?" Ysera finally responded. "If you wish to speak, then you should speak. Simple enough."

Kalec was a little taken aback by her directness. Ysera had been the Dreamer. Now she saw nothing but waste in dreaming or even hesitating. "The contents of the Nexus—"

"Is that *all* it is about?" She looked even less interested than before. "The concerns of any one dragonflight are its alone. You know that. Does your subject concern the rest of us in any way?"

"Not directly—"

"'Not directly.' Then, it doesn't, which means that discussion is at an end. Indeed, there doesn't seem to be any relevant discussion thus far." Turning to Alexstrasza, Ysera grumbled, "I told you, didn't I? I certainly remember wanting to! Yes . . . I did! I told you I thought it was a mistake even bothering to gather here, my sister—"

"We have always met at this cycle of the twin moons. It would have been disrespectful not to."

Nozdormu snorted again. "Disssrespectful to whom? Elune? The Mother Moon has her night elvesss to worship her. Disssrespectful to the titans or their servants, the keepers? We do not even know if the titansss exist anymore! It is certainly not disssrespectful to *us*. I agree with Ysera. This *was* a missstake. There is no point to the Accord anymore. If this gathering has any purpossse to it, it should be to finally put the Accord to rest and let each of us move on with our own problemsss."

Kalec was stunned by the unexpected course of the brief conversation. He waited breathlessly for Alexstrasza to calm the other two down, but the Life-Binder did not argue. Indeed, Alexstrasza seemed to mull over Nozdormu's suggestion as if it had tremendous merit.

The blue dragon abandoned his position, moving toward the center and in front of Alexstrasza as he faced the bronze. "But the Accord is not merely about us! It's become the backbone of all draconic interaction over the millennia! The Accord kept order among our flights, prevented catastrophe more than once! We knew that if we were united, there would always be hope—"

"'United,'" Ysera cut in. "Yes, we have been very united over the millennia, have we not? Neltharion . . . Malygos . . ." She looked as if she intended to say more, but with an apologetic glance at Nozdormu, she quieted.

"Do not leave me out," the bronze grimly added. He stretched his wings. "Call him *Murozond,* lord of the infinite dragonflight, if you like, but that accursed dragon was my far future self and so I am to blame for his evils just as Neltharion was to blame for what he later did as Deathwing. . . ."

Alexstrasza inserted herself at their center again. "Nay, Nozdormu! No one here finds fault with you for what you have *not* done! You fought alongside others against Murozond and altered that future forever! Had there been even the remotest blame on your part, it was erased with Murozond's undoing!"

Kalec and Ysera dipped their heads in agreement. The bronze's tail slowly slid back and forth, a sign of his gratitude for such words. Then his mood darkened again.

"Yes . . . I fought my future self . . . when I had the power to fight. Now, I—*we*—are as any other dragon. The time of the Aspects is past and I say thus that the time of the Wyrmrest Accord is also."

Again, Kalec noted no disagreement from the sisters. "But the three of you are the combined wisdom of our kind! The Aspects have always—"

Ysera thrust her snout into his face. "We . . . are not . . . Aspects."

"But the three of you are still—"

"We understand your concern, Kalec," Alexstrasza said with such clear pity that Kalec winced. "But our time is done and Azeroth must look to other defenders."

As she finished, Nozdormu strode past them toward one of the exits. Ysera followed suit.

Kalec could not believe what he was seeing. "Where are you going?"

The bronze leviathan looked over his shoulder. "Home. We are done here. We should not have even bothered to have this gathering."

"He is correct on the last score," the Life-Binder agreed reluctantly—and only then did Kalec realize that he had been thinking of all of them in terms of titles they themselves clearly no longer acknowledged. They were, in their own eyes, simply three dragons among many now.

"Alexstrasza! Surely you at least—"

It was as if his mother stared down at him. The pity had been replaced by care. "Azeroth will survive without us. You—you who were thrust only so recently into all this—you will survive without us." Alexstrasza looked to the departing bronze. "Nozdormu! A moment! We will meet once more, in a month! If we are to dissolve the Accord, we shall do so with proper respect!"

He paused, then glanced back. "You are correct. It does deserve the proper burial. Agreed. One month from this day."

The gargantuan red focused on her sister. "Ysera?"

"I agree. It makes perfect sense."

Alexstrasza faced Kalec. So shocked that he was unable to speak, he vehemently shook his head.

"Three to one," the female red murmured. "So . . . it is decided."

Nozdormu had not even waited for her declaration, the bronze and his lieutenant already moving on. Ysera and her daughter were close behind.

Alexstrasza watched them for a moment, then turned and, with a grace incredible even for a dragon, slipped out behind Nozdormu and her sister. Afrasastrasz hesitated only long enough to give the blue a sympathetic expression before following her.

Kalec had no choice but to follow or be left alone. Yet, despite his youth and swiftness, by the time he reached the outside, the others were already in the midst of going their separate ways.

"Please reconsider!" he roared, his plea echoing throughout the wastes. Kalec's mind was awhirl. He had actually come here with troubles of his own that he had hoped to discuss with one or more of the elder dragons, and instead he found himself trying desperately just to keep the once seemingly eternal Accord together.

Nozdormu spread his wings to their full span and took to the sky without so much as a last glance at the younger dragon. He was already a small dot when Ysera deigned to speak one final time.

"In truth, we considered . . . yes . . . yes, we did . . . all this long ago. We just needed one of us to speak of it." The emerald behemoth leapt up into the air. "It was only chance that it happened here, barely after you arrived. I apologize for that, young Kalec."

And then, there remained only Alexstrasza and him.

"Fare you well, Kalec. I'm sorry that you came all this way for only a few empty moments . . . and such a turn of events as you certainly did not expect or deserve to be confronted by."

With that, the great red took off, leaving a speechless Kalec to watch as the three vanished among the dark clouds enshrouding

not only the wastes, but nearly all of the bleak continent of Northrend.

What happened here? the blue asked himself over and over. *What just happened here?*

For a brief time, Kalec had thought that things might be taking a turn for the better when he had agreed to stay in Dalaran and, as the mage Khadgar suggested, join the Kirin Tor. But soon, Kalec had seen the distrust in the eyes of the other magi. He was a blue dragon; that was all that mattered to them. In the end, he had made excuses to Jaina, citing the need to oversee the Nexus's crumbling defensive spells and gather its substantial and powerful collection of artifacts together.

Kalec had actually looked forward to this gathering, hoping for some encouragement on several fronts. His own dragonflight had all but fallen apart. With the debacle concerning the Focusing Iris and its theft, he had felt that he had failed in every regard as a leader and that had led to the mass exodus of the other blue dragons. The Nexus had become a place of emptiness, and at times, Kalec had found himself without the inclination to truly fight the departures.

And now, the ones to whom he had desperately sought to turn had themselves turned from the world.

A further irony was that despite *wanting* to come here, Kalec had considered not making the journey. He had been ashamed at his failure to find the Focusing Iris and the dreadful events that had come to pass because of that, especially the destruction of Jaina's own realm of Theramore. Kalec had at first not wanted to admit his humiliations to those who had considered him their equal despite the incredible difference in age and experience. Yet, in the end, Kalec had chosen to come . . . only to find himself in this new debacle.

A chill ran down his spine that had nothing to do with the elements. The blue dragon looked back at Wyrmrest Temple, once

a place of legend to him. Now, he suspected that he was staring at it, if not for the last time, then likely the next to last. Without the Accord, there was only one reason to come to this stark land . . . and that was to die.

But for all his misery, Kalec was not yet ready for death. His youth might be a key factor in his failures, but it also urged him on, even if he had no idea what to do next.

The wind picked up, its rush through the temple creating a surreal howl that finally stirred the blue to begin his own departure. With a beat of his wings, he rose high. Once airborne, the urge to be far from Wyrmrest magnified. Kalec focused on the direction home and increased his pace.

But just as he left Wyrmrest behind, something nagged at his senses. Although no longer an Aspect, Kalec was still a blue dragon and thus more attuned to arcane magic in all its varied forms. The trace was so unique that despite his mood, Kalec sought out its source.

But a first glance at the landscape below failed to give the dragon any clue as to where it lay. Concentrating, Kalec managed to better pinpoint the general area. The catastrophe in the temple momentarily forgotten, the blue descended for a closer look.

His path took him over the remains of more than one dragon. Despite the preservative qualities of the constant cold weather, the wind and other elements eventually wore away all recognizable traces of the dead. Even those already reduced to bone would someday not even be recognizable for the massive, proud beasts that they had once been. After what had happened in the temple, the finality of the scene below struck him anew, but he continued down despite misgivings.

And then at last he sensed from where exactly the magical emanations originated. Kalec veered in that direction—and came to

a jarring halt in the air. So stunned was he by what he beheld that it was all he could do to remember to keep flapping his wings.

It was perhaps its gargantuan size that had permitted the skeleton to remain nearly intact even after so very long. Yet, almost as arresting as its incredible dimensions was the angle at which it lay. Nearly all the other frozen remains scattered through the vast, isolated region lay as if those dragons had simply gone to sleep. Indeed, most had done just so, landing and, with the aid and comfort of others of their kind, breathing their last with relatively little suffering.

Not so, this mammoth creature. This leviathan had died violently.

And so, in the bloody process, had many, many others.

The cracked muzzle of the skull revealed part of a huge maw that could have engulfed Kalec. The lower jaw was nowhere to be seen. The neck area twisted in an awkward manner that revealed just how devastating the collision with the ground had been. The torso, too, lay violently twisted, the spine arched at an impossible angle. The half-buried ribs formed a winding tunnel that rivaled the great chambers of the temple in height.

Within that macabre passage, Kalec pinpointed the location of the mysterious emanations. The dragon shuddered, feeling a sense of dread. Then, steeling himself, the blue leviathan dived in among the gigantic frosty bones.

Dived in among the bones of the Father of Dragons . . . *Galakrond*.

TWO
AMONG THE DEAD

Kalec landed within the ribs with some lingering trepidation. Even though he knew it was only his imagination, there was the constant feeling that the bones might now stir, that Galakrond would rise and engulf him. Even the howling of the wind through the bones seemed to take on a supernatural life, as if the spirits of all the dead dragons here tried to warn him of his folly.

But Kalec still remained more driven by his curiosity. Besides, he had nothing to return to at the moment except more troubles.

The blue had to crouch as he neared the location he sought, so deep had Galakrond's corpse sunk into the harsh soil. That added a claustrophobic touch to an already uneasy situation, but still Kalec was undeterred. He had never sensed a magical trace such as this and found it most curious that it should happen near a place that he had visited more than once.

At first, it occurred to him that perhaps someone had recently set it into place; after all, the rotting servants of the undead Scourge had spent much time excavating the skeleton, their leader hoping to animate the bones and create a monstrous frost wyrm. However, they had been driven away before they could dig too deep and from what Kalec sensed, what he sought was buried very, very far down. With that in mind, the blue could not help but think that whatever drew him here had lain undisturbed for a long, long time—likely since these remains had fallen here.

The dragon concentrated, then exhaled. A purple sphere formed in the air, then drifted gently to the spot. As it touched the soil, a slight mist arose. Under Kalec's guidance, the magical globe melted away thousands upon thousands of years of frost and ice, then slowly burrowed into the ground beneath.

But barely had Kalec's spell pushed below the surface than the sphere faded. Despite the blue's best efforts to keep the spell intact, the globe finally dissipated far short of its goal.

Peering in frustration at the shallow hole, Kalec stretched his forepaws wide. Arcane bands of energy draped over the hole, scratching away the ground. As if guided by invisible hands, the bands continued to scrape away at the spot as Kalec watched. The blue dragon's eyes finally narrowed in satisfaction as the hole grew deeper and deeper—

Images flashed through his mind.

A yellowish proto-dragon arguing with an orange one.

A charcoal-gray proto-dragon laughing harshly.

A robed and hooded figure—a humanoid figure with one arm visible.

A white proto-dragon shrieking as it shriveled to a skeleton.

Another dragon, faint hints of green remaining, flying toward Kalec. Dry skin hung limply on rotting bone, and the eyes of the oncoming creature were milky white and without life . . . and yet still it charged forward, ready to strike.

With a roar, Kalec stumbled back. He crashed into the rib cage, which, sealed in place by layer upon layer of ice, not only held against the blue's weight, but left the dragon momentarily stunned by the collision.

What—what just happened? Kalec shook his head, then eyed the hole. At some point, the second spell had also faded, but for the moment, Kalec cared only about the visions. They had been so lifelike that he had felt as if he had been there participating in the

brief scenes. Yet, none of the images made any sense, especially the last, exceedingly ominous two.

Shaking his head again, the blue investigated the hole. More than ever, he could sense the source of the emanations very near. He only had to dig a little deeper.

Rather than risk a third spell, Kalec hunched over and began tearing at the dirt and frost with his claws. Digging still required great effort, but he made respectable progress. The emanations grew stronger, yet no more visions assailed him.

A soft, lavender aura rose from the hole. Kalec immediately hesitated. When nothing else happened, he cautiously dug around the edges.

At first, he was rewarded only with more dirt, but as Kalec shifted his attention to the center, his claws finally came into contact with something other than earth.

With a delicate touch his reptilian form belied, the dragon brought forth a small octagonal object made from some metal that Kalec could not identify. It reminded him of gold, but if he held it a different way, it looked as if it were simple iron. Tilted in another direction, it took on the brilliant white appearance of rare palladium.

And all the while, the lavender aura surrounded it . . . yet also seemed separate, as if it were clouds over a tiny, oddly shaped world.

Fascinated, Kalec sought to probe the mysterious artifact. The moment he tried, though, the aura faded. The blue quickly ceased his probing, but the aura did not return. Indeed, now the emanations had also ceased.

The dragon growled. He almost put the tiny artifact down, but finally clutched it tight. Backing up, Kalec located a spot where the gap between ribs was wide enough for him to exit. As he stepped out in the open, the gnawing feeling that he was being watched overtook him. Kalec looked to his right.

The empty eye sockets of the Father of Dragons met his gaze.

Kalec let out a grim laugh at his momentary paranoia. He glanced down at the artifact one more time in order to make certain his grip was good, then took to the heavens. As the blue left the desolation below, he found himself breathing much easier. Kalec grunted and turned his attention to the Nexus. There, he thought he might be able to find out more about the object he carried. The blues had gathered much arcane knowledge during Malygos's millennia as Aspect of Magic, and even though Kalec himself no longer bore that title, the knowledge was still his for the studying.

That there were other, more pressing matters, such as the dissolution of the blue dragonflight itself, had never left his thoughts. The artifact gave him a perfect excuse not to think about his latest failures, just as fulfilling the dangerous role of Aspect had once let him now and then try to forget Anveena.

The blue dragon grimaced, then shook away such thoughts. Kalec arced. Wyrmrest Temple briefly came into view below. The blue hissed. Like the thing in his paw, it was a relic of the past, but unlike the artifact, for Kalec, the temple held no more interest. It was as dead a thing to him as the bones from which he had just departed.

And as dead as the future he had once thought awaited him as an Aspect.

The Nexus was more than merely the realm of the Spell-Weaver and the blue dragonflight. It was a place of immense magical power, a gathering of forces from all Azeroth. Although its physical appearance was that of an icy, timeworn fortress, the Nexus was actually a formation riddled with tunnels and caves, and had once been protected by an extensive and intricate series of wards that permitted only the blue dragons safe entrance. However, with the

wards fading, Kalec's excuse for returning had more merit to it than even he had originally thought.

Some distance away, two blue dragons soared through the air. Both headed south, whether intending to ever return, Kalec did not know. He tried not to think about their departure as he neared. Although Kalec had been late to the gathering at Wyrmrest, his tardiness had not been due to having to fly any greater distance than Alexstrasza and the rest. The Nexus was actually based on the frozen island of Coldarra—situated near the northwest edge of the Borean Tundra, which itself was a part of Northrend, the very same continent containing the Dragon Wastes. In truth, the journey had been a relatively short one. Kalec had been last to the Accord for reasons that he believed would have shocked even the legendary three.

But all thought of either *her* or the Accord faded as Kalec entered the protective perimeter of the Nexus. He felt a gentle tingle as he passed through the invisible network of spells. For now they still held, but they were already even weaker than when he had left for the gathering.

Kalec entered through the passage that led into his sanctum. Again and again, he sensed the brief, almost negligible touch of active spells. How much longer they would last, he could not say. Not too long, though.

There was a sound from ahead. Another male suddenly crossed his path. Kalec, not expecting anyone in the Nexus, came to an abrupt halt.

"Hail, Spell-Weaver," the older dragon intoned, at the same time bowing his head. It said something for the size of the passages that both not only could face each other with ease, but would be able to pass by when necessary.

Shaking his head, Kalec replied, "That title is no longer mine, Jaracgos."

"As you wish. I am glad that you returned when you did. I would have felt extremely guilty otherwise."

Kalec tried to head off what he knew was coming. "Jaracgos, you don't—"

"Please, I must speak." Although older, the other blue was smaller than Kalec. "I have loyally followed the Spell-Weaver my entire existence, be the one with that title Malygos or you. I have entered fierce battle, pursued dangerous quests, and never shirked in any other duty. . . ."

"I know that. You were one of those I always admired. You never sought glory for yourself. It is something I have tried to emulate."

The elder dragon cleared his throat, a sound that echoed through the rocky passage. He looked down. "You only make this harder. Kalec, I have had notions I have long wished to pursue, interests in the arcane I never had the chance to study. To do so, I must travel far—"

"You need not feel guilty for telling me this, Jaracgos," Kalec interjected softly. "I respect your choice and thank you for coming to me rather than simply departing without a word. To be honest, I thought when you'd left earlier, you were never coming back."

The other dragon dipped his head in respect. "I *will* return on occasion."

"Thank you. Safe journey."

With another dip of his head, the second behemoth moved on. Kalec watched him for a moment, then continued on in silence toward his sanctum. He had his doubts as to whether Jaracgos would ever return. After all, Kalec had encouraged his fellow blue dragons to do as they desired, even if it meant forever following a path that took them farther and farther from the Nexus—

Do not argue, Neltharion! a hissing voice roared in Kalec's mind.

I do not argue! I fight!

A stunning wave of vertigo overtook Kalec as the mysterious

voices continued to argue. Images began to join them. A young, yellowish dragon with some resemblance to one he knew now. A high peak that reminded him of one to the east, only sharper, less polished by time.

Through the barrage of mixing voices and flashing images he heard a female blue calling to him. Her voice was distant, indistinct, while the others grew stronger, more vivid.

A dragon roared . . . and just as Kalec lost sense, he realized it was he.

Hunting had been good. The icy sea teemed with large creatures full of tasty meat and blubber. Some of his kind preferred to hunt the grazers—and they, too, could provide a welcome feast—but for the time being Malygos enjoyed seeking the shapes only half-seen in the depths and planning for the very moment when they drew near the surface. He liked a mental challenge, more so than most of the other proto-dragons. Malygos took special pride in that; it meant to him that he was far more clever.

The blue-and-white proto-dragon marked one last prey. He spread his wings, which were decorated with icy flakes. More than most, his particular kind was well adapted to this region. Other "families" occasionally ventured up here, but the majority tended to stay in the warmer climes.

Yet, today was to be one of those rare visitations. The shadow rushed over Malygos, soaring ahead at a speed he would have been hard-pressed to match. Kalec peered up in the sky in search of the other—

Kalec. My name is Kalec, a part of Malygos suddenly thought with shock. *What—what is happening?*

He wanted to turn and race back to the Nexus, but his body did not obey. Instead, it rose higher into the sky, seeking the mysterious

proto-dragon whose shadow had passed by. It was not unheard of for members of one kind to attack another. Dominance was always important among proto-dragons.

How do I know that? Kalec demanded helplessly. *Where am I?*

Kalec could recall nothing after his agonized roar. He had apparently been unconscious. After that, he had no explanation as to why he would be here, flying over the water and seeing things through the eyes of *Malygos*. Kalec did not even understand how he knew that the body was that of his predecessor or how he also recognized that this was a very young Malygos from an era before there existed true dragons, much less the Great Aspects.

Kalec/Malygos rose into the clouds. The proto-dragon sniffed the air, enabling Kalec to detect the presence of that other creature. It seemed that the blue could experience everything here, but had no choice as to movement or speech. It was as if he were a ghost sharing Malygos's form, even though the truth was more complicated. This young Malygos was the spirit . . . as was the entire world surrounding them, Kalec suspected.

Suddenly, a fire-orange shape darted by, distracting both Malygos and Kalec. A female proto-dragon hesitated a short distance from the blue-and-white male.

"No battle!" she roared. "I mean no harm!"

Several new things shocked Kalec. First, what little he knew of proto-dragons had led him to believe that they were incapable of speech. He had assumed them the primitive, animalistic ancestors of his kind and nothing more.

But somewhere along the way, some had crossed a threshold. . . .

The female anxiously waited for a response. Kalec recalled a glimpse of a fire-orange proto-dragon in one of the earlier visions and suspected this was the same one. In addition, he again found something familiar about her.

"No battle," Malygos agreed, much to her relief, and to Kalec's as well. Kalec realized that he was not surprised that Malygos also could speak, but only because the blue dragon had seen within the male, known his thoughts.

This was not the Malygos he knew, but even this less sophisticated version was swift of thought. Malygos searched the heavens for other orange figures and, finding none, took a more dominant spot above the female. She, in turn, did not show any unease at his decision, whether a sign of good judgment or naïveté, Kalec did not yet know.

"I am alone," she added. "Looking for another. A male of my kind. Clutch brother."

Clutch brother. Kalec knew that term. Dragons from the same clutch of eggs were considered the closest of siblings. Kalec had been one of four, but was now the only survivor. He assumed that proto-dragons had larger clutches and thus more chances of survival for the young, but evidently familial bonds still existed, at least for some like this female.

Malygos did not hesitate. "No others of yours."

The female looked disappointed. "I have nowhere else to look."

Kalec sensed Malygos's train of thought. She not being one of Malygos's breed, the male had no interest in the female, but he enjoyed proving his cunning. Besides, since he was neither hungry nor tired at the moment, the activity suited him. "There are other places. He hunts?"

She thought for a moment. "He likes to find new places."

This appealed to Malygos, who enjoyed such an activity himself. "If he is not here, he must be south. There is a trail?"

"I know where he was. I do not know where he went."

"Show me."

But as the female veered around and Malygos started to follow,

Kalec's world leapt forward in such a jarring manner that at first he lost all sense. As his mind settled again, he saw that the pair now flew over a rocky but warmer landscape.

"This is where?" Malygos finally asked. "Clutch brother was here?"

"Yes."

Once more, Kalec was taken by the conversational ability of the proto-dragon, but before he could pursue the question, a third, charcoal-gray proto-dragon flew into view from the west. The gray creature spotted the pair and immediately darted toward them.

Malygos let out a low growl. Kalec, who had been expecting another simple meeting, realized that the two proto-dragons were about to do battle.

"No fighting!" the female called. "No enemies!"

"A waste!" snarled Malygos as he surged to meet the newcomer. "He is a stupid one! Not smart!"

The gray suddenly opened wide his maw. A thunderous sound escaped. Kalec suffered along with Malygos as the shock wave struck like a hammer, sending his host spiraling backward.

Without hesitation, the gray eagerly pursued. Unlike the first two proto-dragons, this one was as Malygos had indicated and akin to those with which Kalec was familiar—an unthinking beast.

Malygos managed to right himself just in time. He exhaled in turn, and a chilling frost enveloped the oncoming gray. The attacking proto-dragon spun, his wings and head frozen, then dropped below Malygos.

Malygos dove after, which proved a mistake. The gray shook off the effects of his foe's blast and, still spinning, accidentally caught Malygos directly across the chest with his tail.

Kalec wanted to gasp along with his host as the air was shoved from Malygos's lungs. The icy-blue proto-dragon fought to keep

aloft as he nearly blacked out. Kalec uselessly urged him on, but also felt consciousness slipping away.

Then, a burst of flame caught the gray in the face. The gray roared in pain, the fire having struck close to his eyes. He shook his head, blinded.

Recovering, Malygos unleashed another cold blast just as a second plume of fire also struck. Under the double onslaught, the gray retreated. He continued to roar, in both agony and frustration, as he fled the pair.

Malygos gazed up at the female, allowing Kalec to do the same. She looked both relieved and confused.

"He was scared. I did not want to fight. He gave no choice."

"'Scared'?" Malygos snorted, and Kalec puzzled over her explanation. He shared his host's low opinion of their attacker. "Hmmph! Very stupid beast! Not smart, like me! Not smart like Malygos!"

"You are smart, Malygos," she agreed. "Smarter than me."

Although Malygos accepted her words as fact, Kalec suspected that the fire-orange proto-dragon was smarter than she had thus far revealed.

"I am smart," repeated Malygos, taking pride in the compliment. "I will find your clutch brother, Alexstrasza."

Alexstrasza! Kalec observed the young female through his host's eyes, finally recognizing traits in the smoother, slimmer face. Yes, this was Alexstrasza, but a much younger one he would never have believed could be the Life-Binder. The pair had apparently told each other their names sometime in that lost period between the two parts of the maddening vision.

Curiously, Alexstrasza only nodded disinterestedly. She continued to eye the direction in which their brief adversary had fled. "So scared. He attacked us because he was scared. Why was he scared?"

Not having noticed that himself, Malygos simply shrugged. Again, Kalec shared his predecessor's disinterest. He only wanted to escape this madness. He wondered what was happening to his body.

Another attack of vertigo overwhelmed him. Kalec floated in darkness for a moment, then once again returned not to the Nexus, but rather to some other vision seen through young Malygos.

They were in what to Kalec's judgment was some other part of the same jagged landscape. The sky was as overcast as that over Northrend.

A mournful howl rose from his—Malygos's—side.

Malygos seemed to know what it entailed, for despite Kalec's desire, his host did not immediately turn toward the cry. Only when the howl continued unabated did he finally look.

And there Kalec at last beheld Alexstrasza, her snout pointed to the sky, her cry one of terrible loss. Had he a body of his own, Kalec knew that he would have felt a chill up and down his spine, so terrible was the sound.

Alexstrasza's wings draped the ground like a shroud. Her body rocked back and forth and her tail scraped the rocky soil over and over.

As Malygos had promised, he had found her clutch brother . . . or what remained of him. Kalec now wished that his host would turn away, but Malygos eyed the corpse with growing interest as he tried to make sense of the death.

Alexstrasza's sibling had perished violently—not a surprise in this world—but he had not simply been slain in some duel with another proto-dragon. No breath weapon with which Kalec was familiar or that even Malygos recognized would have left the corpse in such a horribly desiccated state. The fire-orange male was nothing more than a shriveled mass of skin and bone.

And what was worse, the contorted visage gave every indication

that Alexstrasza's brother had suffered throughout the entire monstrous process.

Alexstrasza continued to mourn. Malygos, however, suddenly shivered. A sense of unease filled Kalec's host, though it was clear to Kalec that Malygos did not understand why the feeling now overwhelmed him.

A vast shadow blanketed the area. It vanished as swiftly as it had appeared. Malygos rose into the air, spinning so that he could quickly see in every direction, but all that was visible was the thick cloud cover.

No. There was something high above, discernible to Kalec just for a moment. He tried to urge Malygos to look in that direction.

His host finally did. At the same moment, whatever lurked above briefly darted through the bottom of the cloud cover.

But before Kalec could focus, his surroundings became a chaotic maelstrom of unintelligible voices, roars, and momentary images so brief that he could make sense of none of them.

And then . . . the blackness engulfed him once more.

THREE
FATHER OF DRAGONS

Kalec? Kalec?

Her voice was the first thing to pierce the darkness and it drew him back to waking. He mumbled what should have been her name, although even to his ears the sounds made no sense. The former Aspect opened his eyes, expecting both to be still lying in the tunnel and to have her leaning over him. Which of those would shame him more, he could not say.

But when he peered around, it was to find himself alone . . . and no longer lying in the passage. Somehow, he had come to be transported to the gigantic cavern that was his sanctum. More perplexing, he even lay in his favored sleeping spot.

But the question of how Kalec had gotten here was a minor one to the blue. What was more important was what had happened after he had blacked out. How long he had been lost within, Kalec did not know, but he did have a very good idea as to the source of the startling visions.

Uncurling stiff digits, the dragon beheld the seemingly insignificant artifact. A curse escaped him at sight of it and he almost threw it against one of the cavern walls. Thinking better of it, the dragon instead turned toward a shadowy part of his sanctum.

Kalec drew forth a bit of that shadow. From within, there emerged a large cubic shape that expanded before his eyes, growing immense enough to contain a night elf. Had Kalec desired it larger,

he could have expanded it with only a thought. The arcane prisons had been created for a variety of tasks, including what the second half of their name indicated. This was but one of many secreted in the Nexus, and Kalec had chosen it because it was emptier than most.

Blue energy crackling all around it, the massive cube floated slightly above the ground. To an onlooker, it resembled a large box seemingly made of wood and stone and lined at each edge by a bronze, metallic border. Rich blue seals ran across the center of each of the four sides from the top to the bottom, and a dark border ran across the middle, as if the top and bottom were separate halves kept together only by the seals and border.

At the former Aspect's unspoken command, the seals fell away and the metallic border faded. Now acting like a lid, the upper half tipped open. Not all arcane prisons functioned in this manner; this one, being designed specifically for storage, could also open in several other ways, depending on what Kalec needed of it.

Thrusting his paw inside, the dragon deposited the artifact. There, it not only would be safe from other eyes, but would no longer be able to taint his thoughts.

Resealing, the arcane prison vanished again. Exhaling in relief, Kalec recalled the voice that had brought him back from the blackness. This was not the first time that she had reached out to him since his departure from Dalaran. After their last meeting, she had no doubt assumed that he would contact her again, but he had found so many reasons not to, including his certainty that even she blamed him in part for not finding the Iris.

They could *not* continue this charade, Kalec decided not for the first time. There was no path ahead that the two of them could travel together—

And yet, once again, her voice touched him. *Kalec . . . Kalec . . .*

speak to me. . . . He wanted to ignore her, but his will had been too weakened by the visions. Besides, Kalec told himself, as an archmage—perhaps the greatest one not with the blood of a dragon coursing through her veins—she might know something of the magic that would create a thing like what he had found. Jaina was, after all, the one who had helped him sense the Focusing Iris when his own efforts had failed. From that hunt alone, he considered her in many ways far more cunning, more adaptable than he . . . and that made him all the more shamed by his own failures.

When she called to him again, Kalec finally answered. *I am here, Jaina.*

As he replied, two things also happened. The least of those was a gap that opened in the air before him, a gap in the center of which formed the large circular image of a walled chamber he knew was hundreds of miles away. In that image, a feminine figure began to take shape.

But even before that took place, Kalec himself went through a transformation. He shrank, becoming only a fraction of his original size. The dragon stood on his hind legs, which reversed at the knees and became like those of a man even as the forelegs became matching arms. Kalec's wings and tail shriveled, finally vanishing. His snout receded into his face, which lost its scale and deep blue tint, at last refining into a pale but handsome young face worthy of any of the elven races.

The most obvious hints remaining of his true self were his long blue-black hair and the hunter's garments he now wore, which were also of a dark blue and black. Kalec straightened, in many ways more comfortable as he was now than when a dragon. In this form, he had learned what it was like to truly *live,* to truly understand happiness . . . and pain. Indeed, often there were moments when

he wished that he had been born as the humanoid creature he pretended to be here.

As he finished transforming, the figure in the image also became fully distinct. However, unlike Kalec, the woman before him was exactly what she appeared to be. Human. Beautiful. So very powerful.

And still so young for all she had been forced to experience. Kalec could see how recent events had done even more to harden her, although she tried to pretend that she had not changed. Jaina Proudmoore had not asked to become leader of the Council of Six—the council of wizards ruling the realm of Dalaran—but she had been the one to whom the other powers had turned after the sacrifice of her predecessor, Rhonin. Jaina, the daughter of the late, legendary—and some would also say *infamous*—grand admiral Daelin Proudmoore, had also had to balance her duties on the council with governing the island kingdom of Theramore.

All that would have been too much for many creatures—dragons included—but in addition, Jaina had had to deal with both her part in her father's death and her failure to save Theramore from eventual destruction at the brutish hands of the Horde.

We are two of a kind, Kalec thought as he beheld her.

He kept his expression neutral as she focused on him. In contrast, Jaina smiled gratefully, as if Kalec had granted her a special favor in finally responding. That only made him feel worse.

"I was beginning to worry about you." Her voice was rich and melodious—at least to Kalec—but tinged with past pains and regrets.

He marveled that she had the wherewithal to continue as she did, despite her grief for all those slain in Theramore and her remorse over what she had planned to do against Orgrimmar with the stolen Focusing Iris. Of course, that was also why he both admired and felt a bond with her. "I appreciate your concern, Jaina, but I am fine."

"Are you?" She leaned closer, almost seeming able to touch him. Her gaze bored into Kalec, who felt as if the mage could read into what passed for a dragon's soul. "You aren't sleeping enough. I can see that. You're driving yourself too much. All this work can wait a little longer—"

"It has to be done," he blurted out too quickly.

He was as surprised as she looked by the obvious bitterness tingeing his words. Jaina recovered almost immediately, compassion replacing the surprise. The compassion only made Kalec more abashed.

"How are you?" he asked in a deliberate change of subject. "How fares the Kirin Tor?"

Despite understanding just what he was doing, she allowed the change. "We still struggle to keep things together, but we're doing it. You know as well as I do how things have turned upside down since your last visit. I've been forced to make some changes I don't like, but they're necessary."

When Jaina did not elaborate on those changes, Kalec did not press. He wanted very much to help her, but what could he, who could do nothing for himself, do for her?

Perhaps it is time to end this, the dragon decided. *Perhaps we can do nothing for one another—*

An image of the young Alexstrasza burned through his mind.

Kalec could neither suppress a gasp nor keep his body from shivering. Unfortunately, Jaina noted both.

"Kalec! Are you ill—"

A dragon's roar—or, more likely, a proto-dragon's—drowned out whatever else she said. Still, the blue managed to put on a veneer of strength before the mage. "As you said, I've not gotten enough rest. My apologies for frightening you."

He tried very hard to sound indifferent, hoping that she would

believe that he was well. Kalec was not certain if his thinking was clear, but he had to hope it was, for other sounds and images were already assailing him.

Jaina remained where she was. Her expression was unreadable. "Are you sure you're all right?"

The image of another proto-dragon corpse took his attention. There was something even more unsettling about this one, but the image vanished before Kalec could make sense of just what it was that bothered him. The sounds, especially the voices, grew maddening.

"Yes!" he called too loudly. "Forgive me! I've a council to convene!"

No longer caring if his excuses made sense, Kalec dismissed the vision of the mage. Jaina faded away just as she looked ready to say something. The former Aspect stumbled to the center of his sanctum, already reeling from the onslaught of voices and jumbled images. He was grateful that neither Jaina nor any of his dragonflight could see him staggering.

Kalec fell to his knees. He managed to plant a hand against the smooth rock floor, a hand partially scaled and with long, wicked nails. Unable to focus, Kalec contorted as his body sought some balance between his true form and the humanoid one he had put on for Jaina's sake. His mouth and nose stretched forward and his legs shrieked with pain as his knees shifted back and forth. It was one thing to simply change from one shape to another, but to keep shifting between them took a toll that he had never suffered before.

It was finally too much. Kalec fell forward—

And once again soared through the air as some part of the young Malygos.

Time had shifted again. Alexstrasza no longer accompanied Malygos, but there were other proto-dragons in the sky, proto-

dragons of at least six different colors. Despite their differences, they appeared disinclined to fight one another, although Kalec suspected that could always change.

Malygos radiated agitation, which in turn overtook Kalec. What bothered Malygos was not clear to Kalec. The proto-dragon had buried his thoughts deep this time, even seeming not to want to deal with them himself.

Part of the reason for so many different proto-dragons in the same region became obvious as a vast herd of huge beasts—some sort of brown, hairy caribou—raced along the low, grassy hills below. Two proto-dragons had already dived down and snatched up ready meals, but a smaller, yellowish female failed to judge her dive and almost collided with the ground.

As she pulled up, she was joined by none other than Alexstrasza, who had just snatched up another of the grazers. Unlike the other hunters, the fire-orange female had quickly bitten through the neck where the animal's great vein was located, killing it instantly. Kalec could sense Malygos's amusement at such a tactic; most proto-dragons preferred their prey alive and fresh until the last moment. Alexstrasza, though, appeared to almost feel guilty about having to hunt at all.

She tried to offer the meal to the smaller female—who clearly needed nourishment—but the yellowish proto-dragon instead snapped angrily at her. Rather than grow furious herself, Alexstrasza continued to patiently attend to her companion.

Even now, she takes care of the helpless, Kalec thought with admiration, thinking of Alexstrasza as the Aspect of Life. Here, so very young, she still revealed far more concern for others than most.

Malygos lost interest for the moment in the two females, forcing Kalec's perspective to shift to watching other hunters. The proto-dragon took mild interest in a coarse brown male's technique. The

other male would hover over the running herd, then, seemingly prescient, dive toward it just as it made a sharp turn designed to put the winged predators off their mark. Not so the brown male. In fact, he seemed to know at just what angle and what speed the grazers would turn. Where more than one other hunter ended up only with mounds of torn dirt and grass, he plucked up two tasty morsels in rapid succession.

Malygos admired the other's cleverness and timing, then lost interest as two of the hunters who had failed to snag their quarry now hissed and spat at one another. No words passed between them. Like the gray male Kalec and his host had encountered previously, these proto-dragons were little better than the savage cats or wolves roaming other parts of the world. Malygos watched their angry fight with contempt, while Kalec again wondered why some proto-dragons had progressed toward sentience while others had not.

A few other proto-dragons in the midst of devouring their meals also watched, some with clear intelligence, others like beasts wary that the fighters might try next to steal their food. One blue-green male sneered at the pair, then glared at Malygos when he realized Kalec's host was watching him.

Coros. The name came to mind as if Kalec knew the other male himself. Malygos obviously did, and the enmity between them was clear. Coros hissed at his rival, then thrust his muzzle into his fresh kill. The blue-green male ripped free a hefty portion of bloody meat, then chewed it while staring at Malygos as if it had been torn from the latter's throat.

Kalec sensed Malygos considering fighting Coros, but the dangerous train of thought was interrupted by the alighting of the small, yellowish female near him. She snorted in frustration as Alexstrasza, still gripping the carcass, landed next to her and across from Kalec's host.

"My brother . . ." began the smaller proto-dragon hesitantly. "My sister says you found him."

It startled both Malygos and Kalec that this was Alexstrasza's sibling. Their colors were different, though her yellow tint was also not like that of the two other families Kalec knew existed thanks to Malygos. The only similarity between the females was their smooth, nearly glass-like skin, so different from the typical rough hide of most proto-dragons.

"We were three in the clutch. Three to survive. Now, only two."

Malygos dipped his head in understanding. For proto-dragons a surviving clutch of only three eggs meant ill tidings for the family. Indeed, in many a healthy proto-dragon family, a sickly offspring such as the yellow female would have been slain at hatching.

She seemed to be waiting for some more elaborate response from Malygos. He finally said, "Your clutch brother. His death was strange."

It was certainly not how Kalec would have replied if he were in Malygos's place, but Alexstrasza's sister seemed pleased. "Yes! He died strangely! How did he die?"

"I do not know."

The smaller female leaned closer. "There was another—"

"No, Ysera!" interrupted Alexstrasza sharply. "We agreed that—"

Whatever she said next was lost to Kalec, who took advantage of Malygos's view to stare in amazement at yet another of the Great Aspects. Having known the Ysera of recent times—Ysera the Awakened—he could not imagine how this weaker creature could have become one of the most powerful forces in all Azeroth.

Snapping and hissing brought Kalec's attention back to what Malygos was experiencing. Alexstrasza and Ysera, their necks bent back, maneuvered as if seeking to fight one another. Each displayed

her sharp teeth and claws to her utmost, even Ysera proving capable of an incredibly menacing showing. Several times both heads darted in, but then pulled back once more.

Kalec knew such confrontations from his own kind and could generally recognize what was real and what was simply normal display, but with the sisters it was hard to tell. The jaws of both Ysera and Alexstrasza snapped dangerously close to the other's throat and the claws scraped against hides more than once.

And then . . . a sound louder than thunder stilled not only the sisters, but every proto-dragon in the vicinity.

The sound erupted again, shaking the rocky ridges upon which Malygos and many of the other hunters perched. Several of the proto-dragons were cowed, and Kalec felt even Malygos fight not to prostrate himself.

Only then did Kalec realize that the incredible noise was a gigantic *roar*.

A vast region of the overcast sky broke away, descending with astonishing swiftness. The velocity caused the clouds to quickly scatter, revealing a sight that truly could daunt not only a proto-dragon, but even the most powerful of Kalec's own kind.

This was supposed to be a proto-dragon, but so immense was its size that not even a dragon could be chosen for an adequate comparison. Kalec could think of no creature save one that could be used . . . and that would have meant comparing Galakrond to himself.

Even though Kalec had never seen the gigantic Galakrond in the flesh, the remote possibility that he would not have recognized this titanic being had been eliminated by Galakrond's name racing over and over through Malygos's mind. In addition, through his host's brief glimpse away from the Father of Dragons to the other proto-dragons, Kalec saw that not one of the hunters remained in the sky.

Galakrond now commanded the world above, and there was no proto-dragon foolish enough to challenge that rule.

He swooped down, passing over the entire region in a matter of seconds. In Galakrond's wake there came a vicious wind that even tore several proto-dragons from their roosts and sent more than one meal toppling to the ground far below. Galakrond's roar was no less ground-shaking miles away, forcing Malygos and the sisters to grip their perches tighter.

For such a colossal creature, Galakrond turned with remarkable agility. Once more, he passed over the now-panicking herd, but this time with intent. Galakrond seized up two caribou in each of his much larger hind paws and scooped up another whole in his gargantuan maw, then rose up. The grazer in his mouth vanished down his gullet and a moment later so did both of those in his left hind paw. By the time Galakrond leveled, all five of his catches were well on their way down to his stomach.

But five was not enough. Galakrond veered back and lunged toward the scattering prey. This time, however, he suddenly pulled back. Confused at first, Kalec watched as the bending of the vast wings during the halt created a windstorm that sent dozens of beasts rolling uncontrollably.

Before several of the caribou could rise to their feet, Galakrond plucked them up. With at least eight claimed that Kalec could see, the Father of Dragons soared back into the clouds.

It was not until several seconds after Galakrond's departure that the first proto-dragons dared move. There was no renewal of the hunt; not only were the caribou scattered so far and wide that pursuit would have required too much effort, but most of the proto-dragons were still too shaken up by Galakrond's startling manifestation. Some took to the sky themselves and fled for calmer climes. Others remained subdued.

The Father of Dragons . . . Kalec could still not believe the stunning image. To witness Galakrond alive was something he could never have imagined.

The blue knew little of Galakrond save that he had been one of the largest beings to roam Azeroth and that he had represented the shift from proto-dragon to true dragon. It was not that Galakrond had actually fathered all true dragons—that was a myth somehow spread millennia ago—but that after him had come the five Aspects and their respective dragonflights. Proto-dragons had all but vanished after that.

There were other legends concerning Galakrond, but, in truth, Kalec understood that only his three counterparts knew the truth. He had never thought to ask them about the Father of Dragons, but now wished that he had.

Yet, Kalec's momentary awe soon gave way again to his anger and frustration—and growing concern—over his being trapped in these ancient visions. Each one seemed more and more lifelike, as if his own time were the fantasy and this scene now were the true present.

Not for the first time, he tried to will himself back, but nothing changed. He continued to be an insignificant, unnoticed phantasm trapped within Malygos. Not even Alexstrasza or Ysera—both of whom in the future had abilities that would make them sense his presence—so much as glanced in curiosity at the male beside them.

I will be free! Kalec abruptly roared, though his roar went unheard by any save himself. Bereft of a throat—or a body—he felt like nothing but a memory remembered by no one.

Laughter filled his—or rather, Malygos's—ears. Kalec at first thought that someone mocked him, but instead, the laughter was aimed at the other proto-dragons by a charcoal-gray male a bit larger than most, who actually sneered at the others.

"Little hatchlings!" he bellowed. "Afraid of the sky! Afraid of the ground! Galakrond laughs at you for being afraid, and I, Neltharion, do, too!"

Some of the proto-dragons hissed at the gray male, but no one challenged him. By their glances, they knew him to be strong and able to back up his taunt. Even those proto-dragons who clearly had little more intelligence than their prey appeared to know better than to fight—

Neltharion? The name finally penetrated. Kalec sought in vain to seize control of Malygos's body as the newcomer, still laughing, flew off. Where Galakrond had been a startling, unsettling thing of legend, this gray male represented a danger to the future of all life on Azeroth. If there was a creature more evil than Neltharion, Kalec could not think of one.

Of course, by the blue's time, the gray male would be better known by his more apt title . . . *Deathwing*.

FOUR
UNLIKELY ALLIES

Azeroth had suffered many terrible times and menaces, the demons of the Burning Legion and the Sundering but two of the most devastating. Yet, to the dragons, to many inhabitants of the world, there had been no greater peril than the mad Aspect. From the War of the Ancients ten thousand years ago to recent times, he who had once been the Earth-Warder had sought the destruction of all things.

Deathwing was gone now and at tremendous sacrifice, but Kalec, still able to watch Neltharion flying into the clouds through Malygos's gaze, wondered how Azeroth would have fared if Deathwing had never been.

Follow him! he urged Malygos, to no avail. *Follow him and end the horror before it begins!*

His host did nothing. Malygos lost interest not only in Neltharion, but also in all else going on around him. Without a word to Alexstrasza or Ysera, he leapt into the air and headed to the north. A few proto-dragons nearby hissed at Malygos as he passed, but the icy-blue male ignored them. He had eaten his fill and only wanted to curl up in his remote cavern for a long, pleasant nap while he digested his meal. That Kalec had no desire to do the same was, as usual, lost upon the proto-dragon.

But suddenly something hard collided with Malygos from behind. He rolled in the sky, then began to plummet. As he struggled

to regain control, both he and Kalec caught a glimpse of the cause of their troubles.

Coros and another male of the same hue dived down to attack. Malygos managed to slow his descent, but could still not right himself. Coros and his comrade hissed eagerly as they neared.

Malygos opened his mouth. A shower of icicles shot forth. Coros evaded them, but the other proto-dragon did not entirely avoid being struck. The icicles slashed through one wing.

But once more Malygos was hit from behind as a third foe entered the fray. Kalec, helplessly watching, guessed that Coros had set up this attack before Galakrond's appearance. From Malygos's jumbled thoughts, Kalec picked up bits of a long rivalry over territory, prey, and who was more cunning. At the moment, it seemed that Coros had the advantage in the last.

Coros exhaled, and what appeared to be a web of smoke enveloped Malygos. The icy-blue male fought for breath as the smoke sealed off his nostrils and mouth.

Despite his wounds, the first of Coros's companions reentered the struggle. With an eager expression, the proto-dragon opened wide as he sought Malygos's throat.

Thunder roiled . . . or rather a sound like thunder. Malygos's wounded attacker dropped as if hit by a thousand dwarven hammers.

A hearty laugh followed the jarring sound. Kalec saw a gray blur cross Malygos's path, then collide with Coros.

"You want a fight? Fight me!" cried Neltharion as he grappled with Malygos's rival.

This was a foe that Coros could not have counted on, but he did not back down. He opened wide . . . and Neltharion slammed the blue-green's jaw up, closing the mouth at a critical moment.

Coros jerked away from his opponent. The blue-green male clawed at his mouth, ripping away scale and skin until he managed

to open it again. Neltharion's act had managed to turn the other proto-dragon's breath weapon against him in a manner that both Malygos and Kalec admired.

However, the gray's amusement at his success left him open to the third of the attackers. The remaining blue-green landed atop Neltharion, wrapping his hind paws around the gray's throat. At the same time, he sought to bite through one of Neltharion's wings.

But in the next second the gray's foe was torn free of his prey by Malygos, who had finally had the opportunity to recover. Malygos ripped at the other proto-dragon's wings and neck, scoring two strong strikes. Blood splattered his muzzle as he tore into his target.

A wildly flapping wing hit Malygos hard in the face. It startled him enough to make him loosen his grip. His adversary used that moment to pull free. Rather than turn to fight, the wounded leviathan retreated as swiftly as he could.

Another of the attackers soared past Malygos. Only belatedly did Kalec and his host note that fleeing figure as Coros. Of the final member of the treacherous trio, there was no sign.

"Too short! Cowards! Come! Fight again!" Neltharion roared after the two diminishing figures.

Despite their clear victory, Malygos radiated no interest in wreaking further damage on his old rival. He watched silently as the gray continued to berate the losers until they were out of sight.

Finally losing interest, Neltharion spun to face Malygos. "You fight good! Not as good as Galakrond, not as good as me, but good!"

Malygos nodded. "You fight very good. Malygos thanks you."

The attempt at gratitude received a hearty laugh. "No! Thank you! It was a good fight!"

Malygos did not shrink from a battle but, unlike Neltharion, did not savor it. Within, Kalec remained torn between being relieved

that Neltharion had come to their aid and feeling anxious that the future Deathwing hovered before them.

"A good fight, yes," the icy-blue proto-dragon finally agreed.

"We are brothers in blood," Neltharion continued, shifting closer. "Both smarter than the others, too!"

The other proto-dragon did not disagree. For all his bluster, Neltharion was clever. Malygos's interest turned to another astonishing subject stirred up by a chance mention from the gray. "Galakrond. He never hunts here. Why now? You know?"

"Ha! Galakrond hunts where Galakrond wishes!" Yet, after saying that, Neltharion paused. After visible consideration, he added, "More food. Yes, more food here."

"More food," Malygos agreed. A horrifying thought occurred to the proto-dragon. "Our food!"

Neltharion understood immediately. "Our food . . . not good."

"No. Not—" Something on one of the nearby hills to Malygos's right caught the proto-dragon's attention. Malygos immediately glanced that way, enabling Kalec to also look.

"They come back?" the gray eagerly asked, referring to Coros and the other two.

"No." Malygos remained distracted by whatever he had noticed, but his thoughts remained murky to Kalec. Malygos suddenly arced toward those hills, a curious Neltharion accompanying him. They arrived but scant seconds later, whereupon Malygos began to survey the vicinity.

"Nothing here," Neltharion concluded long before his companion was satisfied. "No enemy to fight. Shame."

"No enemy," Malygos reluctantly agreed. "I—"

Again, the future Aspect noticed something at the edge of his vision. This time, he reacted even more quickly.

"Something?" the gray asked with rising interest.

Malygos squinted. Kalec saw nothing through his host, but felt Malygos tense as if *he* did.

So powerful a sensitivity . . .

The words were not Kalec's. Nor were they Malygos's thoughts.

Despite being well aware by now that he had no true voice, Kalec could not hold back a gasp of discovery. To him, part of the landscape *moved*, a ripple little bigger than a tall human. It moved only a short distance to the side and did so slowly, almost as if seeing what would happen. To the eyes of most, it would have been unnoticeable, and Neltharion was evidence of that. He snorted and peered elsewhere while he patiently waited for Malygos to finish.

Look there! Look there! Kalec demanded fruitlessly, yet it became clear to him that Malygos did not quite see what he did. Malygos finally gave up, turning back to Neltharion—

In that one instant, Kalec—not his host—saw what watched.

And, as he did, the world spun madly. Kalec became lost in a black maelstrom. He had nothing upon which to grab hold, either physically or mentally. The blue sank into a dark, endless hole—

Only to wake up on the floor of his sanctum, his body—his still-contorted, part-dragon, half-elven body—awash in sweat.

Groaning, Kalec dragged himself toward a nearby wall. As he approached, a small, shimmering fountain of silver water rose from thin air. It directed itself toward the slowly transforming dragon, who opened his stretching muzzle wide and swallowed the cool, refreshing contents. As the magical liquid coursed through him, Kalec's mind began to reorganize itself.

His first thought was not about what he had seen in that last moment, but about the true bane of his existence. Managing to rise, the blue dragon returned to the secret place where he had put the artifact.

Not at all to his surprise, it glowed as he had first noticed in the

wastes. The glow faded immediately, but Kalec was not fooled. The artifact was active and had probably been active from the moment that he had sensed its existence.

Kalec no longer cared for what purpose it had been designed. He wanted nothing more than to either destroy it or cast it far, far away.

Well aware of the potential for disaster when dealing with *any* magical object, Kalec chose the latter course. He pictured a place obscure to most and used a spell to send the accursed artifact there.

An immense wave of relief overcame him. Kalec slumped back, grateful for the peace of the moment.

Without meaning to, his attention returned to the essence of the visions. Malygos, Alexstrasza, Ysera, and Neltharion. Four of those who would change Azeroth forever as its guiding Aspects. Kalec assumed that somewhere in those visions, a young Nozdormu had also appeared. The analytical part of Kalec wondered what the visions meant; the emotional part wanted nothing to do with them. Each vision burned deeper into the blue's mind. Kalec feared that if they had progressed, the visions would have eventually stolen his mind.

He returned to the magical fountain, a creation of his own that now proved highly beneficial. At last satiated, Kalec forced the visions from his thoughts. He had more important, more immediate, concerns—

A thing of horror rose before him, a cadaverous dragon with sunken white eyes and shriveled flesh. Rotting tongue dangling to the side, it lunged for Kalec—

And vanished.

Kalec shivered. His heart beat wildly. The stench of decay still lingered in his nostrils, even though it slowly dawned on him that

what he had seen had not actually stood before him but rather had been a product of his imagination. It took much to unnerve one of his kind even for a moment, but this horrific sight had certainly done so. Kalec could still not shake the sense that he had *smelled* the apparition, although that was impossible. . . .

As Kalec's calm returned, his first thought involved the artifact, but it was hundreds and hundreds of miles away. Kalec could not believe that it could affect him from so far. Still, the more he recalled glimpses of the macabre illusion, the more details that hinted of the artifact's connection came to light. This had been no dragon, but a proto-dragon whose size had been shaped by Kalec's own mind . . . and the blue had not even thought about proto-dragons until finding the accursed thing under Galakrond's frozen bones.

Galakrond . . .

Voices arose all around Kalec, but he knew immediately that they came from within, not without.

This thing is dead! This thing cannot fight!

Kalec roared, his cry echoing through his sanctum. The roar did nothing to drown out the ever-increasing voices. The dragon desperately spun around, his tail crashing against a wall with such force that it cracked the rock.

"I will not listen! I will not succumb!"

So many dead . . .

We cannot fight. . . .

It must be done, no matter the sacrifice.

The last voice cut through the rest. With it came another manifestation in Kalec's mind, one so real that yet again he thought it stood before him.

The hooded, robed figure.

The phantasm vanished back into the darkness within. Kalec remained utterly still, afraid that if he even moved, the entire

madness would begin again. When it did not, he took a long breath and thought hard. He could think of only one recourse.

He would have to seek out Alexstrasza again.

For most, the task of finding her, the one who had once been the Life-Binder, would have proved daunting. Alexstrasza stayed in no place for very long, perhaps because if she did, she might dwell too much on what had been lost. Kalec understood that she had come to grips with the fact that the dragons as a race were no longer viable, that the last eggs had hatched and from here there would only be fewer and fewer dragons as time and circumstance took their toll.

Yet, perhaps through some lingering link from their roles as Aspects or simply because he understood her more than he realized, Kalec located her after only a few false trails. He flew low over the forested land, finally transforming to his humanoid form a good distance from his goal. He did the last not because he sought to surprise her, but rather so as not to frighten the inhabitants of the human village he had seen in the distance.

The giggles of children reached him before he found her. Kalec saw the four youngsters playing among the trees just beyond the village's boundaries. The game of hide-and-seek seemed to be a fluid one, for the seeker appeared to change from one moment to the next.

A man's voice called the children back into the village. There was always the danger of wolves or other threats, although this land appeared fairly peaceful in comparison to many in the changed world. Moreover, considering the two figures now nearby, the children and their village were, for a short time, safe from almost anything.

"They seem very happy," Kalec commented.

A part of the tree to his left separated. The facade of bark faded,

revealing a beautiful, fiery-tressed woman dressed in form-fitting gold-and-crimson armor. She loomed over Kalec and appeared to be from some far more glorious and mysterious elven branch. A regal crimson cloak flowed behind her as she joined him.

"They are so young," she murmured, her brilliant red eyes somber. "They have such vitality. I see why Korialstrasz enjoyed their particular kind so much."

Kalec briefly bowed his head in memory of perhaps the most legendary of Alexstrasza's consorts even though his own relationship with Korialstrasz—who had also worked among the younger races as the mage Krasus—had been tempestuous at times, to say the least. They had come to an understanding well before the red male's death, but Kalec felt some guilt about the past schism whenever Alexstrasza brought up her beloved mate.

"Humans hold much hope, but they do also hold much threat," he could not help finally responding. "The Lich King was once human."

"And many of those who fought him hardest were human, too." She returned her gaze to the village. "Was there something you wanted?"

He suddenly felt so very young, almost as young as the children they had been watching. "I wanted . . . I wanted to ask some things of you when we gathered at Wyrmrest, but the gathering ended so quickly, so abruptly. . . ."

Alexstrasza looked back. "I am so very sorry. We did not treat you with the respect we should have. The moment just overtook the rest of us. It is not an excuse. We were remiss."

"I am aware that you three share something I can barely fathom. I am still honored that I was chosen, even if for a short time." Kalec exhaled sharply. "Alexstrasza. After the three of you left Wyrmrest, I found an artifact of an unsettling nature. I need your guidance—"

"'Guidance'?" For the first time, she did not look pleased with his presence. "My advice will avail you little, Kalec. I would think that you, being a blue, would certainly be better at deciphering some artifact's design and purpose than I. In fact—"

The children ran into sight again. Although they remained within the confines of the village, their playing was still visible enough to draw Alexstrasza's attention. She clapped her hands together in delight as a small girl paused in her play to hug what was likely her slightly older brother.

Kalec started to talk, then noticed how strained her smile actually was. He envisioned all the lost lives, especially those young like these children, and how they had affected the former Aspect inside. Alexstrasza herself had suffered more than most. Not only had all her eggs been destroyed by Korialstrasz—in the act sacrificing himself— to prevent their corruption into monstrous twilight dragons, and her ability to lay more been forever taken away, but in addition to all that she lived with the knowledge that the other dragonflights had also suffered so. She might have accepted her loss of power, but not this loss of her kind's future. After all, she had been the Life-Binder.

Stepping back, Kalec left Alexstrasza to her viewing. He could not bring himself to pursue matters with her. In silence, he strode deeper into the forest, waiting only until he was far enough not to frighten the humans before transforming into his true form and flying off.

Twice now, his hopes of understanding and guidance from one of the elder dragons had ended in futility. Alexstrasza had even intentionally pulled away from him when he had mentioned the mysterious find. True, as a blue he was still more in tune with all facets of magic, but her experience might have proven invaluable.

She—they—have withdrawn from the world, he realized. *They have accepted their loss of power, as have I, but now they no longer see*

themselves as part of Azeroth's future. . . . Kalec could only imagine how Alexstrasza and the others, with so many millennia of burdens upon them, felt—

Dead! It is dead! It should not fight!

Another! Beware! Another—

Intense vertigo once again overtook Kalec. The blue dragon tumbled forward, dropping hard as he did. He crashed into several treetops before being able to right himself.

The voices receded. Kalec, exhausted by the struggle, landed hard, then blacked out.

He awoke what seemed barely a few seconds later. The voices had completely disappeared and no visions assailed him. Kalec rose gratefully, peering around as he tried to regain his bearings.

The dragon's gleaming eyes widened in shock. He was no longer near the region where he had left Alexstrasza. The trees around him were more sparsely spread and a deep, twisting canyon stretched for miles to the north. This nameless location was far from any civilized area, either Alliance or Horde. Very likely few knew it to any degree, but of those few, Kalec suspected that he knew this region most of all.

Some force had transported Kalec far across Azeroth . . . and the blue dragon had to look no further than the accursed artifact, which suddenly lay only a few yards before him, once more ominously aglow.

FIVE
GALAKROND

The blue dragon exhaled furiously at the artifact, enveloping it in bitter frost. He brought down one heavy paw on the now-glistening relic. Where good steel—turned brittle by the magical chill—would have easily shattered, Kalec's odd nemesis retained every aspect of its essence, leaving the dragon with a very pained appendage.

"You will not be my master!" the blue roared, not caring if anyone heard the echo of his voice. "Curse someone else, you fiendish toy!"

The octagonal relic glowed brighter yet. Expecting the worst, Kalec immediately pulled back.

Nothing happened. Kalec ran a paw over the piece, but still the artifact did nothing. Even then, the blue could not help feeling that with each passing second the mysterious object insinuated itself deeper and deeper into not only the dragon's mind, but also any *soul* one of his kind might have.

Seizing up the relic, Kalec prepared to throw it deep into the valley. However, as he raised his arm, the limb ached terribly. Indeed, only now did the blue feel the stress and strain all over his body. Kalec felt as if he had flown halfway around the world—

Flown . . .

Testing his wings, Kalec found that they, too, moved with pain. The leviathan's anger kindled anew. It had been his *own* magic and muscle that had dragged him all the way to this land. He could only

imagine how he had made the journey. Had he flown unconscious all that time?

It does not matter! Kalec forcefully reminded himself. *All that matters is to free myself from its foulness. . . .*

But how he could do that remained a question unanswerable. Rather than cast the artifact away again, Kalec pressed it tight to his chest, then leapt into the air.

No sooner had he done so than Kalec abruptly veered north. As if by some miracle, he felt as if he suddenly knew how to divest himself of the monstrous relic. With great sweeps of his wings, the blue dragon headed to the very place from which he had dug out the artifact.

The frozen bones of Galakrond.

Fighting his exhaustion, Kalec continued his hard pace and managed to reach the Dragonblight as dark approached. The wastes and the dragon graveyard came into view soon after. Kalec spotted the outline of the temple, then adjusted his path accordingly.

Even in the gloom, the ancient behemoth's skeleton was somehow visible where the remains of the hundreds of other dragons who had passed on during the many successive millennia were now no more than dark mounds. Kalec landed in silence, feeling suddenly as if he disturbed their rest. Still, now that he had come this far, the blue had no intention of turning back.

Recalling where he had dug up the relic, Kalec transformed, then created a faint golden globe to light his path. Now holding the artifact in the crook of his left arm, the false half elf closed on the towering skeleton. The wind tore through the graveyard and the icy ground crunched under his boots.

A long, lingering moan sent a chill of a different type down his spine. He paused, the floating globe moving by his will in the direction of the terrible cry. Seeing nothing, Kalec took a step toward

the sound. After a moment, he finally realized that the moan was the wind blowing through the eye socket of the gargantuan creature's skull.

A new shiver ran through Kalec as he recalled his vision of the living Galakrond. That such a being had lived, a proto-dragon that dwarfed dragons, filled him with awe. Galakrond was legend, but to see the legend living . . .

But then disturbing thoughts arose. Kalec wondered what place Galakrond had in this madness. The one vision appeared to have focused on him. Kalec vowed that once he had finished with the foul thing resting in his arm, he would still try to find out more from one of his former counterparts. The blue had little else to do anymore.

Seeing the area from a much lower perspective, Kalec noticed things that he had not before. In the glow, he noted footprints. It had never occurred to him that this sacred place had been visited by other creatures. Some of the prints were large, although not as large as those of dragons. The round, blunt shape indicated the presence of magnataur—huge, savage hunters whose lower half resembled the body of a woolly mammoth, while the upper torso was like some bestial version of a night elf or human with giant tusks.

Why the magnataur had been hunting in the wastes was a question that was not satisfactorily answered by the smaller, hooved tracks Kalec noted. At least two of the bison-like taunka had also been through the area, which was situated fairly far from their home territory. The taunka were also more civilized than magnataur and had a great respect for the dead, which made their being here more curious.

Something long and thin lay at the edge of the globe's illumination. Directing the globe closer, Kalec saw that it was a magnataur spear. The tip, partially visible, was stained with blood, and the blue noticed that some of the ice close to the point was

dark. The magnataur had brought down its prey, but there was no sign of the body. Kalec supposed that the beasts had taken away the unfortunate taunka's corpse for food.

With disgust, Kalec turned back to the rib cage. He stepped up to the nearest of the high, arcing bones and, after a hesitation, stepped within the Father of Dragons.

The moment he did, Kalec sensed that he was not alone. He quickly sent the globe forward.

A thickly furred female taunka stood under the arch of another rib. She leaned on a primitive spear made of some long bone and tipped with a rock honed sharp.

"Hail to you, dragon," the white, bison-headed hunter rumbled as she bowed. She was clad in simple leather garments which she had no doubt fashioned from her own kills. "I am Buniq. I did not mean any sacrilege here."

That she had seen him transform despite the darkness did not surprise Kalec. In a land where it was often as dark as night even in the day, a good taunka hunter had to have fair night vision.

"I've no quarrel with you, Buniq," the blue returned. He kept the artifact as well hidden by his arm as possible, even subtly shifting the glowing orb so that it slightly blinded the taunka.

She raised her other hand to shield her eyes. "Nor I with you. My kind do not come here often, but I was in search of a relic from this place to bring back and thus prove myself worthy of him who loves me."

Kalec held his surprise at her reason for being here, but assumed she could not possibly be hunting what he carried. Growing impatient to finish burying the foul thing, he curtly replied, "I will not stop you from going on with your search, then."

"This ground is as sacred to us as it is to you," the taunka went on, as if not hearing him. "The magnataur, they care nothing about

anything. They seek only to fill their stomachs." Lowering her hand, Buniq took a step toward him. "But for as long as there have been taunka, we have respected the resting place of the great ones."

"And I am pleased to hear that, but—"

She set the butt of the spear on the ground again . . . right next to the very hole to which Kalec was heading. "A world without dragons, that would be a strange place. Not so good. There would be no . . . harmony. The world is hard enough to survive. The world needs dragons."

Kalec chose not to comment on the adverse effect Deathwing and Malygos had had on Azeroth. Instead, he sought some other way in which to hint to the overly talkative taunka that she should depart.

Suddenly, he noticed that Buniq was no longer standing before him.

Kalec spun . . . and discovered her near the rib by which he had just passed. The blue could not recall her walking past him, but Buniq, her back now to him, clearly must have. The sphere illuminated several of her steps in the chilling ground.

As if sensing him watching, she looked back. The taunka's large brown eyes focused not on Kalec, but rather on the crook of his arm.

"Some things should not remain buried," Buniq quietly commented. "Fare you well, great dragon."

Somehow, Kalec's hold on the relic slipped. Looking down, he seized it before it could fall free.

Straightening again, he demanded, "What do you mean by—"

But Buniq was nowhere in view. Directing the sphere toward where he had last seen her, Kalec could not even find any trace of the tracks he had seen a moment ago.

The blue stepped back. He refused to think that the taunka had

been some figment of his imagination. What he suspected was that the foul artifact had once more toyed with him. Kalec focused on reburying the relic and leaving its madness behind. He started to set it back into the hole . . . then, in the light of the sphere, he noticed something where Buniq had momentarily set her spear.

A hand.

The blue swore. Despite where it lay, the hand was almost entirely intact. And though it was of similar appearance, the lost appendage was clearly larger than that of a human or a dwarf. It had a peculiar gray coloring that also unsettled Kalec. However, after a closer study, what he had thought flesh proved to be the remnants of a glove.

How he had missed the hand last time, Kalec discovered quickly. A chunk of frosty ground had covered it until Buniq's spear had loosened the dirt. The blue glanced over his shoulder, almost certain that she would be standing there, but of the taunka there remained no sign.

Despite the grisly find, Kalec nearly dismissed it until he saw that there was something else caught in the palm. It was small, round, and at first appeared to be glass. However, when Kalec dared touch it, he felt an odd warmth.

The octagonal artifact began to glow blue. Blue, not lavender.

With an even stronger epithet, Kalec stumbled back. What this meant now he did not know. The relic fell from his arm, landing atop the gloved hand—

The world flashed blindingly bright.

"This is not true," said a voice Kalec recognized as a young Ysera's. "They are wrong. . . ."

"He is not very smart," Malygos's voice returned. "But smart enough. . . ."

Suddenly, Kalec could see again . . . and what he saw was another

shriveled proto-dragon corpse. This one had once been ivory, but now looked dusty white. Like the previous one, the face was contorted, as if the death had been agonizing.

Malygos's gaze swept past Ysera and a briefly viewed fire-orange figure that Kalec assumed was her sister to another location a little farther off. There, a *second* corpse lay sprawled. This one still retained some of the icy-blue coloring that marked it as one of Malygos's own.

And apparently a proto-dragon Malygos knew. Various emotions played out, including those attached to memories of younger days. A name—Tarys—came to Kalec's mind. As juveniles, Malygos and Tarys had hunted together while learning the proper tactics.

Kalec noticed that he felt his host's emotions more clearly than ever. There was some change in the vision, some new vividness, as if Kalec were now even more a part of it than ever.

It was not a thought that, under the current circumstances, comforted him.

Malygos's thoughts came as both words and images. There were tales being told, unthinkable tales. Malygos did not know what to make of them. Ysera thought them false, while Alexstrasza believed that they should at least be considered.

Galakrond had supposedly slain these and at least a dozen others.

The source of this discovery huddled next to Alexstrasza, somehow managing to look smaller than Ysera despite that not being the case. Purple in color, he looked half-dead himself.

"Swallowed them up! Swallowed them up!" he repeated over and over.

"These are not swallowed," Ysera pointed out, still showing her disbelief. "Galakrond not like them?"

"Swallowed them up!"

Ysera scowled. The purple cowered more. Her tone reassuring, Alexstrasza murmured something in his ear. The scowl's focus shifted to Ysera's sister, but Alexstrasza pointedly ignored it.

From his host, Kalec understood that the sisters had come across this shell of a proto-dragon and, after listening to what Malygos secretly half-considered babbling from the purple, had gone in search of the icy-blue male. Malygos did not know exactly why they had decided to come to him save that he *was* very clever.

Trying to find a way to continue to be clever to them, he eyed the corpses. "More around?"

"More . . . yesss . . . more!" The purple male glanced nervously to the west, to where the land first rose to a high ridge, then dropped some distance. The party had come from the east and so had had only a glancing view of that direction. Malygos had been to the area before—the hunting for grazers was excellent here during the spring—and remembered only that there was a river below, knowledge that certainly was irrelevant to the moment.

Not sure what he expected to find, Malygos headed in that direction. Kalec was also curious and glad that his mind and that of the proto-dragon seemed so in sync. Kalec observed everything that passed his host's gaze and suddenly noticed some marks in the dirt that looked as if a creature the size of Malygos had dragged itself toward the ridge.

His host did not see what he did, at least not at first. Only when he had just reached the top of the ridge did Malygos abruptly turn and eye the trail with interest. He leaned over the tracks, sniffing them. A peculiar stench—yet one not all that unfamiliar to either— filled his nostrils.

On the other side of the ridge, rocks clattered. Malygos whirled.

The dreadful vision that Kalec had experienced in the Nexus rose up over the ridge to attack his host. The rotting flesh, the sunken

white eyes . . . Even having seen the fiend before did not keep Kalec from wanting to pull back.

But Malygos threw himself *toward* the monstrosity, exhaling at the same time. His frosty breath enveloped the undead proto-dragon, freezing it.

But for only a second. Barely slowing, the shriveled corpse shook off the frost and continued its attack. The stench of decomposing meat sickened both Kalec and his host as they collided with the ghoulish creature.

Yellowed fangs sought Malygos's throat. Claws tore at his chest. Up close, the undead proto-dragon's countenance was even more awful, much of the skin having at some point been scorched. The scorched areas, more sensitive to decay, had crumbled inward in many places, giving Malygos and Kalec a view of the bloody, ruined interior of their foe's head.

As Malygos inhaled for a second attempt, the undead startled him by doing just the opposite. A putrid green cloud covered Malygos's head, filling his mouth and snout and burning into his eyes. Nausea overcame him and, as a result, also Kalec. To both, it felt as if their insides were putrefying. Malygos weakened, falling to his front knees.

A tremendous *whoosh*ing sound, followed by intense heat, jarred Kalec and his host to full consciousness again. Claws pulled Malygos back from the heat. His eyes cleared enough to give both a watery glimpse at what had happened.

Alexstrasza stood before their ghoulish foe, exhaling more fire on the undead proto-dragon. The creature burned well, but still did not fall. It converged on the fire-orange female.

"Let go!" Malygos commanded Ysera, who was the one who had pulled him to safety. She obeyed immediately. Although still reeling from the undead's ghastly breath weapon, Malygos knew that he had to help Alexstrasza in turn.

Malygos exhaled forcefully. It made his head swim and even Kalec thought they were about to black out, but somehow Malygos retained his sense of mind as his chilling breath joined the female's own strike.

More brittle now due to the flames, the undead proto-dragon cracked and crumbled with the additional and opposing force turned on it. A wing already fragmented broke off, followed by one forelimb. The fiend pressed forward, only to lose its tail and a hind paw.

The corpse collapsed, shattering as it hit the hard ground.

Alexstrasza looked in relief to Malygos, but Kalec's host had already spun around in Ysera's direction. Kalec at first thought Malygos had gone mad, but then sensed what concerned him.

Malygos fluttered up into the air just long enough to pass over Ysera. Of the cowering proto-dragon, there was no sign, and both Malygos and Kalec assumed that he had wisely fled. Still, he was not Malygos's target . . . that was the first corpse upon which they had come.

A corpse that Kalec saw was beginning to move.

The icy-blue proto-dragon fell upon the stirring body. To Kalec's dismay, his host sank his teeth deep into the corpse's throat. Malygos ripped away flesh and bone with abandon even as the body tried to shake free.

With one last vicious tug, Malygos tore off the upper part of the neck. The head flailed, the jaws seeking the living proto-dragon's own throat. Malygos twisted around, then released his hold.

The severed head spiraled through the air, then landed yards away. Its jaws clacked several times before the head finally lay still.

The body quieted a moment later. Malygos shook the foul-tasting bits out of his mouth and turned toward the remaining corpse.

But Alexstrasza and Ysera had already torn that one to shreds.

"It did not move," Ysera said after also shaking rotting flesh free. "We did not want it to."

Malygos nodded, but then saw a troubling expression on Alexstrasza's face. She studied the landscape, then looked at the others.

"More dead, he said," the fire-orange female reminded them. "Where are they?"

There came a plaintive cry from far away, one that made the unseen Kalec think of the cowering proto-dragon. Malygos instantly turned—

And Kalec found himself not only back in his own time, but once again a dragon. In addition, he was flying through the night sky, the artifact *and* the round, glassy fragment both clutched tight. The second piece lay attached to the top of the octagonal artifact, revealing that both had been one from the beginning and had merely been separated by time and circumstance . . . until now.

Yet, that did not bother the blue nearly as much as discovering his body acting on what he considered its own accord or as if another mind controlled it. Kalec halted, hovering over the dark landscape— some of the jagged mountains of Northrend on the edge of the Dragonblight, he belatedly noted—and trying to decide what he could do.

One desperate hope quickly came to mind. *If I can't bury it, maybe I can just let it—them—shatter!*

Without hesitation, Kalec released his hold. The combined relics plummeted toward the hungry mountains.

A sense of foreboding suddenly filled the blue. He dived after the relics.

Far below, their illumination swelled—

Kalec roared in protest even as he felt himself lose connection with the waking world to which he had only just returned. He had

one last glimpse of the sharp, rocky land racing up at him before plunging into the darkness within again.

For a single heartbeat, there was utter silence. Then, the voices rose from the darkness. They quickly grew from whispers to a manic cacophony that threatened to deafen the blue. The voices turned into frantic cries.

The world burst into focus again.

Shrieking proto-dragons darted through the cloudy sky. A thundering roar shook the warmer but still mountainous region Kalec now found himself—or rather, Malygos—in.

Something suddenly blotted out what light there was.

Malygos looked up—and both Kalec and he beheld the underside of a titanic proto-dragon that could be none other than *Galakrond*.

Kalec felt the fear that touched Malygos, but it was fear combined with a determination to live. Fear was no thing of shame, not when confronted by such a horrific threat. Malygos retained his focus, diving down toward a crevice just as Galakrond fell upon a silver-blue proto-dragon too panicked to choose one direction over another fast enough to evade the much swifter behemoth.

To Kalec's horror, Galakrond swallowed the smaller proto-dragon *whole*.

Only then did Kalec notice something even more disconcerting about the Father of Dragons. Galakrond's body seemed distended in odd places, especially his gullet.

What's happened here? Why is he doing this? Kalec wondered.

But there was no chance to seek an answer through Malygos, for just then something collided with Kalec's host. Unprepared, Malygos flapped wildly as he sought to regain control. Through his eyes, Kalec briefly noted Coros hovering near the area before Malygos's spinning took the sneering proto-dragon from view. The blue-and-white proto-dragon's fury infected Kalec as well, and as

Malygos righted himself, Kalec looked forward to seeing his host deal with his rival.

Yet, before Malygos could act, a dread shadow enshrouded him. The proto-dragon looked up . . . directly into the vast gullet of Galakrond.

The jaws closed on Malygos.

Malygos . . . *and* Kalec.

PART II

ONE

THE NEXUS TOUCHED

The hot, malodorous breath nearly overwhelmed Kalec and his host as the jaws closed. Kalec wondered if perhaps it would be best for Malygos to let the stench knock them out so that they would not feel the monstrous teeth crush through their shared flesh and bone.

A violent, steaming burst of wind suddenly threw Malygos back. The burst was accompanied by an odd muffled thunder. At the same time, Galakrond's maw opened wide again, enabling Malygos to tumble to freedom.

Finally out of range, the blue-and-white proto-dragon frantically righted himself. As he did, both he and Kalec saw the source of Malygos's salvation.

With a defiant laugh, Neltharion darted away from under Galakrond's throat. Galakrond hacked, creating another powerful explosion of wind that forced back not only Malygos but also other proto-dragons in its path.

Neltharion had struck at the weakest point just at the right moment, an attack that Kalec would have thought foolhardy at the best of times. Even while regaining his breath, Galakrond had the cunning and fury to snatch at his tiny attacker as the charcoal-gray proto-dragon dived. Claws as large as Neltharion closed on him, but at the last second, a fearsome blast of what appeared to Kalec to be sand half-blinded Galakrond.

A dust-brown male veered off. Galakrond shook his head to clear his vision, enabling his prey to make good their escape.

Neltharion flew directly toward Malygos. "Fly or die!"

It was good advice to both Kalec and Malygos. But as Malygos turned, Galakrond's roar arose from behind them. The roar was accompanied by a *swooshing* sound and punctuated by a heavy thud and Neltharion's pained grunt.

Peering over his shoulder, Malygos saw that where the titanic monster's claws had missed, Galakrond's long, thick tail had not. Several times the length of Galakrond's hind limb, it easily caught Neltharion on the side, striking him hard.

Stunned, the gray male spiraled toward the harsh ground below. Perhaps Galakrond intended to pursue, but a panicked yellow female chose that moment to pass near enough in the gigantic proto-dragon's field of vision to attract his attention. With an eager roar, the hungry behemoth gave chase.

Unheedful of this stroke of luck, Malygos had already dived after Neltharion. The other male had endangered himself to save Malygos, and Kalec saw without surprise that his host could do no less. The blue-and-white proto-dragon stretched hard to reach the plummeting figure, but even as swift as he was, it was clear to Malygos and Kalec that there would be no catching Neltharion before the gray struck the ground.

A fire-orange form rose from below, colliding with the stunned male. Alexstrasza grunted hard as she and the bulkier Neltharion hit, but somehow the female managed to maintain control. For a few vital seconds, she stopped Neltharion's fatal descent, just long enough for Malygos to reach the pair.

Without a word, he gripped Neltharion by the shoulders, hefting the larger male up and relieving Alexstrasza of her burden. She, in turn, rose and assisted him with carrying Neltharion away from the vicinity.

Through Malygos, Kalec observed the area and found it astonishingly devoid of blood and torn flesh. He realized that Galakrond had swallowed nearly *all* of his victims whole. In some ways, the blue found that even more horrific, imagining how those proto-dragons had felt as they vanished in the behemoth's gullet.

"So many . . ." Alexstrasza gasped as they flew. "So many . . ."

Malygos said nothing, but his thoughts mirrored her words. Kalec's host was just as shocked by events as she was.

A new sound rumbled through the area, a sound so odd, so unnerving, that the two proto-dragons nearly lost their grip on Neltharion.

The sound grew more intense, more guttural—and because of that, more terrifying. Kalec still had no idea what it could be, but Malygos at last identified it with something from his own experience. Images flashed through Kalec's mind, images of his host regurgitating bits of bone or other inedible parts of various prey.

Somewhere, Kalec understood with growing sickness, Galakrond was doing something akin to that, only what he was disgorging was not the remnants of any buffalo or fish—

Kalec's world suddenly swam again. His consciousness was torn from Malygos. Visions of Galakrond feasting ran through Kalec's thoughts, and then the accursed darkness overtook the blue.

Yet, once more, a familiar voice called him from that darkness. *Kalec . . . Kalec?*

Why Jaina called him this time, the dragon did not know, but with what sense he still had, Kalec blocked his thoughts from her notice. Even as he did that, he felt the world around him return. A harsh wind struck his face. Kalec instinctively shifted position and discovered himself slipping.

At last able to open his eyes, the blue watched a rocky ridge slide up over him. Kalec realized that he was falling. With one paw, he

dug his claws into the dirt and stone, managing to slow his descent but not to stop it. Kalec tried to use his other paw, but it remained tightly shut despite his desperate need.

He toppled backward, finding out then that it was not a ridge from which he had slipped but a mountain. Kalec sought to right himself, only to have one wing clip the mountainside and send him tumbling faster. Below the blue, jagged rocks that reminded him too much of Galakrond's teeth shot toward him.

Managing to focus, Kalec cast a spell. His wild descent slowed nearly to a halt. It was a very short-term solution, but he hoped that he would not need more than a few moments. Catching his breath, the blue dragon rolled onto his stomach. Already feeling the hastily cast spell dissipating, Kalec flapped hard. As he regained flight, his spell faded away.

The blue dragon alighted on another mountain. There was no continued call from Jaina. He hoped that she had given up. Either way, Kalec had only one interest now, and that was the foul thing still gripped in his paw. The now-complete artifact seemed to taunt him with its persistent glow.

There was, naturally, no point in throwing it away. It would somehow return to plague him. He also doubted the wisdom of attempting to destroy it again. Kalec let the wind clear his head as he struggled to decide what to do next. If not for Jaina's voice, the blue would not have even been certain that he was in his own time and in his own body. It was becoming harder to separate reality from vision.

After several fruitless minutes of ruminating, Kalec launched himself toward the Nexus. Each moment of flight was nerve-wracking, with the blue expecting to be pulled back into the visions at the worst possible opportunity. When he had to fly over water, Kalec paid special attention to his protective spells.

But to his relief and astonishment, the artifact permitted him to reach the Nexus unhindered. Kalec decided to try to focus on something other than the object of his nightmares. The Nexus's collection *had* to be organized, even if he had initially made the suggestion as an excuse, not because he'd had any true desire to take on the task.

But he realized that before he could begin on the collection, he had to work on strengthening the wards. There was no chance that they would remain strong enough to protect the Nexus and its contents for very much longer unless he attended to them now.

He changed to his humanoid form, at the moment feeling oddly more comfortable in it than in his true one. Kalec summoned a simple marble stand with a fluted column and cautiously set the artifact atop the waist-high platform, then turned his attention to the wards. Shutting his eyes, he concentrated. Even with his eyes closed, the blue dragon could see the world around him, but it was a world crisscrossed with a variety of multicolored ley lines. All of Azeroth was draped in this complex arrangement of lines of magical energy, but those he currently viewed served a specific purpose. They powered the various wards that acted as the Nexus's protection. Following along the ley lines, he began to inspect each ward carefully.

Kalec quickly saw the weakest of the wards. He put forth a hand, which in this world view glowed with lavender energy, and gestured at the ley line needed. With his other hand, he drew from another of Azeroth's ley lines and linked the two where the core of the first lay exposed—

But before he could do more, the Nexus itself began to shimmer.

Dismissing his spellwork, Kalec opened his eyes and immediately looked to the artifact. Not at all to his surprise, it had taken on a different glow, this one matching the array of magical colors

associated with the immense forces in and around the Nexus. The stronger the relic's glow, the less intense was that of Kalec's surroundings.

That the artifact could have any effect on the Nexus stunned Kalec. It had done little when he had last brought it here, but then, the artifact had not been whole before. The missing piece had not only magnified the artifact's existing abilities but also possibly even stirred up others formerly dormant.

Kalec grabbed the artifact and transformed. Planting it against his chest, the former Aspect fled through the Nexus as quickly as he could. The energies of the Nexus continued to fluctuate as he raced through tunnel after tunnel, until at last he reached the exit.

Once outside, Kalec soared high into the sky. Below him, he could make out the entirety of the Nexus. The dragon sensed the various energies in play in a manner with which he was entirely unfamiliar. Kalec—who should have understood better than most the nature of such magical manipulation—could not fathom with what intent it was done.

The rich colors normally reserved for the Nexus's forces now radiated strongly from the artifact. As for the Nexus, it abruptly flared bright again, so much so that the blue dragon was forced to look away or be blinded.

And then the intense stirring of magical energy subsided.

What Kalec expected to see when he glanced back at the Nexus, he could not say. What he did see both perplexed and surprised him.

The Nexus looked and felt to him *exactly* as it had before. With a wary hiss, the dragon circled his sanctum once, seeking any change, however subtle. Despite his best efforts, Kalec still found no difference.

"All that could hardly be for nothing," he muttered to the infuriating object in his grip. "What did you do?"

The relic, its glow once more normal, gave no clue.

Snorting, the dragon dived back down to the gap through which he had emerged. As he entered, his gaze immediately went to the artifact. However, there was no change in the glow.

Kalec returned to his chambers, expecting each moment that the foul thing would begin anew to wreak havoc. That there was no visible sign of it doing so did not assuage his fears in the least. While Kalec was aware that he might only be feeling paranoid, there was still the chance that the artifact *might* be up to something even while apparently quiescent.

Determined more than ever to find some other relic that might help him combat the effects of the one he held, Kalec summoned forth an ancient piece in which he had particular hope. An oval crystal of a deep aquamarine hue and the size of his paw materialized in the air before him. Kalec was not certain of all its properties, but some of the knowledge that had been passed on to him gave him the impression that it might nullify the magic of the octagonal relic.

But the moment he touched the crystal, its rich hue faded. Kalec quickly probed the artifact. It was utterly devoid of any trace of magical energy.

A curse that mixed well the best—or worst—of dragon, human, and dwarf escaped the blue's mouth. Enraged at this latest, so swift defeat, Kalec threw the octagonal antiquity without care about what might happen. It flew with tremendous speed toward the wall, then came to a halt barely an inch from possible destruction. From there, it descended to the floor without even a sound.

The dragon roared. Unable to stop himself, Kalec unleashed a barrage of spells upon the relic. Fire sought to consume the piece. Bolts of arcane energy assailed it. A lance of ice attempted to pierce its surface. Lightning blasted it.

And none of the attacks left the slightest scar upon it.

His breathing ragged from the strain of his efforts, Kalec slumped. The artifact continued to glow faintly, again seeming to mock him.

The blue dragon brooded for a while, then suddenly stiffened. *Perhaps . . . perhaps I have been going about this the wrong way.*

Kalec had never really tried to understand the artifact. From the start, he had seen it only as something evil. Yet now he wondered what purpose there could possibly be in driving him mad.

Approaching the artifact, the dragon studied every bit of the exterior that he could see without touching it, but he noticed no change. Another probe with his powers also yielded nothing new. Still, Kalec was not satisfied. The artifact could even at this moment be in the midst of some preplanned spellwork that his acute senses could not detect. It had already proved itself capable of acting upon him without his noticing.

He focused on the small addition he had found during his second excursion to the skeleton. Simple as it appeared, it was obviously an integral part of the overall relic. Thus far, it seemed to him that it had magnified the original effect, but he believed it also did more.

A slight gleam in the center of the smaller piece caught his attention. The dragon squinted.

A young human woman with long blond hair stood before him, a woman he knew too well. There was an innocence about her, an innocence that drew him as much as her beauty.

"Anveena . . ." The blue dragon gasped. He reached a paw to her, only to have it go through her own extended hand.

Suddenly, Kalec stood in a forest. He was no longer a dragon but, rather, a half-elven figure. It was the same form in which Kalec had first met Anveena.

Kalec . . . Anveena faintly called, her outline becoming more faded and distant. She continued to extend her hand toward him, as if beckoning him to join her.

Kalec . . .

He was jolted. The second calling of his name had not been done by Anveena but by *Jaina*. It was enough to bring him back to consciousness.

Kalec wrenched himself away from the artifact. He was covered in sweat. He also noticed that, as in the dream, he had *hands*, not paws. At some point, Kalec had changed shape without even noticing it.

At that moment, Kalec felt the presence of another blue dragon. Somehow, the knowledge that he was no longer alone in the Nexus enabled him to pull himself together. Whirling away from the artifact, Kalec left the chamber to see who had returned and why.

It was not until he was nearly at one of the entrances that he saw movement. Kalec marched toward the newcomer without saying a word.

The smaller blue dragon—a female—had her back toward him. Kalec hesitated. "Tyri?"

The female turned, but she was not the one he had thought her to be. The former Aspect silently berated himself for expecting to see the female blue to whom he had once been promised.

The blue before him stared at Kalec as if seeing an orc. He recalled his transformation; although they were creatures of magic, blues generally retained their dragon forms when in the Nexus.

"Spell-Weaver," she finally acknowledged. "I thought you were away."

This time ignoring the use of a title no longer his, Kalec resumed his draconic shape. Now peering down on her, Kalec could not help

blurting, "And you hoped to be about your business and depart before I returned?"

She looked as aghast as a dragon could. "No . . . no, Spell-Weaver! In truth, I am pleased you are here. I wanted to tell you of an anomaly I sensed near the Dragonblight recently, very near Wyrmrest Temple—"

Kalec knew immediately that she referred to the artifact's stirring. "I know of it. There's nothing to concern yourself about."

The female looked slightly embarrassed. "I should have known that you would be aware of it."

That should have been the end of it, but the other blue dragon simply remained where she was, looking vastly uncomfortable.

Kalec made an assumption about what ran through her mind. "I am grateful for your concern. You were on your way somewhere else, though, weren't you?"

"Yes. I thought I would explore—"

He let her get no further. "Then, by all means, you should continue on. Again, you have my thanks for coming back to give warning."

She gave him another uncomfortable look, then, bowing her head, departed.

Kalec paused in thought for a moment and turned from the entrance—just in time to catch a glimpse of a shadowed figure the size of a night elf or a tall human in the darkened passage from which he had only just come.

The dragon surged forward, moving with more than enough swiftness to catch up with any intruder. However, even though he reached an area where the long passage would have prevented anyone from hiding or escaping into a side tunnel, there was no one. Kalec probed the area with magic, but there was definitely no trace of another.

Only as that knowledge sank in did the blue also see better in his mind just what that intruder had looked like beyond his mere height. The image that formed made Kalec certain that his sanity was indeed crumbling, and crumbling fast.

It was the same cloaked and hooded figure from the visions.

TWO
THE GATHERING

Kalec did not try to deny what he had seen. It had been either the product of his overstressed imagination or some new facet of the artifact's magic. Neither was a pleasant alternative. The first was an indication of just how unstable he might already be; if it was the second, it meant that the accursed object likely had some new game it wished to play with him.

He chose to consider it the latter and immediately raced back to where he had left the relic.

Unfortunately, the darkness caught him first, sending the blue tumbling against the passage walls. As great fragments of stone showered Kalec, the dragon—already barely conscious—pitched forward halfway to his sanctum.

But even before his body struck the floor, his mind found itself soaring in the sky. Kalec was once again a part of Malygos, but this was a Malygos much more subdued, much more driven.

In the distance, a thundering roar that could only have erupted from the jaws of Galakrond shook Kalec and his host. Fortunately, as the roar trailed off, its fading made it evident that the gargantuan proto-dragon was headed in a different direction.

Malygos pushed on, his thoughts so buried by his urgency that Kalec had trouble ferreting anything out. Kalec saw glimpses of Alexstrasza and Ysera, a handful of proto-dragons of the same family as Malygos, and flashes of Neltharion fighting something that was

too small to be Galakrond. After much delving, Kalec discovered that at least one of the memories involved Malygos staving off an undead proto-dragon with faded red coloring.

Kalec remembered the earlier struggle and knew that there had been no red proto-dragon other than Alexstrasza. For a moment, he feared that she had perished at some point and risen as an undead, as other corpses had, but then he realized that could obviously not be the case.

Yet . . . even if the undead proto-dragon had not been Alexstrasza, it still meant that once again, the dead had risen. Kalec did not know why, but he was certain that somehow the answer would be found with Galakrond.

It was something, he sensed a moment later, that Malygos also believed. Indeed, Kalec finally learned that Malygos had only just fled—*fled*—from the undead. There had been more than the one. There had been seven. Worse, Malygos had not been alone. He had been accompanied by two of his proto-dragon family.

They had not escaped.

Guilt washed over Malygos, and Kalec understood that he felt he should have stayed. Yet it was clear from what glimpses Kalec had of his host's memories that Malygos had only fled after the other two had been lost already.

Curiously—and most worryingly to Kalec—his host had blocked out all thought of just how the other two had perished.

There was no sign of any other proto-dragon along Malygos's path. While that meant little to Kalec at first, he gradually sensed Malygos's concern about this point.

It was with relief to both that another winged figure came into view a few minutes later. Neltharion still radiated a bit of his bluster, but even he watched the air around them with the utmost caution.

"Friend Malygos! Ha! You did come! We survive! We are fighters!"

Despite his bravado, Neltharion's tone hinted at relief that Malygos still lived. Kalec wondered how many others had not survived.

What is going on here? Kalec asked, although, of course, no one could hear him. Dragon legend said nothing of this evidently critical time period for the proto-dragons. The age of the dragons had yet to come, but with Malygos and the other future Aspects alive, that shift from proto-dragon to dragon dominance had to be imminent. Yet what Kalec had witnessed thus far pointed toward extinction for all. Even a true dragon could not stand against a horror like Galakrond.

"The others?" queried Malygos.

"The fire one, she is well. The little sister, she barks much." Neltharion paused, then less brashly added, "Zorix . . . he was taken."

In Malygos's mind, there appeared the image of a male proto-dragon with darting eyes and a shining golden hide. Even though Kalec had not seen this male before, both Malygos and Neltharion apparently had known him for part of whatever period of time had passed since the last vision. His loss disturbed the blue's host immensely.

"Talonixa speaks as him. Talonixa speaks too well as him."

Of this Talonixa, Kalec only sensed that she had been Zorix's mate and was a female proto-dragon of strong will. Among those proto-dragons who had made the sudden leap to intelligence, she was evidently considered one of the most cunning.

But for all that apparent cunning, Kalec's host did not have the greatest trust in Talonixa. It had nothing to do with her being a female—Alexstrasza's quick wits and courage had already raised her high in Malygos's eyes—but he considered other aspects of her manner dangerous. More, Kalec could not divine at the moment.

Neltharion's eyes narrowed. He looked past Malygos. The other

proto-dragon quickly followed his companion's gaze but saw only empty sky.

The gray male exhaled. "Nothing. Not him. Not them."

A shudder ran through Malygos, but Kalec's host blocked out all thought of what caused it. "The others gather?"

"Yes. Follow."

Both proto-dragons flew hard and fast, as if Galakrond himself snapped at their tails. Kalec became caught up in their urgency even though he knew only half of what was happening, at most.

Malygos continually glanced around, often focusing on the ground far below. Gradually, Kalec understood what bothered Malygos about the landscape. It was devoid of any visible animal life except for a few birds. No large beasts roamed any of the places over which the proto-dragons flew.

Eyeing Neltharion, Malygos asked, "We are close?"

"More to fly. Other roost fell."

It took Kalec a moment to decipher the last. Whatever previous site the proto-dragons had chosen to gather at had become too dangerous. They had been forced to move farther on.

A rumble from some distance behind stirred up both fliers. The gray proto-dragon glanced back. Malygos instinctively followed suit. There was no sign of Galakrond, but even Kalec was aware that the gigantic fiend could cover tremendous distances in the blink of an eye.

Hissing in frustration, Malygos started to turn his gaze back to the path ahead. Four winged forms coming from the north caught his attention. Eyes narrowed, Malygos studied the oncoming proto-dragons. "Others," he warned Neltharion.

His companion stared at the newcomers. "No one is north. North is bad."

Malygos hissed again. "Yes . . ."

The four proto-dragons drew near enough for some details to

become evident. To Kalec's relief, though, they were not what he expected. These were living, breathing proto-dragons.

But Malygos was not at all pleased, and Kalec quickly saw why. At the head of the formation flew a familiar blue-green proto-dragon. Coros. Kalec also recognized one of the others who had joined in the first attack on Malygos.

With a sneer at the four, Neltharion rumbled, "This fight, I like."

To both the gray's and Kalec's surprise, Malygos shook his head. "We fight the not-living. We fight Galakrond. Not one another."

"Hmmph! Coros know that?"

The other proto-dragons slowed as they approached the pair. Coros surveyed Malygos and Neltharion. "You live. Good!"

"Yes," returned Kalec's host calmly. "We live, and that is good. Coros also lives . . . and that is good, too. No fights between us. Fight only Galakrond, yes?"

Malygos's rival dipped his head as if taking the sentiment to heart. The sly grin ever remained in place, though. Both knew that only the dire circumstances kept them from concluding their bloody feud.

"The north is not good!" interjected an impatient Neltharion. He looked disappointed that there would not be a fight. "Coros should not be north."

"We scout. Talonixa asked."

"Talonixa?" Malygos repeated with some trepidation. "Why?"

"Talonixa plans!"

The icy-blue male refrained from snorting, although it took a struggle to do so. Kalec felt Malygos's growing concern over the female's overwhelming command of the other proto-dragons. Talonixa's kind were headstrong, impulsive, but also dominating. It was not a combination for which either Malygos or Kalec cared, especially now.

"The north," Malygos finally said. "Danger?"

To Kalec, who could do nothing but observe, the grin only grew slyer. "No danger. Coros too clever for stupid not-living."

This was not the first time Kalec had heard the unsettling term used, and despite his own predicament, that concerned him. *How many of those moving corpses are there? How many?*

More important, Kalec wondered just *how* they had come into being. In his own time, he lived in a world where, with the exception of the Forsaken—who had sworn their allegiance to the Horde— the undead were a not-uncommon menace, destroyed on sight whenever possible. Yet in such an early era in Azeroth's history, he had hardly expected to hear of such horrors.

"Too much talk!" Neltharion growled. "We all go!"

Coros did not argue, instead immediately veering past the duo. His comrades, all of the same family, followed without any further glance at the gray or Malygos.

"We fly faster?" Neltharion quietly asked Kalec's host.

Malygos nodded. "Yes. Faster."

And with that, they shot past a startled Coros and the rest. As Malygos pushed, he and Kalec heard Coros's angry hiss.

Kalec was not at all surprised to see that proto-dragons shared more than one trait with dragons. Among dragons, racing had always been a popular competition.

Malygos peered over his shoulder to see Coros and the others trying their best to catch up. However, Malygos and Neltharion set an astounding pace. Kalec could scarcely believe his host still had such strength, then sensed that Malygos had embraced the suggestion not only because of his disdain for Coros but also so that for a short time, the blue-and-white male could focus less on the horrors unleashed upon his world.

Despite the strain, Malygos continued to fly right alongside

Neltharion and several lengths ahead of his rival. Try as he might, Coros could not catch up, although he did soon leave his other companions far behind.

It occurred to Kalec, only too late, that spread out as they were, the six proto-dragons made a much more visible target, but fortunately, nothing happened. Still, he felt Malygos also relieved to arrive finally at a bowl-shaped valley where in the shadows it soon became apparent that scores upon scores of proto-dragons warily gathered.

The valley echoed with hisses as the newcomers descended, but not all of the reactions focused on the arrivals. There were members of nearly every proto-dragon family of which Malygos was aware, plus a few that Kalec's host did not recognize. Many were not by nature or by attitude on friendly terms with one another. Only the disaster sweeping over their world forced them now at least to *pretend* to be allies.

The tension was also magnified by the presence of many of the lesser—as Malygos thought them—proto-dragons, those that were essentially little more than animals. They had to be constantly herded or guarded by their more intelligent brethren. For Kalec, it set into stark relief the curious rise of those of Malygos's generation.

A throaty, harsh hiss rose above the din. It cut off the rest. Malygos followed the hiss to its source.

Talonixa dominated not only in voice but also in size and presence. She was a third again as large as most of the males, only a few, such as Neltharion, outweighing her. Her smooth hide glittered gold even under the overcast sky. Talonixa had sharp, gleaming black eyes that, when fixed upon individual proto-dragons, subdued even the most restive.

Malygos and Neltharion moved to where Alexstrasza and Ysera perched. Unlike many of the other proto-dragons, the sisters had kept to themselves and not their family. Some of Malygos's family

stared at his choice of companions, but there seemed no surprise on the part of Neltharion's family that he chose such odd friends. In fact, Kalec thought that its members looked a little relieved not to have to concern themselves with the brash gray.

Coros alighted a short distance to Talonixa's left. He was obviously out of breath but did his best to pretend he was as calm as Malygos.

"More have come!" Talonixa roared. "We are many! Say it! We are many!"

A chorus of proto-dragon voices repeated her litany over and over. Kalec shared Malygos's frustration with the proto-dragons now risking their hiding place as they followed Talonixa's lead. Strength was important, but common sense was something obviously not shared by all.

"She talks fighting," Ysera muttered. "Not good. Peace is better."

Although looking as disappointed as her sister, Alexstrasza disagreed. "We must fight . . . but not fight like Talonixa."

"We fight . . . we die!"

As the two females argued, Coros slid up to Talonixa and whispered to her. This snared Malygos's attention. He strained to hear anything but could not. Kalec was also frustrated; he did not trust Coros any more than his host did.

Talonixa listened intently, then dismissed Coros with a short hiss. He moved back to his previous position, seeming satisfied with whatever he had passed on to the larger proto-dragon.

"North is empty!" she proclaimed. "No not-living! Galakrond's trail is also found!"

Most of the other proto-dragons welcomed this news with nods and low hisses. Yet there were several who did not take the information with much pleasure. Malygos radiated a certain satisfaction with this as he studied some of the hesitant ones.

He focused on one in particular, but it was Kalec who first

recognized the male with the coarse brown hide as the one who had aided both Malygos and Neltharion during the confrontation with Galakrond. The brown male looked particularly perturbed by Talonixa's declarations and the other proto-dragons' willing submission to her. He turned away, only to meet Malygos's gaze.

Talonixa spoke again. "We fight soon! We gather more! Find others! There are others! Go! Come again with all when the moons are round!"

If the gathering appeared to end abruptly to Kalec, he quickly learned through Malygos that such a coming together of proto-dragons was uncommon in the first place, and it was a sign of both the magnitude of the threat and Talonixa's influence that this many had shown up so soon. Indeed, even despite the danger to all of them, several of the proto-dragons looked relieved to depart. Others went about the task of guiding their bestial brethren away, a scene that once more stirred Kalec's curiosity about the odd transformation overtaking the proto-dragons.

A transformation with little future unless they could somehow bring down the voracious behemoth in their midst.

Malygos watched with veiled eyes what Coros did. Unlike the others, he remained near Talonixa. As she herself readied to fly, the blue-green male slid up next to her and spoke.

Unwilling to trust his rival's influence on this situation, Malygos started for the pair, only to have Neltharion insert himself between Kalec's host and the duo.

"Friend Malygos! That brown! You see him?"

Coros glanced their way. The rival male sneered. Talonixa took that moment to fly off. Coros, now bereft of the subject of his attention, did the same a breath later.

Hiding his annoyance, Malygos turned his attention to the brown proto-dragon—

The world swam. Kalec briefly slipped into darkness, but if he had hoped that this presaged a return to his own time, his own body, he was sorely disappointed.

Malygos flew alone again, the proto-dragon warier than ever. Thanks to images flashing through Malygos's mind, Kalec quickly understood why. The proto-dragon flew over lands to the east, where there had been several sightings of the not-living. However, as with many other things in previous visions, the exact reason why Malygos was scouting on his own was *not* so apparent.

As with the last area the proto-dragon had flown over, the landscape below appeared empty of animal life. However, in this bleak place, neither Kalec nor his host had expected to see many beasts. Still, Kalec gathered that Malygos had seen absolutely nothing.

Alighting on a low peak, Malygos peered around. More thoughts crept through Kalec's mind, filling in some missing pieces. Malygos sought the reason for Galakrond's frightful transformation into this hungry fiend terrorizing all, and he sought it very near where the behemoth kept his lair.

Kalec questioned the sanity of what Malygos desired but had no choice but to hope that Galakrond was far, far away. Malygos believed that to be the case, but both were aware that there was a chance he was wrong.

Malygos's heart pounded from tension as the proto-dragon drew nearer to where the lair was presumed to be. The peaks there were so tall it seemed that they were trying to touch the cloud-enshrouded sun. Such giant mountains would be likely to provide caverns large enough to house a monster the size of Galakrond.

Something below caught Malygos's attention. He dived toward it. At first, Kalec saw only rock, but then he realized that a portion of that rock was of a disquieting and familiar color.

The bones had lain there for some time, possibly four or five seasons. Those that were visible indicated a beast as large as many proto-dragons—or, as Malygos discovered after scraping away the earth from one area, it was an *actual* proto-dragon.

This one had perished violently. Many of the bones were cracked, and the partial skull that verified just what lay there had been crushed by a tremendous force.

Galakrond, Kalec knew. Here was an early victim. While to him it only served to show just how long Galakrond had been on his murderous rampage, Malygos evidently saw something more in the bones.

Although no one had yet witnessed how Galakrond reduced some of his victims to emaciated corpses that would rise as parasitic undead, the evidence of their existence was without question after Malygos's battles. Yet Kalec now wondered, if this was one of the leviathan's prey, why had *it* not transformed as the others had?

Silence reigned about them, but something made Malygos look to his right. To Kalec's observation, there was nothing to see. Even a proto-dragon as courageous as Malygos could not be blamed for being jumpy under such conditions.

Returning to the bones, Malygos nudged a few around. With little exception, they revealed that Galakrond had ripped apart and chewed up this unfortunate creature. Malygos's memories of a much smaller but still imposing Galakrond briefly arose, giving Kalec a startling glimpse of how the latter had changed. Galakrond as seen in the earlier stage had looked much more like a normal proto-dragon and not nearly large enough to swallow others whole. His body also had had a smoother, streamlined appearance. His coloring had been more muted, and the eyes had not had that incessant hungering look to them.

Malygos continued to ferret around among the bones, seeking

clues. It was yet another hint—not that Kalec needed one—of how intricate his host's thinking was compared with that of many of the other proto-dragons.

Somehow, he survived, the disembodied blue thought. *Somehow, some of them survived . . . but how?*

The proto-dragon tensed again. This time, Malygos looked skyward.

To the east, a shape already far too massive to be a normal proto-dragon raced toward the mountains—and Malygos's position.

The mountains were too far away for Malygos to reach before he would be seen. Kalec's host had no choice but to flatten himself out where he was. His coloring did not blend with the land, but the hope was that Galakrond would not fly near enough to notice.

A constant, heavy beat preceded Galakrond, the sound of his vast wings flapping. Malygos knew that with each beat, the gigantic proto-dragon crossed miles. The beat grew louder, closer. Malygos and Kalec knew that Galakrond was almost upon them.

But then the beat began to recede. Through narrowed eyes, Malygos watched Galakrond head away from him and toward the mountains. However, just as the icy-blue proto-dragon dared draw a new breath, Galakrond halted. Hovering, the behemoth suddenly began heaving as if choking on something.

Neither Malygos nor Kalec paid much mind at first to whatever assailed Galakrond, the giant creature's physical appearance drawing their initial attention. Although it could not have been that long since the vision in which they had previously encountered Galakrond, Kalec was especially stunned by how much more misshapen the fiend had become. Not only was Galakrond oddly distorted, but he now had several growths randomly dotting his body. There were also a number of gray splotches that made it seem as if parts of Galakrond were *decaying*.

But just as Malygos and Kalec came to grips with this new, deformed Galakrond, the monster disgorged what had caused him such distress.

Bodies. More than a score of shriveled, limp proto-dragon bodies. They dropped in a horrendous heap to the ground, some flopping about as they struck. Malygos radiated immense distress at the sight, not only because of the awful slaughter but also because among the limp forms, he saw red, brown, gray, and even greenish-yellow bodies.

Kalec wished at that moment that he could throw up. In all his life, never had he—who had seen so much horror—witnessed something that struck him in such a nightmarish manner. He could imagine the final death throes of each and every victim and knew that so many more had perished the same way.

He suddenly felt Malygos's further fear upon seeing this grisly image. Alexstrasza, Ysera, and Neltharion were also in the region, and from a distance, Malygos could not tell whether the other three were among the corpses. Even though Kalec knew that all three had survived this era, he could not help but pick up his host's growing worry.

With one last purge, Galakrond finished. The gigantic proto-dragon immediately turned away, then took to the air again. As sharp as they were, Malygos's eyes could still not make out any detail on the odd growths marking Galakrond's body. Whether they had something to do with the behemoth's madness, neither observer could say, but Malygos at least wanted to see them better.

Yet Kalec's host was not foolhardy. He waited as Galakrond soared away, watching until the fiend had long vanished into the distance. Only after that did Malygos dare begin to rise—and then he instinctively dropped once more as three other proto-dragons flew in the direction from which Galakrond had originally come.

Why exactly Malygos had chosen to hide rather than rise and warn the trio was something Kalec sensed that even his host did not quite understand himself. However, as the three neared, their coloring gave hint that perhaps Malygos had taken the wise course.

The three blue-green proto-dragons soared over the landscape as if undeterred by the potential for disaster. Malygos watched as they neared where Galakrond had last paused. At that point, not at all to his surprise, he recognized Coros as the leader.

One of the other proto-dragons caught sight of the macabre remnants of Galakrond's last meal. He immediately hissed to Coros.

Coros led the descent to the corpses. He alighted near one, studied a few of the bodies for a moment, then glanced in the direction in which the murderous leviathan had headed.

With a hiss, Coros rose into the air and headed the same way. His two companions followed.

Malygos—and Kalec—watched with disbelief as the trio raced after Galakrond. Coros did not strike Kalec as suicidal, and Malygos's own thoughts mirrored agreement. Yet neither could fathom any sane reason for Coros to risk himself to such an extent. If he was simply spying on Galakrond, he was doing so in a far more reckless manner than Malygos.

Rising, Kalec's host stared at the vanishing figures. Malygos did not know whether to warn the three or leave them to their doom. Past animosities paled at the moment, Malygos not wishing even Coros a fate such as these other proto-dragons had—

A ragged hiss erupted from the pile of corpses. Malygos forgot all about Galakrond and Coros as he turned toward the nearby carnage. The first thought flashing through the proto-dragon's mind was that one of the victims had survived. Malygos started toward the bodies, trying to locate the right one.

As he neared, another ragged hiss arose from a different direction. Malygos halted, looking there.

A third hiss came from yet another location.

Several of the victims began to push up. Heads turned almost as one to stare at Kalec's host.

Stare . . . with the empty eyes of the undead.

THREE
HUNTED BY THE UNDEAD

Malygos retreated, the icy-blue proto-dragon already flapping his wings for flight.

Unfortunately, he failed to see one of the undead creatures rising to his right. Its hiss was his only warning.

A foul mist exhaled by the undead touched his wing. Malygos roared as he felt a coldness that even he could not stand burn deep into his body.

Despite his agony, Malygos exhaled in turn. Frost covered the attacking creature, but whereas it would have stiffened many an adversary, it only slowed the undead. Still, that gave Kalec's host just enough time to leap into the air. Ignoring the pain, he pushed higher and higher.

The chorus of nerve-wracking hisses below gave warning that several of the undead were giving swift pursuit.

Despite Kalec wishing desperately that the proto-dragon would look down to see how close they were, Malygos kept focused on his ascent. He flew on, seeking the clouds above. Kalec finally understood that his host hoped to evade the winged horrors by losing them in the murkiness of the clouds.

Malygos did not breathe easier even upon attaining cover. He veered sharply to his left, then, after a short distance, flew level. Behind him, the hisses of the undead spread throughout the clouds. Some sounded farther and farther away, but others still hinted of pursuers yet on his trail.

Malygos kept his jaws clamped tight, breathing through his nostrils as best he could. Any sound, even an exhalation, might prove enough to catch the attention of the undead. Kalec, forced to accept whatever decision his host made, remained impressed with the proto-dragon's intelligence. Despite everything, this Malygos was very much the Malygos who had ruled so wisely for so long. This was the Malygos whom a young Kalec—and every other blue dragon—had looked up to in admiration.

And yet he is still a proto-dragon, Kalec reminded himself. *How can this be? How can—*

Another hiss arose, from in front of Malygos.

The pale red corpse collided with Kalec's host. The stench of decay poured over Malygos as the undead proto-dragon hissed in his face. Up close, bits of the skull could be seen through the areas where shreds of dry flesh had fallen away. One eye had sunken in. Teeth dripping with a thick mucus snapped at Malygos's throat. Claws tore at Kalec's host, ripping through scale.

Malygos lunged, seizing the undead's lower jaw in his teeth. With one powerful bite, the proto-dragon ripped the jaw loose.

A thick black fluid that had once been blood spilled out of the ragged wound. The creature did not falter, but loss of the jaw prevented one source of danger to Malygos. Kalec's host spit out the rotting piece, then quickly exhaled into the exposed throat.

The icy mist poured into the undead, freezing the insides. Malygos's foe contorted. It released its hold on him.

Malygos whipped his tail forward, striking the frozen torso. The undead shattered, the top and bottom halves falling in separate directions. The winged upper half remained aloft for a moment; then even the pretense of life faded, and the remains dropped out of view below.

But from much too nearby came more hisses, indications that

several of the other undead had been drawn by the commotion. The taste of decaying flesh still on his tongue, Malygos pushed forward.

Another of the animated corpses materialized from the murky clouds, blocking his path. Malygos attempted to arc past it, only to have a second come for him from that direction.

Kalec's host immediately stopped flapping. He dropped like a stone, falling beneath the two undead.

But as he broke through the bottom of the cloud cover, Malygos discovered that he had escaped two to fall into the midst of *four*. The empty, hungering faces surrounded him, for the first time causing Malygos to lose hope.

No! Do something! Kalec silently roared, to no avail. *Do something!*

Two of the unliving monsters lunged at Malygos, who managed to evade only one. The second seized his left forearm and wing, snaring Malygos thoroughly. The other three fell upon him.

Malygos exhaled on the one holding him. Again, the ice only slowed, not stilled, the undead. And even though none of the four moved with the smooth swiftness of the living proto-dragon, they had him caught.

Kalec felt the certainty of death—or worse—creep into Malygos's thoughts, even as the proto-dragon continued to struggle.

Then a hard blast of what seemed like sand caught the foremost fiend in the back. The sand struck with such intensity that the shriveled, dry body *cracked* in two. The undead proto-dragon twitched wildly as it still sought to keep hold of Malygos.

There came a ferocious roar from another direction, one so thundering that at first, Kalec and his host both thought that Galakrond had come upon the scene. But the roar was followed by Neltharion's familiar laugh as he ripped into the side of one of the other clinging corpses.

The next-nearest corpse turned to attack Neltharion, but again, a blast of sand shot forth, battering the undead so hard that the creature was sent tumbling away. The blast was followed by a brown form that caught the whirling corpse at the throat and bit through the bone and scale with such force that he neatly severed the head from the torso. The body fluttered around aimlessly, heading off in one direction as the newcomer spat out the other remnants with as much obvious distaste as Malygos had earlier displayed.

With only the fiend with the broken back and one other foe, Kalec's host was better able to defend himself. He grabbed the grasping hind paw of the ruined creature and thrust it at the second undead proto-dragon. The paw instinctively seized the wing of Malygos's other attacker, giving the icy-blue male an opening as his foremost opponent struggled to pull free.

This time, Malygos breathed upon the wings of his broken attacker, exhaling until he had no breath left whatsoever. Vertigo almost overtook Kalec's host, but the proto-dragon fought to stay conscious.

Frozen stiff and heavily laden with ice, the wings pulled the one undead down. The second creature—still clutched by the first—also dropped, unfortunately in the process taking Malygos along with both.

As the three of them fell, Malygos bit at the arm of the second fiend, fighting through the bone as quickly as he could. Past the hissing countenance of the one undead, the proto-dragon and Kalec saw the ground rushing up.

The bone finally cracked—as did one of Malygos's teeth. The pain was a momentary annoyance compared with what would happen if he did not finish biting through the limb. Kalec's host clamped down, and the last of the bone gave way.

Beating hard, Malygos kicked at his foremost foe as he pushed

skyward. With a horrendous ripping sound, the last muscles and tendons separated, enabling him to escape the two undead.

The animated corpses crashed into the rocky landscape, the collision so intense that both dry forms shattered, sending bits scattering in several directions. By that time, Malygos, the remaining paw finally removed from him and tossed aside, was well into the sky again.

And there Malygos beheld not only Neltharion and the brown male whom he and Kalec had noted at Talonixa's gathering, but also Alexstrasza and Ysera. The sisters hovered at opposite ends of the area where the males finished their macabre adversaries, the females keeping wary watch for more threats. Neltharion was in the process of tearing to shreds the creature he fought. Of the brown's foe there was no sign, which could only mean that the newcomer had readily dispatched the undead.

As Malygos neared, Neltharion let the last fragments of his opponent fall away.

Of the group, only the charcoal-gray male looked cheerful. "Ha! We have won!"

"We can still lose," the brown reminded him with a hint of impatience. "Many more not-living near. . . ."

Alexstrasza and Ysera joined the trio. "We see nothing," the yellowish female muttered. "Nothing but death."

Her sister hissed at her, but Ysera looked undaunted. Through Malygos, Kalec learned that Ysera was of the belief that there was still a way to achieve peace with Galakrond. She was not the only one, either.

Malygos eyed the brown male. "I know you."

The other dipped his head. "Nozdormu."

"Fight well."

Neltharion chuckled. "Fights almost as well as me!"

Nozdormu's smile was very brief. "Many not-living. Why here? Why now?"

It became apparent to both Kalec and his host that none of the rest had witnessed anything akin to what Malygos had experienced earlier. Nor had anyone evidently seen Coros seemingly flying after Galakrond. For the moment, Malygos chose not to mention the latter incident, the ghastly sight he had seen before that obviously of much more importance.

As clever as he was, Malygos was still a proto-dragon. The words he needed to explain properly what he had seen Galakrond do with his victims were hard to put together, especially with danger still close at hand. So bound to Malygos was he that Kalec not only felt the proto-dragon's frustration but also wished that he could speak for him.

Through halting words, Malygos did his best. His descriptions were short, but raw emotion filled in many gaps, enhancing his tale. He left the other proto-dragons shocked, even Neltharion. No one disbelieved him, all understanding that Malygos was to be trusted.

"How?" Alexstrasza demanded with much consternation. "How? What has happened with Galakrond?"

Malygos thought he understood. "Galakrond must eat much. Galakrond could not find enough. He grew hungry. Too hungry. Ate one of us."

Although to Kalec such an act might have once seemed not so shocking—these were proto-dragons, creatures he had thought simply brutes—he saw that they had boundaries much like those of dragons. The proto-dragons might fight to the death against one another, but they did not eat their foes. No matter their savagery, this concept revolted them. Even though they had witnessed Galakrond committing the heinous act on a grand scale, they still did not want to accept it.

"Was hungry," Neltharion snarled, his generally cheerful

demeanor at last broken by what they were discussing. "Ate one of us. Why eat more? Grazers came north! More food! You saw Galakrond eat! Enough food now! Why still do this?"

Malygos shook his head. No one else had an answer, either.

There came more hisses. The proto-dragons glanced toward the sounds. The hisses were still far away but seemed to be getting nearer.

"We leave," Alexstrasza decided. "Now."

There was no protest, not even from Neltharion. They had no idea how many of the unliving might attack next. Malygos's discovery of how the unliving came to be had altered everything.

Malygos instinctively took point—

Kalec's world turned upside down, and despite trying to prepare himself for it this time, the dragon blacked out. As ever, the darkness passed swiftly, although in this case, only a brief passage of time—not a return to reality—occurred.

The proto-dragons were on the attack, Talonixa leading the charge. Scores of proto-dragons representing nearly all the families with which Kalec's host was familiar dived into the fray. Their enemy was not Galakrond, however, but several undead.

Where Malygos and his companions had had a disadvantage in numbers, the opposite was true now. The proto-dragons faced perhaps a dozen of the animated corpses, which Kalec immediately understood had been purposely drawn to the deep canyon in which this battle played out.

Through Malygos, Kalec caught a glimpse of Ysera and also knew that Alexstrasza and Neltharion were part of the effort. Nozdormu had refused to be part of it, although not out of any cowardice. Malygos did not know where he was and, at the moment, had no time to care. Outnumbered the horrors might be, but they still dealt death.

The first to learn that terrible fact was an impetuous fire-orange female appearing some seasons older than Alexstrasza. One of the initial attackers, she fell upon a smaller undead, once a proto-dragon just out of its juvenile years. However, although the prey looked easy and Malygos had been among those offering warning about the dangers of their enemy, she left herself open to the undead's "breath."

The dark, noxious cloud draped over the female's head and wings. She shrugged it off, then opened her mouth to unleash her own blast.

But suddenly, the brilliant color of her scales faded wherever the cloud had touched. The flesh withered, and skin flaked away. Instead of exhaling a mighty blast at the fiend, the female let out a rasping cry as her eyes glazed over.

And as Malygos—and Kalec—watched, briefly mesmerized, the scale and flesh fell away in the blink of an eye. The exposed skull— the jaws still open—cracked off and dropped out of sight.

The torso, the ruined wings feebly flapping, followed.

Above, Talonixa roared in anger at the proto-dragon's fatal error. Leading another of her family, she dropped upon the small undead and ripped it apart through the back. For good measure, the imposing female bit off the head and spat it toward one of the other flying corpses.

"*Kill* like that! No more fools!"

Her advice, based in great part on information Malygos and Neltharion had relayed prior to this assault, served the rest well. Acting in teams of as many as five, the proto-dragons tore into the remaining not-living. One corpse was torn apart in short order; another burned to a crisp.

There were still fatalities despite Talonixa's insistence, fatalities that Malygos had expected and believed could have been avoided.

Emaciated they might be, but the undead nonetheless had surprising physical strength and an unnatural tenacity. Moreover, they did not have to inhale prior to unleashing their horrific clouds of decay. That dire fact was discovered by two proto-dragons who assumed that they were safe after avoiding the initial blasts. Their still-twitching, decomposing bodies spiraled to the distant ground below.

Yet another attacker might have suffered the same ghastly fate, if not for Neltharion dropping down on the undead just as it was about to unleash a blast. The future Deathwing seized the corpse's head with both hind paws and ripped it clean off. A small gush of the deadly gas poured forth from the open neck but touched no one. The charcoal-gray proto-dragon roared with laughter as he tossed away the head and began to rip into the torso, which continued to fly in a haphazard circle.

Malygos shook his head at his friend's enthusiasm. For Kalec's host, the sooner this ended, the better. He had no love for what they were doing. Like Alexstrasza and Ysera, Malygos still saw the living in the faces of these abominations. These were victims, too. They had to be destroyed, but there was little reason to take joy in the effort.

Talonixa struck the last blow, exhaling hard at a lone undead. The bolt of lightning she unleashed set the dry flesh ablaze. The animated corpse managed to stay aloft, but a second bolt shattered the already crumbling body, sending ashes scattering everywhere.

With the destruction of her foe, the huge golden female roared triumphantly. Her cry was taken up by many of the others, causing Malygos to wince as he thought of how loud they were. It had been in part their cries that were used in the first place to help lure these not-living to them. Malygos marveled that Talonixa and her supporters did not think this through, but he knew better than to try to speak the truth. Talonixa did not abide those who did not

agree with her and had already scarred a copper male in the face for questioning her. She also had several zealous followers willing to do worse to any other naysayers.

For now, the sisters, Neltharion, and Kalec's host were going along with Talonixa's decisions while they argued over what better choice to make. What that choice might be, none of them had as yet been able to suggest, and all knew that time was quickly running out.

Kalec could also see the disaster looming and did not think this brief triumph foreshadowed the same against Galakrond any more than Malygos did. Kalec silently railed at his own defenselessness in the matter, and at that moment, he realized that he felt more attuned to these ancient events than to his own troubles in the present.

This is not right, Kalec thought. *This is a reflection of the past. It's done! The future is the only battle left to be fought!*

But still, Kalec felt as much a part of this small band of proto-dragons as Malygos was. When Alexstrasza and Ysera spoke to his host, it was as if they spoke to *Kalec*. Even more surprising, when Neltharion stood at Malygos's side, fighting along with him as any true friend and comrade would, Kalec experienced the *same* kinship Malygos had developed with the charcoal-gray male.

Kinship with Deathwing . . . and through a host who would someday become almost as much of a threat to Azeroth. The notion shook Kalec, and he railed anew at what had happened to him, hoping that somehow he could return to his own time and body.

Young Malygos, ever ignorant of Kalec's plight, was more concerned with his friend. He noted Ysera rapidly descending into the canyon, her flight path somewhat erratic. Seeing no sign of Alexstrasza, Malygos chose to follow the yellowish female himself.

With what was obvious effort, Ysera alighted just a few yards above the bottom. The scorched, torn remnants of undead lay

scattered below her. As Malygos dropped near her, he saw that Ysera's breathing had become labored. Within Malygos, Kalec—his own distress momentarily forgotten—shared his host's concern for the other proto-dragon.

Ysera did not notice Malygos until he was almost upon her. Even then, she only looked up at him with sullen eyes, then continued her efforts to regain her breath.

The icy male landed beside her but did not speak. Observing Ysera, Malygos noted her gaze drifting from one ripped piece of dry flesh to another. Neither Malygos nor Kalec could make sense of her observations; the fragments were from a variety of families, including both Malygos's and Neltharion's but not, upon closer inspection, Ysera's.

"Not here . . ." she finally murmured as her breathing calmed. "Not here . . ."

After a moment, Malygos asked, "Who?"

"Dralad."

The name meant nothing to either Kalec or his host. Malygos waited, and both were rewarded a few breaths later as Ysera clarified. "Clutch brother . . ."

Malygos hissed low, then muttered, "He is dead."

"These were, too."

That had occurred to both Malygos and Kalec, but not what Ysera was implying.

"Saw body," Malygos offered.

She looked up at the male, her gaze steady and demanding. "Not burned by my sister. You destroy it?"

Malygos shook his head. There had been no thought of destroying the dead at that point. Even though this generation had seen proto-dragons leap to a level of intelligence far in advance of anything they had developed before, the notion of a proper burial

was not something the creatures had yet conceived. Even dragons, Kalec knew, simply preferred to come to their final rest near the temple.

And, oddly, near *Galakrond*.

"Watched every not-living," Ysera went on, stretching her wings. She looked recovered from her bout, although she was clearly still somewhat weary. "Not found. Not found."

"His body—"

"Not there!" the female snapped. Then, looking more tired again, she shrugged off their conversation and took to the air.

Kalec's host watched as she ascended. What he recalled of that discovery had made him believe that Ysera's clutch brother had not risen as so many others had. Other early victims had remained dead. Alexstrasza had no doubt said something to that effect to her sister, but Ysera's own search and its lack of success bothered Malygos . . . and Kalec. Was it possible that the older dead were also rising? If so, then the threat to the living proto-dragons was far worse than they had imagined.

Malygos shook his head, far too many thoughts assailing him. He was still a proto-dragon, no matter how clever he had always regarded himself to be. That he believed Alexstrasza would have been just as pressed by all these concerns did not make Malygos feel any better. Kalec, with so much going on in the present but now trapped in this vision of the past, could again easily sympathize—

A low, barely audible hiss from the southern end of the canyon drew Malygos's attention. It was so short that neither the proto-dragon nor Kalec was certain that he had heard it, and yet Kalec, at least, knew that both *had*.

Keeping low, Malygos cautiously crawled south. His eyes darted to every shadow, observed every large shape, be it the remains of an animated corpse or what simply proved to be a rock. He listened

carefully for a repeat of the hiss but heard only the wind coursing through the canyon, a sound *both* knew was not the same one heard earlier.

Possible answers ran through the proto-dragon's mind as he moved. A not-living that had managed to hide from the hunters? But these corpses did not hide. They only knew their relentless hunger and thus ever searched for prey; they did not run away from it. Another potential source for the sound was an injured member among the attackers. This made more sense, but why had no one noticed the wounded fighter missing?

Kalec watched with Malygos but saw nothing. He questioned the wisdom of the proto-dragon's determination to find the noise, but there was no stopping Malygos.

Shadows filled the area ahead. Malygos paused, then plunged into the darkness. His eyes began to adjust to the change in lighting—

Something touched Malygos on the back.

The proto-dragon's head twisted around. Both he and Kalec caught sight of a smaller, flowing figure.

Malygos hissed as his head suddenly pounded. For Kalec, though, it was as if all the thunder that had ever raged over Azeroth gathered for one fantastic storm. Had he paws of his own, Kalec would have clamped them against his ears. As it was, he could only roar as the pounding rose beyond bearing—

And for once, Kalec was grateful when darkness finally claimed him.

FOUR
SHIFTING REALITIES

Once again, Kalec woke covered in sweat and gasping for air. He also again woke in his half-elven form. Those things did not surprise him as much as what he saw when his eyes finally focused enough to see his surroundings.

It was, as far as he could ascertain, the same canyon in which he had just left young Malygos.

Rubbing his eyes, Kalec looked again at the rocky landscape. There were many changes, yet somehow Kalec was certain that this was indeed the same location.

And the fact that he was so certain also bothered him. Kalec had visited hundreds and hundreds of places during his lifetime, and while some, such as the Sunwell Plateau—where he had last seen Anveena—and the Nexus, were obviously memorable to him, there was no reason he should be so certain that this was the same place. True, Kalec had just visited it through Malygos a few moments ago— assuming it *was* only a few moments ago—but countless millennia had passed since the proto-dragon had actually been there, and in that time, nature and possibly other factors had remade the canyon over and over.

Yet Kalec could have sworn on his own life that this was the same place.

He spun, expecting to find the accursed artifact on the ground next to him. While it surprised him not to see it, he also had no doubt that it was responsible for this little incident, too.

What devilishness are you up to now? Kalec demanded of the unseen relic. He did not expect an answer, of course. He expected only more questions, only more mysteries. Only more madness.

The calm, almost detached attitude that he had developed while part of the past had once again vanished with his return to the present. Now all the stresses struck Kalec so hard that he abruptly drove his fist into a nearby rock wall. Had he not also instinctively shielded that fist, it would have been his bones, rather than the wall, that cracked. As it was, the shattering rock still splattered him in the face, making the former Aspect step back in surprise.

And only then did he see the footprints in the hard soil.

A hundred thousand beasts and a fair number of sentient beings had no doubt traveled through this canyon during the vast length of time since Kalec's previous sojourn, and these prints could have belonged to any of those, but once more, Kalec knew that these were not random footprints. The first ones were those of some fairly giant creature of a reptilian appearance: a proto-dragon. They came from the same direction from which Malygos had come in those last moments before Kalec had been thrust back to his own time and form. He even recognized places where the proto-dragon had paused before the barely seen flowing shape had fallen upon them.

Thinking about that other figure, the former Aspect turned his attention to another set of prints a little behind those he was certain were Malygos's. Smaller prints. The prints of a booted or sandaled two-legged form such as an elf or a human.

It brought to mind the cloaked and hooded shape that Kalec had caught a brief view of more than once, a being somehow tied to the artifact.

As the blue studied the footprints, he noticed that they went on beyond those of Malygos. Despite the ages, Kalec found it easy to follow them for as far as he could see. They continued on to

the south, each step seemingly seared into the rock just for his benefit.

With a bit of trepidation but even more determination to find *some* answers, Kalec traced the footprints. They quickly moved beyond those marking where Malygos had stood. Kalec wondered what had happened at that point. Had the proto-dragon turned? Had he discovered whatever it was Kalec now headed toward?

That he was still concerned for what had happened so long ago frustrated Kalec. All that should have mattered was to find some escape from the artifact's incessant intrusions into his mind before it destroyed his already wavering sanity.

Kalec did not know why he had transformed into his current shape, but at the moment, he found it comforting despite having to climb over several parts of the rocky path. He had spent so much of his recent past in his humanoid guise, especially when he was with Anveena or, of late, when dealing with Jaina. Once, when he had known Alexstrasza's legendary consort, Korialstrasz, Kalec had wondered why the crimson male had spent so much time in a humanoid form, pretending to be the wizard Krasus. Now Kalec no longer questioned that preference.

The path led into a shadowed region that reminded him that much of the area through which he had tracked had also once been shielded from the sun. Yet, despite the obvious upheaval needed to bring down so much rock, either the prints had remained uncovered, or someone had taken time to clear the rubble away.

Before he could follow that line of thought, the trail turned toward the rock face to his left. Kalec frowned, then saw a narrow cut in the rock, an opening just wide enough for him to slip into in his present form.

For some reason, he did not think that a coincidence.

The slit proved even narrower than Kalec first calculated, forcing him to wriggle to get through. The darkness within stirred

uncomfortable memories of the utter blackness that overcame him almost every time he slipped from reality to the visions and back again. Kalec shivered but pressed a few steps deeper before finally summoning a glowing sphere.

In its purple light, the withered visage of a proto-dragon glared down at him.

Kalec flung himself to the side, at the same time sending the sphere at the looming monster. The former Spell-Weaver's efforts changed the simple illumination spell into a full attack. The sphere exploded as it hit the proto-dragon's chest, searing into the dry flesh.

A musky scent assailed Kalec as the magical energy burned into the proto-dragon. The former Aspect summoned a new and larger sphere, fully revealing the cave's interior.

More than a dozen additional proto-dragons, all as withered, peered at Kalec. He readied a potent spell, then paused when he realized that neither they nor the one he had attacked had thus far moved.

These were *not*, he finally recognized, the undead that Malygos and the others had fought. They were merely dead proto-dragons.

Merely? As Kalec observed them closer, he saw differences. Each of these proto-dragons was in some way misshapen. Yet it did not look as if those defects were the results of something that had happened in the egg. Kalec eyed one proto-dragon who appeared to have a fifth limb starting to grow out of his side. Another had a third eye just above her right shoulder.

What sort of macabre display is this? Kalec stared at the group and saw that each also bore some injury. As he studied one corpse after another, he saw that those injuries had certainly impaired these proto-dragons, if not killed them outright. Moreover, the former Aspect saw that the dead actually lay sprawled against one another, as if they had been gathered in haste.

Kalec paused again. It was clear to him that he had been steered

to this place by the relic or whatever power it served, but what was he supposed to learn from this grotesque spectacle?

A creaking sound set his nerves on edge and made him summon yet another spell. He turned to find the first proto-dragon tumbling forward, the damage done by the altered sphere too much for him to maintain his stability. The towering corpse struck the rocky floor and broke into pieces.

The head rolled closer to Kalec, and in what remained of the second sphere's light, he finally recognized the reptilian countenance. *Malygos.*

Kalec retreated in shock, shaking his head all the while. *This can't be true! It can't be! It's not Malygos! That's not possible—*

His mind spun. Kalec fell against one of the other corpses, which caused it to tilt into another. Suddenly, all the proto-dragons began falling toward him.

In desperation, Kalec shut his eyes and concentrated his power all around him. The cave filled with brilliant white energy, so bright it blinded even its caster.

Gasping, the former Aspect dropped to one knee. Head down, he waited for the corpses to bury him underneath them. When that did not happen, he cautiously looked up . . .

. . . and found himself kneeling in his sanctum.

At first, he dared not move. Kalec shivered as he tried to verify that what he now saw around him was the truth, more than the cave had been. He felt absolutely certain that he had been in the canyon—except that would mean that the relic had transported him from one part of the world to another with less effort than it required Kalec merely to breathe.

A rapid thumping sound echoed in his head. It took a moment for the blue to recognize his own heartbeat. He tried to slow his breathing, also causing his heart to shift to a more normal rhythm.

His surroundings did not change. Still kneeling, Kalec touched the floor. It felt solid, but then, so had the corpse against which he had fallen and the rock through which he had slipped.

"This is real. This is real," Kalec muttered, the next second feeling uncomfortable at the fact that he needed to speak out loud while he sought to convince himself. *But the cave was real, too! It was!*

He could not say which was worse, the notion of being tossed about the world or simply being made to believe it had happened. Either way, the artifact continued to intrude too thoroughly into his thoughts. The present had become a series of moments whose lengths of stability he could no longer trust, while the visions were becoming more and more what seemed the true reality. Kalec knew, though, that if he allowed himself to become too attuned to the visions, he might at some point *never* return to the here and now.

The former Aspect gritted his teeth. *If this even is the here and now.*

Kalec rose and turned. The continued bane of his existence sat where last he recalled it, still gently emanating its own magical illumination.

"I'm tired of all these games!" he shouted at it. "Tell me what you want!"

But although it could do so much, although it could manipulate him in so many ways, the one thing that the relic apparently could not do was speak to him.

Kalec?

The blue male jumped. Eyes wide, he glared at the artifact, waiting for it to speak again.

Kalec?

The voice came from inside his head, but the relic was not the source of it, he finally understood. Someone was calling to him. Kalec knew that he should recognize the speaker.

"Jaina . . ."

Despite earlier misgivings about letting her potentially discover what was happening to him, Kalec now grasped at the chance to answer her call. The archmage represented part of that stability he fought to maintain.

"Jaina!" Kalec called to the empty air, only belatedly realizing how desperate his reply sounded. Taking a deep breath, he tried again. "Jaina, I hear you. Wait."

Steeling himself, he re-created the gap in the air that enabled him to communicate face to face with her. Through it, the vision of Jaina's chambers appeared. Although she had called to him, when the spellcaster first formed, she was leaning over a wide wooden table, inspecting some parchment.

"Kalec . . ." Jaina's initial smile faded as she looked over the former Aspect. "Are you sure you're well?"

He had thought that he had adjusted his appearance appropriately, but clearly, in some way, he had not entirely hidden the incredible stress he was going through even at that moment. "I'm more . . . I've been under more pressure than I wanted to admit," Kalec began, thinking how best to keep vague but not too vague. "The Nexus . . . you understand."

"You don't have to say any more, not unless you want to. I'd be willing to listen, if it would help."

It was an offer he seriously considered, if only for a moment. However, Kalec quickly came to the conclusion that this was a matter he could not involve Jaina in. There was too much risk that she might fall prey to the artifact, just as he had.

"Thank you for that," Kalec finally answered, trying to sound more relaxed. He remembered that he had heard her call to him earlier. His concern for his sanity briefly receded to the background as he concentrated on whatever dire problem the archmage

confronted. "But enough of me. You need my help with something. What is it?"

Jaina looked confused. "What do you mean?"

"You tried to reach me before. I wasn't able to answer as I was this time."

Her expression grew more troubled. "I don't understand. I've only been trying to answer *you*."

"Me?"

She leaned so close that if she had actually been in his sanctum and not merely a projection, he could have touched her. "You've called to me twice since our last conversation. I responded both times, and you finally answered just now—"

"I called to—" slipped from Kalec's tongue before he managed to catch himself. His mind raced. He could not recall reaching out to Jaina either time, instead only hearing her voice in turn. While she might be mistaken, Kalec doubted that. More likely was the possibility that some part of his subconscious had sought help from the only one he thought he could trust to understand his situation. He did not even want to approach the other former Aspects, aware that they had some reason for making no mention of all that Kalec had learned thus far from the visions.

It came to his attention too late that he had been standing in silence before Jaina, his gaze now turned to the empty air to his right. Not at all to his surprise, she was staring at him with even greater worry than before.

"Kalec, tell me what's wrong."

Struggling for an answer, he blurted the only thing he could think of. "The collection is more massive than I could have imagined, and the Nexus's protections are failing at the same time. It's proved to be a monumental task."

Her eyes narrowed in understanding. As a sorceress—and

especially as the leader of the Kirin Tor—Jaina Proudmoore could appreciate the tremendous wealth of magical knowledge and power contained in the Nexus. She also understood the danger of leaving all that unguarded. "I know I offered this before, but please listen this time. I can gather a number of trusted magi and lead them—"

"No. Not yet. Thank you." Kalec had become nearly as distrustful of the other magi as they clearly had been of him after his unfortunate move into Dalaran. He could not imagine that things would go well with them around him in the Nexus, and that was not even taking the artifact in account.

Jaina looked doubtful about his decision but finally nodded. "All right. But the offer is open. I will see to it that any who enter the Nexus will do as they're told. You know thaaaaattttt . . ."

The archmage and her surroundings rippled, grew distorted. Jaina's body twisted, and her face stretched forward.

"Jaina?" Kalec feared some force had attacked her while they had spoken.

". . . wrrrrrrong, Kkkkkaleeeccc," she answered, even as her body grew scaled and her sanctum collapsed, becoming a rocky overhang. Her robes became wings, and before Kalec's eyes, Jaina Proudmoore transformed into a dragon.

No, Kalec thought. *Not a dragon . . . a proto-dragon.*

"Kaaaallllleeeccc?" rumbled the proto-dragon.

He had no chance to answer her, no chance even to dismiss the link between them. Kalec wished it closed, then lost track of both it and the altered Jaina as he felt his body shifting into a more reptilian form. Thoughts other than his own filled his head, dominated his mind.

Kalec tried to roar, but his mouth was no longer his. He felt himself receding into the background . . . and the mind of Malygos taking the forefront.

The Nexus had become a chilly seashore that reminded Kalec

of the area where Malygos had once fished. Malygos was not alone. Alexstrasza stood roughly the same distance from Kalec's host as Jaina had seemed from Kalec.

"I will do that," the fire-orange female said to Malygos as she rose into the sky. Alexstrasza darted off to the east, leaving Malygos on his own.

What they had discussed, Kalec neither knew nor cared about. He strained uselessly to return to the Nexus, even concentrating on Jaina in the hopes that the link that had helped him at least twice would do so again. Yet, as he feared, nothing changed.

Malygos took off, heading out to sea. While it was evident that the proto-dragon hunted a meal, he also appeared to be watching or waiting for something that his vague thoughts did not reveal to Kalec. That further frustrated the dragon, who had assumed that if he had been thrust back into the visions, it had been for *some* purpose.

Kalec's host scooped up one of a pod of aquatic air breathers a half-mile offshore, devouring the creature in two gulps. While not as delicate about his meals as Alexstrasza, Malygos did try to kill his prey quickly and relatively painlessly. Still, Kalec had no taste for the hunt right now and hoped that Malygos would either quickly fill his belly or remember something more important.

The meal did come to an end, but not as a result of one of those choices. Rather, Malygos suddenly raised his bloody jaws from his second kill and peered up into the overcast sky. Kalec instantly thought of the undead, but instead, Malygos's sharp gaze fixed on a pair of proto-dragons skirting the bottom of the cloud cover.

Kalec's host leapt into the air and raced toward the pair. As he neared, it became evident that there were more than two. Kalec counted four, but Malygos counted five, with the fifth being none other than Ysera.

And with her flew *Coros*.

Hissing, Malygos came up behind the pair. Kalec understood his caution, for other than Ysera, the rest of the party were all proto-dragons Kalec knew to be hostile to his host.

Coros noticed him first. Malygos's rival sneered, then hissed warning.

Ysera looked over her shoulder. Upon recognizing Malygos, Alexstrasza's sister grew visibly frustrated. "I will do this!" she insisted. "We are right!"

Thoughts spilled through Malygos's mind and into Kalec's. Ysera continuing to search among the dead—and the defeated undead—for her clutch brother despite knowing that it was unlikely she would find him. Alexstrasza's sister growing more vehement in her distaste for all the violence. The yellowish proto-dragon preaching her beliefs to others and finding a few who saw as she did.

And one of those appeared to be Coros, who had seemed so fanatically loyal to Talonixa not all that long ago. Now Coros also preached peace, preached finding a way to live *under* the rule of Galakrond. His notions did not exactly match those of Ysera, but they were close enough for both to suddenly want to work together to convince others.

Malygos saw only naïveté in Ysera's dreams and did not trust the mercurial nature of Coros's. Kalec now understood what his host and Alexstrasza had been discussing; Ysera's sister had been searching for her for three days, hoping to make her see the error of her ways before she did something foolish. To Malygos, Alexstrasza appeared too late to prevent the last. He felt that any plan hatched even in part by Coros was certain to be filled with danger and treachery.

Once Malygos might have simply let things happen as they would, but more and more, Kalec's host saw the intricacies involved in even the simplest decisions. The repercussions for the proto-dragon race as a whole were many, not to mention the fact that Malygos now felt

a loyalty to the sisters that in some ways surpassed even that to his own family. He had fought side by side with both of them and knew their dedication and trustworthiness.

He also knew that Coros lacked either of those qualities.

"Sister seeks you," Malygos informed Ysera, indicating the direction Alexstrasza had flown only a short while ago. "That way."

"Saw her," Ysera responded with a snort. "Let her fly on."

This startled Malygos, who knew how close the pair was despite the constant bickering. "Should listen to her! Galakrond will not—"

"Galakrond *will*."

Her short but incredible interjection caught both Malygos and Kalec by surprise. Malygos hissed in confusion. Coros grinned but did not interrupt.

"There will be peace," Ysera announced with some pride. "Galakrond will talk peace."

"You do not know—"

She raised her head higher, taking a dominant position over Malygos. "*We* spoke with Galakrond. He *will* talk peace."

The madness that had affected Kalec in the present now looked as if it was taking hold of him in the vision. He could not believe that he had heard correctly, and judging by Malygos's racing emotions, Kalec's host could not believe it, either. "Galakrond . . . *talked* with Galakrond?"

Coros finally joined in, his triumph clear in both his tone and his expression. "Peace we will have . . . if all will *listen*."

Before Malygos could retort, Ysera said, "All *must* listen . . . and we must go."

"Go where?" asked Kalec's host as both his mind and Kalec's raced.

"Find Talonixa," she answered, as if that should have been clear to anyone. "Tell her. Tell *all*."

That said, she veered off. Coros, the other three proto-dragons in tow, followed.

Malygos stared, wanting to believe Alexstrasza's sister but also aware of just what a monster Galakrond had become. Still, if Ysera spoke the truth—

"No." Malygos shook off that possibility, and Kalec once again admired the analytic abilities of the future Aspect even as a proto-dragon. However, his admiration faded as both he and Malygos thought of what would happen if Ysera *did* convince the others.

The proto-dragon quickly turned. He had to find Alexstrasza and somehow help her make Ysera see sense. Even though Kalec's host—and Kalec, too—understood the odds of Ysera convincing Talonixa and the rest of the merits of her plan, the two could not help but feel that somehow matters would end in new disaster and that more, many more, would die as a result.

FIVE
FATEFUL DECISIONS

Malygos grew more desperate as his search for Alexstrasza stretched to hours. At that very moment, Ysera—with Coros's aid—might already be convincing Talonixa of the merit of her intentions and Galakrond's willingness to agree to everything. Malygos could foresee only catastrophe if that happened.

His thinking was another example of the leap Kalec had witnessed among several of the proto-dragons. Malygos saw nothing new or odd about his considerations for the future, whereas among some current proto-dragons, the here and now was all that existed.

The lengthy search had had its own effect on Kalec. Able to feel the wind as Malygos flew, Kalec had calmed down somewhat. When he was in the visions, he had no choice concerning the path upon which he had been set and therefore tried to become as detached as he could.

Yet Kalec could not help but consider the choices left to his host. Unaware of how this entire struggle had ultimately turned out, Kalec was not even certain that Malygos was right in seeking Alexstrasza's aid in stopping Ysera. Although Kalec had believed as Malygos had when first hearing about the suggestion of peace with the marauding behemoth, he also knew that, in his time, Galakrond's skeleton lay near the heart of the Dragonblight and that the gigantic proto-dragon was considered the Father of Dragons. How that had come to be, Kalec could not fathom. Had Galakrond achieved

salvation after all, something that had escaped the future Neltharion and even, regrettably, Malygos himself?

He forgot all about such questions as Malygos spotted a red speck perched atop a tall hill. While to Kalec it might have appeared to be any member of Alexstrasza's family, his host was absolutely certain that he had found Ysera's sister, and within a few strong beats of the male's wings, that proved to be the case.

She noted Malygos's arrival with a hopeful gaze. Kalec felt his host's guilt at coming with something other than good news.

"Found Ysera," he started. "With Coros."

Alexstrasza eyed him in disbelief. "Coros?"

Malygos quickly explained what had happened, including Ysera's current thinking.

The fire-orange female hissed in growing frustration as she listened. "Must go to her!" Alexstrasza snarled as soon as Malygos had finished. "This must not be!"

The male proto-dragon blocked her path. "Wait! Ysera will not listen!"

She glared at him but finally nodded. "No. Ysera will not listen. She will die."

"Will *not* die," Malygos insisted. "Ysera will not die."

Alexstrasza shook her head. Yet rather than shove past her companion, the female proto-dragon hesitated. She *wanted* to believe Malygos.

"Coros not good," he informed Alexstrasza. "Coros always lies." It was a simplistic declaration but, from what Kalec could glean from Malygos's memories, close to the truth. "We watch Coros. Find truth. Show Ysera."

While Kalec's host did want to help the sisters, the icy-blue male also looked forward to revealing his rival as he knew him to be. Coros was one proto-dragon Malygos would not have minded being

devoured by Galakrond, provided Coros could be prevented from rising from the dead afterward.

Cocking her head, Alexstrasza considered his words. It did not take her long to nod eagerly. "Yes. Prove Coros false! Ysera will see truth!"

Kalec was not so certain about the merit of Malygos's suggestion, but he distrusted Coros as much as Malygos did. Kalec suspected that Coros thought he could take advantage of everyone, even Galakrond, while raising his status among the other proto-dragons in the process. It was a foolish, dangerous notion—

A familiar roar thundered across the heavens.

Immediately, Malygos and Alexstrasza dived from their perches into more shadowed regions below. Neither proto-dragon cared about dignity. Malygos found an overhang that had enough room for one and left it to Alexstrasza, who reluctantly accepted his sacrifice. The male moved on until he came to a depression in a hillside. It was not large enough to fit him, but he nonetheless planted himself against it, then held his breath.

And barely had he done so than a darker, vaster shadow engulfed everything. A hulking form covered the sky: Galakrond, on his endless hunt.

Despite his much-too-near proximity to the insatiable leviathan, Malygos forgot his danger as details of Galakrond's underside swept past. The smaller proto-dragon even slipped out of the depression as he stared at the growths more and more dominating Galakrond.

Growths that had an odd resemblance to unfinished *body parts*.

Kalec watched with equal horror as Malygos glimpsed one rudimentary limb after another dangling from random locations. There were forelimbs and hind, with partial paws. Vestigial wings flapped futilely in the wind caused by Galakrond's swift flight. What

might have been a partially formed head—a *head!*—thrust out of a region near the behemoth's hip.

There were other shapes that neither Kalec nor his host could identify but that both assumed were just as unnerving. Malygos sat where he was, entirely oblivious to the fact that all Galakrond had to do was glance back to see him.

Fortunately, the gigantic proto-dragon continued on, not only racing beyond view mere seconds later but also heading in a direction that would not set the two smaller ones on the same path. Malygos exhaled as Galakrond vanished; then he quickly joined Alexstrasza.

"Must go now!" the fire-orange female urged. "Now, before Galakrond comes again."

"Now," agreed Malygos, following as Alexstrasza took off. However, unsaid by the male proto-dragon—but sensed by the ever-present Kalec—was the thought that even if the pair flew faster than Galakrond, it might already be too late to avert catastrophe.

The two proto-dragons headed toward the region where Talonixa had previously called the gathering. It had not yet been discovered by Galakrond, but Talonixa had already used the growing risk of that happening to stir the other proto-dragons toward mounting their attack. Her sense of urgency, fueled by her desire for vengeance, clearly still prevailed.

"More of us here!" she roared. "So many more! Galakrond cannot fight all! Cannot!"

Proto-dragons everywhere hissed and roared their agreement. Kalec judged that Talonixa had been speaking for some time, which gave credit not only to her relative eloquence but also to her continued domination of the others.

"There!" rumbled Alexstrasza. "She is there!"

Following her gaze, Kalec's host beheld the smaller sister not far from Talonixa's rocky perch. Coros stood next to her, his three comrades a little farther back and looking as if they did not wish to be anywhere near the pair. Both Malygos and Kalec found that odd, especially where the trio's leader was concerned. Why avoid Coros?

Talonixa hissed in pleasure at the gathering's response. Coros chose that moment to ease up to her. He leaned close and whispered in her ear. Her black eyes narrowed as they fell upon Ysera. Coros immediately retreated, his expression veiled.

The dominant female unleashed a mighty roar that made Kalec's host cringe as he landed, for surely every living creature within half a day's flight could hear it. Still, out of respect to Alexstrasza, Malygos did not depart for safer climes. Instead, he alighted with her at a place where they could view the tableau unfolding.

"This runt speaks," Talonixa declared, with one wing indicating Ysera. To Alexstrasza's sibling, she curtly added, "Speak!"

Ysera looked to Coros, who merely nodded.

Alexstrasza growled low at the male's action. "He leaves Ysera alone!"

"That is Coros." Malygos had already expected his rival's support of Ysera to be weak. Coros would do what he could to deflect focus away from him unless it served to raise his status. If Ysera managed to sway the majority, Coros would suddenly be there beside her.

The yellowish female pulled herself up to her full height. While she was not a very impressive proto-dragon when compared with Talonixa, there was something in Ysera's manner that Malygos— and Kalec—found admirable. Weak though she was, Alexstrasza's sibling had an inherent determination that made her seem larger, more dominating, than she physically was.

"We are many!" she began, her first statement receiving a chorus of approving hisses. "We are many . . . but Galakrond is Galakrond!"

The approving hisses faded as the gathered proto-dragons tried to digest what she meant by the last.

"Galakrond is strong! Galakrond is powerful!"

"We are many!" one of the listening crowd roared back. Others hissed in agreement.

"We are many," Ysera repeated with a nod. "And many will die against Galakrond."

Several of the listeners glanced with unease at one another. Seeing this, Talonixa unleashed an angry hiss.

Ignoring her, Ysera pressed her case. "Many can be saved! Peace will save them!" She stepped toward the thickest part of the gathering. "Must talk with Galakrond! Galakrond talked before! Remember when Galakrond was with us! Hunted with us! We talk peace, Galakrond will listen—"

A thundering laugh cut her off. Talonixa looked around at the other proto-dragons as she mocked Ysera's earnest words. "Galakrond will listen? Ha! Galakrond hunted with us? Galakrond now *hunts* us, yes? Listen? Never!"

Ysera tried to interject, but she was drowned out not only by more laughter from Talonixa but also by the laughter of those joining in with the larger female.

Alexstrasza growled. She started forward, clearly wanting to stand by her sister.

Malygos cut in front of her. "No. Ysera will not like that."

The fire-orange female almost snapped at him, but then she hesitated. She eyed Ysera, wanting to comfort her, then finally nodded. "Yes . . . would not like that. Never liked that."

Malygos and Alexstrasza—and Kalec, who initially had expected Alexstrasza to fly to Ysera, something he would have done in her

place—could only watch as Ysera's effort fell apart. Ysera looked crestfallen and confused. She glanced around as if seeking someone who was clearly not there.

"Coros," Kalec's host rumbled. "Where is Coros?"

Indeed, the other male had vanished at some point, along with his three comrades. Malygos searched the gathering and caught a glimpse of what he thought was one of the trio disappearing over a distant rock.

Before he could decide what to do, Talonixa seized control of the gathering again. With a tremendous roar, she silenced those who had been mocking Ysera with her.

"No peace!" she called. "Never! Galakrond hunts us. We now hunt Galakrond, yes?"

Roars of approval reverberated through the area. Ysera, her head low in a submissive posture, crept back. Alexstrasza, looking more distraught than ever, pleaded with her eyes to Malygos.

Kalec's host nodded. "Yes . . . now good."

As she rushed to console Ysera, Malygos quickly sought out Neltharion. Finding neither him nor even the brown male, Nozdormu, Malygos climbed down from his perch in search of them, just as Talonixa took further advantage of Ysera's failed attempt for peace.

"We are many! We will win—"

"Attack now!" urged one proto-dragon.

"No! I decide! Others come! Three suns pass, and we attack! Galakrond falls!"

Malygos paused at hearing this decision, the first time Talonixa had proclaimed it. He hissed, not liking that things were abruptly moving so fast.

As the other proto-dragons drank in this grand proclamation and began to cheer, Malygos caught sight of Coros himself. The

other male's head had risen above an outcropping farther to the north. Coros immediately sank out of view, but without seeing that Malygos had spotted him.

More distrusting of his rival than ever, even in this dire time, Malygos scurried faster among the rocks. He did not want to be seen in turn. Coros intended something sinister, and both Malygos and Kalec were in agreement that he needed to be followed.

Crawling along the landscape like one of the tiny lizards that made for the good occasional snack, Malygos circled around the area, seeking some hint of Coros or his companions. In the background, Talonixa continued to proclaim to the other proto-dragons. While Malygos could not understand her words anymore, her tone preached triumph over Galakrond.

Pushing aside all thought of what would happen three suns from now, Malygos increased his pace as best as he could in such an awkward position. He yearned to fly but dared not until he knew where those he hunted were. Kalec, with no body of his own, more than understood.

Then, as if something sensed their desire, a single shape rose in the distance. It was followed by a second, then a third and a fourth. Coros and his followers flew low and quickly vanished over the northern horizon.

Malygos kept equally low as he pursued. He still had no proof that Coros was up to something, but the simple fact that it was Coros was all that mattered. Kalec mostly knew of the other proto-dragon from Malygos's memories, but what little he had seen of Coros matched well with what his host thought of his rival.

Malygos wished that he could have located at least Neltharion, but there was no time. Coros's speed indicated urgency. Malygos *needed* to know where he went, and because of that, so did Kalec.

More than once, Malygos lost sight of the four, but persistence

enabled him to regain the trail each time, until the point where they descended over a series of ridges.

Malygos hissed angrily as he smelled the air in hopes of locating the four. He knew Coros's stench well enough, yet he could not locate it.

But another, unsettling scent wafted past his nostrils. It was fainter yet so distinct that the proto-dragon could not help but focus on it. There was something about it that spoke of a strength different from that of one of his kind.

Despite wishing to follow Coros, Malygos veered toward where the scent had come from. Kalec, too, was intrigued, but for other reasons. There was something familiar not in the scent but rather in its very existence.

Malygos followed the trail a short way before it abruptly vanished. He alighted on a high rock and searched his surroundings but saw nothing—

And he suddenly had the sensation that *he* was being observed.

The proto-dragon quickly peered over his left wing. Both Kalec and his host expected to see nothing, yet this time, they were wrong.

The figure was tiny in comparison with the proto-dragon, but neither Malygos nor Kalec truly believed that it lacked the power to confront Malygos should that be its desire. While the proto-dragon vaguely recalled a glimpse of this creature, it was Kalec who was most stunned. It was the same figure he had seen in other flashes of vision, even in his own time.

Who are you? What are you? Kalec demanded uselessly.

"Who are you?" Malygos also demanded, echoing the thoughts he could not have heard. "What are you?"

Even as he repeated Kalec's questions, both found themselves staring at empty space. However, barely had this registered with

Malygos than he noticed the figure at the edge of his vision. Turning that way, the proto-dragon again confronted the billowing shape. While Malygos tried to make sense of not only the rippling appearance—not having any notion of what garments were—but also the creature's ability to vanish and reappear elsewhere, Kalec noted the powerful magic the mysterious form wielded.

Powerful magic that might at some point have created the infernal artifact.

When the figure did not answer, the proto-dragon snarled and leapt closer.

The cloaked and hooded form vanished again, this time reappearing farther to the southeast.

It's leading us somewhere, Kalec thought. The answers that he so desired looked to be just beyond the nearby rocks, answers that might end his curse.

A hiss arose from the direction in which Malygos had flown. Kalec's protests went unheard as his host immediately reacted. Although it was only a hiss, Malygos knew who had spoken, knew all too well.

There was no glimpse of Coros, but Malygos was certain he had heard his rival near. Kalec's host leapt into the air to give chase, then hesitated as memory of the mysterious figure resurfaced. To Kalec's relief, Malygos looked back.

But of the figure there was no sign. It did not reappear anywhere.

That decided it for Malygos, if not Kalec. Coros was again the subject of his hunt. Malygos's rival had to be very near.

A proto-dragon of Coros's coloring briefly rose above the hill ahead, then dived down. Malygos dropped to just a few yards above the ground. A sulfuric scent assailed him as he neared the area. Malygos was not familiar with this region, but he knew of some such regions. The world was unstable there, sometimes as violent as a beast.

After landing against the hillside, Malygos drew to the top. He heard voices, one of them that of his rival. The proto-dragon bristled at the sound.

"He comes here! Always comes here!" snapped Coros.

"We should not be here!" protested one of his followers.

The protest was followed by a snarl and a whine. As Malygos thrust his head over, he saw Coros looming above the proto-dragon who had complained. That proto-dragon now had a long, bloody gash across his forehead. Nearby, one of the others watched the pair with some trepidation. Of the fourth there was no sign.

"We will live!" Coros sneered. "They will die! All will die! We will live!"

The other two nodded. As they did, all three took turns looking to the north.

Malygos also looked there and saw a dark, massive shape forming on the horizon.

"He comes!" Coros hissed triumphantly. "Coros called him, and he comes! Galakrond comes!"

Galakrond! Malygos stiffened, and Kalec would have done the same if it had been possible. Coros had *summoned* Galakrond?

Malygos and Kalec had expected treacherous behavior from Malygos's rival, but neither had thought that Coros would have the audacity to reach out to Galakrond on his own. This could have nothing to do with either Ysera's hope or Talonixa's plan, except to bring ruin to both.

Malygos cautiously wended his way down the hillside and away from Coros as quickly as he could. The proto-dragon's mind raced as he tried to decide what to do. This was beyond the sort of plotting that even Malygos would have anticipated from his rival—

There came an angry hiss from behind him. As Malygos started to turn, another proto-dragon—the missing fourth—crashed into him.

Malygos tumbled and plunged through what had initially appeared to be solid ground. The proto-dragon battled to free himself but succeeded only in becoming more mired in the soft, hot, and sticky tar previously hidden under a thin layer of normal dirt.

Gasping for air, Malygos managed briefly to push himself to the surface. As he did, he and Kalec saw two things. One was the fourth proto-dragon vanishing over the hill toward where Coros and the other two waited for Galakrond.

The second was a short, so very short, glimpse of the hooded form peering down at the struggling Malygos just before the ground again swallowed him up. Kalec watched as the world vanished in darkness. Yet this time, it was the smothering darkness of the tar pit engulfing not only his host but also Kalec, who, despite his every effort, could not *wake*.

PART III

ONE
PATH OF HORROR

Jaina Proudmoore left her meeting with the Council of Six with the subjects of that convocation only briefly still her focus. Her thoughts quickly turned to a more personal matter, one that had intruded more than once during the gathering.

Kalec. Even before his recent odd—no, *unsettling*—behavior had begun, he had filled her thoughts more often than not. Jaina still vividly remembered that kiss just after he had asked if he stood a chance not only with the other magi but, more important, with *her*. She had answered him by lifting her face toward him, and he had responded as she had long hoped. At that moment, all had seemed right with the world.

But since his troubled departure, things had gone awry . . . and now this had happened.

While Jaina knew that she could not take time away from her duties for a personal matter, Kalec was still the former Aspect of Magic and thus privy to many of the secrets gathered by him and his predecessor—especially his predecessor—over the countless millennia. A wealth of magical power that could potentially wreak havoc upon the world was under his control, control that was slipping more and more with each passing day. It behooved her for that reason—so the archmage convinced herself—to find out what was wrong with him.

But he cuts contact off each time I try to find out more. Simply

reaching out to him was not enough. If she wanted to find out what was actually happening, the archmage had to take a different course of action, and in her eyes, there was only *one* course.

Suddenly eager to return to her sanctum, Jaina picked up her pace. She already had a plan formulating, one that made absolute sense to her.

And one that Kalec would probably not like in the least.

He was suffocating. Kalec was *suffocating*.

It mattered not that it was the Malygos of the far, far past who was actually the one struggling for breath; Kalec experienced everything that the proto-dragon did, and that made him wonder at that dark moment what would happen if Malygos perished. A part of Kalec knew that such a fate had not befallen his host, but another part of him—the part that most dealt with the immediate lack of air—still questioned whether both of them might *yet* die.

Malygos shuddered as he sank deeper into the cloying tar into which he had been pushed. Kalec expected the proto-dragon to black out, but instead, Malygos startled his unfelt companion by *exhaling* what air was left in his lungs.

But what at first Kalec took for suicide was instead the proto-dragon's attempt to save himself. Head pointed up, Malygos used his last breath to unleash frost. The force of his icy exhalation not only cleared the area above his head all the way up but also cooled the sides of the gap solid.

Sucking in the air that filled the narrow passage, the proto-dragon bent his head down and exhaled again. The molten ground froze just enough, exactly as Malygos intended. He broke free and immediately shoved himself up.

Below, both Kalec and his host could already sense the ground shifting again. Malygos pressed harder. The passage was too narrow

for him to twist his head down and exhale again. If he was to escape, he had to move even faster.

The opening beckoned. At the same time, a rumble rose from below. Hissing, the proto-dragon dug in his claws and pushed up the last few yards. He thrust his head out of the passage, then dragged the rest of himself free.

The rumble grew thunderous. Although still fighting for breath, Malygos whirled around and exhaled at the opening.

The frost covered the hole just as it filled. The ground sealed. Malygos spread his wings and took to the sky as the frozen pit shook. He rose higher and higher, both he and Kalec hoping that the freeze would last long enough—

The pit exploded. A molten column shot up into the sky.

Malygos managed to dodge the column just before it reached him. He flew as hard as he could in the direction he faced, even though it meant heading in the opposite direction from where he wanted to go.

Only when the proto-dragon hoped he was far enough away did he look back. The column appeared to veer toward him but at last seemed unable to hold together anymore. It collapsed, spilling over the area of the pit and far beyond.

Exhausted, Malygos alighted on a ridge and tried to focus. Taking a deep breath, he exhaled over his body, freezing the tar in most places. That done, the proto-dragon shook hard, sending much of the stiffened tar scattering. The effort cost him, though, and he had to use a few more precious minutes to recoup. Kalec felt every bit of his host's weariness . . . and the proto-dragon's increasing impatience. Malygos wanted to follow after Coros, but he still needed to regain his breath. That meant he would risk losing his rival's trail. As good a tracker as Malygos was, the stench of this region mostly masked the other proto-dragon's scent, very likely what Coros had intended.

His breathing finally regular again, Malygos leapt into the sky and headed in the general direction of his rival. There was, of course, no sign of the four, but Malygos pushed on. He constantly smelled the air, seeking some hint of any of the other proto-dragons.

But it was another scent that finally seized his attention and gave him a possible trail. It also presented him with the choice of fleeing to safety or racing toward the jaws of death.

Galakrond was somewhere far ahead. Part of Malygos shrieked that he should turn back—a part that Kalec found quite sensible—but another part urged the proto-dragon on. Malygos recalled what Coros had said about Galakrond. If Coros had come this far, he would not stop until he achieved his goal.

And if that happened, the other proto-dragons would become easy prey for Galakrond and his new followers.

Malygos flew low and fast, eyes now seeking any object in the sky. Aware of how swiftly Galakrond himself could fly, Malygos knew that he would have very little chance of escape should the gargantuan proto-dragon spot him. Everything Malygos planned revolved around seeing the behemoth first.

Kalec searched his host's mind for details of what he planned and quickly discovered that Malygos's strategy consisted mostly of finding Galakrond and taking it from there. While Kalec was well aware of how adaptable the future Spell-Weaver could be, seeking out the monster terrorizing the land was, to the blue dragon, insane. However, as always, the choice was not Kalec's. He could only pray that history would be as he recalled it—and he was questioning those recollections more and more with each vision—and that Malygos would survive.

Survival instinct did not seem a trait of his host, as the proto-dragon pushed harder and harder, almost as if eager to confront Galakrond face to face. The landscape changed more than once

as Malygos followed the behemoth's odd and unnerving scent. In addition, the fresher the trail, the more Malygos began to notice the wrongness in that scent. There was a sense of decay, as if Galakrond himself were dead and yet was not. Moreover, there was something else inherent in the scent that to the proto-dragon felt twisted, frightening. Evil was not a concept understood much by Malygos's race, but Kalec recognized that it was that very notion that his host sought. Whatever Galakrond had once been—and Malygos's memories indicated a past in which the leviathan had been thought of as almost benevolent—he had crossed to a darker path at some point.

Much like Deathwing, Kalec thought with growing horror. *But in some ways worse and more primal.*

Why this had never been passed on to the blue's own kind plagued Kalec despite his own trials. What had made the original Aspects and the other first dragons agree to keep this terrible era a secret from the generations to come?

Malygos came to a sudden halt. Kalec belatedly sensed that mixed in with Galakrond's ever-fresher scent was a trace of another scent Malygos recognized. Not Coros but one of those with him. The blue-and-white proto-dragon banked, following that scent.

Although the essence of Galakrond still prevailed, the other scent began to take on more freshness. Other smells joined it, among them Coros's.

Then another, fouler odor caught Malygos's attention. He immediately descended.

A pair of undead proto-dragons dropped down from high above. Their claws just missed rending Malygos's wings. With ragged hisses, they pursued him to the ground.

Through his host's eyes, Kalec sought out someplace from which to better defend himself—only to bitterly recall that he was not in

command of the body he inhabited. Had he been, a natural stone arch to the west would have been his choice of destination.

Malygos headed for the arch.

Kalec could not be at all certain whether Malygos had made the same choice on his own or whether the proto-dragon and he somehow had been for a moment as one. Kalec settled for hoping that the arch would prove the correct decision. The two undead were right on their tail and gaining.

Malygos darted through the arch, then immediately rose. Spinning in the air, the proto-dragon landed hard, paws first, on the arch. Kalec felt every bone shake from the impact and hoped that his host had not badly injured himself.

The arch collapsed. Tons of rock rained down as the two undead, relentlessly pursuing, passed underneath.

The rubble pressed the foremost pursuer to the ground below, where it reduced the corpse to pulp. The collapse did not entirely catch the second undead, but it did throw the fiend out of control. The animated corpse crashed into one of the fragmented arch walls.

Already inhaling, Malygos dived after his pursuer. As the undead attempted to right itself, Malygos unleashed the frost.

The undead's movements slowed. Malygos increased his velocity. He tore into the fiend before it could recover from the blast, biting into the throat and tearing at the chest.

The dry scale and flesh gave way easily, but that did not mean that the corpse ceased its assault on Malygos. The effects of the frost faded. Even with its throat nearly torn out, the undead tried to bite into Malygos's wing. Claws sought his own throat.

Thrusting his head into the chest cavity, the proto-dragon clamped down and ripped out everything he could. As he pulled out, the upper part of the body collapsed into the ruined chest. The undead's flailing head snapped up.

Malygos finished decapitating the creature, letting the head fall to the side. The ravaged body continued awkwardly seeking him. The proto-dragon shifted, and the body stumbled past.

But as Malygos did that, a sharp pain coursed through his left hind paw. He roared in anguish as he fought to shake free the tightened jaws of the head. Blood poured from where several teeth had punctured the proto-dragon's hide.

Seizing the jaws, Malygos finally pried them loose. He threw the head as far away as he could.

His injured paw throbbed. Blood continued to flow. Malygos studied the wounds, then carefully exhaled.

A finer stream of frost blanketed the injured area. The coolness eased the throbbing and helped slow the blood flow, which finally stopped on its own a few moments later.

Kalec felt the pain every bit as much as Malygos did. As it was, he was grateful for whatever the coolness did to ease matters.

The wind coursed through the region. Malygos sniffed the air. Both noted the clear scent of Coros and some of his followers. Why they had diverged from their pursuit of Galakrond, neither Kalec nor his host could say, but the two were of one mind in wanting to find out.

Not desiring to fall prey to another trap, Malygos took a circuitous route that also prevented his own scent from drifting back to his enemies. As the proto-dragon neared, a new, very powerful scent joined that of Coros and the others. The scent of blood.

Very fresh blood.

That disturbing scent was followed by the snarling voice of Coros. What the other proto-dragon said was not clear, but he was obviously angry.

With great caution, Malygos peered around the rocks. His eyes widened.

Coros and his followers were not alone. Between them lay a juvenile male of Alexstrasza's family. There were also two more members of Coros's family, one of them a female slightly smaller than the group's leader. She had a look of sly pride on her countenance that appeared to both Malygos and Kalec to have nothing to do with Coros's anger, which was evidently focused on two of the other males.

"Do it!" their leader growled. "Must be done this way! Galakrond did it this way!"

The juvenile tried to rise, then slumped. His savage wounds now revealed themselves. His chest had been torn open and his wings ripped apart. Malygos's gaze shifted to the new pair, where he saw that both had claws stained crimson.

"Brought him here for you!" interjected the female, taking up Coros's cause. "Now eat!"

Malygos recoiled, and if Kalec could have done the same, he would have. Neither could believe what he had heard.

The other proto-dragons remained hesitant. The female looked at Coros, who hissed. In doing so, Coros revealed that his teeth were as red as her claws.

Without warning, she lunged at the wounded juvenile's throat. As the other males except for Coros recoiled with as much shock as Malygos had, the female ripped out a monstrous chunk of flesh from the side. With great gusto, she tossed it up, then let it fall into her gullet. She swallowed it whole and sneered at the rest of the party.

Malygos wanted to go to the aid of the juvenile but knew not only that it was already too late but also that he would simply be throwing his own life away. Kalec understood that but suddenly wished that he stood *beside* his host. The two of them together could have taken Coros and his party, of that he was certain.

And yet he could do nothing more than Malygos, who shared his frustration and horror at watching the butchery.

One of the hesitant males finally lunged. He ripped a mass of flesh from one of the juvenile's arms. As he swallowed it, the rest finally joined in.

The feast proved too much even for the stalwart Malygos. He turned away and quietly retched. Kalec experienced every raw emotion as Malygos fought to come to grips with the atrocity Coros had led his followers to perpetrate. Proto-dragons did not devour proto-dragons. Yes, they tasted the blood of their rivals in duels, but even when a duel ended in death, it did not continue with the consuming of the dead.

Not, at least, until Galakrond.

Malygos stiffened. *Galakrond.*

Neither Kalec nor his host could have imagined the situation worse than it was, but now it came to both of them that what Coros intended was for him and his followers to become like Galakrond.

Shuddering, Malygos forced his gaze back to the scene. The fire-orange juvenile had mercifully died and no longer suffered as bite after bite was ripped from him. Coros's followers quickly left little beyond bones and torn skin.

It was Coros who brought an end to the hideous tableau. Muzzle soaked, he raised the ruined head by the jaw and tossed it aside. "Done! All done! We grow stronger! We see it soon!"

"Soon!" the female echoed.

"Soon!" the others repeated.

Coros stretched his wings. "Now . . . now you see how Galakrond will not eat us! We are like Galakrond! We will be with him! He will not eat us now!"

This encouraged even the most reluctant of his followers. The gathered proto-dragons raised their heads and hissed as one. Coros

then took off, the female immediately joining him. The rest followed, leaving in their windy wake the jumbled remains of their victim.

Malygos almost gave chase but suddenly found himself drawn to the ravaged corpse. The pungent odor of a fresh kill filled his nostrils. For reasons clear to neither Malygos nor Kalec, the proto-dragon bent to investigate the grisly pile. Kalec's host sniffed the juvenile's remains and then, on impulse, seized one of the bones in his jaws.

Barely had Malygos done so than the proto-dragon spit the bone out. Even then, though, there was a desire to take it or another piece and work what fragments of meat remained off of it and into his gullet. Both Kalec and his host recoiled at the idea, yet Malygos had to fight hard to pull back from the corpse. Hunger filled him, a hunger that revolved around more than merely the eating of flesh. Malygos yearned to taste something else, something that Kalec first recognized.

Malygos hungers for the juvenile's lingering life essence. The blue dragon could feel the proto-dragon straining not to tear at the remnants in search of what little had not faded away.

Stifling a roar of anger, Malygos turned and flew from the spot. At first, he simply flew as far as he could from the corpse, even though that took him in the wrong direction. Only after the wind in his face cooled Malygos enough did the proto-dragon finally arc back toward the path Coros's band had taken.

Their scents were strong, but both Malygos and Kalec noted something different. A hint of the wrongness that pervaded wherever Galakrond flew now tinged their spoor. It stirred the disquieting desire in Malygos again, but Kalec's host fought it down, although the strain was greater this time.

Malygos picked up his pace. Kalec understood that the proto-dragon still did not know what he would do, but he at least had to

find out what happened when Coros made his offer to Galakrond. Images of Coros leading the other proto-dragons into a trap where Galakrond would then devour them all flashed through Malygos's— and also Kalec's—mind over and over.

A flash of blue-green below caught Malygos's attention. The sharp-eyed proto-dragon spotted movement near a small creek. While Kalec tried to make sense of what his host saw, Malygos landed a short distance away from what he had seen.

A rasping sound echoed from ahead. Malygos crept toward it.

Something gulped a great amount of water. Seconds later, Kalec saw through Malygos's eyes the familiar figure of one of Coros's family. While Kalec had no idea which of the band this was, his host recognized the male as among those most hesitant to partake of the gruesome repast.

The other proto-dragon did not look very well. His eyes had turned a pale yellow, and his breathing was ragged. He swallowed another mouthful of water, then coughed up half of it, along with some undigested flesh.

Malygos's stomach churned in turn. Perhaps he made some noise or movement that neither he nor Kalec noticed, for suddenly, the other male whirled in his direction.

With a savage hiss, the blue-green proto-dragon lunged at Malygos. The sickened male moved with a speed his condition belied, falling upon Malygos.

Kalec's host barely pulled back enough to keep from having his throat ripped out. His attacker fought with an almost mindless fury that more than made up for any cunning. The slavering maw seemed everywhere. How Malygos managed to avoid being slaughtered, neither Kalec nor his host could fathom, and yet the icy-blue male succeeded, if barely. Within seconds, Malygos sported a half-dozen slashes, fortunately none of them more than superficial.

But the number of wounds and the strain of the struggle began to stir anew the throbbing where the undead had bitten Malygos. The proto-dragon's head pounded. Kalec felt the intelligent, adaptable Malygos give way to a beast as unthinking as the one that attacked him.

A beast that struck with more rage than the sickened male.

Now it was Malygos who bit and tore and ripped mercilessly. His great hind claws cut deep scarlet ribbons in his opponent's hide. His smaller forepaws clung tightly to the other male, keeping Malygos's foe where he desired him. Even when the second male finally began to try to pull away, Malygos gave no quarter. Kalec could only watch in growing dread as his host fell upon his weakening adversary. Spittle dripped from Malygos's jaws as he loomed over the other proto-dragon. Malygos was eager for the kill, eager for that and for something else that Kalec only now recognized but could not stop.

With one last lunge, Malygos bit through his opponent's throat, tearing off almost half of it in his frenzy. Yet he did not simply toss it aside, as Kalec hoped, but rather eagerly threw it above his head in order to swallow it.

However, as he caught it in his gullet, Malygos came to his senses. Hacking, Kalec's host disgorged the gobbet of flesh. The proto-dragon stumbled back, as dismayed as Kalec at what he had been about to do.

The bite from the undead pounded harder than ever. Malygos glared at it, then stared wide-eyed. Within, Kalec also realized what had overcome his host. The bite had infected Malygos, urged him toward the same foul course that Galakrond followed, the same course that Coros now also desired to pursue.

And although Malygos continued to fight the desire, it remained strong. The nearby body, still fresh, radiated traces of the victim's life essence, which continuously enticed the proto-dragon.

With an anxious hiss, Malygos launched himself after Coros again. The proto-dragon concentrated as hard as he could on his rival and the expected encounter with Galakrond. Malygos dared not think of anything else.

But Kalec was thinking long and hard, making a further connection that his host had not. A single bite had nearly driven Malygos beyond saving.

How many other proto-dragons had been bitten? How many others *would* be?

And how many of those bitten would fail to fight off the effects as Malygos had done so far, paving the way for a tableau of horror even greater than Coros's betrayal portended?

TWO
THE BETRAYERS

Time had come to have little meaning for Kalec anymore—at least, the more he remained caught up in the past. Indeed, as things progressed here, he felt less inclined to return to his own era. Even though he was but an unnoticed, incorporeal companion to the young Malygos, Kalec could not help but feel as if, in some ways, he now had more purpose here. He experienced all Malygos did—both good or ill—and the two progressively appeared in harmony when it came to the proto-dragon's course of action.

We are becoming one, Kalec finally decided, as Galakrond's growing stench gave every evidence of the gargantuan beast's nearing presence.

Not at all disturbed by the esoteric path his thoughts were taking, Kalec urged Malygos to use greater speed, and Malygos did just that. Yet with Kalec's increasing satisfaction at his growing part in these visions, there also came the determination that Galakrond and the corruption he spread had to be stopped. Kalec no longer felt certain just how the future was supposed to turn out; it was possible that the Azeroth he knew was only a delusion of his own mind.

Galakrond must be stopped, Kalec kept insisting to himself, that mission more real to him at the moment than his own life. *Galakrond . . . and Coros.*

Malygos suddenly dived for the ground. At the same time, through his eyes, Kalec caught a glimpse of Coros and the others

rising higher into the sky just ahead. Kalec could only assume that the band had paused for some reason before continuing on.

And even though Malygos reacted quickly, the female with Coros turned her head back as if sensing something. Belatedly, both Kalec and his host realized that she looked for the missing member of their party. Unfortunately, instead, she had discovered their lone pursuer.

There was no need to hear the sharp cry to know that she warned Coros and the rest. Malygos continued to descend until he was just feet above the ground. The tips of his wings scraped the rough soil more than once as he sought out some cover. He darted through a narrow pass, gaze constantly judging which of the various pathways ahead might be the best. He veered through one after another, risking a glance back and above whenever it was safe for even a moment to do so.

And so he did not see Coros come at him from around the next bend.

The other proto-dragon rammed into Malygos. The pair crashed into one of the rock walls. Malygos gasped as the air was forced from his lungs. He tried to regain his breath, but Coros shoved his hind paws deep, keeping Kalec's host from inhaling.

A second attacker—the female—dropped down on Malygos, pushing him to the ground. She and Coros sought his throat.

The land shook. Rock and earth tumbled down on the three. Malygos, nearly on his back, received the brunt of the collapse. Coros and the female thrust themselves away, vanishing behind the falling debris.

A heavy rock pinned Malygos's wing. He struggled at first, then swung his body over the trapped appendage. The pain in twisting shook Kalec and his host hard, but it enabled the proto-dragon finally to slide the rock off despite the continued deluge.

It seemed forever before Malygos managed to draw a breath, even if it was filled with dust that made him choke. Malygos immediately exhaled, sending a strong wave of frost above him. It slowed the collapse, giving him a few vital seconds to cover himself better with his wings and take another breath.

The collapse at last ended. Malygos struggled to free himself but at first could barely breathe, much less move. The frost he had exhaled had begun to break up, and more rock threatened to come down. It was clear to both that they needed to push free fast.

While Malygos's forepaws were small in comparison with the hind ones, they still had strength enough to help him claw forward until his larger appendages could better push him on. With his snout, the proto-dragon shoved the rocks ahead. The stones shifted around him.

He managed to shove another rock aside, and a puff of air touched his nostrils. With more effort, Malygos kicked himself toward the small gap. His head thrust through, and for a moment, he hesitated, certain that Coros was waiting for just this to happen.

But when his rival did not snap his head off, Malygos dug himself out the rest of the way. His wing now vied with his leg for which pained him more, but a short test proved the former was still functional.

The collapse had left his hearing all but gone for the time being. He could not make any sense of what was happening except for what he saw and felt—which was more than enough, considering the second tremor that forced him to retreat from his location.

As Malygos paused again, his hearing slowly returned. Both he and Kalec heard what sounded like either thunder or another tremor beginning, only to realize that, instead, they were hearing the wary rumble of a very large creature. It was then that Kalec and his host understood that what they had both taken for the shifting of the ground had been the simple landing of Galakrond.

With the utmost caution, Malygos wended his way up. He could hear another voice then, the voice of Coros.

"Many will be there! All waiting like grazers to be eaten!"

"So very many . . ." Each word Galakrond spoke reverberated in Malygos's still-tender ears. It was doubtful to both him and Kalec that Galakrond could speak at anything less than a roar.

"We will feast well!" Coros assured him. "We will grow strong!"

Malygos carefully poked his head over the edge. Coros obviously assumed that he was buried beneath tons of rubble, but the icy-blue proto-dragon remained wary of sentinels arranged just in case some other foolish creature dared spy on Galakrond. Indeed, through his host, Kalec observed at least one of Coros's band clearly acting as a lookout, although, fortunately, not glancing Malygos's way at that moment.

Coros and the female hovered before Galakrond, who appeared larger than ever to Malygos and Kalec. Even more disturbing was that the various protuberances pockmarking the behemoth's skin were more distinct than before. Full limbs dangled everywhere. There were even wings that fruitlessly flapped, as if seeking to lift Galakrond in the air.

But most disturbing were the eyes. Scattered about, the singular orbs stared with the same malevolent intent as the two original ones now fixed upon Coros and the female. The scores of extra eyes blinked randomly, as if each was from an individual and not part of the same beast.

One of the nearest turned its baleful gaze toward Malygos.

He ducked immediately. The icy-blue male held his breath and waited. There was no outcry from Galakrond, though. The only sounds were the voices of Coros and the female.

Still full of trepidation, Malygos raised his head again. The eye now looked past him to the small band facing the gargantuan fiend.

"Great Galakrond will lead us!" Coros continued almost gleefully. "Great Galakrond will rule all!"

This Coros is mad! Kalec thought, well aware that Malygos thought the same of his rival. Still, they both saw that Galakrond listened with interest to the words.

"Where will they gather?" Galakrond finally asked Coros.

"The jagged valley! Soon!"

Although Kalec did not recognize the description, Malygos evidently did. His low hiss marked the truth of Coros's words and the depths of the other proto-dragon's betrayal.

"I know this place," Galakrond remarked, his gaze looking inward. "Hunted there when I was small . . . when I was nothing. . . ."

"But you are great now!" said the female, the others adding their agreement with a chorus of hisses.

Some of the vestigial limbs twitched, paws snatching as if seeking prey. Several more of the eyes followed Galakrond's gaze.

"Great I am," the gigantic fiend rumbled. He studied Coros in particular. "You would be great, too."

"Not so great as Galakrond!" Malygos's rival immediately replied, as the female swiftly nodded her agreement. "Not so great as Galakrond!"

"No . . . never so great as me. . . ." Galakrond stretched his wings, which quickly shadowed the land for some distance. One forepaw—small in comparison with the rest of him but far larger than the full form of any normal proto-dragon—scraped at the hard ground, ripping through stone as if it were sand. "There can be only one me. . . ."

An unsettled expression fell over the lookout's countenance. He suddenly took to the sky. Malygos and Kalec both believed that they had been discovered, but instead, the lookout continued higher and higher as fast as he could. There was no doubt now that he

was abandoning the others. The fleeing proto-dragon raced off, vanishing into the distance.

And at the same time, Galakrond roared and rose into the air just above Coros and the rest of his band. Coros and the female leapt back as the darkness that Galakrond's vast shape created now enshrouded them.

The remaining two members of Coros's band sought escape but in doing so only drew Galakrond's attention to them. Despite the speed with which they flew, it was easy for the behemoth to catch up to them. The smaller proto-dragons separated, but even that was not good enough. As Galakrond banked toward one, he brought his wing around. The massive appendage swept up the second of Coros's followers.

Coros and the female took flight, heading over where Malygos hid. In their haste, they did not notice Malygos, who remained flattened against the shielding ground.

Shrieks filled the air. Malygos dared to peer over. The proto-dragon caught up in Galakrond's wing had now been tossed up before him. With an eager roar, Galakrond swallowed his victim.

The monstrous proto-dragon's remaining prey used his comrade's doom to try to slip past the leviathan. He darted to the left side of Galakrond's head and continued to the shoulder.

One of the extra limbs seized the fleeing proto-dragon's wing. The male let out a frightened squawk as the paw held him.

Galakrond shook, letting the paw toss its victim forward.

The shrieking male vanished down Galakrond's gullet.

Barely had the monster finished when he veered toward Malygos. Kalec felt the urge to seek escape fill his host, but somehow Malygos kept his position. The wisdom of that decision revealed itself a moment later, as Galakrond soared over and past him.

The ease with which the gigantic proto-dragon had taken his

other prey meant that neither Coros nor the female had gotten very far. Kalec and his host could still make out both tinier proto-dragons desperately trying to keep the gap between Galakrond and them from closing. However, a few flaps of Galakrond's wings brought him right behind the pair.

Without warning, Coros rammed the female in the side. She lost control, her speed faltering in the process.

He's sacrificing her for his own hide! Kalec realized, both he and Malygos stunned at the betrayal.

The female righted herself just in time to see Galakrond almost upon her. In desperation, she exhaled. However, what worked well against a foe the size of Malygos only futilely draped one of the behemoth's huge yellowed fangs.

Galakrond swallowed her without even slowing in his pursuit of Coros.

Malygos's rival strained to keep ahead, but even his treachery with his own family could not keep him from Galakrond's endless hunger. The mighty jaws opened wider.

In what seemed madness to the onlookers, Coros abruptly turned directly toward the gaping maw. But before the jaws could shut, Coros darted up and attacked the underside of Galakrond's mouth. Claws tore at the softer, unprotected flesh.

Galakrond reared back. Neither Malygos nor Kalec believed that Coros had actually hurt Galakrond, but the attack had certainly caught him by surprise.

Coros used that surprise to begin his flight anew. With a swiftness that even Malygos could not have matched, the blue-green dived toward the ground, where he maintained his tremendous velocity despite having to navigate one change in terrain after another.

Galakrond pursued. Malygos finally rose from his hiding place, which gave him one last glimpse of hunter and prey.

And in that moment, he and Kalec both saw that despite Coros's cunning, Malygos's rival could not escape. Keeping low briefly kept Galakrond from easily snapping him up, but a rise in the land finally forced the speeding Coros to overestimate his path. Momentum sent him high above the security of the ground, and the leviathan swallowed him whole.

The abruptness with which Malygos's rival perished did not in the least disturb Kalec's host. Both had seen that all that mattered to Coros in the end was his own existence, not even that of those closest to him. Malygos's only concern was that Galakrond would suddenly turn about and spot him before he could make his escape.

Fortunately, Galakrond instead alighted in a vast plain farther ahead. The macabre behemoth landed with as heavy a thud as earlier, sending a tremor through the region.

Quickly descending again, Malygos waited. Galakrond settled his head on the ground. A few moments later, a low, steady rumble escaped the enormous proto-dragon.

When the rumble continued, Malygos dared to take off again. How long Galakrond would rest, neither Kalec nor Malygos could guess, but the icy-blue proto-dragon could not assume that he would have much time. Following Coros's tactics, Malygos kept low as he flew with as much speed as he could muster. Even when the rumbling faded into the distance, Kalec's host did not slow.

One notion began dominating the proto-dragon's thoughts, and thus Kalec's. While Coros had paid for his betrayals, he had still in the end performed one more misdeed. Galakrond knew where Talonixa had the others gathering for her charge. As suicidal as the female's plan seemed to both Malygos and Kalec, at least it offered *some* chance. However, if Galakrond struck while they were still coming together, there would be utter disaster.

The proto-dragon pushed harder. If Malygos could warn Talonixa before Galakrond awoke—and if he could make the female listen—then there was hope.

Renewed rumbling sent Malygos dropping, but almost immediately, he recognized the sound as thunder, not Galakrond. The exhausted proto-dragon finally paused in his flight. The effort thus far had taken a lot out of even the sturdy Malygos.

It started to rain. The storm was not a strong one, but there was the fear that if the rain continued on its present course, it would soon reach Galakrond. If it woke him, he might decide to fly in Malygos's direction—

Kalec's world turned upside down. The vertigo struck him as if he were experiencing it for the first time. To his surprise, the blue dragon found himself struggling to remain with his host. He could identify with this battle for survival more than with the growing number of questions that represented his existence in the present.

And yet, as ever, Kalec had no choice. Malygos and the past vanished . . . and Kalec awoke on his back and in half-elven form somewhere in the Nexus.

There was no immediate hint to how much time, if any, had passed. It was dark, and that also disturbed Kalec, since there should have been *some* illumination. Rising from the floor, he summoned a sphere of light.

He bared his teeth in frustration as he discovered that his surroundings were not where he had last been standing but rather a chamber deeper in the Nexus. He looked around, seeing nothing but emptiness. Even the artifact was nowhere to be seen, not that the fact encouraged him at all. By this point, he knew that it mattered not where the physical form of the relic sat; its power could reach him anywhere—

Kalec spun around. For a moment, for just the briefest of

moments, he thought that someone had been standing behind him. Someone wearing a voluminous cloak and hood.

But a short search of the passage in that direction revealed nothing. Still, Kalec found himself drawn that way and continued on. As he moved, the former Aspect wished that somehow he could just return to the young Malygos. Better the sanity that the madness of the past brought him than the madness his own era offered.

Yet despite his growing willingness to accept what the artifact appeared to be demanding of him, he remained conscious. His disappointment was magnified by the fact that he was nearing his original location without having discovered any reason for the feeling that he had again been watched.

But just before he would have entered, he sensed the presence of another. Whoever he was kept himself well cloaked from most magi's abilities but not Kalec's yet considerable powers. He could not tell who or what had invaded the Nexus, but the intruder was very near.

Kalec dismissed the sphere, then cautiously proceeded. A faint illumination immediately spread through the area around him. It was a sign that the Nexus still responded readily to his will, which gave him a formidable line of attack. Any thief seeking the Nexus's collection would soon rue the day.

Shadows filled the great chamber, which seemed natural considering the faint illumination remaining, but there was a very slight wrongness to one area that made him wary—

"Kalec? Are you there?"

As the voice echoed through the chamber, the wrongness vanished. Instead, the Nexus alerted him to the obvious fact that someone he knew very well now called to him from the more accepted entrance to his sanctum.

Someone who was none other than Jaina Proudmoore.

He turned just as she entered. Jaina did not see him at first, but when she did, her expression went from open apprehension to relief. "There you are! Praise be! I was beginning to think you'd either left or . . ."

Her voice trailed off without her explaining what fate she had imagined might have taken him, but Kalec did not care. There should have been no difference between seeing her actually standing before him and viewing her through the tear he had earlier created, but now the scents that Kalec had come to identify with Jaina and only Jaina reached the blue dragon. Even in his half-elven form, his senses were more acute than those of the being he resembled and, in this case, more acute than Jaina's. She did not know how she smelled to him . . . or how welcome those scents were to the former Aspect.

"Forgive me," she went on at last, approaching him at the same time. "I tried to contact you again, and when I didn't even sense you, I finally had to travel here myself."

His brow furrowed. Kalec was well aware just how much effort Jaina would have had to put in to journey here so quickly. While a part of him was very grateful on a number of levels at this tremendous show of concern, he reminded himself of the potential danger facing her if she came into close contact with the artifact. Even if it only cast her mind into the visions, that might prove too much for her. The artifact had taken enough of a toll on him; while very powerful, she was still human.

"You should not have concerned yourself, Jaina. I did hear you call to me, but I was in the midst of trying to revitalize some of the wards and could not risk halting the work at that point. I intended to contact you as soon as I could."

"Kalec, you should really have some help, even if it's me and me alone."

Kalec knew that even if he did agree to her aiding him, no good would come of it, especially for Jaina. He remembered too well the distrust with which some of the other magi had begun to look at their leader because of her growing relationship with a blue dragon.

"I'm grateful for the depths of your concern," he began carefully, not only hoping to avoid offending her but also praying that the artifact would not choose this moment to cast him back. "But you have so many other matters you need to worry about. The others—"

"I *know* about the others," Jaina interjected just a bit sharply. "I need no counsel from them regarding what I can and cannot do! They wanted me to be their leader; now they can accept my choices."

For the moment, Kalec forgot his troubles. The last thing he wanted was for Jaina to jeopardize her position. In addition to his own concerns, he had hoped that by leaving, he would cause no more harm to the archmage.

"But as leader, you also have responsibilities to your people," the blue dragon reminded her. "And I am not part of your people. I'm sorry I have added to your worries, Jaina. Please trust me that your place is with your own, not assisting me here."

It came out colder than he had planned. Jaina's expression did not change, but there was a subtle shift in her gaze.

Finally nodding, she looked away. "Perhaps you're right. Forgive me for being impetuous. I just had to come myself to see what was happening." Her eyes returned to his. "But I take your word that you're well, Kalec."

He kept his own eyes steady despite the guilt growing within him. "All is well." He started to reach for her but put his hand down before she could notice the movement. "Thank you."

Where he had held back, Jaina chose to act. One slim hand

touched his arm, remaining there long enough to make an unspoken point. Then the archmage stepped back and, with a brief smile, began her teleportation spell.

When at last he was alone again, Kalec exhaled sharply. He hoped that Jaina would take to heart his reluctance to have her near and would not try to attempt any further contact. At least then, one fear of his would be no more.

And as for the greatest of his fears, Kalec could think of only one course of action to take with the relic. While he could not yet prevent it from affecting him, he could make certain that it bothered no one else. That meant that more than ever, the wards had to be strengthened. At this point, no one—not even other blue dragons— could be allowed to enter the Nexus. Not until he had dealt with the situation. Kalec felt fortunate that Jaina had not come any earlier. If she had, she might have discovered the truth and endangered herself by trying to help him.

The task giving him renewed focus, Kalec headed back to where he had been working when the visions had last taken him. He prayed that he would be given the time at least to do this, if not for himself, then for the sake of Jaina or anyone else who sought entrance to the Nexus.

There was no hint of anything wrong when he arrived, for which he was grateful. He considered confronting the artifact first but chose to remain with his decision. If the powers of the relic were for the moment dormant, he preferred to keep it that way.

Kalec prepared himself for his work just as he had before. The ley lines appeared before his veiled gaze. He began manipulating the power, growing more satisfied with each step he completed. Within minutes, the first ward had been strengthened enough that he decided to go on to the next.

The second proved even quicker to fortify. Kalec felt a rare

moment of pride. It had been a long time since he had accomplished *anything*. He reached for the third ward.

There was something attached to its spellwork, something neither he nor any blue dragon had cast.

The artifact's magic had insinuated itself in the ward.

Kalec immediately withdrew for fear that he would stir up whatever the artifact intended. An unease crept over him, and he sought out the next ward.

That, too, was now linked to the artifact.

The former Aspect frowned, then returned his attention to the one he had just finished strengthening.

Like the others, it was also linked . . . linked when it had not been a few seconds before.

Quickly dismissing the rest, he focused on the first and, not at all to his surprise, found that the artifact had also connected its power to that ward.

The uneasiness swelled. Kalec took a deep breath, stepped back, and without hesitation, brought forth the entire array that formed the Nexus's network of defensive spells.

The hiss that escaped him was far more suited to his draconic form than to the half-elven one he currently wore. The former Aspect glared.

The power of the artifact was now a part of each and every ward in the Nexus.

THREE
THE AFFLICTED

Jaina Proudmoore reappeared in her chambers, her exhaustion having more to do with Kalec than with her magical efforts. She knew that he was hiding much from her, and while she appreciated his obvious worry for her, she also resented it. Kalec was a blue dragon, and yes, that meant that he understood aspects of the magical arts in a way that even she did not, but Jaina also considered herself more than capable of facing most such situations and using human adaptability to ferret out solutions that perhaps a dragon might not think about.

She summoned a chair to her. Taking a minute to gather her thoughts, the archmage relived her visit to the Nexus. With those thoughts came guilt of her own. She had held back some of the truth from Kalec, too. Jaina had not arrived just before he had noticed her; in fact, she was the one he had almost discovered. Only a quick manipulation of magic had enabled her to focus his attention elsewhere long enough for her to shift her location to where it would seem she had just entered the area.

And even that might not have been necessary if Jaina had not been concerned that Kalec would realize just how long she had been there.

Long enough to discover the relic.

The archmage had no more precise name for it. Artifact. Relic. Jaina suspected that Kalec thought of it in the same terms. It was like nothing she had ever seen, and that included personal knowledge of

a variety of powerful magical objects comparable to the collection stored in the Nexus.

Yet if it was like nothing she had ever seen, it was not entirely a mystery to her. She did identify one significant factor, possibly something that even Kalec might not recognize.

She had come across such spellwork in the past. Only twice and of a much lesser degree, but she had definitely seen its like before. It was a spellwork older than dragons, spellwork that bespoke of a unique knowledge lost to magi of her time.

Spellwork that Jaina, at least, believed had ties to the legendary keepers or even the titans themselves.

The archmage had certainly not journeyed to the Nexus with such a discovery in her mind. All she had truly had to go on was her suspicion that there was something in the Nexus tied to Kalec's strange behavior. It had been her intention to speak with him and find an excuse while doing so to use her power surreptitiously to seek anything amiss. Jaina had believed that she could do this without even Kalec sensing it.

And had that opportunity not presented itself, she had plotted other ways by which she would have had some time alone to try to decipher the truth. However, all of her planning had proved unnecessary, for there had been no hint of Kalec upon her arrival. The weakened wards had made it easy to gain entrance, and once she had verified that Kalec was nowhere to be seen, she had begun to investigate her surroundings.

To her surprise, finding the relic had been quite easy. It had radiated a unique magical trace. In addition, it seemed that Kalec had not even bothered to secrete it in one of the many arcane prisons or other caches designed to hold such powerful magical items. The artifact had simply sat out in the open in the first major chamber she entered.

Some might have been unnerved by the thing, but Jaina had only been fascinated. She studied its aura, admired its design, and delved as deeply as she cautiously could into its core.

But in the end, Jaina had learned little. So significant was this find that she had actually considered taking the artifact with her, even despite the near disaster created by her intention to use another relic—the Iris—in revenge for Theramore's destruction by it at the hands of the orc Garrosh. However, before Jaina could bring herself to seize the artifact in the Nexus, the archmage had suddenly sensed Kalec nearby. Not sure how he would react to her obvious intrusion, Jaina had masked her presence as best she could, then worked to make certain that Kalec did not know she was there while she quickly shifted her location. Even then, he had almost noticed her.

Yet if Jaina did not have the artifact with her to study, she did have access to other avenues that might give her a clue to what it was and how it might be related to the changes in Kalec's personality. Jaina was convinced that he was in desperate danger, perhaps not only to his mind but also to his body.

Jaina summoned a thick silver tome from the highest shelf. As it neared her, the book opened, and pages began flipping. A narrowing of the archmage's eyes caused the pages to cease turning. With the book still hovering at reading level, she surveyed the contents.

The archmage who had written these pages had marked the two items she was particularly interested in as remnants of the period shortly after order had been brought to Azeroth. Jaina had sought these because something in the artifact's appearance had reminded her of something the archmage had read when first she had combed through this book for other reasons.

To her frustration, the two pages before her presented Jaina with

nothing. There were details of where the items had been found and who had been involved in discovering them. There were also notations on previous studies of the titans and keepers believed to have been identified as having influenced the regions where the finds had been made. While such notes were interesting to Jaina in a scholarly way, she sought more.

The page turned. Theories about the titans and the keepers dominated, some concerning the extent of their ties to one another. Jaina started to skip farther ahead, then recalled something mentioned within the theories.

She found it: . . . *as the young mage Rulfo insisted. The vision he claimed to have had from touching it suggested keeper influence in its design. Archmage Theolinus had his own theory on keeper influence in other regions. . . .*

Jaina let out a grunt of exasperation. She skipped down past theories that she normally would have had more interest in, hoping to find what she thought she recalled.

"Ah!" The name Rulfo finally came up again. It had been so long since Jaina had read through this part that she could not remember what else Rulfo had told his masters about the vision, but surely it had to be in this section.

But scarcely had she begun reading when the archmage stepped back in such shock that she accidentally canceled the spell holding the book in place. The ancient tome dropped with a loud thud on the floor, the pages now askew.

Her heart pounding, Jaina knelt by the damaged book. Her concern was not for what she had allowed to happen to it but for rereading the passage. With a wave of her hand, the other pages flew by until the one she sought once again faced her.

"Rulfo . . . Rulfo . . ." Jaina muttered, seeking his name.

. . . Rulfo might have had the answer to that. His death is a sad

footnote to an otherwise intriguing expedition into a study of the past. . . .

She had gone too far. The archmage went back a few paragraphs. Once there, Jaina read more carefully.

. . . the third day after the find. An entire afternoon of searching revealed nothing, not even with the finest spells at work. Only after dark, only when one last attempt was made, did someone find his body.

"Body," Jaina murmured, praying that she had read wrong.

According to reports, at first glance, the consensus was that he had somehow lost his way and fallen off the peak. Certainly, that explained how mangled Rulfo's corpse was said to be. However, later conversations by the representative of the Kirin Tor with those who knew him best give indication of a peculiar and sudden madness that descended upon Rulfo prior to his disappearance. The ultimate conclusion was that this vision the young mage mentioned was the start of his insanity. . . .

It ended there, the next paragraph continuing on with matters Jaina found for the moment tedious. Still certain that she had read more than this previously, she desperately searched the succeeding pages but to no avail. She returned to the ones she had read and studied them closely, but quickly verified that she had missed nothing.

And yet . . . somewhere she had read more.

The archmage cast her eyes upon the many tomes, scrolls, journals, and other writings before her. Within one of them, the details she hunted for surely existed. She just had to recall which one or keep looking until she found what she sought.

But staring at the imposing collection, the archmage wondered if after she managed to locate the information, it would already be too late for Kalec.

The artifact was as bound to the Nexus's wards as if it had been so set since the latter were first cast. Kalec doubted that Malygos could

have weaved the accursed thing's power into the array with such mastery. It again bespoke the great skill of whoever had created the relic, a being the blue dragon could only assume was the cloaked and hooded form of which both he and the young Malygos had caught glimpses.

A being Kalec had already come to hate deeply.

For what seemed the hundredth time, Kalec followed a magical trail in the array in the hopes of finding some flaw that he could exploit. He did not want to leave the Nexus at the mercy of the artifact, even though thus far, it had done no visible harm to the place. Still, considering what it had done to Kalec, the blue did not want to take any chances—

Tainted! Tainted!

With a pained roar, Kalec pulled back from his work. He clutched his head, trying to keep the voices at bay, but they shouted so loudly that all else was drowned out.

Must destroy them!

No! They are us!

No! They ate one of us!

The Nexus became a maelstrom. Kalec lost his balance, spun around, and fell.

But before he struck the floor, he suddenly hovered above the ground, surveying what appeared to be the start of a civil war among the proto-dragons Talonixa had gathered. At least seven individual combats caught his eye—or, rather, Malygos's eye—and one of them included both Neltharion and Nozdormu.

Despite the fight being two against one, the pair was very tentative in its attacks against the silver-green female before them. She, on the other hand, snapped and clawed at them with abandon, eschewing tactics of any sort. As Malygos landed nearby, she lunged at Neltharion.

Malygos knew well by now the charcoal-gray male's eagerness for battle and so was surprised when Neltharion sought desperately to avoid her sharp but smaller teeth. Neltharion scuttled back as the jaws neared his throat—

—and Nozdormu leapt in at the perfect moment and tore out the preoccupied female's gullet. He struck so artfully that he had already withdrawn before the female even realized that she was mortally wounded. Her chest quickly soaking with her blood, the stricken proto-dragon started to turn toward Nozdormu, then fell on her face.

As Kalec and his host struggled to make sense of events, the other seemingly mad proto-dragons were herded together. Some of those facing the prisoners appeared to be barely able to keep from trying to rip them apart. One of those preventing that was Ysera, who was issuing a warning.

"Be careful! Watch teeth! Stay back!"

Beyond the scene, Talonixa watched with an unreadable expression. Kalec wanted Malygos to keep an eye on her, but his host was more interested in what Ysera was attempting to do. The more the tableau unfolded, the more it appeared that Alexstrasza's sister was every bit as concerned for the afflicted as she was for those surrounding them.

While both Malygos and Kalec could appreciate that she was trying to prevent further bloodshed among proto-dragons when the true threat was clearly Galakrond, the blue dragon and his host were in agreement that this could not end well. The surrounded band snapped at their captors and seemed not to recognize those whom Malygos knew they should.

Malygos noticed something about each of the captured proto-dragons. Every one of those whom the icy-blue male could see sported bite wounds from some previous but still recent fight.

Bite wounds . . . Malygos started to glance down at his paw, only to be interrupted by Alexstrasza.

The fire-orange female looked relieved to see him. "You live! We thought you dead!"

"Almost. Coros . . . he is dead."

Before he could relay to her the full tale and its import, Alexstrasza looked back at where her sister still worked to keep the two groups from converging on each other. "She does not understand! They must die! Even I know that!"

That drew Malygos's attention from the need to tell his story. "Must die? Why?"

"The bites . . . the bites of the not-living! They make a hunger . . . they make these want to eat one another! They make them like Galakrond!"

Her words shook both Kalec and his host. Malygos could not keep from shivering as he remembered his struggles after being bitten. He looked past Alexstrasza to the maddened proto-dragons, recalling his own growing bloodlust and how he had barely kept from doing just as these apparently desired.

Alexstrasza mistook his reaction for disgust at what the captives had turned into. She hissed. "Ysera thinks of our clutch brother. She thinks him out there still."

This further dismayed Malygos. "Would be not-living!"

"Clutch brother long dead," Alexstrasza reminded him. "Long dead when Malygos finds him . . ."

That should have reassured him, but so many things had happened that even a clever proto-dragon, such as Malygos considered himself, had doubts. True, other old corpses had remained dead, at least the last time Malygos had seen them. Now the icy-blue male wondered whether those corpses would still be there if he went to find them again.

And then his thoughts returned to just how these other proto-dragons had been changed. They had all been bitten. They had all succumbed to the monstrous hunger that Malygos had fought more than once.

Kalec sensed his host considering fleeing before someone recognized the wound and added him to the mad. Still, Malygos held his ground and watched as the tableau played out.

Talonixa finally acted, shoving past smaller proto-dragons to face Ysera and the afflicted. Despite their growing madness, the imprisoned proto-dragons remained cowed by the powerful female.

"Kill them. . . ."

"No! Must help them!" Ysera insisted, staring defiantly.

"Kill them, or they bite us." As she spoke, Talonixa pressed Alexstrasza's sister back, forcing her closer to the mad. "They bite you. . . ."

Whether a bite from one of the afflicted would affect a proto-dragon the way a bite from the undead did was a question Kalec doubted any there knew the answer to yet, but Talonixa's words stirred fear in several of those in attendance. Even Alexstrasza's sister looked uncertain.

Without warning, one of the afflicted hissed and started toward Ysera. Before Alexstrasza could go to her sister's aid, Ysera, her uncertainty vanishing, turned her steady gaze on her would-be attacker.

The madness faded somewhat. The other proto-dragon let his head drop low, then shuffled back. To Kalec, he seemed ashamed that he had tried to harm the smaller female.

Ysera again faced Talonixa. "Must help them. . . ."

"No time! We must fight Galakrond!" the larger female declared. She looked to those watching the argument. "We fight! Yes?"

As they had before, the majority of the other proto-dragons hissed their agreement.

Even in the face of such a lack of support, Ysera pressed. "These are us! These are us!"

The gathering quieted.

Alexstrasza's sister moved toward the crowd, beseeching. "These are us! We help them, we help us!"

Some of those listening looked at one another in thought.

Talonixa's eyes narrowed more. "Yes . . ." she hissed quietly, suddenly very agreeable. "Yes . . . we help them. . . ." Talonixa eyed the afflicted. "But must keep them safe. Must keep *us* safe. Help them when we can. . . ." She turned and studied the west. "Must keep them safe, yes. Come! Bring them!"

Clearly confident that she would be obeyed, Talonixa took flight. Several of the proto-dragons surrounding the afflicted looked warily at Ysera.

Alexstrasza's sister stared at them with defiance, then glanced at the captured figures. "Come . . ." she murmured soothingly. "Come . . ."

Slowly, Ysera rose into the air. As she did, she gestured with her head after Talonixa.

The surrounded proto-dragons reluctantly followed Ysera. They were flanked by Talonixa's ardent supporters. The rest of the assembled proto-dragons looked more than willing to stay behind, but to Kalec's surprise, his host suddenly leapt after Ysera. Even Alexstrasza was not so swift. Out of the corner of Malygos's eye, Kalec saw Neltharion and Nozdormu follow suit.

The scene abruptly shifted, but Kalec sensed that only a short time had passed. Now Talonixa led the band toward a narrow valley.

"There!" she roared, indicating with a dip of her wing another pass. Talonixa descended.

As the proto-dragons landed, the large female strode toward what initially looked simply like a rock wall. However, as they followed Talonixa around, a narrow crevice revealed itself.

At first, Kalec thought it was the entrance to the cave from the one disturbing vision. However, almost immediately, too many details gave indication that it was otherwise. Still, Kalec could not help feeling that he knew the reason Talonixa had brought them to this place.

"Why here?" Ysera asked with a hint of suspicion.

"These ones you defend, they go in here and wait."

The pale yellow female peered at the narrow entrance, her suspicion growing. "In there?"

"All . . . or we must slay."

The finality of her tone brooked no argument. With reluctance, Ysera at last nodded.

"They stay here," Talonixa commanded. She indicated some of those guarding the afflicted. "Four here, they guard. Entrance narrow. Four enough."

It was clear to Kalec and his host that Talonixa would have gladly had the afflicted slaughtered there and then, and Ysera obviously also saw that. She finally acquiesced, then led those she had championed toward the narrow entrance.

One by one, the trusting proto-dragons entered the cave. Some had to struggle to get inside, so restrictive was the entrance. Ysera had to keep calming both those waiting to enter and those already inside.

The last finally entered. Ysera backed away in order to let the guards take their places.

But as the first began to move, Talonixa rumbled, "Wait."

Ysera hissed. Malygos and Neltharion started toward Talonixa, only to have some of the golden female's most ardent followers block their path.

Talonixa exhaled. Lightning shot from her maw.

Three bright silver bolts struck the rock face above the entrance. As that happened, a calm Talonixa fluttered back a few short yards.

The entire rock face collapsed, spilling over the cave.

Ysera leapt toward the avalanche, but before she could sacrifice herself in a vain attempt to save those within, Malygos lunged for her. To his surprise, Nozdormu reached her first, seizing one of her wings with his jaws and carefully but firmly pulling her back just before she would have been crushed to a pulp.

Despite there being no doubt regarding Nozdormu's or Malygos's intentions, Ysera snapped at both of them. Her rage undiminished, she whirled on Talonixa.

Four other proto-dragons blocked her path. Two opened their mouths, but Talonixa's hiss rose above the confrontation, stilling their attack.

"It is done," she proclaimed, her massive wings stretched to enhance her size and, thus, her dominance. "No taint among us! All tainted must die!"

Ysera exhaled. The two guards directly in front of her blinked and nearly collapsed. Stunned, they proved no impediment to her charge. She burst past them and sought Talonixa.

But the larger female awaited this foolhardy act. She shifted as Ysera neared. Her long, powerful tail struck her much smaller adversary across the head with a loud crack.

Alexstrasza rushed by Malygos and the others in time to reach her sister, just as Ysera fell back, stunned. The two crashed into each other, ending in a heap.

"It is done," Talonixa repeated, acting as if she had not even noticed Ysera's impudence. "Come . . . must be ready for Galakrond. . . ."

With that, Talonixa and all except for Malygos and his friends silently departed. The males moved in to aid the sisters, only to have Ysera roll to her feet and rush to the buried cave. Ignoring the small bits of stone and dirt still raining down, she used her hind paws to try to rip away at the tons of rock.

However, as Ysera tore at the avalanche, additional stones loosened above. They fell down, not only more than replacing what she dug away but also battering her enough that Alexstrasza, at last righted, risked injury to herself and pulled her struggling sibling to safety.

"Save them!" the smaller sister insisted, her frantic gaze darting from Alexstrasza to the males. "They still live! Hear them!"

Malygos listened but detected nothing. Yet both Kalec and his host—and also the other future Aspects—knew that Ysera spoke the truth.

There was just nothing they could do. A hundred proto-dragons digging without pause would not have been able to reach those within in time. Malygos understood that as well as Kalec, and so did the rest, even Ysera. Still, despite her awareness of the futility of what she attempted, Ysera again rushed to the fall and tried digging. She kicked away rock after rock, only to have more fill the momentary gaps.

The others finally shoved in front of Ysera and forced her away. She continued to stare at the buried entrance, and at one point, through Malygos's ears, Kalec heard her say, gasping, "Dralad . . ."

After several tense moments, Alexstrasza's sister stilled. However, now there was a distant look in her eyes, as if her mind remained elsewhere.

"We must go," Malygos at last suggested quietly.

Neltharion added, "The hunt for Galakrond will begin soon! We must be there!"

"The hunt *for* Galakrond?" Nozdormu mocked, startling both Malygos and Kalec by even speaking. From what Kalec gathered from his host, young Nozdormu spoke only when he seemed to have something significant to add. Otherwise, some might have taken him for one of the less advanced, more animalistic proto-dragons, unable to talk. "Hunted *by*, it will be."

Yet, despite saying that, the brown male was the first to leap into the air. To the surprise of the rest, Ysera immediately followed. Alexstrasza joined her sister, leaving Malygos and Neltharion to find themselves bringing up the rear.

However, as they ascended, Kalec—but not Malygos—noticed Ysera surreptitiously glancing back at the ruined cave, where some of the afflicted proto-dragons likely still struggled to survive before the air gave out. She then glanced at Malygos, but not directly at his face. Rather, Kalec noted that she eyed his lower leg.

The same leg where the one undead had bitten Malygos's paw.

FOUR
THE WATCHER

Kalec's view shifted again. Ahead of the five, Talonixa and her gathered host hovered in the air. He realized that they were already setting out to find Galakrond. Several of the other proto-dragons noted the small band's arrival, which in turn alerted Talonixa.

She soared toward the five, her attendants flanking her. As Talonixa confronted Ysera and her companions, the attendants spread out in obvious battle formation. Malygos and the others instinctively did the same, even against the greater odds.

"These can join the hunt," Talonixa decreed. "You, runt, will not."

"I will come with!" Ysera insisted.

"Why? Talk to Galakrond? Make a tiny bite for him!"

Recalling Coros—whose fate Malygos had still not yet told to Talonixa—the icy-blue male shuddered. Kalec shared his unease and wished that Malygos would quickly tell everyone in the hopes that perhaps it would deter them from this mad attack. However, his host didn't speak, at the moment only concerned with the safety of his friends and not thinking of the potential repercussions of saying nothing.

"Will not go," Alexstrasza said. "Will stay with my sister."

"I stay also," Nozdormu briefly added.

Neltharion momentarily looked frustrated, his natural tendency being to go wherever a fight could be promised. Still, he grudgingly nodded his agreement with the other two.

Malygos added his voice to his friends', not that Talonixa seemed to care at that point. She started to turn from the five. Only then did Kalec's host finally recall what he should have told everyone at the first chance. "Wait! Must speak of Coros!"

A suspicious Talonixa looked back. "Coros?"

As best he could, Malygos quickly related to her and the rest the fate of the treacherous proto-dragon, leaving out only those details where his own struggle with the infection from the undead's bite were concerned. The far simpler language of his host frustrated Kalec, who knew that he could have explained much more clearly, but the essence of what Malygos sought to tell was evidently understood by Talonixa and the others.

But rather than be daunted by the savage tale, the imposing female simply sneered. "Coros fool . . . but gives us victory!" She peered at her loyal but confused followers. "Galakrond knows where we are, where we go! We fool *him*! We attack *before*! We attack in different place!"

"Not good," Nozdormu muttered, his words going unheard by the increasingly confident Talonixa.

"Must strike now!" She spun from Malygos again. "Come! We attack!"

The gathered proto-dragons left the five behind.

Neltharion fluttered back and forth, obviously desiring to be a part of the coming battle but in the end choosing his comrades over his desires. Still, he could not help expressing himself. "Why we not fight? Not like Talonixa, but we fight our way! We fight our own plan—"

"And die as stupidly as they," Nozdormu, proving quite talkative this day, interrupted calmly.

"There *must* be peace."

Even Alexstrasza eyed her sister with something close to exasperation. "Ysera—"

Without warning, the smaller female darted off. There was no doubt about her intentions. She still hoped to change the course of events, however mad that seemed to both Kalec and his host. Worse, Alexstrasza immediately chased after her sister, which caused the increasingly impatient Neltharion to do the same.

Nozdormu looked to Malygos. "If this—"

The scene suddenly shifted. Even though Kalec was better prepared for it, he still raged at being ripped from the moment before he knew how it would continue to play. There was a very real feeling running through him that despite the fact that all of this took place in the past, it had a relevance to his time that he dared not ignore.

He—as much as Malygos—darted among the frosty peaks of the northern regions in great haste, searching with more and more desperation for someone whom at first Kalec could not identify from the proto-dragon's racing thoughts. The only thing that Kalec could tell was that something had caused a change in events. What it was finally flashed through Malygos's mind as he dived to investigate a shallow cave in one frosty area.

Talonixa's great host had been unable to find the gargantuan Galakrond.

How a creature as huge as the twisted proto-dragon could suddenly vanish was a question that greatly plagued Kalec's host and also bothered Kalec. However, it was not the reason for Malygos's mad hunt in this obscure place far too near the misshapen leviathan's known haunts.

Malygos was hunting *Ysera*.

A shadow crossed Malygos. Neltharion dropped down.

"Nothing!" the charcoal-gray male bellowed. "I smell her . . . but nothing!"

Her scent pervaded the area but was not strong enough to be identified as very recent. Ysera might have passed this way as long

ago as two days. Kalec understood now that it had been four days since the shift in the vision. Indeed, the last time anyone had seen Ysera was shortly after that scene had changed for Kalec. The weaker female had risen into the thick clouds, whereupon her trail had somehow faded. It had taken a frantic Alexstrasza another day and a half to locate a trail, but only after the four had already confronted an angry Talonixa leading a befuddled force in search of the absent Galakrond.

"He is scared!" Talonixa had roared at the top of her voice for any to hear, perhaps even Galakrond himself. "He knows we hunt! He flees us!"

This had hardly been the opinion of Malygos or his friends, but their voices had not been of interest to Talonixa. She had led her army off to the east, leaving the four to continue their own search.

But why Ysera had abandoned the others when she had was still not apparent. Malygos had his suspicions, and from what Kalec divined, his host believed—not unreasonably—that Alexstrasza's sister had sought out Galakrond to plead again for a stop to the carnage.

If so, there was a very good reason she had thus far remained unfound, a reason that none of the three males dared speak out loud in the presence of Alexstrasza. Ysera might already be a victim of Galakrond, foolishly placing herself in the mad behemoth's maw as easily as Coros had.

"Saw nothing," Malygos informed Neltharion now, his pulse still pounding from his own swift search. Another proto-dragon soared above. Seeing that it was Nozdormu, both calmed. The third male appeared to have had no better luck than they. Of Alexstrasza, there was no sign, although Kalec understood that Malygos had a fair notion where she could be found. Once arriving at this place where Ysera's scent had grown stronger, they had divided up to cover

certain areas where a proto-dragon could more easily be hidden from sight.

But thus far, they had discovered nothing.

"She is not here," Neltharion suggested. "Was . . . but is not."

His tone echoed Malygos's own concerns about Ysera's fate. Neither wanted to be the one to approach Alexstrasza with what seemed more and more the truth.

"Maybe search more," the charcoal-gray male recommended with some hesitation. "Maybe flew too fast. I do that."

They both knew that they had scoured their respective areas thoroughly, but being reluctant to face a dismayed Alexstrasza, they split up again. Malygos banked, then dropped lower. He did not expect to find anything, Kalec knew, but the only other choice was to report his failure to the fire-orange female.

The sharp eyes of the hunter surveyed the icy soil and frosty rock walls ahead. Malygos quickly recognized the few places where Ysera might have been able to secrete herself. However, he already knew that she could not have possibly slipped by him, and sure enough, the first three locations were as empty as he recalled them—

Something moved near the mouth of the last cave. It was such a brief glimpse that neither Kalec nor his host could identify just what it was.

The proto-dragon dived to investigate. He slowed when he neared the cave. There was the danger that whatever lurked within was not only not Ysera but a threat.

Malygos squinted. The cave was utterly dark. That in itself unsettled the proto-dragon; his sharp eyes should have been able to penetrate the blackness for at least a few feet. Kalec's trepidation matched Malygos's as the proto-dragon first sniffed the air, then, scenting nothing, chose to enter.

Visibility remained almost nonexistent as Malygos progressed.

The icy-blue male hesitated. Kalec's host sensed something amiss, but it was nothing that his mind could identify. However, Kalec, able to feel the ancient world, noted the hint of some great power nearby.

"Welcome, clever hunter," came a deep voice with an otherworldly quality that made Kalec want to gasp and made Malygos instinctively retreat a step from that direction.

A low silver light arose from the darkness.

Within, a cloaked and hooded form already familiar to Kalec coalesced.

Hissing, Malygos retreated again. Yet if the proto-dragon sought the way out, he was not to find it, nor was even Kalec able to note where it was. Only darkness prevailed except where the tiny figure stood.

Curiously, though, despite the fact that Malygos loomed over it, the mysterious figure unnerved the proto-dragon. It had little to do with what was to Malygos a very odd two-legged shape and more to do with the tremendous power Kalec had earlier felt.

But while Kalec had come to grips with the fact that through his host, he confronted the form he had caught out of the corner of his eye in the Nexus, the dragon began to notice something else amiss with the being before them. Although by Kalec's estimation, the murky figure was barely taller than a night elf, the more Kalec studied it, the more the blue dragon could not help thinking that what he saw was not what actually stood there. He had the feeling of a being far more imposing than this, a being that instead of gazing up at the proto-dragon, should have been gazing down.

"Who are you?" Malygos demanded. "Who?"

"Follow the strengthening wind when you depart," the figure answered, at first making no sense to either Kalec or his host. "You will find your friend there."

Another hiss escaped Malygos. "What thing are you?"

"A friend . . . I hope." From the cloak emerged the strong hand of what Kalec judged to be a warrior. It pulled the hood back.

For the proto-dragon, it was yet another revelation of just how strange the creature was. For Kalec, though, what stood revealed was enough to identify the figure for *what* he was, even though the dragon had never himself seen such beings in the flesh.

A keeper . . . it can only be a keeper, Kalec thought with awe. The keepers were creatures of myth and legend to most other races. Even as the Aspect of Magic, Kalec had learned little of them beyond their work overseeing the refinement of Azeroth after the titans brought order to it and the fact that several of the keepers had built temples in the Storm Peaks. Evidence of their achievements could also be found in obscure places around the world, but the full effect of their great task remained a question.

The skin was a brilliant silver. A thick, long mustache stretching down to the chest matched the golden hair framing the sturdy, broad-jawed face. Under a heavy brow, eyes the color of the sun and like those of night elves, outwardly seeming to lack pupils, studied the proto-dragon with not only interest but what appeared to be pride.

What does he find of so much interest in Malygos? Kalec wondered.

"You may call me Tyr," the keeper finally answered the proto-dragon's original question. "And you are, of course, Malygos."

Kalec's host understandably flinched. Baring his teeth, the proto-dragon growled, "How do you know my name?"

"I have watched you. I have watched others. I see much potential in you, in these friends of yours . . . and I say that as someone who has watched many of your kind since the first of you began to stir toward self-consciousness."

His answer only made Malygos shake his head in bewilderment and growing mistrust. Tyr was not a huge creature. Malygos believed

that he could bite Tyr in half, but he also believed that attempting to do so would for unknown reasons be something that the proto-dragon would regret.

He turned away, once more seeking the missing entrance. This time, it revealed itself. However, Malygos made no move toward it, as aware as Kalec that it had reappeared too conveniently. Malygos, of course, did not yet understand magic as Kalec did, but he was clever enough to link the odd happenings with the being who already knew his name without asking.

Malygos peered over his shoulder at Tyr.

"If it is your wish to leave, I will not stop you," Tyr said.

With a reptilian grin, Malygos chose to take him at his word. He darted through the gap, clearly expecting to be prevented at the last second.

Instead, the open air greeted the icy-blue male. The moment he was fully outside, Malygos swung around to face the cave. Kalec understood that he expected to find Tyr following, but of the keeper, there was no sign.

"You see? I did not lie."

Snarling, Malygos gazed up at the top of a low ridge. There, an innocent-looking Tyr stood patiently waiting.

The proto-dragon rose into the air until he hovered over the cloaked figure. Tyr calmly spread both hands wide, a sign of peace. Despite that display, Malygos did not relax, and even Kalec wondered what exactly such a formidable being wanted with a proto-dragon.

"Not funny!" Malygos snapped, rearing his head. He prepared to exhale, something that Kalec thought would only lead to disaster.

But at the last moment, the proto-dragon changed his mind. Instead, Malygos veered from the tiny figure and headed on.

He did not get far before discovering Tyr standing atop another ridge ahead of him.

While this hardly surprised Kalec, the young Malygos proved a hardheaded sort. He immediately turned in another direction and flew as hard as he could from the spot where Tyr stood.

The cloaked figure reappeared a short distance ahead.

This time, Malygos did not hesitate to exhale. Kalec sensed that his host wished not to slay Tyr, only to keep him from following.

The stream of frost shot toward Tyr, then split, spraying the rocky surroundings but not touching him in the least.

"Please," Tyr quietly began again. "I wish only to talk with you . . . about Galakrond."

Malygos's mind struggled between attacking, fleeing, and hearing the strange creature out. To Kalec's relief, his host chose the last.

"What do you want? Where is Ysera?"

"You will find her . . . and you will find other things, but those I cannot change." Tyr did not elaborate, instead returning to his original subject. "But for the moment, we must speak quickly and about Galakrond."

The continued mention of the sinister behemoth made the proto-dragon anxiously glance around, but of course, there was no sign of the gargantuan fiend. Malygos peered expectantly at Tyr.

"We never intended this path," Tyr continued, his own gaze turning inward. A shadow crossed his features. "Galakrond should never have journeyed in the direction he did, and we did not prevent it. Now . . . now this young world faces annihilation."

While Malygos did not understand all of the complex words, he understood enough to catch that there was some tie between Galakrond and this thing. Kalec understood even more than Malygos, but in the end, his thoughts finished the same. This being—this keeper—knew why Galakrond had become the monster, and felt some fault at that happening.

Before Malygos could press the questions that Kalec and he shared, Tyr cut him off. "I have been observing so many of you, seeking an answer. I thought for a while . . . but Coros proved as focused in his obsession as Galakrond, but with more foolhardiness than even Galakrond contained, it seems."

"Coros? You watch him? Why?"

For the first time, a hint of frustration passed across Tyr's sturdy face. Kalec, though, saw that it was frustration not with Malygos but with Tyr himself.

"A good question with no good answer. I leave it at that. What matters is that *you* might be the key to salvaging this situation . . . if we can turn this mad charge from disaster to victory."

The proto-dragon continued to hover, but Kalec felt his patience quickly fraying. Proto-dragons did not have the patience of dragons, although even Kalec knew his could be very short at times. Malygos was coming close to trying to flee again.

Tyr obviously saw that also. He smiled briefly as if to reassure the proto-dragon. "In our seeking to guide Azeroth's growth as a whole, we have been too long removed from the daily aspects of the world, too long from interacting with the life of that world. Without guidance, events somehow brought us Galakrond. With guidance, we and your kind might be able to set Kalimdor back on its destined path."

"We fight Galakrond?" Malygos's tone made clear his questioning of the sanity of Tyr's suggestion. "Talonixa fights Galakrond! I— we—do not fight!" He shook his head. "Foolish creature you are!"

This time, Malygos did attempt another escape. He flew around Tyr, going such a great distance to the side of the cloaked figure that Kalec could not help but wonder if the proto-dragon also sensed that while Tyr appeared tiny, he was in actuality something far larger, far greater.

Kalec and his host both expected Tyr to materialize before them, but there was no sign. While Malygos took heart from this, Kalec could not fathom why Tyr would simply let the proto-dragon go.

Suddenly, what appeared to be a wall stood before the racing Malygos. He managed to bank at the last moment, and as he did, something unsettling about the wall registered with both the proto-dragon and Kalec.

It was not a wall but the torso of some gigantic two-legged form.

But as Malygos spun back, he found no giant . . . only Tyr.

Still, even the young proto-dragon understood that he had caught a glimpse of what Tyr truly was. That glimpse was powerful enough to make him eye the tiny creature once more standing before him with something near awe.

But Tyr's expression extinguished Malygos's obvious hope that what the proto-dragon had momentarily seen could mean Galakrond's defeat. "We are not tied to this world as your kind is. The others . . . the others of my kind cannot be urged anymore to face this danger. We have grown too weary from our past battles. We—I—need your kind, Malygos. I need you."

Still hovering, the proto-dragon finally nodded. "What we do?"

Tyr looked vastly relieved. "First, we must gather your friends. Together, I think they could be the answer. Nowhere else have I seen this immediate and intricate bonding among those of different proto-dragon families. Perhaps it might ironically even have something to do with Galakrond's coming. I do not know. Whatever the reason, this bonding may be the key to the only chance of victory still left to us."

Some of the words were, again, more than Malygos could comprehend. However, he could easily detect Tyr's uncertainty that even Malygos and his kind would be enough to prevent Galakrond from ravaging Azeroth.

"Gather the others, Malygos. They trust you. Lead them here. I will be waiting—"

A warning roar echoed from the east, a roar so thundering it could only belong to Galakrond.

Tyr turned at the cry. Malygos's gaze swept past him to look in the same direction, and in that moment, the cloak swung aside, revealing something that only Kalec noticed and only Kalec would have recognized.

Attached by netting to a thick silver belt was nothing less than the artifact itself.

Even as Kalec saw this, the scene turned on its head, and its elements shattered, scattering in all directions. The blackness held sway for but a second before the elements regathered and formed a new scene.

Proto-dragons filled the sky. By the scores, they roared their challenge at the horizon before them. As Kalec sought to identify what was happening, Malygos joined the others in seemingly challenging the empty air.

And the sky answered.

Galakrond, still so distant that he could not be seen, answered.

Kalec silently swore. Somehow he—or, rather, Malygos—had become part of Talonixa's grand and likely doomed charge after all.

FIVE
THE DEAD AND THE UNDEAD

Jaina woke with a start, her head snapping up from the pages of the musty book she was reading when exhaustion had claimed her. The archmage eyed the faint moisture on one page and gestured with some slight irritation. The page dried, none the worse for the wear.

Another waste of time! She pointed her finger at the wall of books and parchments. The book fluttered to the spot from which she had summoned it.

Thoughts other than her own abruptly filled her head, messages sent by various magi seeking her advice or reminding her of tasks she should have been working on instead of this increasingly futile quest. Jaina knew that her position demanded that she deal with these other matters, but she rose from her chair and once more approached the trove of magical knowledge.

Before she could make a decision, another voice overwhelmed the rest.

Jaina . . . come quickly. . . .

"Kalec?"

The contact broke, but not before she sensed from where he was calling. The location surprised her, but the archmage did not hesitate. She exhaled and cast.

Her arrival did not go as expected. She appeared not only many yards from where she had intended but also more than a foot above

the ground. The archmage landed hard on her heels, the collision vibrating through her bones.

Biting back an epithet worthy of her naval father, Jaina focused. Regaining her equilibrium, she surveyed the dark land before her, wondering why Kalec would call her to, of all places, the Dragonblight.

Moreover, the archmage wondered why he would summon her not from the temple but from the shadows of the incredibly vast skeleton ahead.

Jaina knew of the huge bones that had once been a behemoth called Galakrond, but there her knowledge faded into what myths and legends the Aspects had passed along over the millennia. When they did speak of Galakrond, dragons made vague comments honoring him as the Father of Dragons. It was supposedly why so many of those dragons who came to die in the Dragonblight chose to set their bodies, if not facing Galakrond, then certainly in the vicinity of his skeleton.

Jaina concentrated on Kalec, silently calling his name and awaiting a link with his mind. When that did not happen, she sharpened her call by directing it toward the monstrous rib cage.

But although there came no answer, Jaina could not help feeling that the skeleton was where she needed to go. A fear abruptly arose in her that Kalec might now lie injured and unconscious—or even worse—somewhere within the half-buried bones.

A haze draped over the region, making it impossible for the archmage to see anything inside the ribs. She probed with her power but found nothing—

No. For just a moment, Jaina thought she sensed Kalec.

Without hesitation, she transported herself nearer. This time, the archmage appeared where she desired. The ribs loomed over her.

But of Kalec, there was still no sign.

Jaina finally called his name. The only answer was the growing

wind blowing through the bones. Aware that her destination had been this desolate place, using magic, she had shielded herself from the expected cold, and so the chill that ran down her spine had nothing to do with the elements. Despite that, though, the archmage did not hesitate to enter.

The moment she did, she sensed something else. A faint magical trace that reminded her of the artifact's aura.

The source of the trace proved to be a hole dug deep into the frozen ground, a hole that also radiated hints of Kalec's unique magical signature.

This is where he found it, Jaina realized. *He went to a lot of trouble to dig it out. Why?*

She looked over her shoulder, suddenly certain that she was not alone. Even though the archmage saw nothing, she could not shake the feeling. Still, she returned to her inspection of the hole.

Searching beyond Kalec's trace, Jaina studied the residue of ancient magic continuing to permeate the area. It grew stronger the more she delved into the hole itself. The archmage marveled at the efforts Kalec had used to free the artifact.

And again came the question of *why*. . . .

The shadows around her deepened. Jaina created a small golden sphere and sent it into the hole the better to see . . . anything.

An exasperated sigh escaped her. She glanced around again, seeking either Kalec or some other figure. Jaina now knew that she was being led, but whether this was all a trap or something far different, the spellcaster could not say. Thus far, she detected no threat, but she also detected no reason for her being there.

Her sphere changed color without warning, turning from gold to a deep blue, and in that blue light, Jaina Proudmoore saw something not evident before. It was not a physical object but a force somehow tied to the relic that had been buried there.

It was also something that she had seen once before and that she knew was recorded in the very tomes through which she had been burrowing before thinking she heard Kalec's summons.

The artifact itself at last began to make some sense to the archmage, but this only fueled her concern. If what she sensed about the magics involved in its creation was true—if what this radiant force meant to her study of the artifact was true—then there was something terrible going on that—

Again, Jaina felt as if someone watched her. This time, she quickly cast a spell behind her, and for her efforts, she was rewarded with a slight grunt.

Spinning around, she discovered a female taunka standing only a few feet from her.

"Who are you?" the archmage demanded.

"Buniq . . . my name is Buniq," the taunka rasped. Jaina's spell held the creature in place. The taunka was armed with a spear, but Jaina saw that the weapon was held casually and had not been readied for throwing.

"What are you doing here?"

"Hunting. Saw the light. Thought it was another hunter."

The archmage could detect nothing amiss and finally released the taunka. Buniq exhaled and stretched her arms, although she was also careful to keep her grip on the spear loose at all times.

"You're free to go," Jaina remarked, her tone indicating that she would prefer Buniq did as she suggested.

The taunka started to turn, then glanced past the spellcaster at the hole. "He searched there, too. The blue one."

The blue one? Kalec? Jaina's mind raced.

Before the archmage could ask, the hunter abruptly added, "He found something. I think."

While the information was of some relevance to Jaina, it did not

resolve anything for her. She nodded her thanks, her interest in the taunka fading.

"Saw something else . . . after he left."

Jaina stared at her. "What else did you see? What?"

Buniq hesitated. "Saw another. All covered."

"All covered? A cloak?" After Buniq bent her head forward in what was evidently a nod, the archmage, now very much interested again, asked, "You could make out nothing else about this figure?"

"Tall. Taller than you. It looked into hole, just like you."

There had been no magical trace from some other spellcaster, at least not that Jaina had detected. With her skill, it was unlikely that she would have failed to notice that another mage had been there . . . unless . . .

She needed to know more. "Did this figure do anything?"

"Yes." Buniq thought for a moment, then carefully passed the spear from one thick hand to the other. She raised her now-freed hand and began to draw something in the air. Once finished, the taunka stilled again.

Jaina tried to make sense of whatever Buniq had done but could not completely recall it. "Draw it again, but slower."

As Buniq began, the archmage cast a simple but useful spell. Immediately, the air flared silver where the taunka had started drawing. The hunter hesitated.

"Go on, please, Buniq."

Exhaling, the taunka obeyed. The silver fire followed as she completed the symbol. Jaina watched with ever-increasing interest, all the while hoping that Buniq had a very sharp memory.

The taunka stepped back. Jaina summoned the glowing pattern to her, examined it for a second, and then, with a grimace, turned it around so that she saw it as Buniq had. A crescent star overlooking a stylized bird greeted her, both bound in the center by three simple but significant runes of triangular shape.

The archmage gasped. She had seen this symbol before, and she recalled just where.

Returning her attention to Buniq, Jaina asked, "Was there anything else—"

The taunka was gone. Jaina squinted and saw a few tracks leading off beyond the rib cage. She should have expected that a hunter would be skilled in moving stealthily, but not only had Buniq evaded the archmage's enhanced senses, but she had done so with astonishing swiftness. Moreover, Jaina had no idea why Buniq had left without warning, although perhaps the simple fact that Jaina was a spellcaster was answer enough.

She dismissed the taunka from her thoughts. Jaina needed to return to the books immediately. It was possible that this clue would be nothing more than a dead end, but from what the archmage already recalled of the pages she intended to hunt down again, she doubted that would be the case.

Her hopes rising, Jaina silently thanked the absent Buniq for having still been in the region hunting, then cast a spell to return herself to her sanctum.

But had the archmage chosen to glance one more time at where the taunka had stood, she might have this time noticed that there were no hoofprints anywhere.

Kalec did not recall so many proto-dragons collected at the previous gatherings. Their numbers were staggering. Through Malygos, he saw more family patterns than he had known existed among the proto-dragons. Even Malygos appeared somewhat awed by the legions around him, although it quickly became clear that he was there not because he wanted to be but because Tyr had asked him to be.

The others were also present but scattered among the many. Even Ysera was there, having been located by Alexstrasza in a narrow

ravine riddled with small caves. Malygos's thoughts constantly went to Ysera, who appeared to be a tremendous question mark in whatever Tyr had planned with the five. Malygos's concern over Ysera overwhelmed Kalec's ability to understand what the plan involved.

From what Kalec could sense about Ysera, the others believed that she hid some secret from them, something she would not even speak of to Alexstrasza. Ysera had too readily agreed to come with them, as if eager to be away from the area in which they had found her. All of that left Malygos wondering if the pale yellow female would suddenly abandon the attack at just the critical moment for whatever she kept from them.

Fragmented memories concerning Tyr revealed a surprise to Kalec: his host was still the only one who knew of the cloaked figure. Tyr wanted to work through Malygos, believing that it would be best if the others thought that it was the icy-blue male who had come up with the plan. Kalec gathered that the reason for the secrecy had to do with something Tyr had not revealed even to Malygos, perhaps some portion of the plan that Kalec's host might have rejected.

And not at all to his surprise, Malygos suspected something similar.

Talonixa roared again, her cry the signal for a new chorus of challenges focused on the yet-unseen Galakrond. In truth, the collective roar seemed as impressive to Kalec as that of the distant behemoth, and he began to wonder if perhaps Talonixa had chosen the right course of action after all.

Out of the corner of his eye, Malygos watched Ysera suddenly drop below the rest. He immediately dived after her.

She looked up as he neared, her eyes narrowed. Malygos's suspicions of trouble heightened.

"Stay with us!" he called. "We must lead the others high!"

"Only resting! Tired!"

It was true that Ysera did not have the stamina of the others and that there had been little time for her to rest since Malygos had gathered his companions and told them of his plan, but the male remained distrustful. Fortunately for him, Alexstrasza chose that moment to join them.

"You are well?" she anxiously asked her sister.

"Just . . . tired . . ." Ysera seemed no happier to see Alexstrasza than she had been to see Malygos.

"I will stay with you until we need to rise higher." Alexstrasza gave Malygos a glance of dismissal. The male quickly veered away from the sisters. The fire-orange female would keep a proper eye on Ysera. The plan Tyr had suggested could still—

A roar a hundred times more resounding shook both the land and the air. The great formation created by Talonixa briefly lost order. She snarled furiously at her followers, bringing them back in line.

Yet still there was no sign of Galakrond. Talonixa laughed. "You see? He fears us!"

It was the moment that Malygos had been waiting for, and thus, it was also the moment when his thoughts on the plan grew clearer for Kalec. *Height*. The plan involved height. Tyr knew something about Galakrond that the proto-dragons did not. The higher up, the thinner the air. That much even Malygos knew. However, the limit to how high Galakrond could fly for more than a few minutes was lower than that of the smaller fliers. The key to victory lay in drawing the monster up where he would grow more sluggish, be forced to gasp for the air needed to fill his massive lungs. At that point—and perhaps only at that point—Galakrond would be vulnerable.

The icy-blue male came up beside Talonixa. "Must fly high! Very high! Galakrond cannot fly high long! Cannot breathe well there!"

The imposing female snorted. "Away!"

"Fly high!" Malygos insisted. "Galakrond cannot breathe well there! Will tire! Will fail!"

This time, Talonixa appeared to consider his suggestion. Tyr and Malygos had counted on her cunning to enable this plan to work. Malygos exhaled in relief.

It was a mistake. Talonixa's expression hardened. Both Kalec and his host realized that she took Malygos's reaction for satisfaction at her having to bow to his wisdom.

She snapped at Malygos. Simultaneously, two of her lieutenants dived in to aid her.

As if out of nowhere, Neltharion and Nozdormu joined Malygos. Neltharion let out a challenging roar, which was answered by both of Talonixa's followers. Behind the six, the rest of the proto-dragons faltered, uncertain whether their charge had now turned into a war among their own members.

"Retreat!" Nozdormu hissed to Malygos. "Retreat!"

Neltharion also heard the other male's warning. "No! Fight her! Become alpha! Command all!"

Unlike Nozdormu, Neltharion had not bothered to be quiet. His words sent Talonixa into a rage. She unleashed a bolt not at Neltharion but at the trio's apparent leader, Malygos.

Kalec's host twisted but still received a painful scorch on one wing. As he did, more of Talonixa's most loyal followers joined.

"Retreat!" Nozdormu urged once more.

Malygos did not dive, as might have been expected, but rather pushed higher. His comrades followed without question, and behind them several of Talonixa's acolytes pursued.

But the pursuers stopped short at an abrupt snarl from the female. As Malygos continued rising higher, he glanced down to see the formation tightening again. He had hoped that Talonixa and her

lieutenants would give chase, possibly leading the rest of the proto-dragons upward after all.

Momentum pushed Malygos into the clouds. Flying became more of a strain as the air thinned. He paused, waiting for the other two to catch up.

"Knew this would fail!" Neltharion rumbled. "Told you!"

Malygos did not answer. Kalec sensed that there had been more complexity to Tyr's plan and that Malygos silently berated himself for misplaying the situation. Based on what he could read of his host's thoughts, Kalec could find no fault in the proto-dragon's actions, but the blue dragon knew that there were things still hidden from him.

"What now?" Nozdormu asked.

"Follow from above!" Malygos told them. "Alexstrasza! Ysera! They join soon!"

In truth, Malygos had some doubts about Ysera's resolve, but he was certain that Alexstrasza would bring her sister along. Kalec saw that his host also had a secondary plan in mind, still based on Tyr's original notions. Already aware that Talonixa might not listen to reason, Malygos had suggested that the five of them could yet lure Galakrond up by attacking him from above. It was a more desperate hope but still a hope.

Glancing down, Nozdormu muttered, "They move on."

As he warned, the proto-dragons below were already far ahead. Malygos saw no sign of the sisters but could not delay. He would have to trust in Alexstrasza.

"Come!" Not bothering to wait, the icy-blue male flew through the clouds after Talonixa's legions. In order to keep her followers together and not too exhausted to fight Galakrond, the female had to set a pace that some of the slower fighters could keep. Malygos soon not only caught up to those below but also began to pass them.

The clouds thickened ahead. Malygos did not fear finding Galakrond among them; the gargantuan fiend could have never hidden his bulk in the clouds, no matter how dense they became.

Unfortunately, as he pressed, Kalec's host began to flag for the very reason that he had tried to convince Talonixa to lead the others up. The thin air had his breathing becoming more and more ragged. He had not intended to fly this much above the ground until almost upon Galakrond, but now he wanted to avoid being seen by Talonixa or her followers.

Neltharion caught up to him. He, too, looked to be struggling for air. "Must—fly—lower—"

Something collided with Neltharion.

The proto-dragon went flying backward, the momentum of the thing that had flown into him sending the charcoal-gray male hurtling uncontrollably. Malygos immediately turned about, hoping that it was not too late to help his friend.

Only then did he see that what had struck Neltharion was one of the not-living. Indeed, its stench spread even through the thin air as it and the living proto-dragon tumbled together.

Curiously, Malygos noticed that the undead seemed to have collided with Neltharion at an angle that made any attack of consequence initially impossible. It dawned on both Kalec and his host that the animated corpse had not actually attacked Neltharion but, rather, had simply run into him by accident in the dense clouds.

In fact, the undead almost seemed more interested in flying on than in fighting. Neltharion evidently noticed this, too, for he pushed himself away from the monster and let it move on. The undead slowly began circling back the way it had come . . . or it would have, if Neltharion had not taken advantage of its ignorance of him by ripping its neck out from behind, then tearing both wings with his powerful hind claws.

The charcoal-gray proto-dragon watched with amusement as the sundered parts dropped, and Malygos and Nozdormu rejoined him.

"Stupid creature!" Neltharion mocked. "Brain all rot! Not even see or fight now!"

"Strange," Nozdormu murmured.

Malygos—and Kalec—very much agreed with Nozdormu's succinct assessment. Malygos's gaze followed the estimated path the undead would have taken had Neltharion not destroyed it. An uneasy feeling filled Kalec's host.

"Follow!" he hissed.

Quickly but carefully, Malygos pushed higher despite the increasing desire to drop to thicker air. So pressed was the proto-dragon that Kalec could not at first fathom what so bothered him.

And then, as they reached a slight break within the cloud cover, what Malygos had feared became evident to his unseen companion.

The sky was filled with undead. They circled constantly, as if that was the only desire left in their putrefying brains. Over and over, they circled, some in great arcs, some in tight ones. One flew much too near Malygos but did not take any notice of him.

Neltharion and Nozdormu caught up with him, and even the charcoal-gray male appeared stunned. "So many, almost as many as us!"

There had been a few sightings of the undead, but in the growing anticipation of battling Galakrond, the living proto-dragons had not paid that much mind, not even Malygos. Now that lapse was coming back to haunt them.

"Why here? Why do they just fly circles?" Nozdormu asked.

Kalec knew, and so did Malygos. "They wait . . . for us. For all of us."

"They wait?" Neltharion shook his head. "They not smart! No thinking!"

Malygos nodded. The undead proto-dragons had no true minds, but something they were bound to did. "No. Galakrond smart. Galakrond thinks . . . he thinks very well."

It was a frustratingly uncomplicated way of phrasing it, but Kalec saw that somehow the other two understood what Malygos tried to convey. As for the dragon, he shared both his host's astonishment and his growing fear.

The undead were circling because they were indeed waiting for the living to pass underneath them. They had not planned it themselves—Galakrond had.

Through the same foulness that mutated him, the monstrous proto-dragon also now appeared to control his victims, and he was using them to set a trap of his own that would engulf everyone.

"Must warn all!" Malygos shouted as best as the air permitted. "Must—"

As one, the undead ceased their circling . . . and dived.

Malygos and Kalec could only watch in horror. The discovery had come too late.

The trap had been sprung.

PART IV

ONE

UNDEATH IN THE SKY

As Malygos dived in what he—and thus Kalec—knew to be a futile attempt to warn those below, the proto-dragon tried to think of what could be done to avoid the disaster looming. Tried and failed.

The catastrophic scene in which Malygos found himself was even worse than Kalec and he imagined. Above a suddenly scattering legion, the undead spread out with a precision their mindless forms were clearly incapable of on their own. Galakrond controlled them all, even from a distance.

Malygos searched the front of the growing disarray and saw to his shock that Talonixa and her closest followers did not yet know of the catastrophe developing behind them. Talonixa herself flew with utter confidence, and Malygos, very familiar with the arrogant female, had no doubt that she still exalted her cleverness. Big Galakrond might be, but proto-dragons had taken down larger prey than themselves by working together. Galakrond was just *very large* prey. All Talonixa's followers had to do was stay clear of his jaws, and they would eventually slay him. True, several of the others might perish accomplishing that feat, but as Talonixa no doubt did not think she would be one of those, the great golden female was willing to accept the sacrifices.

But before Malygos could fly within calling distance, the rising hisses and roars from behind Talonixa at last shattered her reverie. With a reprimanding expression on her face, she looked over her

shoulder, just as the shriveled corpse of a proto-dragon of a hue that had once matched her own attacked.

Surprise did not keep Talonixa from reacting. She exhaled immediately. The lightning bolt burst through the undead's dry hide, the cadaverous body exploding into flames.

Twisting, Talonixa evaded the fragments, and in doing so, she found herself facing the collapse of her great charge. Curiously, her gaze cut through the chaos to fix upon the swiftly approaching Malygos. The glare she gave him almost made it appear to both Kalec and his host that the female blamed *Malygos* for all this.

"Beware!" Neltharion shouted, barreling past his friend. Two undead just dropping down upon Malygos from the side collided with the charcoal-gray male. Roaring cheerfully, Neltharion ripped through one undead, sending the pieces scattering, then exhaled on the second. The shock wave he emitted literally shook the corpse apart.

But for all the ease with which both these and the one attacking Talonixa perished, there appeared to Malygos to be far too many of the not-living in the sky, and surprise had given them a savage advantage. Neither Kalec nor his host could imagine that Galakrond still completely controlled his cadaverous servants. Now they simply followed the one urge remaining in them: to engulf the living.

A brown female, turning too late, became caught in the clutches of a blackened corpse that then exhaled on her. Thick green fumes enveloped the female's head and throat. She shrieked as the affected flesh dried and crumbled. Her anguished cry became a fading gurgle as her head first dropped to the side, then broke off. Even this did not stop the undead, which then began with its teeth to rip apart the bloody area at the base of the neck and swallow large gobbets of still-warm flesh.

To Malygos's far right, two undead caught a fire-orange male between them. The male let loose with a brief blast of flame, which

set one of the undead ablaze. Unfortunately, it was not enough to keep that corpse from continuing its own assault, forcing the flames on the male even as the second undead snapped at his neck from the opposite direction.

Malygos raced to aid the other male, but before he could reach the battling trio, the flames from the burning corpse spread to the living proto-dragon and his other foe. Trapped within the fire, the male succumbed quickly.

Outraged at his own failure, Malygos ignored the risk to himself and joined the fray. He exhaled on the undead's victim, with the faint hope that the other male still lived urging him to cover the trio with his icy breath.

His impetuous attack only served to smother many of the flames eating at the undead, enabling them now to turn on Malygos. Realizing his mistake, Kalec's host raised his hind paws and ripped at the wings of the nearest, even as it opened wide its withered maw. The dry, scorched wings readily tore, sending the undead falling before it could unleash a blast of the sinister, decaying gas.

The body of the fire-orange male also dropped as the second undead focused entirely on Malygos. Yet barely had it done so when another familiar form came in from behind and ripped through the animated corpse's back. Nozdormu gave Malygos a short nod before moving on.

Kalec knew that Malygos could have dealt with the second undead, but the timely act by Nozdormu freed his host for what they and the other male knew was a priority. Malygos continued on down to Talonixa, who hovered in place, blasting at one rotting figure after another.

"Must beware!" he roared. "Galakrond does this! Galakrond does this!"

Talonixa managed to sneer at him even as she exhaled again.

Another corpse exploded. "Galakrond still dies!" she declared. "He still dies!"

Kalec had never seen true madness in a proto-dragon before, but he could describe the intimidating female's attitude as only that, and Malygos's opinion leaned in that same direction. Talonixa could see nothing but her imminent triumph. The attack by the undead was, to her, simply a delay.

As if to emphasize this, Talonixa utterly dismissed Malygos from her attention and darted up to seize a foe that had just finished biting through the throat of a smaller male. Talonixa first ripped off the wings and then, for good measure, clamped her mouth around the rotting jaws and pulled the head from the top of the neck with little effort. She almost seemed to revel in her act, which to Malygos was an unnecessary waste of precious time.

In frustration, he looked in search of Neltharion and instead noticed Ysera moving on from the struggle. After a moment, Malygos realized what Kalec had known immediately: Ysera was headed in the direction of Galakrond.

With an aggravated hiss, Malygos raced after her. Of Alexstrasza there was no sign, but neither Kalec nor Malygos expected that Ysera had left her sister in danger. Indeed, Alexstrasza would have been in more trouble if she had also to concern herself with the nearby presence of the weaker Ysera. Unfortunately, that meant Alexstrasza was ignorant of what her sibling intended.

Ysera sought to speak peace with Galakrond.

Reason demanded that Malygos leave her to her fate, but loyalty urged him on. Wings beating hard, he began to catch up to the smaller sister. Malygos knew that he still did not fly fast enough. Galakrond was surely near and drawing nearer. He had to know that his creatures had done their work and that bedlam reigned. And while several proto-dragons had perished, there were many, many more left to feed Galakrond's tremendous appetite.

And this was the monster Ysera sought to reason with.

Kalec urged his host forward, even though Malygos not only could not hear him but also was going as fast as possible. Ahead of them, Ysera vanished over a low rise, and when Malygos reached that same point, he discovered her trail suddenly gone.

The male paused in confusion and then saw Ysera darting around another low hill. Relief combined with the fear that she was nearing her goal and thus soon to face the same fate as Coros. Malygos pushed hard, but now the gap did not close.

To both Kalec's and Malygos's surprise, Galakrond still did not appear. While in one obvious way that was to Malygos's benefit, in another it did not bode well. The gargantuan proto-dragon would certainly not have abandoned his plan at this point.

Whatever the reason for Galakrond's absence, Malygos knew that he could not count on it for very long. Unable to catch up to Ysera, he finally dared call out to her.

And no sooner had Malygos done so than the ground ahead erupted. Yet here was no place of volcanic pits. The ground in this region was rocky, uneven. . . .

Kalec once more recognized what it took the young Malygos a moment more to understand. The landscape was rocky and uneven for one very good reason: Galakrond had burrowed deep—no doubt beginning from some more distant cavern—and had secreted himself just below the surface, waiting.

He waited no longer.

Tons of rock and dirt flew up as the malformed leviathan burst free. Malygos gazed at Galakrond with new dismay; not only was he larger, but he was also more misshapen. His entire body was covered in growths, some of them simply lumps, others fully formed parts. Many of the latter twitched. Eyes surveyed the world in every direction, but most fixed upon the tiny figure now heading directly toward Galakrond.

But another proto-dragon, sleek and fire-orange, suddenly dived from above and seized Ysera just as Galakrond took a snap at the yellowish female. Alexstrasza, her sides heaving from effort, continued to push her sister farther and farther from Galakrond.

The behemoth turned after the sisters, in the process shaking more stone and dirt from his gigantic body. Malygos and Kalec both knew that in rising now, Galakrond would be visible to Talonixa and the rest, assuming that the defenders had any chance to pay mind to anything other than the undead. Galakrond obviously had planned to fall upon the embattled proto-dragons, but at the moment, his attention was taken by Ysera's seemingly suicidal act.

Galakrond left a wide valley where once there had been a shallow cavern. As he took to the air, a rain of fragments battered the ground in his wake.

Malygos hesitated. Ysera and Alexstrasza were in desperate straits, but this was the one opportunity to try to save those under assault. Not for the first time, loyalty struggled with other considerations.

This time, those other considerations won. The fate of many was in the balance, as opposed to that of the two sisters. Malygos turned around.

He found Neltharion and Nozdormu closing with him. The pair hovered as he neared, Neltharion looking perplexed and Nozdormu looking contemplative.

"The not-living!" Malygos called. "Must destroy them now! Quickly!"

If it involved a fight, Neltharion was all for it. Nozdormu mulled it over for a second, then responded, "Yes. Must be now."

Malygos led them back. Kalec was nearly overwhelmed by the thoughts racing through the supposedly primitive mind of his host. More than ever, Kalec saw the Malygos to come, the planner and calculator. Malygos thought of and discarded more than half a

dozen viable plans before the trio reached the chaos, and only made his final choice when he could think of nothing better to do.

A quick glance at the battle verified what the icy-blue male had assumed. There was no visible sign of any remaining control on Galakrond's part. The undead attacked with the relentless urge with which Kalec was familiar. There was no coordination, not even as much as when Malygos had left.

"Come!" he roared to his two companions. "Fly high! Lead others to the clouds!"

As they obeyed, Malygos veered off toward another male proto-dragon. Malygos slammed into an undead with which the other male was fighting, then had the rescued proto-dragon join him. The pair successively freed a third and a fourth proto-dragon—females— from the struggle.

Malygos shouted, "Tell all, fly high! Fly into clouds until almost top, then fly north ten beats! Drop!"

The rest soared away, shrieking for all to hear as they separated. Within seconds, living proto-dragons everywhere began to head up into the clouds. Close behind came the hungry corpses. A few proto-dragons did not make good their escape, but there was nothing Malygos could do but hope that their losses would mean that others would arrive at the clouds.

There were some proto-dragons who did not fly as Malygos suggested. Far in the distance, Talonixa hesitated, her chief followers awaiting her decision despite the precarious circumstances. She glared at another proto-dragon who approached her and who, by her gesture upward with one wing, was clearly informing the lead female of Malygos's suggestion. However, after scanning the chaos one more time, Talonixa let out a commanding bellow and soared after the rest of the defenders.

Seeing that there was no more that could be done below,

Malygos himself surged into the clouds. He estimated the pace of the defenders as a whole and thought he had guessed correctly. Kalec could find no major fault with Malygos's estimates, although they would certainly not be perfect.

Another live proto-dragon flew past Malygos. Three wing beats later, the other flier dived. Malygos counted his own tenth beat, then did the same.

As he broke out of the bottom of the cloud cover, Kalec's host saw that a good many survivors were in the process of following suit. A few of the undead still hovered among them, but proto-dragons led by Neltharion were making short work of them. That had not been part of Malygos's plan, but Neltharion's effort only increased the chances of success.

The moment he was far enough below the clouds, Malygos roared loudly. He had the attention of nearly all those gathered. Without another word, he faced the clouds above and opened his maw wide. He took one more quick glance at the others. Both Malygos and Kalec were pleased to see understanding spread across the rows.

Another proto-dragon dropped out of the clouds, but this one was skeletal and had vacant though somehow still hungry eyes.

Malygos exhaled as hard as he could, aiming foremost for the wings. As he had hoped, the stiffening appendages sent his would-be attacker hurtling to the ground.

All around, other defenders struck as soon as an undead reappeared. Malygos had turned Galakrond's original plan around to his advantage. Without Galakrond, the undead could only follow their urge, which meant that they could not understand that a trap had been set. They chased their prey into the clouds, then followed back down, but more slowly.

This time prepared for attackers above, the waiting proto-dragons decimated the unliving. The defenders exerted themselves

as much as they could, amplifying their attacks. Columns of sand, spouts of water, plumes of flame, and other proto-dragon weapons shattered the dry, emaciated forms.

Despite incurring terrible damage, some undead managed to evade complete destruction long enough to attack. But as they did, Neltharion led those who had earlier followed him into a new assault on the remaining corpses. Malygos observed this out of the corner of his eye, even as he took on another undead. Kalec's host first focused on the head and then, before his horrific foe recovered, bit through the neck.

As Malygos let the pieces fall their separate ways, Kalec sensed the insidious urge filling the young proto-dragon. Malygos quickly fought it down again. Still, Kalec could feel how much the effort cost Malygos and knew that if something did not happen soon, the proto-dragon might yet succumb.

Victorious roars began to resound through the ranks of the survivors. Talonixa's roar was loudest of all, as if *she* were the one who had brought about this triumph. Malygos snarled, wondering how they could not see past this moment. Nothing had been won but a reprieve. Indeed, if not for Ysera's foolhardy act—

Kalec's host hissed. The sisters were probably dead now, and Malygos felt in great part responsible. Even though he knew that they would have expected him to do as he had, the deep regret still remained.

Nozdormu rose before him. "Good plan! Quick! Done well!" The other male's exuberance faded. "But Talonixa claims victory is hers!"

Much to Malygos's surprise, not only did Nozdormu speak the truth, but also many of the other proto-dragons appeared to believe her. More and more began flocking near her, the golden female's grand and reckless crusade taking shape despite Malygos's disbelief.

"No!" he cried, streaking down toward Talonixa. "No! This is not right—"

Her eyes disdainful, Talonixa opened her mouth wide.

Even though Malygos instantly understood what she intended, and moved to evade, the bolt still struck him almost squarely. His entire body shook, and both he and Kalec suffered incredible torment. Blackness nearly overtook them, but Kalec knew it was not the same blackness that meant a return to his own body and the present. With Malygos, he spiraled to his doom, half aware through the entire drop that he could do nothing to stop the end.

Claws suddenly dug deep into his hind legs. The pain was minor in comparison with the shock from the bolt, but it served to give Kalec and his host something else to focus on. They felt their descent slow, and as it did, consciousness began to take a better hold.

It was not Nozdormu, as might have been expected, but rather Neltharion. For a change, the charcoal-gray male did not have a cheerful expression. Fury filled Neltharion's countenance, and for a moment, it unnerved even Malygos and especially Kalec, who caught a brief glimpse of something akin to the future Deathwing.

"Foul female!" Neltharion roared. "Saw that! She will pay!"

"No . . ." Malygos croaked. "Must . . . must all be one! Must . . . to survive—"

Talonixa's roar cut through Malygos's words. As Kalec's host flapped his wings and righted himself, Neltharion finally released his hold. Both gazed upon the re-formed legion, which to Kalec's observance was a quarter less than it had been. Malygos noted that also. If there was any hope, he had to find a way to make a workable alliance with Talonixa. Only then would the proto-dragons have a chance of—

Galakrond's roar thundered across the sky.

Talonixa answered, her savage cry sounding meager and weak

to Kalec and Malygos. She roared again, and this time, the other proto-dragons behind her joined in. To their credit, while they did not shake the heavens as Galakrond had, their united challenge was very impressive.

The horizon in the direction from which the great roar had come seemed to swell. The swelling grew and then separated from the ground. As it did, the shape of a huge proto-dragon coalesced.

Galakrond again issued his challenge. The gathered defenders answered in kind.

"Must not—"

Before Malygos could finish what he wanted to say, the vision shifted. The shift caught Kalec by surprise, more so because it had clearly been only a matter of moments.

But those few moments left him now in the middle of the savage struggle against Galakrond.

The titanic fiend hovered, surrounded by darting proto-dragons that to Kalec's eye seemed more like mosquitoes in comparison. They veered around, below, and above Galakrond, striking with a barrage of attacks that stunned Kalec with both their intensity and their variety. Acidic burns and scorch marks already dotted the enormous torso, and several of the extra limbs either hung limply or had been ripped apart. Kalec watched through Malygos's eyes as a brown-and-black female rushed in, seized a flailing hind leg in her jaws, and bit through flesh and bone. She quickly turned off again, taking with her all but a bloody stump.

Talonixa and her most trusted companions assailed the head, their withering attack forcing Galakrond to keep his gaze downward. The golden female let loose with a powerful bolt that left a blackened mark just above one of the leviathan's original eyes.

Kalec watched with awe. Galakrond was at bay. Here was the end to the gargantuan fiend.

But this place is wrong! Kalec realized. *This is not where the bones rest! What could—*

It occurred to him only then that despite his close proximity to the battle, Malygos was not part of it. Neither were Nozdormu and Neltharion. Their hesitation made Kalec turn to Malygos's thoughts, something he had not done in the face of such a spectacle.

And there Kalec saw that what he believed to be an imminent victory was anything but. With Malygos's mind to guide him, Kalec realized that all the wounds, all the damage to body and limbs, none of those slowed Galakrond in the least. As many as they were, the wounds were merely annoyances. Kalec's initial impression of the defenders as seeming like mosquitoes was still closer to the truth.

"Well?" Neltharion rumbled, ever the most impatient.

"The eyes," Malygos murmured. To Nozdormu, he repeated, "The eyes . . ."

"The eyes . . ." the brown proto-dragon agreed.

Kalec thought that they meant to attack Galakrond's two mammoth eyes, but the tension he felt overtaking Malygos warned him that the three were concerned with something far more dire. Kalec focused carefully on what Malygos observed, understanding only now that he might visually *see* the same things as his host, but he did not always *comprehend* matters as Malygos did.

His host and the others were concentrating not on Galakrond's original eyes but on all those additional ones the trio could see from their vantage point. *Those* eyes, Kalec realized, moved as if mad at first glance. They looked up, rolled around, gazed down. . . .

If not for what Malygos had already deciphered, it would have taken Kalec longer to understand that these other orbs moved with purpose. Each eye was fixed on one thing and one thing alone.

Each eye was focused on a particular proto-dragon. Galakrond was not at bay. He was merely waiting.

TWO
DOOM

Jaina sensed someone seeking her the moment she returned to her sanctum. Unfortunately, that someone was none other than Archmage Modera. Modera was one of those Jaina most respected and admired among the magi. She had become a member of the Council of Six long before Jaina—during the Second War, in fact—and many were the times the younger archmage had turned to Modera for guidance in one subject or another.

Instead, Jaina now concentrated on cloaking herself with a spell she hoped would keep her from even Modera's notice.

"Archmage?" the other woman called from outside. That Modera had come in person meant that she had already attempted to locate Jaina by magical means and had not been pleased by her failure. Jaina had not given any official notice of her need to depart the city, and as leader, she should have at least informed the rest of the Council of Six. Modera was rightly interested in finding her, but even that did not dissuade Jaina from keeping herself hidden . . . if possible.

"Archmage?" Modera repeated more firmly. "Forgive me. Are you within?"

It could not be as simple as the elder woman giving up when she did not receive an answer, Jaina noted, for only a breath later, she felt the casting of a subtle spell outside the door. Jaina, planted against one wall just beyond the entrance, watched as a transparent form materialized near her.

"Jaina?" The figure coalesced into the image of Modera. Although much older chronologically than Dalaran's leader, she still appeared as a handsome woman with snowy white hair bound in a braid. The image peered around, obviously seeking the sanctum's owner. "Forgive this intrusion. I really *must* speak with you."

It said something about the urgency of whatever situation concerned Modera that she would enter Jaina's chambers uninvited, even through illusion. Jaina found no fault with the action, although she did vow that if things normalized, she would strengthen her wards. Clearly, Modera was more powerful than even Jaina had taken her for.

The other archmage frowned. She already faced slightly toward where Jaina stood but suddenly looked directly at the blond woman.

Just as Jaina was certain that Modera had sensed her, the elder spellcaster turned her head to the opposing wall, eyeing it much the way she had done where Dalaran's leader hid.

"Where is she?" Modera murmured, looking more pensive. "Where could she have gone at a time like this?"

Her last question almost made Jaina reveal herself, but then Kalec's exhausted face formed again in her thoughts. Jaina's resolve strengthened, even though a part of her knew that she was choosing emotion over sense.

Modera's ghostly image looked over her shoulder, as if listening to some other specter yet unseen. "Very well," the older archmage muttered to the air. "I will see you shortly. We will have to consider a different course of action."

Turning back to the seemingly empty chamber, Modera raised one hand and began writing in the air. Runes flared before her.

Please see me the moment you return. . . . It is urgent. . . .

Modera left the words floating in the chamber. She looked around one last time—her eyes only briefly passing over Jaina—then simply dissipated.

Jaina waited a moment longer, until all trace of Modera's presence had faded into the distance. The younger archmage exhaled as she reappeared. She stared at the floating message, swearing to find out what Modera wanted as soon as she had assured herself of Kalec's survival.

Returning to her collection, Jaina sought out the tome she needed. That proved more troublesome than the spellcaster had thought; the volume Jaina expected to hold the answers was apparently the wrong one, even though she was certain of her memory. The archmage set the book aside, then thumbed through another that she recalled had some associated information.

But yet again, her memory contradicted what she discovered in the book. She set the second volume down, then eyed the two tomes lying side by side.

Holding a hand over each book, Jaina concentrated. A white glow surrounded both hands and spread to the two volumes.

The glow was met by a lavender haze surrounding each book. Jaina gasped; she could not say how she knew, but she could tell that what enveloped the tomes was some very old, very subtle spell. It was meant to keep something hidden, presumably the very information the archmage sought. However, Jaina also sensed a fraying in the spell, as if after so much time, the original intent of the casting had begun to be lost.

The original intent was lost. . . . Jaina could not help but think that this was also the key to what was happening to Kalec. The artifact had been created with some purpose in mind, but she wondered if the exact focus of that purpose had faded with the fraying.

It also interested her that these books, clearly written long after the artifact's creation, should react to her so precisely. Somehow the ancient magic had detected her intentions, which meant spellwork of the highest skill.

But who would have not only the ability but also the cunning to track

down these tomes . . . and over such a span of time? Jaina knew that there were, of course, mundane possibilities—such as the high elves—but for some reason, this spellwork did not feel like their work. In fact, it had a feel to it much older than even that venerable race.

Her brow wrinkled. She withdrew her hands from the two volumes. Their glow instantly vanished. The archmage eyed her collection, then hesitantly cast a more generalized version of her spell over the rows of tomes and scrolls.

Not entirely to her surprise, every piece in her collection glowed lavender.

Jaina immediately delved deeper into the spellwork. As she had begun to suspect, the casting included what she thought of as an infection subspell. If there was an object of similar tendencies nearby—in this case, a book of magic next to another book of magic—the original spell would spread to that other object. To do it so thoroughly, so successfully, was yet again a sign of how adept the caster had been.

Dismissing her own work, Jaina carefully thumbed through one of the two books. With her expert memory, the archmage verified that everything she expected to find remained where it should have been. As best as she could establish, the spell had changed nothing else. Only what Jaina sought appeared to be affected.

The archmage was not daunted. She had confronted complicated and confounding puzzles of a magical nature before and solved them. She would let no spell defeat her.

More to the point, Kalec was at stake. To Jaina, nothing else mattered.

Galakrond remained under heavy assault. A female of Malygos's family exhaled on one of the extra hind limbs, then tore off the frozen appendage before it could warm up again. Another female

of a silver hue unleashed a shower of what appeared to Kalec to be steaming liquid metal. The blue column seared Galakrond's thick hide, leaving a festering streak twice as wide as the proto-dragon who had breathed it. Two males a deep green in color used their larger-than-average hind paws to rake the base of the leviathan's neck.

"It is nothing. . . ." Malygos growled. "It is all nothing. . . ."

"The eyes," Neltharion suggested. "Strike when they follow away. Blind Galakrond eye after eye—"

Nozdormu snorted. "If this many eyes," he responded, holding up one of his tiny forepaws, "we attack for more days than we have."

The brown male had a very good, if demoralizing, point. With so many extra eyes, even if the trio managed to persuade the other attacking proto-dragons to follow through on such a plan, the time needed was surely far more than Galakrond intended to give them.

"Must warn Talonixa." Even as Malygos said it, his certainty concerning the futility of trying once more to make the imposing female see sense touched Kalec. Yet Malygos saw no other chance but to try—

Next to him, Nozdormu let loose with a low warning hiss.

The many, many eyes had suddenly narrowed.

Despite being aware of what that might presage, Malygos nevertheless started for Talonixa. He did not get far.

Galakrond unleashed a roar that silenced all other proto-dragons and made the sky shake. Several attackers near the gargantuan fiend tumbled uncontrollably from his vicinity.

Galakrond exhaled, and the air everywhere filled with a foul mist that reminded the oncoming Malygos much too much of that "breathed" by the not-living. Kalec's host recoiled as the mist rushed toward him. His wings beat hard as he fought to reverse direction before it was too late.

But the mist still caught Malygos. The proto-dragon and his unseen companion awaited the agony that would surely accompany the rotting of Malygos's living flesh.

Instead, a powerful lethargy overtook the icy-blue male. It touched so deep that even Kalec's thoughts were muddied. To Kalec, it was as if his very life was slowly seeping from him, and he vaguely noticed that Malygos felt the same.

Yet some part of the young proto-dragon continued to urge his wings to flap. Malygos exited the mist. The moment he did, both his mind and Kalec's began to clear, and strength started to return. The feeling of utter listlessness dwindled.

Slow death . . . Malygos pondered as he tried to comprehend in simpler terms what Kalec recognized in more sophisticated ones. *He breathes slow death.* . . .

His thoughts finally clear enough, Malygos surveyed the horror unfolding before him. A great portion of Talonixa's grand charge had been caught within the massive cloud exhaled by Galakrond. The behemoth's countless eyes had been watching for one thing: the very moment when most of Galakrond's foes would be within range of this new and horrific breath weapon.

Some of the stricken proto-dragons tried to turn and flee, while others simply fought to stay aloft. A few could not summon the will to keep their wings flapping and plunged to their doom.

But even in the midst of the cloying mist, some proto-dragons still managed more control. Chief among them was Talonixa, who appeared to Malygos to be suffering a different malady: the utter madness Kalec and his host had noted earlier. Talonixa roared over and over, perhaps in part, both Malygos and Kalec believed, to keep herself from falling prey to the mist. She moved not away from Galakrond but closer to him, challenging him as if the two were the same size and strength.

Galakrond laughed, the sound deafening. With a single beat of his wings, he cut the distance between them.

Talonixa opened her mouth wide, but this time, not a roar but a bolt of lightning issued forth. It struck Galakrond directly on the snout . . . and had as much effect of slowing or injuring him as a pebble might have.

Now it was the misshapen proto-dragon who opened his maw wide, a maw so great that the mighty Talonixa was but a fly in comparison. The jaws closed upon the female, even as she spun about in a futile attempt to escape.

The huge, sharp teeth caught Talonixa between them. Galakrond made no attempt to correct his bite. Rather, he shook his head back and forth, violently shaking his prey. Talonixa snapped in vain at the teeth and managed one more bolt, but to no avail. Her head quickly dropped, and her wings ceased beating. She still lived, but barely.

There was no help from those she had once led. The other proto-dragons could hardly keep in the air or protect themselves, much less come to her aid. Even had they wanted to, Kalec and his host knew that it was already too late. Blood spilled over Talonixa, and her breathing came in gasps.

Galakrond ceased shaking her. With barely any effort, he clamped down and bit Talonixa in half.

The still-twitching upper torso slowly tumbled out of sight, a shower of blood and other life fluids in its wake. With mock disdain, Galakrond unclenched his jaws just enough to let the rest of Talonixa fall free. He laughed then and, with a powerful beat of his wings, moved among the lethargic proto-dragons.

Mouth opening much wider, Galakrond began to feed.

His first victims scarcely seemed to notice their demise, so quickly did the horrific leviathan swallow them up. Five vanished

in the space of a single breath. Galakrond barely paused, turning to take in three more a moment later.

"What can we do?" Neltharion growled in frustration. He looked nearly ready to try to defy the mist, despite the obvious result of doing so.

Malygos could not blame him for his rising exasperation. Wholesale death played out before them, and none of the three could offer any way to put an end to it—not, at least, without likely committing suicide in the process. Yet Kalec, feeling his host's raging emotions and thoughts, knew that Malygos would have willingly sacrificed himself if it meant stopping the slaughter.

Then Malygos noticed something about the mist. He started forward. "Come!"

It said much to Kalec that the other two males obeyed. Malygos headed toward the mist, then abruptly rose. A faint, cloying scent infiltrated his nostrils, immediately causing a slight slowing of his thoughts.

The icy-blue male took an almost vertical shift in direction, rising several yards before daring to take even the briefest breath. When he did breathe, Malygos found no trace of the scent that pervaded Galakrond's evil fog.

Adjusting to a more horizontal path of flight, Kalec's host found the lack of scent continued. He now flew above the mist and its effects.

The other two males flanked him as he soared toward Galakrond. Intent on his feeding, the gargantuan proto-dragon failed to notice the tiny trio above. Even had he done so, it was doubtful that Galakrond would have seen them as anything but amusing. After all, what could three do that hundreds could not?

That was a question for which Malygos did not yet have an answer, even as the three reached a spot almost directly above the monster. He peered down at the terrifying tableau, watching as four more proto-dragons disappeared down Galakrond's gullet.

"Mist dwindling above," Nozdormu offered. "Too slow below, though."

"Little wind," Neltharion added, sniffing the air. "Not enough."

Malygos continued to study Galakrond. The only real wind was that caused by the enormous wings. They were beginning to scatter the mist, but not soon enough to save the others.

A curious thought stirred in Malygos's mind, one that caught Kalec by surprise. Malygos imagined himself when he hunted over the water and would dive with great velocity so as to strike deeper and seize the better prey lurking farther below. His eyes narrowed as he focused on Galakrond's head.

"The head," he muttered to his companions. "Breathe little, strike hard."

Understanding dawned. Neltharion grinned, and Nozdormu nodded.

Satisfied that they knew what to do and that they also knew they might very well die in the attempt, Malygos arced down. As he descended, he beat his wings as hard as he could, pushing his velocity to its utmost. Below, Galakrond's head appeared not only to swell in size but also to rush up to meet him.

Kalec also understood his host's plan but had doubts regarding its merits. Still, there was nothing he could do but watch as Malygos reached Galakrond.

At the last moment, Malygos shifted so that his hind paws were underneath him. He pulled himself into a ball as much as possible, even folding his wings tight behind him. Out of the corner of his eye, Malygos saw Neltharion do the same.

In rapid succession, the three proto-dragons struck Galakrond hard on the head.

Malygos dared not hope to cause much, if any, damage to his target. There was only a very minor chance of that. What Kalec's host did seek was exactly what he got.

He made Galakrond *very* angry.

The three proto-dragons striking so hard did induce some pain. Their velocity was also enough to shove Galakrond's head down so that he missed swallowing two more victims. The shock of nearly being devoured finally stirred the pair to some effort of escape.

It was Neltharion who proved most decisive in causing Galakrond momentary distress. When his hind paws struck, they did so with a force only one of his family could create. Seismic waves shook the hard head, briefly making the behemoth disoriented, an added respite that Malygos could not have dreamed of gaining.

But Galakrond recovered too soon. No longer even caring about the pair slowly fleeing from him, he looked up. His wings beat wildly as his fury at actually being assaulted overtook him.

And as Malygos had hoped, the gigantic proto-dragon's wings did what the weak wind could not. The mist that Galakrond had breathed dissipated rapidly around him.

Proto-dragons began to flee in earnest.

Galakrond did not at first notice that his prey had scattered, so outraged was he at the small foes above him. "Little bugs . . ." he rumbled, each word all but deafening the trio. "A meager meal you are . . . but a meal you are. . . ."

To the surprise of not only Galakrond but also Malygos and Nozdormu, Neltharion plunged toward the misshapen creature. While Galakrond sneered at his puny challenger, Neltharion changed direction and, instead of Galakrond's snout, attacked the huge proto-dragon's left eye.

In few other areas could the impetuous Neltharion have caused any actual harm. Even his previous strike had only irritated Galakrond. Yet now, opening his mouth wide, the charcoal-gray male erupted with a cry of sheer force.

Galakrond roared in what was no doubt the first true pain he had felt in some time. He shut the eye hit by Neltharion's strike, and

then, when that proved insufficient to put an end to his agony, he shut the other, too.

"Fly! Fly!" Malygos shouted to anyone who could hear, including Neltharion.

"But we have him!" his friend insisted. "We do!"

Galakrond opened his eyes. The left one was as red as blood, but it could still see as well as the other, and both glared at Neltharion with a rage such as Malygos and Kalec had not seen directed at even the icy-blue male.

Great jaws snapped at Neltharion, who barely evaded them. Nozdormu and Malygos came to the aid of their companion, aiming for the sensitive eyes. Galakrond instinctively looked down, making both of their attacks instead hit his thick, armored brow ridge.

But Malygos had not expected anything more than those results and knew that Nozdormu had thought the same. Once again, Galakrond had been distracted, this time saving not only Neltharion but also Malygos and Nozdormu. With Malygos in the lead, the three took to the higher sky and vanished into the cloud cover.

It did not take Galakrond's fearsome roar to inform them that he pursued. The three glanced at one another, then split up.

Malygos pushed as high as he could. The thinner air made flying more difficult, but he hoped that would also make it troublesome for Galakrond to follow. The icy-blue male believed that his friends would do as he did. At the very least, the risk they took aided the survivors of Talonixa's ill-fated plan.

Silence reigned. Struggling to maintain his position, Malygos looked over the clouds. There was no sign of any other proto-dragon, alive or not.

After all Malygos had been through already, the effort to stay aloft grew too taxing to bear. Listening carefully, Kalec's host still heard nothing. He began to wonder if Galakrond had moved on.

It mattered not. Malygos finally had to descend. He planned to

drop only as far as he needed to in order to breathe properly. From there, he would have to judge whether it was safe to continue on.

His heart pounded, both from the struggle for air and from the tension of keeping an eye and nose out for Galakrond. Kalec, experiencing the same, at times forgot that he was but a passenger. He tried to steer toward the east, only to be reminded that this was not his body when Malygos turned south instead, then dived a little farther.

The proto-dragon left the cloud cover. The area was empty. The rest of Talonixa's followers had wisely fled as fast as they could.

But where, Malygos and Kalec wondered, were Neltharion and Nozdormu? Where, indeed, was Galakrond—

Something suddenly collided with Malygos from behind. The impact sent both him and the object hurtling toward the ground. He fought against the drop.

"No struggle! Galakrond close! No struggle!"

Malygos ceased struggling. He let himself be guided to just above the ground and toward a set of low hills.

Far above, Galakrond's roar reverberated.

A few small caves appeared in the distance. Malygos's companion led him into one.

They landed in semidarkness. Kalec's host turned to face his rescuer. "Alexstrasza . . ."

The fire-orange female hissed quietly. "Galakrond hears well. Must speak softly."

Before he could answer, he heard movement coming from deeper in the cave. Malygos looked there, expecting Alexstrasza's sister to be joining them.

Instead, the withered, decaying visage of an undead filled his view.

THREE
UNDER THE SHADOW OF GALAKROND

Kalec shared Malygos's consternation. He also shared his host's decision to attack without hesitation. Malygos started to exhale—

"No!" Ysera collided with him from the side. Malygos's frost shot deep into the cave.

The undead reached for him . . . or tried to. It also attempted to exhale in turn, but now Malygos saw that its mouth was bound by a strong vine found growing on rock faces in the vicinity. The paws were also bound. Proto-dragons as a species did not use tools of any sort; they had hardly been sentient long enough to develop such interests and in general did not even need them. However, Ysera had adapted quite well to finding a use for what Malygos would have considered food for some grazer.

As his eyes became better attuned to the fainter light, Malygos saw that this animated corpse had once had a hide the same brilliant color as that of Alexstrasza.

Clutch brother.

Before he could state what appeared obvious, Alexstrasza leaned near. "It is not him. We knew this one, but it is not our clutch brother."

Ysera had already lost interest in Malygos, her focus on the undead. She guided the fiend back, all the while murmuring to it.

"Found her with one like this before," Alexstrasza admitted. "Another of our family. She cannot find our clutch brother and so helps other family."

Malygos had not given much thought to Ysera's earlier obsession but now suspected that if she had not been able to find the remains, they had likely been dragged off by any number of scavengers or moved by the weather. It was still possible that he was now one of the not-living, but Kalec's host very much doubted it.

All of that, of course, did not explain what Malygos saw here or how it happened to be so very near the site of Talonixa's disastrous defeat.

Galakrond's roar erupted once more. This time, though, it sounded farther away.

"The smell," Alexstrasza explained. "The smell of the not-living smothers ours. Galakrond only smells death nearby."

That, at least, answered one vital question for Malygos and Kalec. "But that is not why not-living is here."

"No . . . I had a little hand in that," another voice said.

Alexstrasza did not appear startled that there was a fifth figure in the cave, a fact made even more interesting by the speaker being none other than Tyr.

Something that did not surprise Malygos when he looked upon the cloaked and hooded form was that Tyr was now several feet taller than before and much wider. Even then, Malygos—and Kalec—could not help feeling that Tyr only wore this size because it was convenient for the moment. He still radiated a presence far greater than his current height indicated.

This is only a slight reflection of him, Kalec vaguely recalled. He struggled to remember more, but his own time had become fragments of scenes that were harder and harder to think of as fact. Jaina's face was the strongest bond remaining, and on occasion, even she briefly faded from his mind.

He was interrupted in his attempt to strengthen his few memories by the undead's muffled hiss. The animated corpse tried to move forward again, but Ysera blocked its path. She continued to

speak quietly to the creature as if it were actually her missing clutch brother.

"She must give this up," Malygos finally muttered.

"It helped draw her and, thus, her sister here," Tyr remarked. "In that, her desire to save her missing sibling has merit. I had a different intention when I drew this creature to this cave early on, but fate appeared to have another purpose."

"Saw it when we fled from Galakrond," Alexstrasza added. "Ysera wanted to return to Galakrond. Wanted to try again to speak peace." She peered at her sister and the undead. "Told her I saw our clutch brother. She believed. We followed to here."

Tyr grunted. "It was a variation of my plan." He did not bother to tell them what that variation was, even though the proto-dragons cocked their heads in confusion. "It saved your lives. Now we only have to figure out how to save the world."

"Neltharion and Nozdormu . . ." Malygos muttered. "They are not saved."

Alexstrasza's eyes widened. In all the excitement concerning her sister, she had forgotten about the other two males. "Galakrond! Are they—"

"I do not know. We flew to the clouds. Split up. Saw nothing. Heard nothing."

The urge to return to the outside and head off in search of the missing pair grew strong enough that Malygos took a step toward the entrance.

"Wait." Tyr passed by both proto-dragons. He stepped up to the entrance but did not proceed. For a moment, the two-legged creature stared out into the open.

Alexstrasza used the delay to tell Malygos, "He came from nowhere. Said he knew you. Offered help." She shook her head. "I believed all. Did not question Tyr."

While Malygos was glad to hear that he would not have to

explain or defend Tyr, that subject did not concern him so much at the moment. Instead, he could not help still being bothered by Ysera and her horrific charge. Alexstrasza's sister went on speaking softly to the corpse.

"Tyr says let this be," the fire-orange female muttered. "How long, not said."

"Not good. Cannot stay here."

They were interrupted by the return of Tyr. "Galakrond is still in the region, but he is taking a path to the southwest. If he keeps that direction, he'll soon be far enough away that you can go in search of your comrades."

Malygos snorted. "Will find them. What about *her*?"

Tyr followed his gaze to Ysera. "There is a facet to her that must be encouraged, must be explored. I feel that this is significant, if not for now, then for the future."

"Hmmph!" The future was a concept only recently appreciated by Malygos and other proto-dragons, having once been creatures who had purely existed for the moment at hand. Now that concept seemed a very fragile one. "Galakrond may *be* the future."

His remark did not appear to strike Tyr as dramatically as the proto-dragon expected. Instead of solemnly nodding, Tyr smiled slightly. "I think I've finally chosen well."

The comment both mystified and infuriated Kalec's host. "Riddles! Wingless Tyr talks riddles! Proto-dragons dying!"

"And no one knows that better than I," the two-legged being answered, much too calmly for Malygos's taste. "No one feels more responsible than I. I should have watched. I knew the others were beyond caring. I should have watched . . . but even I grew distracted."

The animated corpse chose that moment to begin a new tirade. Why it had been stirred up was quickly apparent. Ysera had dared to undo the mouth. What she hoped to accomplish, neither Malygos

nor Kalec could guess, but what she almost earned for her decision was a bite across her throat. Only her quick reflexes kept Ysera from a mortal wound.

A red rage overtook Malygos. He shoved past Ysera and attacked the undead. With its paws still bound, its remaining defenses were its slavering jaws and its horrific mist. Malygos shifted to the monster's right. The undead, unable to turn well, could not bring its head around far enough to reach him.

Malygos ripped into the dry neck, easily tearing through the rotting flesh and cracking bone. It was enough to cause the neck to collapse, taking the head with it.

With blackened blood slowly dripping from the savage wound, the torso continued to twitch. Still caught up in his fury, Malygos ripped open the chest. That appeared to be sufficient. The body quieted, then slumped.

Kalec's mind also swirled with rage, although to a lesser degree. He fought against the desire for blood and flesh, even as a voice tried to reach through the haze that Malygos's thoughts had become.

The icy-blue male turned on Ysera. She met Malygos's gaze squarely and began talking to him in a tone like the one she had used with the corpse. Malygos at first sneered, only interested in her life. He smelled its freshness, and his hunger grew. Kalec understood that his host had fallen prey to the bite from the earlier undead and doubted that Malygos would be able to shake himself out of it this time. Worse, Malygos towered over Ysera, who made no move to flee.

Then a quiet voice penetrated Malygos's thoughts. Like something out of a dream, it gently touched some remnant of sanity left in Kalec's host and urged it forward. Kalec felt Malygos's hunger begin to subside. His reason started to take dominance again.

We are your friends, Malygos. . . .

At first, Kalec believed the voice belonged to Tyr, for not only did it have an otherworldly quality to it, but who else would have the ability to draw reason back from madness? However, as the voice repeated itself, he caught its feminine facets.

It was Ysera's voice. With the subsiding of the blood rage, Malygos's vision cleared. Now both Kalec and his host could make out that Ysera was speaking. While that certainly made sense, it had been impossible for even Kalec to identify her under such circumstances.

"You do not want to do this. You are one who fights *for* us, not against us."

Listening through Malygos, Kalec noticed how much more succinctly Ysera spoke. She was more intelligent—if also more *impulsive*—than other proto-dragons. Kalec wondered if her small size and inability to fight as well as many normal proto-dragons had contributed to her need to hone her intellect even more than most of her kind.

Malygos finally nodded. "I am well."

But for the first time, Tyr was disturbed. Barging past Ysera, the two-legged being angrily peered at Malygos. "You've been bitten. The hunger is within you."

Alexstrasza joined her sister. The elder female appeared almost as dismayed as Tyr. Ysera, on the other hand, looked very interested and, at the same time, disappointed.

"Could have saved them," Ysera muttered. "Did not have to die in that cave. . . ."

Both Malygos and Kalec recalled the infected proto-dragons buried alive by Talonixa. Kalec doubted that those poor creatures, so much farther gone than even Malygos, could have been turned back to sanity, as his host had been. Still, he felt Malygos's guilt grow at the thought that perhaps somehow he could have helped Ysera in that regard.

Tyr ignored Ysera, his attention fully on studying Malygos for any sign of the hunger returning. "I've seen others. None fought it down. How long has it been since you were bitten?"

"Several suns."

Tyr's eyes—so very different from those of proto-dragons—narrowed further. "That long, and you haven't succumbed. That bespeaks a strong will, although evidently not strong enough. She kept you from falling too deep into the hunger."

Malygos straightened. "Not happen again."

To Kalec's surprise, his host spoke with the utmost certainty. The dragon could sense a change in Malygos, a change in great part the result of Ysera's efforts to guide him back to sanity.

Tyr did not look convinced. He raised a hand to Malygos. The hand glowed white.

Malygos instinctively retreated. Alexstrasza hissed. Only Ysera appeared unperturbed. Even though Malygos had seen Tyr appear and disappear and knew he had amazing powers, it was another thing to have those powers focused at him. Only great restraint kept the icy-blue male from defending himself.

"I cannot sense the taint. Either you have buried it so deep that it should never resurface, or you have purged it somehow from your body and mind entirely." Tyr looked back at Ysera. "One must never overestimate appearances, it seems."

Alexstrasza's sister betrayed no evidence that she heard Tyr's compliment. Rather, the slighter female moved back to the ravaged corpse. She muttered something, then began to mourn it as Malygos recalled Alexstrasza mourning the remains of their actual clutch brother.

Tyr tolerated this for a very short time. "There are other lives that can be saved. I think it best that we do what we can for those, including your missing friends."

"But there is still Galakrond," Alexstrasza pointed out. "Even if he is gone now, he will always hunt us."

"And that is why we must hunt him instead."

Malygos was not alone in eyeing Tyr with some suspicion. "We hunt him? Talonixa hunted Galakrond! Speak with Talonixa, Tyr!"

"Your point is well taken, proto-dragon. Still, this time will be different."

Kalec's host cocked his head. "How?"

Tyr reached into his cloak and removed what only Kalec recognized but even Malygos and the sisters understood was a weapon of some sort. Tyr might lack claws and sharp teeth, but he wielded the blunt-ended thing with an ease and skill that the proto-dragons could appreciate.

As for Kalec, he had seen many a war hammer in his time, but even the sturdiest of those, used by the dwarves especially, paled in comparison to the huge weapon Tyr held, a weapon that Kalec and his host felt was of greater power than it appeared, like the hooded figure himself.

"Because I will not stand by this time! When you face Galakrond, I will be at your side."

He returned the hammer to the confines of the cloak, the weapon seeming to vanish into a void rather than simply hanging at Tyr's side. As astounding as that was to Malygos, for Kalec, the act revealed another, more urgent sight.

Hanging next to where the hammer had vanished was none other than the artifact.

Kalec expected to watch the cloak again obscure the bane of his existence, but to his shock, Tyr brought forth the artifact. The proto-dragons peered at the object, Malygos's utter bafflement clearly matching that of the sisters. Various explanations ran through Malygos's mind—an egg, a rock, a piece of star—but none approached what Kalec already knew about the insidious relic.

Tyr held out the artifact—which looked to Kalec as if it was smaller than he recalled—toward Malygos.

In contrast with the lavender color the blue dragon was familiar with from his own time, now the artifact glowed a faint white . . . and only in the direction of Kalec's host. Malygos grunted, but before he could react, the glow ceased.

Tyr turned to Ysera and Alexstrasza. Again, the artifact glowed faintly. Having already seen nothing happen to Malygos, neither sister so much as blinked.

Kalec wanted to shout questions, but Malygos asked only one of the many the blue dragon sought the answer to. "What did you do?"

"Try to ensure some future."

It was as vague a response as Kalec had expected. He would have followed up with a pointed query, but Malygos was not of the same mind. His concerns were more immediate to the overall situation.

"We go now. We find the others."

Tyr hid the artifact again, leaving Kalec to fume silently. "Yes, we find them—"

Galakrond's roar, suddenly close, shook the cavern. Heavy chunks of rock broke from the ceiling, and if not for Alexstrasza quickly covering her head with her wings, she would have been wounded. Ysera and Malygos were also pelted, but not as badly.

The rocks seemed to fall around Tyr without touching him. Still, he did not take the incident lightly. Scowling, he steered the three back from the entrance. His decision proved providential; a major section of the ceiling there crumbled a breath later. It did not bury them alive, but it meant that to escape, they would have to crawl out one at a time.

And out there, Galakrond continued to rage.

"Something has brought him back here!" Tyr rasped. "Your friends, perhaps!"

Whatever the reason, Galakrond appeared determined to stay

in the region. The ground shook again and again, creating more showers of rock but, thus far, no new collapses. All four—five, including Kalec—knew that their luck could not last much longer.

Tyr started back to the entrance, only to have Malygos charge past him. The male proto-dragon thrust out his snout just enough to see what was happening.

Galakrond chose that moment to land. The new tremor rocked the landscape. The monstrous proto-dragon's head whipped back and forth in search of something. Kalec and his host both noted that Galakrond looked amused. Kalec had seen that expression before on such predators; the behemoth was toying with his prey, whatever it was.

A moment later, that prey also appeared. Not at all to Malygos's and Kalec's surprise, it was Neltharion.

The charcoal-gray male dived down from behind Galakrond. Neltharion unleashed another roar, aimed at the base of Galakrond's skull. The misshapen leviathan shook from the force of the shock wave and fell forward to the ground.

Neltharion laughed and came around to attack again.

"He's being led to his death," Tyr said from beside Malygos. "I knew him to be rash but not suicidal."

Several of the eyes along Galakrond's torso had been observing Neltharion the entire time. The smaller male reached the location Galakrond evidently waited for. He twisted his head around and opened his mouth to exhale.

A thick column of sand shot down his gullet.

A fit of coughing overtook Galakrond as he suddenly had to fight for breath. The massive proto-dragon struggled to dislodge the sand from his throat.

Another, smaller figure dropped down just behind Neltharion. Nozdormu hissed at Galakrond, a taunt that the hacking beast failed to notice.

"Excellent coordination!" Tyr roared. "So I was right about all of you!"

Malygos failed to see what so cheered the two-legged being, and Kalec had to agree. Yes, the pair had outmaneuvered Galakrond, but he was hardly defeated.

Some impulse drove Malygos out into the open. He was through the half-ruined entrance before anyone could stop him. Alexstrasza called after him, but he did not hesitate. Kalec felt Malygos's intense sense of loyalty urge the icy-blue male into the fray.

Snout down, Galakrond finally began dislodging chunks of solidified sand. His breathing took on a more normal rate. He started to look up again—

Malygos exhaled. As Nozdormu had done, Malygos aimed at the gullet.

At the last moment, Galakrond sensed him. However, in turning to face Malygos, Galakrond only gave him a choicer target. The frost hit the same eye that Neltharion had earlier attacked.

By itself, the frost might not have slowed Galakrond, but it aggravated the injured eye. Hissing, the enormous proto-dragon shut both eyes. Of course, that did not leave him sightless; several of the extra eyes now glared at Malygos.

Yet no sooner had those orbs fixed on Kalec's host than fire assailed the shut ones. Alexstrasza soared over Malygos, the plume of flame she exhaled continuing. Her attack kept the main orbs from reopening and drew the other eyes from Malygos.

Neltharion chose then to attack some of the extra eyes. He first roared at them, and then, when he was able to get near enough, he tore away two in successive swipes of his hind claws.

But the reckless male failed to pay sufficient attention to some of the extra limbs. Perhaps seeing them as little other than useless growths, Neltharion let his tail come too close to one dangling leg.

The paw seized his tail and held on with a tight grip. Neltharion tried to back away, which only brought him near another paw. The second grabbed one of his hind legs.

Galakrond opened his eyes. Mouth widening, he turned to swallow the captured morsel.

Malygos and Alexstrasza tried to draw his attention again, but Galakrond cared only to devour Neltharion. Their attacks, now striking mostly the scaled hide, did little more than cause their foe to twitch slightly as his jaws neared the charcoal-gray male.

A shadow swept over Malygos, immense enough to make him think that perhaps *another* Galakrond came up behind him. He started to look over his shoulder, but the shape moved so quickly that both he and Kalec had no time to ascertain what it was before it reached Galakrond.

A thick form that Kalec initially identified as a fist as large as a full-grown proto-dragon hit Galakrond on the side of the jaw opposite from Neltharion. It hit with such force that the behemoth stumbled away from the blow.

Only as the shape receded did both Kalec and his host catch enough of a glimpse to see that it was not a fist but the head of a hammer that had made the blow—a hammer identical to what Tyr had wielded but many times the size of the one they had seen earlier.

And while Malygos had missed it, Kalec had noticed that there *was* a hand gripping the hammer, a hand also much larger than previously seen.

But just as the hammer withdrew, Malygos's attention was caught by Ysera, who darted dangerously close to the briefly stunned Galakrond's jaws. However, instead of seeking the gullet, Ysera rose before Galakrond's nostrils and exhaled.

Galakrond grunted. He hesitated.

The paws holding on to Neltharion seemed to lose control. He pulled away and fled from Galakrond. As he did, Alexstrasza and Ysera also turned away.

"Flee! To the south!" Tyr called from somewhere beyond the icy-blue male's sight. Tyr's resounding voice well matched his titanic proportions, which made his sudden command more shocking to Malygos. All appearances were that they were at last winning.

But as he thought that, Galakrond began to stir again.

Kalec's host veered away. He saw his companions, Nozdormu included, awaiting him in the south. Of Tyr there was still no sign. Malygos picked up his pace.

Behind him, Galakrond roared. Malygos flew faster. He joined the others as they raced on.

"Tyr?" Malygos called.

In response, a sound that echoed like thunder rocked them from the direction of Galakrond. A second later, the leviathan roared again, but this time from farther away.

Malygos almost halted, but Alexstrasza shook her head. "Tyr says fly south! Keep flying!"

With much regret, he obeyed. He did not entirely understand this being called Tyr, but he recognized that the two-legged creature knew far more than he or any of the others did. Their hopes of defeating Galakrond rested greatly on Tyr.

Tyr . . . who at this moment risked himself to help the five escape.

And for Kalec, who was forced wherever his host went despite the fact that he would have flown in the opposite direction, it was the same Tyr who carried with him the artifact and the blue dragon's fading hope that he would free himself of these visions with his mind intact.

FOUR
WİTHİN THE NEXUS

Jaina glared at the offending books. She had exhausted a repertoire of spells designed for such delicate searches, to no avail. Now the archmage considered stronger measures, her only hesitation being that Modera or someone else would certainly notice her presence then. Still, every second lost might also mean further danger to Kalec.

She had to take the risk of discovery. Her mind made up, Jaina began casting—and then halted. Atop one bookcase sat the skull of an ancient, savage reptile that she had inherited with a number of unusual and arcane objects from her predecessor, Rhonin. While in itself it meant nothing to Jaina, it caused her mind to shift back abruptly to the huge skeleton and her encounter with Buniq. She saw again how the taunka drew the pattern. Only at this moment did Jaina ponder the fact that the taunka had had a very precise memory for a symbol like nothing she would have seen before. At the time, the archmage had chalked it up to the focused nature of Buniq's kind, but now she wondered if it had been something more.

Were you really a taunka? Jaina asked the distant Buniq. *I shouldn't have believed in coincidence.*

Jaina drew the symbol in the air. She then turned it about so that she looked at it as it had been drawn by the hunter.

"What a fool I've been!" the archmage blurted. She bit her lip,

then simply prayed that no one had heard her. She eyed the reversed symbol, seeing it anew.

Had she paid more attention when first seeing it by the skeleton, Jaina would have noticed that turning it revealed a different and obvious meaning. Turned this way, the symbol was also a key.

Or, rather, the key. Jaina cast the reversed symbol over the original tome. The archmage watched as it sank into the book.

The lavender glow faded not only from the book in question but also from the entire collection.

Jaina seized the thick tome and began flipping through the pages. There, where she had expected to find the information she needed, she finally found it. The archmage carefully read over the passage.

When together, the two parts were more than the sum of their individual measure. Their power magnified. Archmage Wendol suggested that there were also other combinations that the pair could make but that the immense time since their creation had caused some of those combinations to function in error—

Jaina shut the book. "Yes . . . that must be it."

Voices arose outside her chambers. Jaina quietly swore at her outbursts. She should have known that Modera would have someone listening for any sign of her return.

But discovery mattered no longer. Jaina believed that she had what she needed. The archmage set down the book . . . and vanished.

She materialized a few seconds later just beyond the magical boundaries of the Nexus, the humming accompanying her teleportation spell fading away even as she registered her location. Jaina frowned upon seeing where she had appeared; the archmage was far from her intended goal. She cast another spell and vanished again.

Jaina rematerialized in the exact same location.

Staring at the Nexus, the archmage attempted a different tack. This time, she simply tried to probe what was currently happening.

The probe failed to breach the Nexus's protective wards.

Having entered the sanctum just recently, Jaina believed that Kalec had adjusted the wards to keep someone or something out. That was followed with the concern that he had wanted *her* specifically to be kept from entering. He had already sought to keep his troubles from her, and it could be reasonably assumed that this change in the wards had been done with that intention in mind.

The trouble was, Jaina believed that she held Kalec's only hope of being freed from whatever the artifact was doing to him. If he had sealed the Nexus off, it was possible he had condemned himself.

No! I will not lose you! Jaina cast another spell, this one draping over the entire field of wards. She looked for some fault, however slight, of which she could take advantage. Unfortunately, she found none.

The blue dragons themselves aside, few alive understood the complexities of the Nexus's wards as well as Jaina Proudmoore did. Aware of their general matrix, Jaina sought out the key points. She did so not to seek weaknesses but to find alterations. By understanding what had been changed, the archmage might be able to see how she could adjust it to her desire.

But what Jaina discovered when she located the key points was not what she expected. Kalec had not made these alterations; the same energy signature she had noted in the artifact now permeated the Nexus's defensive network.

At first, the archmage stood daunted, but then an idea occurred to her. She re-created the symbol and, keeping it reversed as she had done with the books, incorporated it into her next probe of the key wards.

There was resistance, but the symbol finally imposed itself on the altered wards. As it did, the artifact's influence on that area faded.

Encouraged, Jaina probed deeper—

The alteration reconstructed itself, in the process rejecting her spellwork from the wards. The force with which it reversed matters struck Jaina's mind hard.

Gasping, the archmage fell to one knee. Her head throbbed. However, her initial frustration at this setback quickly changed to curiosity. What she had sensed was no personal purpose on the part of the artifact; it had simply restored an area that had been disrupted. There had been no malice, no intentional attack on the archmage. Once the area had been returned to its previous state, the artifact's efforts had ceased.

Standing, Jaina grimly smiled. She had a better idea of what she faced. Next, she had to learn its limits . . . and whether those limits were greater than her own.

With Kalec in her thoughts, the archmage once more re-created the symbol. She then made a second, a third, and so on, until within the space of a few breaths, scores of the reversed image hovered before her.

"Let's see what happens now," Jaina murmured. "Let's see what happens when you have to readjust *everything*."

She sent her army of glowing symbols into the air. They hovered together for a moment, then spread out, circling the expanse of the Nexus and its unseen protective wards. When they reached where Jaina wanted them to be, the archmage had them pause just beyond the wards. Heightening her senses, she took one last look at how the wards were arranged, then sent a sigil hurtling toward each.

As the reversed symbols touched the wards, the Nexus erupted in an explosion of white and lavender energy.

The five proto-dragons alighted on a set of sharp ridges along the side of a wide, stark peak. All were extremely exhausted, and had Galakrond chosen that moment to attack them, Malygos had little

doubt that he and his friends would have been easy morsels for the behemoth. Kalec, experiencing Malygos's weariness and foul mood, could not help but think the same.

For several minutes, the five simply crouched where they perched, caught in their own thoughts but all clearly having the same thoughts. The devastation wrought by Galakrond had begun to sink in, as had the fact that they seemed to be the only ones left to face him. More and more, the immensity of that was becoming apparent.

The mountain wind howled, but Malygos suddenly heard another sound mixed in with it. Stirring, the icy-blue male listened but noted only the wind now.

Kalec's host saw that Ysera also listened. She did not look Malygos's way but, rather, at where two mountains to the east seemed as if they fell toward each other.

Again, there came a brief sound. This time, Malygos recognized the mournful hiss of a proto-dragon.

Ysera flew off toward the sound. The others took notice of her action but evidently had not heard the cry. Malygos immediately followed, with the rest in pursuit.

Ysera dived in between the two mountains. Malygos pushed to keep up with her, amazed that the weaker female now had more strength than he did.

The yellowish proto-dragon entered a shadowed area that reminded Kalec and his host too much of the very region they had just left. Visions of animated corpses rose in both minds.

Alexstrasza's sister vanished into the shadows. Malygos slowed slightly, then entered.

Barely had he done so when another proto-dragon rose in front of him. Despite the shadows, it was clear to Malygos that this was a living creature, not one of the undead.

The two collided, but not because the other proto-dragon—a

young male—sought battle. Malygos's supposed opponent squawked in fear as he tried to untangle himself.

A third proto-dragon—Alexstrasza—joined from behind Malygos. Ysera's sibling aided Malygos in pinning the young proto-dragon against one rocky wall.

As they did, Ysera joined them. "No . . . he was only startled. Let him go."

The captured male frantically looked from Malygos to Ysera and back again. He let out a low whine. Only then did Malygos realize that this was one of the lesser proto-dragons, one of those that had not made the leap to intelligence.

From behind Ysera arose more whining. Malygos caught sight of several shapes moving about in the back.

Neltharion and Nozdormu landed near them. At the same time, Alexstrasza released her hold on the captured proto-dragon. Malygos did the same.

The young male immediately rushed back behind Ysera. He vanished among the other shadowy forms, all of which grew even more agitated.

"What is this?" Neltharion muttered.

Ysera turned to the shadows. Malygos and the others finally followed.

The agitated forms turned out to be a motley collection of proto-dragons, which Kalec and his host saw included mostly the lesser ones but also a few of the obviously more intelligent. Whichever they were, they shared a tremendous anxiety.

Among them, Malygos spotted two whom he recognized from the doomed charge. They looked even more disheveled than the lesser proto-dragons and in some manner also more anxious. Eyeing the smarter ones, Malygos came to the conclusion that they were probably all from the charge.

"Galakrond comes! Galakrond comes!" a silver-blue female cried without warning. The assembled survivors grew yet more agitated.

"No Galakrond!" Neltharion roared with impatience. "No Galakrond! Quiet!"

They quieted, but only out of a more immediate fear of the charcoal-gray male. Neltharion's outburst also greatly shook Ysera. She placed herself between the unfortunates and Neltharion.

"You be quiet! Quiet!"

Startled, Neltharion clamped his mouth shut and backed down. Ysera, her eyes widening by the second, turned to the shivering proto-dragons.

"All good," she continued in a calmer tone. "No Galakrond . . . all good . . ."

Her audience became less restive but did not completely calm. Kalec, observing all, could hardly blame them. Those who had been a part of Talonixa's campaign would live with the horror of the debacle for the rest of their existence—very possibly a short time unless something changed.

"So many dead," Ysera muttered. "So many dead . . ."

Alexstrasza came to her side. "Sister—"

"Galakrond! We must—"

Kalec's world turned on its head. The vision changed to darkness with a suddenness that jarred the blue dragon as none of the previous shifts had. He felt as if his mind were being torn in a thousand different directions.

What at first sounded like the rapid beating of his own heart pounding in his head quickly became a steady noise that he realized originated from beyond his ears. In understanding that, Kalec also understood that he was somewhat back in his body. Why he had not completely left the vision for the present, the blue dragon could not say. Kalec tried to move, but it was still as if he was a part of young

Malygos. Kalec had no sense of his legs and arms, no sense of any part of his body except that if he could hear the pulsating, then he did have ears.

Then an indistinct shape caught his attention. Kalec found himself grateful that it also revealed that he did still have eyes. He tried to identify it but could only make out that it stood over him.

The pulsating increased, again causing him tremendous strain. He wanted to shut his eyes and hold his hands to his ears.

And as if he had done the latter, the beat grew muffled, distant. As the intensity faded, Kalec felt the world slowly try to coalesce about him.

With it came some semblance of form to the shape looming over Kalec.

The shape was clad in a hooded cloak like the one Tyr had been wearing.

Kalec tried to speak, but no words escaped him. Frustrated, he threw all of his will into making some sound.

His ears resounded with the bellowing cry of a dragon—his own cry, despite the fact that he awoke in his humanoid form. Kalec gritted his teeth and then took satisfaction in not only being able to do that but also having finally made himself heard.

Details started to come into view around the vague form that might be Tyr, details that Kalec recognized from the interior of the Nexus, and among them, naturally, was the artifact. That it was so nearby did not surprise him. He was relieved to find that the artifact had not sent him flying halfway across Azeroth but wondered why he still heard the pulsating. There was no reason for the Nexus to have such a sound coursing through it. Yes, some of the wards set off warnings of a magical nature, but this was not one of those alarms.

Even as that came to mind, it suddenly occurred to Kalec that

the vague form no longer stood over him. He glared at the empty air, then forced himself to his feet. As he did, he sensed the influence of the artifact extending through the entire arrangement of wards, as if it sought to alter everything anew.

No. . . . As he fought to focus better, Kalec noticed that there was a difference in the way the artifact's power flowed. It was not simply seeking to alter things; it was attempting to correct abrupt changes made to the wards from the *outside*.

But who would have the audacity—

"Jaina?" he whispered, both hoping it was her and praying it was not. She could not possibly have any idea what was happening within, so Kalec believed, and even if somehow she had gained some knowledge, Jaina still risked herself needlessly. There was nothing she could do for Kalec.

More fearful for her life than for his own fragmenting sanity, Kalec stumbled forward. He heard an ominous rumble echoing through the Nexus, which struck his very core.

Galakrond.

It was not possible for the proto-dragon to be there. Kalec knew that with absolute certainty. Yet again, he heard Galakrond's distinctive rumble, this time closer than ever.

A shadow crossed over Kalec, a vast shadow that only served to verify that what he had heard was, indeed, fact. However, when he tried to spot the source of that shadow, he could locate no sign.

The Nexus shook, but the tremor had nothing to do with shadows of the past. Whatever was affecting the wards from without had caused greater turmoil to his sanctum than Kalec would have expected. More and more, he believed that Jaina had come in search of him, and more and more, he feared what the artifact might choose to do with her.

Kalec staggered toward the accursed relic. Another shadow moved over it, a smaller one.

The vague form stood behind the artifact, its hooded gaze fixed on Kalec.

"What do you *want* from me?" he shouted. "What?"

A rasping hiss from his right made Kalec quickly turn. Out of the corner of his eye, he thought he saw one of the undead proto-dragons, but when Kalec sought out the monster, it, like Galakrond, was nowhere to be seen.

And neither, when Kalec turned back, was the hooded figure.

Fury rising, the former Aspect reached for the artifact. Around him, the pulsating grew stronger, deafening. That brought to mind Jaina again, which only further stirred Kalec toward the relic. If only for her, he needed to find some manner by which to stop it—

We must stop him here and now. Any longer, and I fear for this world.

Tyr's voice. Kalec knew it very well at this point. He wanted to curse the keeper, but no words came from the blue dragon's mouth this time.

Galakrond's roar filled his ears again. As before, the vast shadow swept over him and the chamber.

I have observed him long enough. I think I have discovered two weak points that we can exploit.

"I do not—" Kalec could not finish. Nor could he reach the damned relic. He fell to his knees and then, still grasping for the octagonal artifact, pitched forward.

But instead of falling, Kalec awoke in what he recognized as the same region where Malygos, Ysera, and the others had come across the survivors from the charge. Concerns about Jaina and the Nexus faded, despite the blue dragon's best efforts. His mind and that of the young Malygos melded again.

And through his host, Kalec instantly understood that they had not come across the ragged group by chance. Tyr had sent them

in that precise direction because he had known that they would discover one of the bands hiding from Galakrond's horrific gluttony. If it had not been this one, it would have been another group.

And now Tyr stood among the five, a hint of weariness in his tone, but weariness mixed with confidence. How he had evaded Galakrond, he had apparently not told the proto-dragons. Instead, what he appeared to be doing was organizing Malygos and the others for another mad attempt at taking on Galakrond.

What was worse to Kalec was that the proto-dragons were listening, especially Ysera.

"Where? Where is he now?" she demanded.

"The icy peaks over the north ridge."

Kalec found the description maddeningly vague, but his host and the rest nodded as if they knew the area very well. An image of the peaks in question briefly formed in Malygos's thoughts. Kalec tried to identify them with some area in Northrend, but the image faded before he could do so.

Ysera leaned close to Tyr. "We go now?"

"What does Galakrond do now?" Nozdormu interjected. "What?"

"He sleeps," Tyr answered solemnly. "He sleeps deep. Now *is* the time to attack him. We shall never get a better chance, in fact."

None of the proto-dragons, not even Malygos, seemed to notice a slight hesitation at the end of Tyr's statement. Kalec wondered if it meant anything or if Tyr was simply still exhausted from his own efforts.

"There is a river nearby," the keeper continued. "Flush with fish. Go there. Eat your fill. Then we head north for Galakrond."

Alexstrasza indicated the huddled survivors. "What about these?"

"They would be no help."

Neltharion grunted in agreement. He looked at Malygos,

who nodded. Kalec's host had no other plan and trusted in Tyr's intelligence. Tyr would lead them to victory.

Neltharion spread his wings, but before he could take flight, Tyr reached into his cloak and, to Kalec's tremendous frustration, brought forth the artifact. He held it toward the charcoal-gray male. As before, it glowed, startling Neltharion. Tyr held it near Nozdormu, who simply waited for it to stop glowing. Neltharion snorted at the brown male.

"We go *now*?" a more impatient Ysera asked.

"Yes. The river first. I will meet you after."

No sooner had Tyr said that than he no longer stood among them. Now only Malygos did not react.

Kalec did react, although of course, no one saw that. And no one evidently saw what he reacted to. Kalec might have been wrong about the earlier hesitation, but he could not have been wrong about the wary gaze Tyr had given before disappearing.

And Kalec was certain he could not be imagining that whatever the reason for the gaze, it warned of a threat not just to Malygos and his friends but to everything.

FIVE
HUNTING THE HUNTER

Malygos's feeding left Kalec adrift with his own thoughts, which at last led back to the blue dragon's time . . . and Jaina. He knew that his body lay in the Nexus and more than ever believed that she, and she alone, was responsible for what was trying to interfere with the wards affected by the artifact.

Jaina! he silently called, hoping that perhaps she would notice him. *Jaina!*

There was no response, and in truth, Kalec had hardly expected one. There was nothing he could do for her here except pray that somehow he might be able to find a way from the visions before they consumed his mind.

Kalec could also not comprehend why the vision did not shift from this mundane moment to a more significant one. He was both grateful and concerned when Malygos and the other four suddenly finished their feeding and looked to the sky as if hearing something. The next instant, Kalec's host rose into the air and flew north, followed by his companions. Kalec still did not understand what had alerted Malygos and the others and could not fathom anything from the icy-blue male's thoughts except that they needed to head toward Galakrond *now*.

Their surroundings grew chillier as they neared where Tyr had indicated the leviathan slept. Seeing the landscape from such a height, Kalec finally recognized a few points from his own time.

They were far into the most desolate of the young world's northern regions. This was nowhere near where Kalec knew that Galakrond's skeleton lay, and that boded ill for the blue dragon.

With Malygos in the lead, the five descended. Kalec saw no reason for their doing so, unless they feared Galakrond spotting them. Then a familiar form materialized atop a ridge.

The proto-dragons alighted near Tyr, who seemed as tiny as when Malygos had first met him. Yet more than ever, Kalec and his host could sense that what they saw was only a hint of the true Tyr. Kalec recalled the brief glimpse he had had of the massive hammer and wondered at the full extent of Tyr's power. Certainly, all of that power would be needed if the six hoped to defeat Galakrond.

"He still sleeps," Tyr announced, his voice reaching the five despite the wind and distance. "We must strike quickly."

Again, there was an edge to what he said that made Kalec suspicious that the proto-dragons were not being told everything. Malygos caught that edge, too, but did not outwardly reveal anything. Still, Kalec was relieved that his host knew to be wary.

"Now," Tyr continued, his countenance darkening further. "This is what I—"

At that point, the vision shifted. Here, when matters most concerned Kalec, the artifact betrayed him in a new way. He now found himself soaring over another bleak region, surely only moments away from confronting their monstrous foe.

The overcast sky combined with the descending sun to create a greater gloom over the already inhospitable landscape. However, from a valley just to the northeast, there came a faint, deathly white glow, as if another sun or one of the moons nestled there.

That Malygos banked toward it barely a breath later did not at all surprise Kalec. The blue dragon's suspicions about Tyr holding something back were verified.

Out of the corner of Malygos's eye, Kalec saw the other four spread out. Whatever plan Tyr had explained to the proto-dragons remained ambiguous. There was something about a succession of attacks at the proper signal and then Tyr acting. The vagueness of it infuriated Kalec.

The vision shifted again—or did *not*. There was a brief blackness; then all was as if nothing had occurred and no time had passed. Kalec, still attempting to digest what had happened, also noticed a haziness around everything. Definition returned a second later, yet the memory of what had taken place remained with the blue dragon.

This is wrong. . . . Kalec could only guess that something had gone awry with the artifact. He had to assume that it was through Jaina's efforts to enter the Nexus; if not that, then degradation had spread through the relic by other means.

Whichever the case, if it continued, it threatened to take Kalec's mind with it.

The vision lost some definition again but corrected. The deathly glow increased as Malygos neared.

And then Kalec and his host beheld Galakrond.

Bigger . . . he's grown bigger yet. The blue dragon could not believe the size of the malevolent proto-dragon. Galakrond had to be half again his previous size. He filled up much of the area below.

Malygos's thoughts momentarily turned to distrust in Tyr. This was surely what their supposed comrade had kept from them. It made some sense; Tyr might have been concerned that his chosen champions would have been more reluctant to do battle if they knew that their adversary had become more dangerous than before.

But while Malygos's focus did not go beyond Galakrond's growth, the blue dragon studied the glow. There was more to it than merely

increasing the behemoth's size. Galakrond was going through another transformation, one that, if completed, Kalec feared would make the insidious creature impossible to destroy.

Had it been his choice, Kalec would have had Malygos retreat until they could better identify just what sort of overall change was taking place. However, Malygos, no doubt acting on Tyr's plan despite misgivings, dived toward Galakrond and looked ready to assault the gigantic proto-dragon's head.

Galakrond's breathing was low, rhythmic. He was deep, deep asleep, perhaps more so because of the transformation. Every extra eye that Malygos's view took in was shut tight. The various limbs dangling from the body hung as if dead. Kalec could see why Tyr would recommend attacking while Galakrond looked so defenseless, but he doubted that it would be that simple.

Whether or not it would be simple, Malygos chose that second to strike.

The frost battered the eyelid of the injured orb. Malygos exhaled with a fury Kalec had thus far not witnessed. The eyelid pressed in, and Kalec could not imagine that it did not hurt Galakrond.

The misshapen leviathan roared as he awoke. His wings spread, shattering rock formations on both sides. His tail whipped back and forth, leaving similar devastation in its wake.

"Llllitttllle mmmmorrrsssellll!" Galakrond spoke as if time itself had slowed down for him. Yet he moved with incredible swiftness, his head darting skyward as he attempted to snap Malygos up—and almost succeeded. "Baaaadddd llllittle morsel!"

Taking to the air, Galakrond pursued Kalec's host. The huge jaws once more sought to close on the icy-blue male—

Neltharion landed on the snout, his hind paws hitting with such force that, as mighty as he was, Galakrond could not prevent his mouth from shutting hard.

Alexstrasza and Nozdormu assaulted his two true eyes, forcing the behemoth to close them again.

Ysera . . . where is Ysera? Malygos thought then. Only at that point did Kalec understand that the yellowish female should have been the next to add her strength.

A shadow loomed before Galakrond, a shadow that could hardly have been that of the smaller Ysera.

And a shadow that, as it shifted, revealed that it could not possibly be cast by any four-legged creature, much less a proto-dragon.

A tremendous force battered Galakrond's jaw, causing the monster's head to jerk to the side. That force, Kalec saw with no surprise, came from a huge hammer.

Tyr—the true Tyr—stood revealed before the proto-dragons and Kalec and dived directly and eagerly into battle.

Kalec could not judge Tyr's exact height, but the lunging warrior had to be nearly as tall as Galakrond's shoulder. Yet that was perhaps the least of revelations, for in entering battle, Tyr had tossed away his obscuring cloak and was revealed as he truly was. The crimson tunic that crossed over from the right side of his waist up to his opposing shoulder left clear much of a muscled torso that belied Tyr's previous use of magic. A spellcaster he might be, but the keeper was hardly one who shied away from physical threats.

Tyr wore no armor except shin guards and seemed unconcerned at charging unprotected against his scaled foe. A band with diamond patterns wrapped around his right arm above the elbow, and behind him flowed a lesser cloak of the same coloring as his tunic and connected at the neck by a high, pointed collar. The cloak moved as if of its own accord, seeming like an extra appendage as Tyr positioned himself to strike again.

But as Tyr swung his hammer, Kalec briefly forgot the struggle as an object still attached to the keeper's thick belt dangled. The

artifact's simple presence seemed to mock the unseen blue dragon. It glittered despite the lack of bright sunlight, and Kalec could swear that it was conscious of every critical moment.

Then Tyr hit Galakrond, this time battering the other side of the proto-dragon's huge jaws. Galakrond tumbled back, crashing into a mountainside to his right and sending a tremor through the vicinity.

"Now!" Tyr shouted.

Neltharion landed on the mountainside against which Galakrond had crashed. The charcoal-gray male stomped hard against the peak, sending a shock wave through it several times stronger than even the leviathan's collision. A tremendous rockslide rained on the monstrous proto-dragon.

Even as the rocks tumbled down on Galakrond, Tyr brought up his hammer. However, instead of battering his adversary, the gigantic warrior hit the ground right before Galakrond.

Assaulted by yet another tremor, the malformed behemoth sprawled. Galakrond tried to use his enormous wings to push himself upright, but the new tremor caused him to slip back.

Barely had Neltharion pulled away when Alexstrasza reentered. Flames shot dangerously near Galakrond's true eyes, causing him to shut them instinctively.

Kalec expected the other eyes to make up for that but then saw that the incessant rockslide had also forced most of them shut. Tyr had Malygos and his friends working a very coordinated attack against Galakrond. Not for one second was the fiend allowed respite.

However, even though victory appeared to be leaning toward the defenders, one thing continued to very much disturb the blue dragon. The glow had not faded in the least; it had actually magnified since Galakrond had been attacked.

Malygos joined in. Kalec barely had time to comprehend what was happening before his host exhaled at Galakrond's exposed maw.

The frost left Galakrond gasping, but as Malygos pulled away, Kalec sensed something his host did not. The power radiating around the gargantuan proto-dragon was increasing.

Galakrond expanded.

The abrupt escalation in size sent Malygos scurrying away even faster. Neltharion, just diving in again, quickly veered off.

With a tremendous roar, Galakrond righted himself.

Tyr's hammer slammed into his jaw—and bounced back without making the monster so much as flinch. Every eye on the disfigured proto-dragon now glittered furiously.

The vast wings flapped once. Funneled by the curve of the landscape, the gust they created threw the smaller proto-dragons and also Tyr in every direction.

With another beat, the wings lifted the incredibly huge beast high above the ground. As that happened, it became apparent that Galakrond had increased in dimension and had become more distorted. His head was longer and thinner, and his snout stretched half again the length of that of any normal proto-dragon. His sharp teeth were wickedly curved, so much so that they greatly protruded whenever he clamped his jaws shut.

And not only did more growths seem to be spreading across Galakrond's hulking form, but his skin also had a crustier, drier finish to it, almost as if he had become an undead like so many of his victims. Yet one only had to look at the fearsome hunger radiating from every eye to see that Galakrond lived . . . and lived for one thing.

He paid no mind to Tyr, instead seeking the nearest of the smaller proto-dragons. That proved to be Malygos. As he lunged for his prey, Galakrond exhaled.

Try as he might, Malygos could not escape the noxious cloud. It draped over him, instantly sapping his strength and will. Kalec felt

his host's mind grow disoriented, despite Malygos's attempts to fight the effect. The blue dragon struggled to do something, already well aware that his efforts would come to nothing.

Galakrond loomed over Malygos. To his credit, the smaller proto-dragon forced his wings to flap, gaining him a few precious seconds . . . but no escape.

A gray streak collided with Galakrond at the monster's throat, Neltharion coming to the aid of his friend. The daring proto-dragon landed hind paws first against the hard hide.

Although Neltharion clearly hit with at least as much effort as in the past, the effect of his collision was markedly less than before. However, it was just enough to turn Galakrond's head from Malygos as the behemoth tried to snap up the icy-blue male.

No sooner had he struck than Neltharion raced away. It startled Kalec that the other proto-dragon did not try to reach Malygos, but then two pairs of hind paws seized the blue dragon's host and dragged him from the foul mist.

As fresh air filled Malygos's lungs, the proto-dragon looked up. Alexstrasza and Nozdormu, inhaling with as much relief as Kalec's host, held on to Malygos until he had recovered enough. Only then did Kalec understand that they and Neltharion had all held their breath for as long as they could during their effort to save their comrade. In assaulting Galakrond, Neltharion had expended much of what little air he had retained, which was why he had been unable to aid Malygos.

"Ysera!" Alexstrasza abruptly called, turning from the two males. Nozdormu let out a low hiss of anger as he and Malygos followed with their gazes the suddenly racing Alexstrasza's intended path, which led back to none other than Galakrond.

And there, a determined Ysera hovered directly before the leviathan, who regarded her as Kalec did, as if she was truly mad.

In Galakrond's case, though, a growing sense of amusement took command, and he grinned as she neared.

"A tiny morsel you are," he rumbled. "Maybe I should let you grow a little fuller, a little stronger—"

"I am strong!" Ysera roared. "You are not!"

Her incredible remark made Galakrond laugh.

Ysera dived for the open mouth, only to have Alexstrasza seize her tail in her jaws and pull as hard as she could. Ysera came up short, just missing being swallowed when Galakrond instinctively shut his maw.

He laughed again at Ysera and her futile attempts to pull free of her sister's tight hold.

Tyr's hammer silenced the laugh with a blow so hard that even Galakrond as he was now could not stand against it. The enormous proto-dragon spun away from the powerful hit, several bits of scale flying from the damaged spot. The keeper, who had leapt an incredible height to reach his target, seized Galakrond's shoulder and, with the sudden shift in mass, brought his hideous adversary back to the ground.

Even then, Tyr did not let up. Releasing his grip, he followed the hammer strike with his fist, bringing it up under Galakrond's jaw.

The massive proto-dragon's head snapped up from the force. Tyr threw himself into his foe's exposed chest, shoving the hammer toward Galakrond's unprotected throat.

Galakrond blocked the blow with his paw. The move caught Tyr off-guard, and with good reason, for with a normal proto-dragon, the forelimb would have been too short for Galakrond to have been able to defend himself. Now, though, his distorted shape worked to his advantage. Indeed, Kalec saw similarities to true dragons.

Yet, just like Tyr and Malygos, Kalec could not recall Galakrond having such longer limbs only moments before. Through his host,

Kalec observed the monster and saw Galakrond's shape alter slightly. The tail stretched, and the wings took on a sharper cut to their outline.

Even in the midst of pitched battle, the forces within Galakrond were continuing to transform him.

The tail came around and circled Tyr's left leg. Tyr brought the hammer down, but the tail retreated.

Galakrond exhaled on the keeper.

But Tyr appeared ready for such an attack even then. He drove his fist into Galakrond's throat.

Hacking, the proto-dragon stumbled back. Simultaneously, Malygos and his companions flew in to aid Tyr.

Galakrond took to the air again. Tyr seized one wing, hanging as the fiend rose swifter than the smaller proto-dragons. Once again, he brought his hammer into play, landing a heavy blow against the side of Galakrond's skull.

The hammer bounced back with such force that Tyr could not maintain his grip. Galakrond, utterly unfazed and glowing brighter than ever, twisted in the air. The wide wings sent Nozdormu and Neltharion fluttering back in order to avoid being hit. Tyr, trying to retrieve his weapon before it flew beyond recovery, almost lost his hold on Galakrond.

Already aware that Tyr would not reach the hammer in time, Malygos raced after it. As he did, another flying object caught Kalec's attention.

The artifact, somehow torn free from Tyr's belt, spiraled through the air.

Tyr, still clutching the wing, evidently also noticed the loss. With his hammer obviously beyond retrieval, the keeper sought not to lose the relic, too. His hand closed on it, just as both artifact and appendage came within range of Galakrond's teeth.

Tyr's scream echoed through the land. His grip on the wing vanished. He dropped from Galakrond.

Forgetting the hammer, Malygos lunged for Tyr. He caught the bleeding keeper by the shoulder, grunting as he discovered just how heavy Tyr was. The keeper's descent slowed but did not stop.

It was Ysera who helped him prevent Tyr from slipping free. Hissing from effort, the smaller female proved hardy enough to enable Malygos to guide all three of them to a ridge. Alexstrasza followed close behind.

Both Kalec and his host expected Galakrond to be right on their tails, but instead, the misshapen monster hovered in the sky, glowing more ominously than ever. He also appeared to still be growing.

There was no sign of Nozdormu and Neltharion. Malygos looked to Tyr, who had been the proto-dragons' guide in trying to destroy Galakrond. Tyr's entire hand had been bitten off, and blood drenched not only the stump but also much of the rest of his body.

Galakrond roared again, his thundering tone filled with disdain for the tiny creatures that sought to put an end to his glorious ascension. Malygos glanced from the badly wounded Tyr to the colossal beast, and his thoughts of dread at the imminent fate of himself and his world touched Kalec's mind.

Kalec knew that Azeroth should survive, but watching Galakrond fill the sky with his awful presence made the blue dragon doubt the very future of which he already no longer felt a part. Moreover, with Tyr's life ebbing away and the artifact now lost to the behemoth's insatiable appetite, Kalec saw no future for himself. He and Malygos would perish with the rest of the proto-dragons.

And as if to testify to the certainty of that dire fate, Galakrond continued to grow and change. . . .

PART V

PART IV

ONE
İNTO THE NEXUS

Sweat dripped over Jaina's face as she continued to focus on her spell. The Nexus pulsated, the outer wards now visible even to a non-spellcaster, not that there were any nearby. The archmage felt the resistance to her work pushing back, but she countered it as best she could.

And then . . . all opposition to Jaina's efforts evaporated. The wards returned to their original states. The Nexus ceased glowing.

Without hesitation, Jaina transported herself inside.

To her surprise, the chamber in which she materialized looked untouched by all her efforts outside. Pushing that fact aside, the archmage used her powers to seek out any unseen threat still lurking throughout the sanctum. Finding none, she sent herself to where she last recalled Kalec being.

He was not in sight. Panic arose, but as she peered over her shoulder, Jaina found Kalec's prone form lying on the other side of the chamber. From what she could determine, he looked as if he had crawled there.

Even as she thought that, Kalec's left arm moved. His fingers scratched at the floor, and to her further dismay, Jaina saw that those fingers ended in the claws of a dragon. In fact, as she neared him, the spellcaster saw other distorted features.

Stepping next to Kalec, Jaina almost slipped. The floor around him was slippery with his sweat. In addition to his altered state, he also appeared more emaciated.

With growing fury, she turned her attention to the relic. It sat slowly pulsating, hardly radiating any noticeable magical emanations, and to her practiced eye seemed perfectly harmless.

Her personal protective spells strengthened, Jaina surveyed the object. While on one hand the archmage could appreciate the elements of its creation, on the other she despised it for what it was doing to her Kalec. With that last sentiment firmly entrenched in her heart and mind, Jaina formed the reversed symbol and sent it flying toward the artifact.

But as the icon touched it, the relic shimmered. Its energy reached through the link Jaina had to maintain with the symbol and caught the archmage square before she could dismiss the spell.

Jaina's world turned upside down. That was followed by utter darkness and then a babble of voices with a particularly reptilian hint to them. And that was followed by a mad array of images, including creatures she recognized as proto-dragons. In the midst of those, Jaina realized that *she* was a proto-dragon herself—and one whom she knew, albeit in a far altered form.

Alexstrasza? I'm part of Alexstrasza?

It was a very young Alexstrasza, an Alexstrasza whom Jaina had never really known existed. Through Alexstrasza's eyes, she saw other proto-dragons whom she vaguely recognized but would not have specifically known if not for her host. She saw Ysera (a shockingly small Ysera), Nozdormu, Neltharion—*Neltharion!*—and Malygos.

Each of the scenes lasted barely a breath, and many appeared to Jaina to be out of sequence. Most made no sense, and more than a few filled her with dread. The archmage saw horrific, rotting proto-dragons that were surely undead. She saw the wasted corpses of others. Most daunting to Jaina was the monstrous reality that was Galakrond, and she felt Alexstrasza's chilling dismay as if it were her own.

It was all too much. Jaina almost passed out under the strain.

At the last moment, she imagined the reversed symbol and tried to impose it on every image that confronted her.

With a gasp, the archmage discovered herself stumbling back from the artifact. If not for her protective spells, Jaina would have fallen and likely cracked open her skull. As it was, she had to plant herself quickly against the nearest wall and stand there for more than a minute as she fought the residues of vertigo.

The voices still echoing in her head, Jaina looked from the relic to Kalec. She had some notion of what he was going through, but suspected that her experience had been only a fraction of what the blue dragon was caught up in.

The moment that Jaina felt able to, she returned to Kalec. With gentle hands, she turned his face to her. Up close, his condition was worse than she imagined. He reminded her of how it had been said some of the more severe victims of the Emerald Nightmare had appeared, when thousands had fallen to the power of the Nightmare Lord and his master. They had lain helpless, unable to wake from their tormented sleep even as their minds began to waste away.

Jaina shuddered. *She* had been one of those victims—one of the earliest, in fact—but until now, the extent of her condition had not truly registered with her. That, in turn, only magnified her current fear for Kalec.

He mumbled. Jaina leaned close.

His eyes opened wide—eyes that were pure dragon, not those he had when wearing this form. The archmage pulled back in surprise.

A frosty exhalation enshrouded her.

Had she not protected herself, it was very likely she would have died. Even despite her spells, the archmage could feel the intense cold. Yet this was not the breath weapon that she knew Kalec used. Rather, from the fragmented vision that she had experienced, Jaina realized that Kalec had acted as young Malygos had.

Kalec settled down again. Jaina cautiously touched his cheek, then his throat. What he was currently experiencing in the vision, she did not know, but his blood raced.

Casting a spell, the archmage searched for the link between the artifact and Kalec, only to find no trace. She had been certain that she could locate some connection and take steps to sever it.

That forced her focus back to the artifact. Moving more warily, Jaina inspected every visible side. She neither saw nor detected anything new. However, as she started to pay attention to the aura surrounding it, the archmage noticed something about the pulsations.

Jaina quickly returned to Kalec and felt his pulse. This time, though, the spellcaster simultaneously turned her gaze to the relic.

The pulsations matched the throbbing in Kalec's throat. The artifact had become attuned to his life . . . or perhaps had attuned him to its spellwork.

In either case, Jaina Proudmoore had a plan. With it, she believed that she could finally free Kalec from the artifact's overwhelming influence.

There remained but one flaw with her plan, a flaw that made Jaina hesitate to commit to it even as Kalec began mumbling again. Yes, she could very well free him, but it was just as likely that her attempt would also end in his painful death.

Kalec renewed clawing the floor. His claws tore valleys in the hard surface.

Gritting her teeth, the archmage saw that she had no choice. She immediately began casting.

Casting and praying . . .

Malygos tore his gaze from the ever-swelling Galakrond and concentrated on Tyr. As Tyr lay there, the proto-dragons' ally had at some point shrunken down to nearly the size he'd been when Malygos had first seen him. A desperate notion ran through

Malygos's mind, a notion that seemed desperate even to Kalec. Yet the dragon agreed with his host that there was no other recourse.

As he had done with his own wounded leg, Malygos exhaled on Tyr's ruined limb.

The stump froze. The blood ceased flowing. Tyr let out a moan but otherwise seemed to calm.

"Must take him away," Ysera declared as she joined him.

"Where?" The shadowed region in which the survivors hid appeared to be the most logical conclusion, but if Galakrond followed the scent of Tyr's blood, then Malygos might end up betraying the ragged refugees. He could not bring himself to do that, and from what he had seen of Tyr, he doubted the two-legged being would have wanted such a sacrifice on his behalf.

"Must take him away," the yellowish female repeated. Shrugging, she added, "We find somewhere! Just far from Galakrond."

Kalec's host glanced up at their monstrous foe. At the moment, Galakrond appeared lost in his latest transformation, but whether that stupor would last a few more seconds or keep on for longer was impossible to say. The fact that Galakrond continued to hover as this happened made Malygos believe that they did not have much time at all.

Without waiting for Ysera to help him, Malygos seized hold of Tyr by his shoulders and took to the sky. Instinct drove him toward the most desolate region he could think of beyond the place where they were already. He only hoped it would be desolate enough and that Galakrond's condition would give them the time they needed.

Looking over his shoulder, Malygos saw a proto-dragon coming up behind him. Instead of Ysera, it proved to be Alexstrasza. With her hind paws, she seized Tyr's legs. The weight better distributed, the icy-blue male and Alexstrasza were able to pick up the pace. They matched wing beats as they flew, the coordination further adding to their speed.

Daring to glance back again, Malygos became both more relieved and apprehensive. Relieved because not only did Ysera follow, but also, at a greater distance, followed Neltharion and Nozdormu. Apprehensive because Galakrond had grown yet again and changed form somewhat. His body was now bulkier, and jagged spikes dotted the upper part of his torso. And although he continued to hover, he looked finally to be stirring.

Alexstrasza, too, had been peering back at Galakrond. "Fly faster," she suddenly suggested to Malygos. "Lower. Galakrond will not see us so soon."

The icy-blue male nodded—

And the vision shifted.

The cold, stark landscape startled Kalec, for at first, he thought he was back in his own era. The high peaks, the desolate, flat plains beyond—he knew this place.

They were in what would someday be the Dragonblight.

Malygos and Alexstrasza still held on to Tyr, but now they descended. A choice had been made, but why it was this particular location was not clear in Malygos's thoughts. Kalec assumed that they had simply chosen somewhere they hoped would not be readily discovered by Galakrond.

With extreme care, the pair set Tyr on the chilly ground, then alighted next to him. Malygos peered around as if expecting something, but even Kalec's host did not seem to know just what he sought. Alexstrasza looked to Malygos, as did the rest once they landed.

"Here?" Neltharion finally growled. "No good hunting. Grazers far from here. Some good hiding in mountains, but too open here."

"Here," the icy-blue male replied with a certainty that did not match the knowledge Kalec could glean from his host's mind. Malygos simply knew that he had to come to this place.

Nozdormu looked satisfied with the vague answer but then asked, "What now?"

Malygos looked south, deeper into the flat, stark plains that made up much of the Dragonblight. "That way."

He started off, only to have Ysera block his path. With a puzzled expression, she gestured with her snout behind Malygos. "What about Tyr?"

Kalec's host glanced back. Both he and the blue dragon had somehow forgotten the keeper's presence. While Malygos took this in stride, Kalec wondered at the proto-dragon's memory lapse. It was too sudden.

Fluttering off the ground, Malygos took gentle hold of Tyr again. As far as Kalec could tell, Tyr looked no worse than before, but whether that was good or bad was impossible for the blue dragon to say. He knew only that the proto-dragons had to do more for Tyr very soon.

But what? Kalec wondered. Had it been he to decide, he would have figured out a magic spell to preserve Tyr until some method of healing could be found, but the proto-dragons did not have any ability to do even that.

Magic. . . . Now Kalec felt as if *he* had forgotten something else that was vital, something having to do with his own existence.

Something to do with . . . the *Nexus*?

Malygos chose that moment to descend again. Focusing on the landscape below, Kalec at first did not see anything other than more icy ground. Then a slightly darker spot caught his attention. As Malygos drew nearer, Kalec realized that the dark spot was a frozen lake. The blue dragon could not remember such a spot in his time, but he knew that his memory was faultier than he had originally thought.

Landing on the edge of the lake, Malygos again set Tyr down,

this time placing the keeper on his back. That allowed Kalec to study the prone form. Tyr's breathing looked shallow but regular, and the stump was still protected by the frost Malygos had previously sprayed over it. The proto-dragon carefully exhaled on the savage wound again, reinforcing his earlier efforts. Yet, doubts about Tyr's survival once more began to creep into the mind of Kalec's host, doubts the blue dragon shared.

Despite that, Malygos abruptly abandoned Tyr for the frozen lake. Neltharion and the others joined him, the four looking oddly breathless as they landed.

"So fast!" Neltharion finally managed after taking a couple of big gulps of air. "Malygos flew so fast!"

"Should have waited for us," Alexstrasza reprimanded him. "Saw a not-living far that way." She indicated the west. "Maybe others near. . . . If they see us, Galakrond sees us. . . ."

Malygos saw nothing in that direction, and to Kalec he seemed not inclined to be concerned despite Alexstrasza's sensible words. Again, it was not Malygos as Kalec had come to know him.

The icy-blue male continued to the frozen lake. As he peered down into it, he and Kalec saw some slight movement in the water. That his host was hungry Kalec could understand, but Malygos bordered on the obsessive.

In fact, Kalec's host was persistent in pushing the other four to join him. "Come! Must eat! Strength needed!"

Neltharion obeyed without question, his appetite always the greatest of the five. Nozdormu looked dubious, then nodded. Ysera quietly followed the three.

Only Alexstrasza did not move. "What of Tyr?"

"He sleeps," the icy-blue male responded. "Let him."

The answer was not said with coldness but with practicality. Alexstrasza considered the suggestion, then finally nodded and

joined the four. Kalec would have preferred that someone watched Tyr, but now all five of the proto-dragons were eager to feed.

The ice supported not only Malygos's weight but also that of the rest of the group. Nozdormu scratched at the ice but, despite his sharp claws, made little headway. Neltharion looked ready to stomp on the frozen surface—which would have no doubt shattered all the ice, including where the five stood—but Alexstrasza quickly hissed and shook her head.

With the others watching, she chose a spot a little farther into the lake, then carefully exhaled. The concentrated flame melted a hole into the thick ice until water bubbled up to the top. She expanded the hole until it was a satisfactory width.

Although Alexstrasza had created the hole, she let Neltharion feed first. He eagerly leaned over it, then suddenly thrust his head down.

The charcoal-gray male withdrew, a thick fish in his mouth. Grunting with satisfaction, he stepped back.

Alexstrasza went next, her task taking slightly longer before she caught sight of her prey.

Malygos finally took his turn. He had barely leaned over when another fat fish swam into range. Catching it was as simple a task for Kalec's host as it had been for the others.

As the icy-blue male backed away, Ysera moved toward the hole. Malygos turned to the shore, his catch still wriggling in his jaws. Once off the ice, the proto-dragon surveyed the chilly landscape. There was no sign of either Galakrond or any of the undead. Malygos focused his attention on the fish, tearing into it with such gusto that Kalec wished his host would shut his eyes so that the blue dragon would not have to watch.

Trying to concentrate on anything else, Kalec shifted his thoughts to Tyr. That the proto-dragons had left the keeper in order to eat

was not entirely a surprise, but they needed to find other aid for Tyr as soon as possible. Kalec wondered where the other keepers were. Did they not sense Tyr's urgent situation? The blue dragon had thought that they would have some kind of link with one another, something that would—

A ragged hiss arose from Malygos's right. Both Kalec and his host recognized the foul sound.

How the two emaciated proto-dragons had snuck up on the party, neither Malygos nor Kalec knew. There was no time to consider that, either, for one of the undead lunged for Malygos, its yellowed teeth dripping with a sickening green fluid that surely boded ill if it even touched the living proto-dragon.

Spinning to the side, Malygos brought his tail around. Like a whip, it caught the undead's hind leg. Malygos pulled just as what passed for the brain of the monster registered the attack.

The cadaverous proto-dragon fell onto its side. However, Malygos's tail briefly became tangled with the fiend, leaving Kalec's host vulnerable to the second undead.

But a hard column of sand struck the creature, sending it flying. As it landed, a plume of flame draped over it. The dry flesh ignited.

Despite that, the burning undead rose. So, too, did the first.

Freeing his tail, Malygos swung in the opposite direction. This time, he knocked the first corpse toward the lake.

While Kalec's host had not done so with any other intention than to bowl his foe over, the sprawling undead landed just in front of Ysera. Adapting quickly, the smaller female used her tail to help the monster continue its slide—but in one particular direction.

The struggling corpse plunged into the hole in the ice. It clawed the edges, seeking some hold.

With the lightest tap of his hind paw, Neltharion made the ice shake. It was enough to put an end to what little hold the undead had.

The shriveled proto-dragon vanished below. Through Malygos, Kalec caught a glimpse of the thing flowing away from the gap before sinking into the frozen depths.

The other undead, entirely oblivious to the fire raging over its body, trudged toward Alexstrasza. Before she could exhale, Nozdormu unleashed another column of sand.

The column hit squarely. Combined with the damage already inflicted by the flames, the sand shattered the creature, sending sizzling fragments all over the area. Some of those continued to move for several moments after landing, then gradually stilled.

Moving out onto the ice, Malygos stared into the frozen lake. After a few seconds, he spotted the first undead. The creature once again moved toward the surface, still searching for a path out.

Heading to the hole, Kalec's host exhaled on the opening. It took little effort to freeze the already sluggish liquid. The proto-dragon stepped back. Even if the undead did reach the hole, it would find no exit now.

Malygos returned to the others. Neltharion was in the process of prodding various bits of burnt cadaver in order to assure himself that nothing remained animated. Nozdormu had once more started on his fish, and Alexstrasza was staring at the distant mountains, her expression thoughtful. Only Ysera paid attention to Malygos as he returned.

Kalec's host eyed the remnants of the one creature. Something bothered him, but the proto-dragon did not know what. That stirred a similar concern in Kalec, who felt that he had also missed something earlier.

The icy-blue male's head snapped up. He whirled to where he had left Tyr.

The body was gone. Only a few faint specks of blood decorated the impression Tyr's form had made.

Leaping past the others, Malygos searched in every direction. Yet

no matter where he looked, there was no trace, not even the least of trails.

"Gone," Ysera murmured to him. "Gone."

"Where? How?"

She shrugged.

The others had finally taken notice of the situation. They joined in a quick search, Neltharion even darting over the frozen lake, but all to no avail.

"Lost. Tyr lost," Malygos snarled, angrier with himself than with anyone else. He considered Tyr his to protect.

But while the proto-dragons continued what they obviously considered a fruitless hunt for the missing Tyr, Kalec, his only recourse to think, finally realized what had bothered him. When Malygos had turned toward the shore, fish in his mouth, his gaze had passed where Tyr had been set down.

The only problem, Kalec now realized, was that Tyr had *already* vanished by then.

Something had taken the keeper . . . something that Kalec could not help but think had done so with a purpose other than to eat. . . .

TWO
UNDER GALAKROND'S EYE

"What now?" Neltharion asked. "What now?"

Malygos gave it strong consideration, his mind darting over a number of choices with a clarity that impressed Kalec.

However, it was Alexstrasza who answered first, firmly stating what Malygos had also concluded. "We must fight."

There were no protests, no refusals. Both Malygos and Kalec were pleased by how quickly the rest agreed with her suggestion, and Kalec began to remember the leadership role that Alexstrasza had assumed as one of the five Great Aspects. His host also appeared relieved that some of the responsibility for their chances had been taken up by another. Even Ysera did not argue with the decision, although judging from her expression, she appeared to have doubts about something. Kalec guessed it had to do with her own strength. While she was very determined, she showed signs of not having recovered nearly as much as her companions, despite the meal.

His host vaguely noticed the same but said nothing. Meanwhile, the others awaited Malygos's word on their course. His thoughts were still of import to them, he, after all, having been the one first picked for contact by Tyr. Malygos had been more than happy to turn to Tyr when the odd being had appeared. Tyr had looked so clever, so confident, and despite appearing smaller, he radiated a power far exceeding any individual proto-dragon's.

Tyr was nowhere to be found, though, and there was no sign of what had taken him or in which direction they had gone. To a

creature such as a proto-dragon, the most logical conclusion was that a beast had taken the body and even now was feasting on Tyr.

And that left facing Galakrond to the five, with Malygos obviously seen by the others as one of the party's more clever planners.

Kalec understood all that passed through the icy-blue male's mind, but he had additional considerations. More than ever, he was certain that something with a more intelligent purpose had stolen Tyr away. Yet that availed Malygos and the rest of the proto-dragons nothing—

Neltharion let out a warning hiss. The five immediately crouched low.

Near the mountains, three figures slowly flew northeast. There was something in their movements that did not indicate the fluidity with which proto-dragons soared through the sky. Although they were fast, these flew with halting, almost haphazard motions.

"Not-living," Nozdormu muttered.

The three forms vanished among the peaks. Malygos hissed. He had noticed something that even Kalec had not seen at first. "Fly too smart. Not like others. Search too good. Not-living do not think. They eat. Only eat."

Neltharion looked puzzled, but the other three understood what Malygos meant. So did Kalec. The animated corpses had acted with intelligence, something they entirely lacked.

"Galakrond is their master," Alexstrasza blurted. "They hunt what he hunts."

Malygos finished the thought. "And he hunts us. You said before. The not-living. They see us . . . Galakrond sees us."

It was probably not quite so clear-cut as that, but Kalec, too, had no doubt that if the undead located them, Galakrond would find out. The behemoth evidently *did* have control over his emaciated victims. Indeed, it was surprising that, with two of them having just battled the defenders, Galakrond had not already appeared.

Studying the land again, Malygos focused on the mountains. "We go there."

Their gazes followed the direction in which he pointed his snout. The undead had only passed beyond that region a minute before.

"They search there," Alexstrasza reminded Malygos.

He shook his head. "No . . . they searched there *before*."

There was logic to Malygos's thinking but not enough that Kalec would have readily agreed to such a course. However, Malygos's comrades were more amenable, nodding and following as the icy-blue male took off. Kalec was pleased to see that Malygos at least kept low to the ground, the choice in altitude more likely to keep the proto-dragons from being easily seen.

They reached the mountains quickly, but not quickly enough for Malygos or Kalec. Kalec's host slipped in among the sharp peaks, seeking cover wherever possible and watching for undead that might have done the same at Galakrond's direction.

Turn here.

Malygos did so instinctively before both he and Kalec wondered just who or what had told him to. It had not been a voice that his ears could hear, but his mind could.

Confused, the proto-dragon pulled up short. Neltharion almost collided with him. The five hovered as Malygos all but spun in search of the speaker.

But instead of finding that, he found Galakrond.

His shadow covered the narrow pass through which they flew. The smaller proto-dragons instantly separated, heading to whatever overhang or other cover they could locate. It was not that any sought to abandon the others; they knew that their only chance was for them to scatter. There was not enough protection in any one direction for all five.

The shadow spread everywhere. Yet it was nothing compared with the first glimpse of Galakrond's immense body hovering over

the area. The huge proto-dragon kept passing above without end, so great had he grown.

Malygos waited for Galakrond to completely pass—only to see the misshapen leviathan pause. One huge hind paw, large enough to grab at least three of them whole, came crashing down on a peak. A landslide commenced, tons of rock spilling down where Malygos knew that Alexstrasza and Nozdormu had taken different hiding places.

The deadly downpour continued. It had not been done out of intention; Galakrond was just that heavy. Another landslide rumbled in the distance, where, no doubt, his other hind paw had settled.

With somewhat ponderous movements, Galakrond shifted position. That resulted in additional collapses but nothing that threatened as much as the previous. A smaller forepaw—smaller only in comparison with the hind paws—came into view. Galakrond was backing up, possibly to search in the very region where they hid.

Worse, even without yet bringing his head back, Galakrond had already inspected the vicinity, the extra eyes eagerly darting here and there. Malygos pressed harder against the rocks, certain more than once that he was spotted. Yet Galakrond did not leap back and thrust his head down in order to devour him. Instead, the savage behemoth shifted around so that his forepaw became more evident, and then he moved forward again.

The new landslides that action brought about were a small threat compared with not only the first but also what would have happened had Galakrond seen any of them. As the gargantuan proto-dragon's tail finally vanished over one peak, Malygos exhaled in the relief that both he and Kalec felt.

The mountains around them shook.

Scarcely a breath later, Galakrond's head thrust over the area. He did not look Malygos's way but stared down in the vicinity where

Malygos remembered Ysera heading. The icy-blue male could not see her, but he was certain that the very shadows at which Galakrond stared most attentively were the ones hiding Alexstrasza's sister.

The misshapen behemoth hissed. A hint of the foul mist he had earlier exhaled drifted from the massive jaws. Fortunately, it proved to be only an aftereffect of his breathing and not a focused assault. Still, Galakrond continued to try to see what lay in the shadows below. He did not glow anymore, a fact that worked to the smaller proto-dragons' favor, as the glow would have been strong enough to illuminate most, if not all, of the shadowed region.

Suddenly, Galakrond began coughing. Within seconds, the coughing grew so intense that Malygos wondered if perhaps they might be saved by Galakrond simply succumbing to whatever afflicted him. That was not to be, though, for after a few thunderous moments, the coughing subsided.

But during that fit, Kalec observed minute changes in Galakrond. Some of the extra appendages and eyes shrank, and a few even shriveled to little more than mottled flesh. Even when the fit ended, those did not revert to how they had been before.

Kalec feared that his host would miss what he now noticed, but soon discovered that he had underestimated Malygos. Suppressing a hiss, Malygos stored the knowledge away as he waited for Galakrond to depart.

After another brief study of the area below, Galakrond finally moved on. However, Malygos did not move for several minutes afterward, nor could he see any of the others shifting position. After the sudden return, none of the five wanted to take the chance that Galakrond might come back.

Finally risking himself, Malygos darted from his hiding place to where he had seen Alexstrasza disappear. The remnants of the landslide at her location at first concerned him greatly. However,

as he neared, she thrust her snout out of the deeper shadows and sniffed the air before fully coming into sight.

"The others?" she asked worriedly, her greatest concern without a doubt for her sister.

Malygos could only shrug. They headed to where Nozdormu had last been seen and where even more rocks buried much of the area. Unlike Alexstrasza, though, Nozdormu sat perched atop the rubble, waiting expectantly for his comrades.

"Hurt?" he asked both. When they shook their heads, he stretched his wings. The left one moved noticeably more slowly than the right. "Pain . . . but only pain."

Despite Nozdormu sounding unperturbed, Kalec could tell that Malygos and Alexstrasza were concerned. A minor injury could still slow Nozdormu at a critical time.

For all of her worry over Nozdormu, Alexstrasza changed the subject to one dearer to her. "Ysera?"

"Here." The yellowish female alighted just behind her sister. "Safe." To Kalec, Ysera sounded slightly annoyed, as if she did not want her sibling to be so fearful for her, despite the dangerous predicament through which they had come.

They waited a moment more before Malygos cautiously asked what was probably on all their minds. "Neltharion?"

None of the others offered news. Malygos hissed. Taking flight, he soared toward the charcoal-gray male's last known location . . . only to pull back abruptly at what he found.

The spot Neltharion had chosen had been hit by far more rubble than any of the other locations. Eyeing it, Malygos could not imagine any hope of survival. Kalec shared his doubt, despite managing to recall that Neltharion *should* survive—to eventually become Deathwing.

Then a faint sound farther on attracted Malygos. Simultaneously,

Alexstrasza and the others alighted next to Kalec's host. They, too, heard the sound.

Scrambling over the rocks, Malygos discovered that the overhang the charcoal-gray male had rushed to extended farther than first assumed. While that offered hope, the fact that part of the overhang had also collapsed under the weight of the avalanches did not. Neltharion might still be alive, but what condition was he in?

The sound arose again, this time nearly under Malygos's paws. He leapt back, concerned that his weight might be crushing his companion.

Malygos planted his head against the rubble. He heard movement, followed by the intake of breath.

"Here!" With his hind paws, he began excavating the pile. The others took up positions nearby, Alexstrasza helping to shovel away the rocks that Malygos pushed back. Nozdormu moved to help Malygos with his task, only to have Ysera shove her way in front of him. She began digging with earnest. Nozdormu finally joined Alexstrasza in clearing away what had been dug up so that Malygos and Ysera could shovel more from where Neltharion had been buried.

It grew silent below them. That made Malygos dig harder, but to his surprise, Ysera dug harder yet. She moved at a manic pace, and although Kalec's host did not think about it, Kalec understood that she had to be thinking of those Talonixa had buried alive. Ysera did not want Neltharion suffering such a fate, even though a part of Kalec wished that the proto-dragons would leave Neltharion to perish. A future without Deathwing was something generations of creatures on Azeroth would have been very grateful for.

But Malygos and the others worked diligently to rescue one who was their friend. Ysera let out a hiss and used her weaker forepaws to pull a rock away. That revealed part of a wing. It was immediately

evident that Neltharion's wings had been pinned around him, which explained his inability to assist in his own rescue. One thing that had saved him, though, was that the part of the overhang where his head lay had remained intact. Had it collapsed, Neltharion's skull would have been crushed like an egg.

The future Deathwing hacked as he tried to breathe in fresh air, the manner of his near death an irony not lost on Kalec, who knew that Neltharion would somehow become the Aspect of Earth. Still pinned, he had to wait as Malygos and Ysera uncovered the entire wing before he was able to move. Once the wing was free, Neltharion started stretching it, which also enabled him to use one of his forepaws. While weak compared with his hind paws, it was still capable of shoving away more of the rocks keeping him trapped.

As they freed Neltharion, his injuries became more apparent. While, like Nozdormu, he had survived intact, severe bruises covered his body, and blood spattered him in several places. There were some rips in his wings, but a glance by Malygos revealed none that looked as if it would impair the charcoal-gray male's flying.

Neltharion stumbled to his paws. He twisted his neck around and looked up. "Galakrond?"

"Gone," Malygos replied. "For now . . ."

"So powerful," Ysera muttered as she stepped closer. "So powerful! What can we do?"

Her sister did not hesitate. "Fight . . . or die."

Neltharion, his breath recovered, snorted. "Hmmph! Probably die." But immediately, he added, "Better to die fighting, though."

"Better to die fighting, yes," Malygos agreed, eyeing Alexstrasza most of all. "Better to *live* after, though."

"Better, yes," she echoed.

But just how they could do that was a tremendous question.

First and foremost, they had to find another place to hide while they considered how to combat what appeared invincible.

Follow the ridge.

While the thought had eased into Malygos's mind with such subtlety that the proto-dragon did not realize it was not his own, Kalec knew that it had come from elsewhere. He could not identify its source; it did not sound like Tyr, who surely would have identified himself. And if it was another keeper, why would the speaker not say so? Curiously, it reminded Kalec of something, but just what escaped him.

And in truth, he had to admit, it mattered not. Kalec still had no part in this endless vision except as an imprisoned observer. While he railed at that, it was the only existence he knew . . . or, at least, remembered at the moment.

But I have another life! Kalec suddenly insisted to himself. *The—the Nexus and—and—*

There was a name the blue dragon wanted—no, *needed*—to recall. Not his own. He had remembered it only a short time ago. A female name. One Kalec should have known well—and one that more often had been part of his thoughts before these visions had overtaken him.

That realization at last stirred some of those forgotten memories. *Ja—Jalya? Jay—Jaina? Jaina!*

His most immediate recollections returned full-blown. Jaina was possibly trying to enter the Nexus, and if she was, she was in grave danger.

I have to save her! I have to—

The vision abruptly faded. The darkness that Kalec had so often cried out against he now welcomed wholeheartedly, if only it would bring him back to the Nexus.

Something hard lay against him, or, rather, he lay against a hard

surface. Despite being unable to see it, Kalec had to assume that it was the floor of the chamber, and that further encouraged him. He tried to summon enough strength to move some part of his body.

Ka—

He knew that voice, but he wondered again whose it was. *Jaina.* It was Jaina. He had already forgotten. *How can this be? How can I keep forgetting?*

The artifact. Kalec now discovered he had forgotten the accursed relic!

Kalec?

Jaina's voice came clearer but fainter. She repeated his name, but this time, he could barely hear her.

In desperation, Kalec tried to reach out. To his surprise, he felt his nails—claws?—scrape the floor. The act sent shivers through his nerves, but he welcomed that discomfort for the slight sense of reality it gave him. He focused on that and on Jaina, trying to create a more powerful anchor by combining both.

Kalec! Listen to me!

Her voice came stronger again. Simultaneously, the blue dragon managed to scrape the floor a second time. Sensation began to return to his body. He felt the blood flowing through his limbs and torso. What sounded like breathing—whether his own or hers, he could not say—echoed in his ears.

Jaina! Jaina! Kalec cursed his mouth, which still did not function. He had to let her know that he could hear her—

A distant roar drowned out Jaina's voice just as she repeated his name.

The roar shook Kalec, not only because of its suddenness but also because he knew it not as a dragon's but as a *proto-dragon's.*

Jaina! Jai— Kalec hesitated. Did he have the name right? And whose name was it, anyway? A female's, certainly, but the only

females he was familiar with were Alexstrasza and her sister Ysera. Had he tried to call one of them?

The darkness faded . . . and he and Malygos, as it had always been, flew together.

But this time, Kalec knew that things had changed. He could not say how, though. He still existed as some hidden part of Malygos, ever there observing. Kalec didn't know how that had begun; he only knew that he was and would always be linked to his proto-dragon host.

And forgotten completely, at least for now and perhaps always, was a future where a frightened female voice continued to call his name in vain.

Jaina collapsed. Her plan had failed. She had made an ambitious attempt to bind herself to the link between the artifact and Kalec so she could, by matching the pulsations, reach out better to the unconscious dragon. In this manner, the archmage had intended to draw him to her and, thus, back to reality.

But the artifact had proved to have the greater hold on him. For a few moments, Jaina had almost succeeded. However, the bond she had forged had been cut without warning. The relic had corrected for her intrusion, just as it had for a time corrected for her attempts to invade the Nexus in the first place.

And yet . . .

Jaina pushed herself up from the floor, also using that moment to study Kalec. His breathing perfectly coincided with the artifact's pulsations. His body had contorted more, becoming less humanoid but not quite that of a dragon. There were traits growing on him, especially his torso, that did not remind her of any of those she had seen among the various dragonflights, yet they were still vaguely familiar. She *had* seen them before.

Some other creature—what was it? Jaina Proudmoore had studied virtually every major beast during her training. Members of the Kirin Tor had to know the flora and fauna of Azeroth for a variety of reasons, many of them dealing with survival. This one she had definitely seen—

A *proto-dragon?*

It did not seem possible. While she was aware that Kalec could assume more than one form, Jaina had no idea why he would take on that of something akin to a dragon but not nearly so powerful. Still, when she took a closer look, more proto-dragon traits became apparent. Worse, one of Kalec's arms was clearly shorter than it should have been, another change that added to his similarity to the beasts.

Kalec suddenly let out a loud roar, not quite like that of a dragon. As he did, he altered further. His feet became more ponderous, as the hind limbs of proto-dragons were when compared with their forelimbs.

And at the same time, the artifact's pulsations grew more rapid. The relic's aura intensified, and it enveloped Kalec, too.

Jaina reached for him, only to nearly singe her fingertips. There had been no trace of heat from the aura before, but now it burned like fire. Kalec's shifting continued unchecked. His body darkened.

The archmage shielded herself and tried a second time to get to Kalec, only to retreat from even stronger heat. Gasping, Jaina saw also that Kalec's breathing quickened more, ever matching the increase in the artifact's pulsations.

This can't go on long! It can't! Jaina understood all too well that there would come a point where his body could not withstand this mad metamorphosis. A creature of magic he might be, but he still had mortal limitations.

Kalec, although he was a dragon, would literally burn out, and thus far, Jaina had no idea how to save him.

THREE
FIVE AGAINST THE IMPOSSIBLE

Malygos and Kalec followed the ridge just as the voice in the proto-dragon's head had suggested, but if they expected something spectacular or startling at the end, they were both disappointed. Instead, the mountains opened up into a bowl-shaped valley that, for some reason, bothered Kalec. Malygos simply saw it as another destination, one that Galakrond perhaps would not search or already had searched and abandoned.

A stream flowed through the area. The five proto-dragons landed to drink. And think. Never in their lives had they had to think so much. Glancing at the others, Malygos wondered if they felt as worn out as he did.

He blinked. Far beyond the five, a rounded rock drifted where the water widened. Even proto-dragons knew that rocks did not drift, so Malygos fluttered up into the air and flew to the object.

Kalec's host veered back the moment he recognized what it was that lay half-submerged. As Malygos had suspected, it was another proto-dragon body. However, as he finally dared to alight next to it in the stream, he noticed something peculiar.

A splash behind him announced Neltharion's more enthusiastic arrival. Striding up to Malygos, the charcoal-gray male scrutinized the find.

"Dead. Galakrond. We should destroy before it rises."

Malygos shook his head. "Already did. This was not-living that is again dead."

The other proto-dragon let out a snort of disbelief. He prodded the corpse, which, having already been rotting before its second "death," now easily began breaking apart in the water. "How can not-living be not-living again unless we destroy it?"

Kalec, ever paying attention, also wondered. His first inclination was that either another proto-dragon had managed to do as Neltharion suggested, or the undead had, for some reason, simply collapsed. Yet Kalec had seen no evidence of the second occurring, and his host was also disinclined to that answer.

Which only left the question of *who* had indeed destroyed this fiend. Another keeper?

Malygos leaned closer. His sharp sense of smell detected another scent, one that at first he assumed had to be there for a very logical reason. Then, as he eyed the decaying remains, something else about their condition registered. Before, they had looked dry. Now, they were barely holding together. When Malygos did a little prodding of his own, the part not yet touched by the flowing water simply crumbled to ash.

As that happened, the scent—or stench—Kalec's host had smelled increased tenfold.

The source escaped Neltharion's mouth before the other proto-dragon even knew why he spoke the name. "Galakrond!"

"No Galakrond!" Malygos interjected. In a more subdued voice, he added, "Not anymore."

"What do you mean?"

Even Kalec was not sure of Malygos's thoughts at that moment, for what little he could read from them did not make sense. Yet Malygos quickly verified those questionable thoughts. "Galakrond was here. Galakrond . . . devoured this not-living."

Neltharion looked at him as if he were mad. The other three, just joining to see what fascinated the pair so much, had heard Malygos's declaration.

"Galakrond ate this . . . this not-living?" Nozdormu asked in utter puzzlement. "Already ate it alive! Why eat it dead?"

"What's left to eat, then?" asked Alexstrasza, sniffing at the corpse and wrinkling her nose. "Galakrond, yes. Not long ago." The female's eyes narrowed in thought. "Malygos is right."

"But this was dead!" Neltharion insisted. "Long dead! No meat! No life!"

Indeed, there was only the growing odor of rot. However, Malygos smelled a wrongness in that rot, as if something else tied to it also escaped at the same time.

"This lived. This died," he began, seeking to organize his words enough to make sure that everyone—himself included—understood the full extent. "Became not-living. Moves but is dead. Dead but moves."

Kalec was naturally the first one to grasp what Malygos was leading up to. Even as a former Aspect of Magic, Kalec doubted that he would have come to what was the only possible conclusion before his young host had.

Of the other four proto-dragons, it was Ysera who comprehended quickest. "Not-living move. Something moves them. No blood. No life. But something."

"'Not-life'?" Neltharion muttered. "They have 'not-life'?"

The proto-dragons had not lived long in a world full of undead, as Kalec abruptly recalled he had, but they had come to grasp an important point. Still, the animated corpses of Galakrond's victims were not exactly like most of the beings the blue dragon gradually remembered having confronted. What drove these appeared merely to be as Malygos hinted, a force that was perhaps a by-product of Galakrond's absorption of the living creatures' life essence. It was almost a parody of that essence, which made calling it "not-life" very appropriate.

But to go from that step to Galakrond now absorbing *this* essence

was disturbing. *Why?* Kalec asked himself, aware that he echoed Malygos in this regard. *Why?*

Again, it was Kalec's host who discovered the possible reason. Malygos raised his head and looked off in the distance. Only Kalec knew that he listened for something in particular.

"No cries," Malygos rasped. "No calls."

"All fear Galakrond," Alexstrasza pointed out. "All flee or hide . . . or die."

"Galakrond still grows, still changes. Proto-dragons grow when they eat enough." The icy-blue male used his wings to indicate the mountains. "Nothing else for Galakrond. Nothing big enough. Nothing simple . . . except not-living."

Even though all five understood now, Kalec saw through Malygos that they nevertheless did not want to accept such facts. Galakrond devouring what animated the undead was to them like the behemoth moving far beyond cannibalism.

However, what bothered Kalec most was what this new and horrific feeding meant for Galakrond's continuing metamorphosis. If absorbing the essence of his victims had turned him into such a misshapen monster, it followed that this would only twist him more.

The five proto-dragons took no heart in the possibility that the number of undead might eventually be eradicated by Galakrond's hunger. They knew that the foremost focus of Galakrond's existence remained seeking out *living* prey, especially them.

To Malygos, that gave him no choice. Still, once again, he tried to keep the rest from what appeared a doomed quest. Malygos looked to the other four. "Must face Galakrond. Now. Alone."

"No." Alexstrasza pushed herself into the middle of the group. "We are family. We fight together. Always."

She did not mean *family* in the sense that they were simply loyal

friends but, rather, as if the five of them were of a like color and appearance, born from the same kind of eggs. There was no deeper connection.

"Yes," Neltharion agreed, with some indignation at Malygos's initial suggestion. "We fight as family! We fight together!"

"But we are not family," Ysera countered. "We fight differently. Not same." She did not say it in denial of her sister's words but with the tone that those differences were still important.

Malygos nodded, having considered that and also seeing it as their greatest strength. Perhaps their only hope, too.

"We fight differently," he said. "We fight together. More. We use differences. Tyr showed some, but Tyr not proto-dragon. Not plan like proto-dragons. We must plan like proto-dragons."

It made the only sense to Malygos, although Kalec was not quite so certain. Tyr, for all his might, for all his obvious wisdom, had led the five as if they fought like him. He had used their individual abilities, yes, but in terms of complementing his own. He had been fighting a proto-dragon—a huge proto-dragon—as if facing something like himself.

But Tyr had been correct in that their individual abilities could work in concert better than if they had all been of one true family. Five Malygoses would not have had a better chance. Five Neltharions would not have.

And Malygos also had to admit that not every combination of five different proto-dragons could have worked together as well as when Tyr had led them. He could only imagine what a group that included someone like Coros would have done against Galakrond.

We have not won, Malygos curtly reminded himself. *More likely, we will lose everything.*

But even more than for himself, Malygos remained concerned for his four companions. He had to make certain that he guided

them as best as possible, and that meant using their different skills to their utmost.

I am only a proto-dragon! The thought jolted through Malygos with such force that Kalec also felt the flash of fear. Still, all Malygos had to do was look at Neltharion and the rest—who, in turn, waited for his word—to know that there was no retreating from his dominant role.

But there *was* another who seemed willing to help take much of the burden from him. He looked to Alexstrasza.

She already appeared to understand his concern. With a brief, solemn glance at Malygos, Alexstrasza immediately focused on Neltharion. "How do your kind fight? Tell us . . . show us."

Neltharion bared his teeth in a reptilian grin. He spread his wings and began to display the fighting skills of his family—

The vision shifted, but while Kalec would have liked to know more about the abilities of the other four, he was not surprised about the change. In fact, for the first time, the blue dragon felt comfortable with the shift. He did not see that this might not be a good sign for him.

The scene before him could not be taking place all that long after the previous one. The five remained in the mountains, but now they perched atop part of a crooked peak, watching and waiting.

But the sky remained conspicuously devoid of a creature so vast he could hardly be hiding. There were also no signs of the undead, which disturbed the group's leader.

"Where is Galakrond?" Malygos growled. "Where?" He stretched his wings restlessly before finally understanding what they had to do. "Must bring him to us! Must let him know about us!"

He let out a roar. As he expected, it echoed throughout the mountains. Yet to his ears, it did not sound nearly loud enough.

Before Malygos could suggest it, Alexstrasza raised her head

and repeated his call. The other three imitated her, all five within seconds shouting as one.

The echoes of their combined cries resounded, even building as they rushed away from their source. As loud as they were, it would still have been impossible for most normal proto-dragons to hear them unless they were within two or three hours' flight away.

But then, there was nothing normal anymore about Galakrond.

Thunder rose in the east, thunder with an oddly regular pattern.

No, not thunder, Malygos finally deduced. *Only the beating of very, very large wings.*

And as the rest of the five turned in that direction, the heavens there darkened.

A Galakrond half again as huge as when they had previously seen him moved ponderously toward the five. He hacked and coughed every now and then, and each time he did, the aura faded slightly.

Malygos took note of that as he rose from his perch. Not for a moment did he think that Galakrond would fall easy prey to them, if defeating him was even possible. However, any potential weakness had to be exploited if there was any hope for the proto-dragons.

Confident that the others knew their parts, Malygos flew without hesitation toward Galakrond.

The behemoth ceased coughing. The aura returned. Galakrond stared at the puny figures approaching—and laughed. The mountains shook at the sound, which would have easily drowned out the smaller cries Malygos and his companions had uttered earlier.

"Little morsels!" he bellowed almost congenially. "There you are!"

The five defenders said nothing. They spread out as they approached.

"My meals grow dry, so dry," Galakrond continued merrily.

"Nasty taste, but I am so hungry. . . ." The brutal eyes focused on Malygos. "I am *alwaysss* hungry."

He exhaled.

The five had been waiting for just such a move. They immediately rose higher in the sky and also separated farther. The noxious mist unloosed by Galakrond spread far and wide, but in trying to keep all five in range, the misshapen behemoth instead came up short against each. Ysera came closest to being caught at the edge of the mist, but a hard push by the yellowish female saved her at the last second.

Hiding his relief at her narrow escape, Malygos bore down on Galakrond from above. The icy-blue proto-dragon opened wide and attacked. The column of frost shot toward the gigantic Galakrond, who met the tiny assault with another mocking laugh.

At that point, Alexstrasza shot in and grazed a long section of Galakrond's torso with flame. Against the hard hide, the fire did little.

Against the extra eyes, it did much more.

They melted like butter. They dissolved like water. They blackened like wood. With expert aim, Alexstrasza destroyed every eye in a broad section of Galakrond's left side before immediately soaring far out of sight.

The monstrous proto-dragon roared, but this time in a tone that brought grim pleasure to Malygos and Kalec. Galakrond had experienced pain that he had not suffered even against Tyr.

"I will devour you first!" he shouted at the vanishing Alexstrasza. "I will savor your life! I will make you one of mine, and then I will devour you again!"

Malygos could not help shuddering as he continued with his part of the attack. All five faced the same potential fate: being turned into one of the not-living and then having even that existence serve as a bitter but still desired snack.

No sooner had Galakrond turned to look after Alexstrasza than

a column of sand coursed over the other side of his torso. Spread in much the same manner as Alexstrasza's flames, Nozdormu's assault also concentrated on whatever extra eyes had grown there. At such velocity, the sand cut like tiny claws, at the very least blinding by irritation but more often scoring and scratching orbs until no ability for returning sight remained.

And as the fire-orange female had done, Nozdormu shot off in another direction.

Tyr had made some use of the methods by which proto-dragons fought, but that use had been tempered by his non–proto-dragon mind. Malygos's kind—meaning all families—preferred to hunt alone, but when there was the need to go after very large prey, proto-dragons became adept pack hunters. Packs kept their prey off-balance and fought as partners. Tyr had failed in the end because he had chosen to make himself the primary threat against Galakrond. The lack of equal coordination between Tyr and the five had been the reason for their failure then.

Together, Malygos and Alexstrasza had sought to correct that mistake. They only hoped that they had not simply found another path to failure. There would be no third chance. They fought and won here, or they fought and perished here—and if Tyr was correct in one thing, after their destruction, there would be no hope for their world.

Concern for more than where his next meal came from was not something Malygos would have ever believed possible for himself. He knew that the others had come to be like him; they feared not only for themselves but for everything. They were even willing to sacrifice their lives if it meant saving their world.

Malygos had thus far been the only one of the three to remain dangerously near Galakrond. He now became the rapidly more infuriated monster's center of attention once again.

But Galakrond did not exhale, as Malygos had calculated he would. Instead, the leviathan reached down with both hind paws and ripped away parts of the nearest mountains. He did so with such speed that Malygos was only just banking away when the huge chunks of solid earth came hurtling after him.

One missile passed Malygos barely a breath later. The icy-blue male gritted his teeth as he waited for the second to do the same.

Unfortunately, it caught his left wing hard instead.

The impact first spun Malygos around. The agony stirred up nearly forgotten pain from previous injuries, but that meant little compared with the short, rapid glimpses of Galakrond that the smaller proto-dragon caught while tumbling in the sky. Galakrond took up more and more of his view each time, and yet Malygos could not right himself any faster.

Worse, he saw that not only were all four of Galakrond's major paws filled with more dirt and rock, but those extra appendages that Malygos could make out were doing the same. The terrifying behemoth unleashed an immense barrage with only one obvious purpose, ensuring that Kalec's host would not escape destruction.

Despite the peril to Malygos, he wondered where Ysera was. She had been set to attack when next Malygos distracted their foe, and regardless of Malygos's own fate, he had expected the others to carry on.

But instead of Ysera, it was Neltharion who dived into the fray, ignoring the part of the plan he was supposed to undertake. He shrieked loudly as he neared Galakrond's ear, more loudly, in fact, than Malygos could ever recall the charcoal-gray male roaring.

The sonic attack literally shook Galakrond, so close had Neltharion dared to get. A storm of rock and earth rained down on the mountains as the misshapen beast involuntarily released his hold on nearly everything.

Growing too confident, Neltharion remained to watch his assault a moment longer than sense indicated. For that, he received a hard blow as Galakrond's wing swept forward.

Malygos saw their plan collapsing faster than Tyr's. He had thought that he and Alexstrasza understood their own kind better than the two-legged being had. Of course, Galakrond, for all his transformation, was also still a proto-dragon. In some ways having forgotten that, Malygos wondered if he and his companions had simply flown into certain doom.

He started forward to help his rescuer, only to have Alexstrasza fly in before him. Like Ysera, apparently, she had abandoned their strike-and-retreat plan, but unlike her missing sister, the fire-orange female had not abandoned her comrades any more than Neltharion had.

Coming from the side where she had blinded Galakrond by searing away his extra eyes, Alexstrasza raced toward the massive gullet. As she closed, she performed what Malygos and Kalec thought looked like an act of suicide. Alexstrasza briefly roared. It was enough to draw Galakrond's eager attention. Anticipating devouring a tidy morsel, his jaws opened wider.

Alexstrasza exhaled, clearly using every bit of breath she had. A huge plume of fire raked over the gargantuan proto-dragon's inner mouth, an area as unprotected as the eyes.

The soft flesh near the gullet blackened. Galakrond reared back, all thought of devouring the female proto-dragon gone. Malygos watched, wide-eyed, astounded that their fearsome adversary still had such a tender area. He had thought the region within the maw might be vulnerable, but targeting that had been too much to ask of any of his comrades. What proto-dragon would willingly fly into Galakrond's mouth?

Alexstrasza, it seemed.

Galakrond began to hack and cough. He violently shook his head. His pained roar resounded so loudly in the mountains that it threatened to deafen the others. Wings flapping, he pushed higher into the sky. The hacking and coughing continued as Galakrond swung his head to and fro in an attempt to ease the burning.

Alexstrasza continued on to Neltharion, who remained aloft but still suffered visible disorientation. She reached out with her hind paws to take his shoulders and guide him to safety.

Over the mountains, Galakrond's cry came to an abrupt halt. The hacking and coughing faded a moment after. The malevolent eyes of the huge proto-dragon swept over the vicinity.

Although it clearly aggravated his new injuries, Galakrond exhaled long and wide. At the same time, his gaze went beyond Malygos.

A sense of foreboding stirred within Malygos, and he hurriedly looked over his shoulder.

More than a dozen not-living converged from behind him, cutting off that path. Malygos understood then that Galakrond had also planned ahead—and with better success. The angle at which the not-living flew revealed that they had come from above the cloud cover. Having only found the destroyed corpse, Malygos had assumed that the rest had followed that one into oblivion. Instead, Galakrond had at least Malygos, Neltharion, and Alexstrasza trapped between the undead and the will-sapping mist.

Nozdormu appeared on Galakrond's other blinded side. He assailed the exhaling monster with one sand blast after another, obviously using himself up but as aware as Malygos of the dire circumstances.

Without turning his head to the brown proto-dragon, Galakrond brought his tail up and, with perfect aim, struck Nozdormu hard.

Stunned, Nozdormu collided with one peak. Chunks of rock

flew free. They dropped in among the mountains, accompanied by the limp body of the brown male.

And as the tail withdrew, an increasingly frantic Malygos saw that, like the rest of Galakrond's macabre form, it had eyes. Eyes that more than made up for those lost to the smaller attackers.

Galakrond continued his impossibly long exhalation. Malygos retreated backward as the cloying mist closed on him. Alexstrasza, still aiding the disoriented Neltharion, was easily caught up in the mist. She attempted to thrust Neltharion ahead of her, but although he tried to fly harder, it was not enough.

A ragged hiss from behind Malygos was his only warning that he had nearly flown into the approaching undead. Kalec's host spun to face the new threat, well aware that doing so also enabled the mist to cut the distance to its victim.

A hungry pack of undead or a fog that would leave him easy prey for their even hungrier master. Malygos anxiously looked back and forth, trying to find some path to freedom. The mist blanketed everything above and below, and the animated corpses blocked all routes ahead. There was nowhere for the icy-blue male to fly.

And as death encroached from all directions, Malygos and Kalec wondered what had happened to the one missing member of the failed venture.

Where was Ysera?

FOUR
THE FÍVE

Jaina knelt between Kalec and the artifact, caught between the knowledge that she needed to work fast to save the blue dragon and the great desire to hold and comfort him if these were to be his last minutes no matter what she attempted. Kalec continued his grisly metamorphosis, the proto-dragon elements far more pronounced and the rate of his breathing so rapid that the archmage could not believe that his lungs had not already exploded.

This can't be what this device was meant for! Jaina insisted to herself. *It makes no sense!*

She concentrated on the pulsating artifact. Her eyes widened as she noticed that what she had believed to be a single solid object actually had two components.

"He found something," Buniq had said. Buniq, who could vanish without a trace even when very near the archmage.

But no sooner had she started to make some connection between the mysterious taunka and the discovery of the second part than Jaina felt as if someone watched her. The spellcaster quickly looked up beyond the artifact.

There was no one there—or, rather, no one there now. Yet a peculiar thought ran through Jaina's mind, the thought that she *had* seen someone. Not a dragon and not a human but something closer to the latter in shape. As she concentrated, the archmage imagined that it had been a cloaked and hooded figure a bit taller than even Kalec in his humanoid form.

Jaina knew something of keepers, and while they were much taller—like giants, actually—she was certain that they had the power to make themselves be seen otherwise. Yet even if that was the case, if she had seen some keeper image, Jaina wondered why it had faded away so quickly.

I didn't imagine it. . . . It stood there. And it had not appeared until Jaina had begun to investigate the fact that there were two components to the artifact, not one.

That also brought her back to Buniq, whom she increasingly considered something other than a taunka. It would not be difficult for a keeper to take on such an illusion, either.

Certain that she had come upon the right track, Jaina investigated where the two pieces looked as if they were fused together. Had it not been for her expert eye, the archmage doubted that she would have noticed. Moreover, they were also blended together by spellwork.

Spellwork. . . . Jaina thought again of how she had first confronted the artifact. Perhaps her attack had been too broad for this part of the situation.

Re-creating the symbol, she studied the bonds between the two components, then cast.

The image draped over the smaller part and, thus, where it was sealed to the larger. As that took place, Jaina reinforced her personal spells yet again. She had no idea what might happen, but experience had taught her to expect the worst.

Both parts flared white, blinding her. The archmage fell back, certain that the relic was about to either explode or strike hard against her.

Instead, the bright illumination faded, and the smaller component turned half a circle.

Blinking, Jaina tentatively reached for it.

A stream of white energy struck her forehead. She jolted, but out of surprise, not pain.

And suddenly, Jaina saw . . .

· · ·

The world rippled.

It did so in a manner Kalec had not experienced before. He felt as if one moment washed over another like waves in the sea. It was disconcerting, even more so because everything he viewed through Malygos's eyes flowed on just like waves, too. The mist drew closer and closer, Galakrond behind it.

And when Malygos glanced back at the undead, it was the same. As if made of water, they spilled toward him, an image that only served to make them even ghastlier.

We are going to die, Kalec thought with both dread and wonder. He had not believed that Malygos could die, but his memories of his own time had grown so vague that Kalec wondered if they were memories at all or merely fancies.

But that hardly mattered. All that mattered was that he and his host were about to perish in some gruesome manner.

A mournful roar interrupted Kalec's thoughts and drew Malygos's notice. The icy-blue male turned to the sound.

Something else had drawn Galakrond's attention, a pitiful but still-fiery plume exhaled by a straining Alexstrasza. Behind her, Neltharion—once-powerful Neltharion—struggled just to stay aloft. It was immediately clear that Alexstrasza wanted Neltharion to fly off, but he fought to stay near, as if he could help.

Galakrond sneered. Malygos forgotten for the moment, the behemoth exhaled lightly at Alexstrasza, sending another gust of his foul mist over her. What fight the fire-orange female had managed to draw up faded. Worse, in her struggle to keep her wings flapping, Alexstrasza drifted toward their gigantic foe.

Galakrond opened his mouth wide. He waited with amusement as Alexstrasza unwittingly continued toward the massive jaws.

Malygos threw himself forward, choosing the mist over the

undead. Kalec was glad for his choice, even as the mist began sapping both their wills, for at least the rippling ceased as soon as that happened. Whatever their fates, the five had shown themselves to be as loyal to one another as any true dragon. Each had tried to save one or more of the others, never shirking, never fearful of death—

No . . . not five. *Four . . .*

That thought faded with all others as the mist proved too great for Malygos. His charge had turned out to be as futile as Talonixa's grand one. His wings slowed. It was all he could do to force them to move fast enough to keep him from falling to his death.

Which meant that there was nothing he could do for either Neltharion or, more imminently, Alexstrasza.

As Malygos and Kalec's own struggle worsened, they saw that the fire-orange female registered her doom. She managed a few flaps that slowed her, but already the jaws began to close on her.

Something dropped onto Galakrond near the side blinded by Alexstrasza's earlier attack. It landed hard, and as it did, a great gust of sand swept over the gargantuan proto-dragon's head, blanketing it.

Kalec and his host vaguely made out a battered Nozdormu fighting for a hold as he exhaled again and again. Galakrond sought to shake Nozdormu off. The brown proto-dragon flopped back and forth but kept claws secured. Nozdormu looked very weak, and that he had somehow managed to return to attack Galakrond anew amazed Malygos and Kalec.

But what appeared to be hope for Alexstrasza faded as Galakrond, clearly seeing Nozdormu as more of a nuisance, once more concentrated his focus on her. The respite had not been enough to allow her any true chance of escape. It didn't even help that, in trying to rid himself of Nozdormu, the monstrous leviathan

had forced away much of the mist. Having inhaled so much of it, Alexstrasza, like Malygos and Neltharion, could not recover in time.

Nozdormu let loose with one last blast of sand. It slammed into Galakrond's brow, but as hard as it hit, it was already evident that the blow would not even distract their horrific foe for more than another breath. Yet that was not Nozdormu's full intention, for barely had he brought Galakrond's attention toward him when the blast shifted downward and *clogged* the huge proto-dragon's nostrils.

Galakrond instinctively opened his maw wider in search of air—

And in that critical moment, a slighter, yellowish female proto-dragon placed herself before Galakrond and exhaled into his mouth.

He pulled back his head, his expression peculiar. As the mist faded from Malygos and Kalec, they recalled the effect of Ysera's breath weapon, in some ways akin to that of Galakrond, if not so debilitating.

Ysera did not go to Alexstrasza as Malygos had assumed. Instead, she did the unthinkable—again—and continued her mad assault on Galakrond, all the while keeping herself between him and her sister. Kalec and his host saw that they had underestimated Ysera; perhaps she had been hesitant in her role, but she had not abandoned Alexstrasza or the rest of them.

Indeed, it became clear that Ysera had been the one to aid the injured Nozdormu in reaching Galakrond and that Nozdormu's attacks had all been designed as feints for Ysera.

Ysera . . . and, perhaps unintentionally, Malygos.

His mind clear, the icy-blue male knew that they would not have another chance. Galakrond hovered, disoriented, but that would not last much longer. If Malygos could—

A hiss warned him of a threat that he had forgotten. Yet when Malygos turned to face the undead, he found them flying even more haphazardly and, in one case, fighting each other. At first perplexed,

Malygos realized that Galakrond's disorientation had affected his rotting slaves.

Malygos exhaled on the fighting pair, sending them falling frozen together. He wanted to deal with the rest, but Ysera's warning roar brought him back to Galakrond. Alexstrasza's sister raced about Galakrond's head, exhaling into the monster's mouth and slashing with her claws elsewhere. Her adversary kept shaking his head in what seemed irritation but was still a need to clear his mind of the effects of her breath weapon. Malygos admired Ysera's efforts thus far but could not help noticing that Galakrond's eyes were becoming more focused. Worse, with a great snort, he finally managed to force the sand from his nostrils, at which point he inhaled huge gasps of air to help speed his recovery.

But in observing all this, Malygos forged a plan. It was akin to a past attack they had tried against Galakrond, but in that attempt, they had fought more as individuals and not as one. Moreover, Galakrond had not been as huge as he currently was. If the five could do as Malygos had earlier dreamed . . .

He rushed to Neltharion, who had at last shaken off his own stupor. "Come! Hurry!"

To his credit, the charcoal-gray male followed without question. Malygos soared to one of the peaks shattered in the struggle. Huge, jagged chunks of stone clung precariously to the mountains of which they had once been wholly a part. Malygos eyed the largest and sharpest one that two proto-dragons could possibly carry with their hind paws.

"Help me!"

Between Neltharion and him, they broke the fragment free. Malygos guided them back to a path toward Galakrond. As the behemoth came into sight, Malygos saw that Alexstrasza had done as he had thought she would: the instant her head had cleared,

she had gone to stand with her sister. Now the pair flew in from opposing sides, moving almost as if reading each other's thoughts. They struck simultaneously, keeping Galakrond from choosing one victim over the other. In the process, they also served to prevent him from noticing the two males' approach.

But while the sisters and Galakrond saw only one another, Nozdormu caught sight of Malygos and Neltharion. He also saw the rock they brought with them. Whether or not Nozdormu understood just what they planned to do with it, he evidently realized that they needed to get much closer.

Throwing himself up from the relative safety of his current position, the brown proto-dragon managed another exhalation. The column caught the top of Galakrond's browridge, causing him to look down instinctively as he had before.

As he did that, Alexstrasza and Ysera increased their own assault, now alternating so that as he raised his head again, Galakrond remained concerned only with them.

But just as it seemed things were at last coming together, Neltharion roared, "Not-living!"

Twisting his neck hard, Malygos discovered some of the undead almost nipping at their tails. The creatures did not fly with the relative coordination that they'd first had, which to both Kalec and his host revealed that Galakrond had completely released his hold on them. Whether he had done so intentionally or simply because he had become too distracted to maintain any link could not be said. What did matter was that the animated corpses had returned to whatever passed for their instinct and were flying after the closest potential meals.

And with Malygos and Neltharion carrying a heavy burden between them, the two males looked like very *easy* meals.

"Neltharion—is—strong!" Malygos roared, a desperate addition to the plan hatching. "Neltharion could carry this stone by himself!"

The charcoal-gray proto-dragon's eyes narrowed. "Neltharion is strong. So—is Malygos—and smarter than Neltharion."

Neltharion opened one paw. The rock shifted. Without thinking, Malygos tightened his own grip. He knew what Neltharion intended—it was what he himself had been about to do—but it was already too late to stop the other proto-dragon.

Neltharion released his remaining hold. Malygos grunted from effort as he fought to keep the rock from slipping free. Kalec knew that Malygos had intended to ask Neltharion to carry the rock while the icy-blue male went back to face the undead. It was not that Malygos thought fighting Galakrond's puppets was easier; in some ways, it merely offered a more immediate and just as grisly death.

But Neltharion knew what Kalec also knew about Malygos. For the plan against Galakrond to succeed, Malygos had to coordinate it. Neltharion was a fearsome fighter, the strongest of the five, but he was not the planner Malygos was.

At least not yet, Kalec abruptly recalled. As Deathwing, Neltharion proved far too cunning. *But that's in the future . . . I think.*

As Kalec battled with himself over whether or not there was a future, Malygos took one last glance at Neltharion, who at that moment barreled into three of the encroaching undead. Then, steeling himself, Malygos faced Galakrond. Inhaling deeply, Kalec's host pushed harder. He could not prevent Neltharion's likely death, but he could help make that sacrifice count . . . even if he and the others also had to sacrifice themselves to do that.

And as Malygos closed on the deformed leviathan, he felt very certain that they would have to.

Galakrond chose that moment to twist to the side. He snapped at Ysera, the huge fangs coming within a few feet of her. She backed up as quickly as she could, but Galakrond continued to pursue her, his jaws again opening.

Fire scorched near his eye. Alexstrasza exhaled twice, attempting

to draw his attention to her. However, Galakrond ignored the minor pain she caused.

To Malygos's shock and probably that of everyone else, including Galakrond, Ysera reversed direction. She flew into the opening maw, then immediately rose, her hind paws pulled forward and her own jaws open.

Her mad actions served to make Alexstrasza continue to exhale, even though she fought for breath each time. The flames rained over the entire side of Galakrond's scaled countenance. Extraneous limbs twisted, sizzled, and withered under the onslaught, so much so that it did cause Galakrond to roar in pain.

As his mouth then widened, Ysera scraped her claws across the blackened flesh inside the top. Blood and pus poured forth from the sorely wounded area. Ignoring the fluids spilling over her, the yellowish female took a savage bite from the same flesh before turning away.

Galakrond's roar trebled. He snapped shut his jaws, but by then, the impetuous Ysera had just made her escape.

Seeing Galakrond clamp his jaws, Malygos feared for his own plan, but then his gargantuan foe opened his mouth wide once more. Galakrond hacked and coughed—and for a moment looked slightly smaller.

He is weakened, Malygos thought. *Not for long, but he is weakened.*

Kalec knew most of Malygos's plan by this time, but that knowledge did not encourage him. Nor did it encourage him to have his host flying as fast as he could with such a tremendous burden into the very maw from which Ysera had just barely escaped.

Galakrond sniffed the air. He turned toward Malygos.

Nozdormu blasted the nearer eye with sand.

Neither Malygos nor the monster had seen Nozdormu closing, the brown proto-dragon timing his attacks perfectly, as usual.

Galakrond tilted his head away from the irritating sand, which gave Malygos the opening he needed.

The icy-blue male flew under the upper fangs and into a place that stank not only from the ravaged flesh but also from the breath of the ultimate carnivore to stride across the young world. Both Malygos and Kalec tried not to think of just how many proto-dragons had gone down that much-too-close gullet.

Malygos's grip slipped. His exertions had finally taken their toll. He felt the rock almost fall free. Struggling to keep what grasp he had, Malygos pushed on toward the frightening gap. All Galakrond had to do was shut his mouth and swallow, and that would be the end of the tinier proto-dragon.

Now! Kalec silently shouted at his host. *Now!*

But Malygos kept on a second longer. He sought just the right angle.

Darkness enveloped Kalec, but this time, it was the darkness of Galakrond's jaws closing.

Releasing his hold, Malygos banked.

Neither could see the rock's descent, but they knew the results of it in the next breath. Galakrond's jaws shot open yet again, and new hacking almost deafened Kalec and his host.

Taking the chance that he might be bitten in two just like Talonixa, Malygos darted out the side. However, it appeared that he need not have feared being bitten, for Galakrond continued to cough, this time for another reason. As Malygos had planned and hoped, the rock he had chosen, a large, pointed projectile, had slid down deep into the behemoth's throat. There it lodged, cutting off most of Galakrond's breathing.

The enormous proto-dragon thrashed in the sky. His tail shattered part of a mountainside. One hind paw kicked tons of stone from another.

Still unable to dislodge the rock, Galakrond collided with a mountain. Rather than flying into the air again, he swiftly crawled over it. His claws and tail left devastation in their wake.

Leaning over a valley, Galakrond lowered his head. He shook it back and forth hard.

He will free himself! Malygos had hoped that the rock would remain lodged enough at least to make their adversary collapse, preferably die. Now he worried that Galakrond still had a very good chance of freeing his air passage. If that happened, Malygos doubted he would get the opportunity to try a second time.

Malygos sought out Nozdormu and the sisters, roaring for their attention. With his head, he indicated Galakrond. As weary as they all were, they had to move in close yet again and do what they could to keep the rock lodged.

Despite the urgency, Malygos looked back for Neltharion. There was no sign of either the charcoal-gray proto-dragon or his horrific opponents. Malygos hissed, imagining the undead feeding on Neltharion's torn body with such vividness that Kalec could also see it.

The hiss grew more angry, more determined. Taking in Galakrond, Malygos thought of not only Neltharion's death but also those of the monster's previous victims. He dived.

The grotesque leviathan's sides heaved rapidly. It seemed impossible to Kalec's host that Galakrond could breathe at all, but some air had to be writhing its way down the throat. Not enough to satisfy Galakrond's needs but enough to keep him a viable threat.

The four of them swarmed the head, each coming in from a different direction. Galakrond kept his head down. His body quivered.

Malygos heard a change in the breathing. It was not quite

so rapid. If the stone was still stuck, it had at least shifted, giving Galakrond more air.

Too late, Kalec's host realized that their monstrous foe had to be more aware of what was happening around him than he was before.

As if hearing that thought, Galakrond gazed skyward. He took in the four tiny figures.

"Lit—little morsels!" Galakrond somehow managed. "I will—will eat you when I can!" He coughed violently, but at the same time, his wings flapped wildly—not to fly but to purposely keep his enemies away.

The wings did that to Ysera and Alexstrasza but not to Malygos and Nozdormu. Nozdormu seized hold of one webbed wing and, perhaps too out of breath to exhale at the head, ran his claws over the wing's membrane. The claws cut deep, proving that there were some parts of Galakrond's skin that were not impervious.

Galakrond's coughing ceased. He angrily snapped at Nozdormu, giving Malygos the opening he desired. The only hope remaining was keeping Galakrond's airway from clearing. Malygos knew he could have ensured that earlier. Instead, he had let his natural survival instincts take over. He had fled the behemoth's jaws rather than doing what must be done. The rock could never be dislodged if another large object kept it wedged in tighter.

Malygos intended to be that wedge, although doing so might well promise his destruction along with that of Galakrond, considering the great height from which they would plummet.

Kalec, too, understood the need for the sacrifice and welcomed it. He still had slight memories—or imaginings—of some life beyond that as an unnoticed portion of Malygos, but those only pained him, for they hinted at someone lost to the blue dragon, someone fading farther away.

Let us die saving this world, he told Malygos, even though his words continued to be unheeded. *Let us die. . . .*

Rising on his hind legs, Galakrond set one smaller forepaw against the nearest peak. Even the forepaw had the strength to crush rock and packed dirt as if they were loose sand. The wings continued to flap, yet not only did Nozdormu cut deeper ribbons in the one, but Alexstrasza and Ysera also attempted to do the same with the other. The attacks by the three probably would have been insignificant if Galakrond had been able to breathe properly, but as it was, they further disoriented the half-suffocating beast.

But then an unsettling gurgling noise escaped Galakrond. It was followed by a raspy breath that extended several seconds too long for Malygos's comfort.

That Galakrond could breathe so well could only mean that he had the rock nearly dislodged. More than ever, Malygos saw the need for his choice. The others were doing as originally planned, keeping their gigantic foe distracted for the critical blow. They just did not realize exactly how their chosen leader had decided to make that final assault.

The jaws were open just wide enough. Malygos took a fleeting measure of the gap and thought that Galakrond appeared to have slightly shrunken again. The behemoth's growth and transformation had become more chaotic, likely because of the diet that had perverted his shape in the first place.

Malygos tightened his approach. Pushing his momentum as hard as he could, he folded his wings against his body and darted inside. Galakrond's fetid breath enveloped him, and hints of the foul mist threatened to dull Malygos's mind before he could commit himself.

He saw the rock, now halfway out and leaning to one side. Galakrond tried to shift it with the back of his tongue, creating more complications for the much smaller proto-dragon.

The icy-blue male collided with the stone, shoving it deeper. That, though, caused an instantaneous reaction from Galakrond, who shook his head with greater violence and tried to exhale. Undeterred, Malygos dug into the back of the behemoth's tongue and shoved against the stone, sending it as far in as he could.

A sudden tremor shook Malygos, but it was nothing that Galakrond had done. Something had struck Galakrond hard in the skull, with such force that the head still reverberated. Malygos saw that working to his advantage. With his monstrous opponent so otherwise occupied, Kalec's host exhaled at the area around the stone.

The harsh frost sealed the stone in place, at least for the moment. Both Malygos and Kalec knew that the heat generated by Galakrond would quickly overwhelm the frost. Malygos had merely wanted to give himself time to adjust his position.

Seeking air yet again, Galakrond opened his mouth wider. Malygos eyed the opening, the temptation to fly out of the beast a very reasonable one. Still, he knew that he had to stay.

A whirling form barreled into Galakrond's mouth.

It quickly proved to be not one thing but, rather, *two*. One of those things was a battered and ravaged undead, which at first made Kalec and his host fear that Galakrond had come up with the startling plan of sending his puppets in to do what he himself could not. Yet while the potential for that only now occurred to them, it was not the case, for the second object was clearly very much alive.

Battered and bruised, scratched but not showing any signs of having been bitten, Neltharion bared his teeth in a grin at the sight of Malygos.

"Fly! Fly away!" the charcoal-gray male insisted.

Malygos peered at his own handiwork. The frost was already melting. A sudden dip nearly sent them tumbling into the jagged teeth and also showed much jostling by the rock.

"Must stay!" he shouted back. "You go!"

"All fight together! One family!" Neltharion glared at the rock as he swatted the still-struggling corpse. "I will keep it in! You go!"

But Malygos instead leapt at Neltharion—or, rather, the ripped and torn undead. He seized the flailing body by the throat, twisting the neck so that the claws and the teeth could not threaten him.

Galakrond shook back and forth. Malygos and Neltharion had just enough room to flutter up into the air, keeping them from being affected very much. Malygos launched himself toward the rock again, carrying the animated corpse with him.

The rock began to slide. The upper part of the mouth suddenly loomed in Malygos's path as Galakrond dipped his head down to aid his breathing. Kalec's host corrected.

The undead struggled to free itself. Malygos shook his foul catch hard, then sent it tumbling forward.

The ghoulish creature collided with the rock, shoving it slightly deeper. But that was not Malygos's full intention. He bent his hind legs forward, ready to push as hard as he could.

"Move!"

Malygos veered off just in time. Neltharion, hind paws bent forward in the same manner as his friend, crashed against both the undead and the stone.

With a force that Malygos could not have possibly mustered, Neltharion jammed the bony figure and the rock deep into Galakrond's gullet.

Teeth slammed against Malygos as Galakrond reacted. A muffled roar still almost deafened him. Neltharion, seeking to avoid the rippling tongue, collided with Kalec's host. Malygos hurtled out the side of the mouth.

Neltharion! He's still inside! It was impossible to say whether the thought first originated from Malygos or Kalec, but the blue dragon found himself astounded that he, who could yet recall some

bits of his supposed future, would want to rescue a creature who would, in turn, threaten Azeroth. Yet when Malygos immediately arced back, Kalec cheered him on.

Neltharion lay sprawled on his back, trying to right himself despite the mad swinging of Galakrond's head and the writhing tongue. If not for the fact that the passage was blocked, Neltharion would have been swallowed twice.

Galakrond's jaws snapped shut. Malygos feared for his companion, but the mouth opened again. Neltharion had managed to turn onto his stomach, but he had still not regained his balance.

Dodging teeth larger than him, Malygos soared back inside. Hind paws ready, he seized Neltharion by the shoulders and pushed on without hesitation. Neltharion went limp in his grip, but only to keep from distracting Malygos.

The jaws started to close again. With another beat of his wings, Malygos pulled himself tightly together.

The two proto-dragons returned to the outside just as the jaws shut. Neltharion stirred to life, and Malygos, barely able to hold on, let him go.

The two exhausted males did not go far, instead banking together and returning to the aid of their comrades.

But both pulled up short at the sight before them. Alexstrasza, Ysera, and Nozdormu no longer sought to keep Galakrond occupied. It did not just have to do with the fact that Malygos and Neltharion were no longer in danger; simply staying near Galakrond was to invite doom.

The gargantuan proto-dragon thrashed wildly, ravaging the nearby mountains and sending one avalanche after another down on the areas below. His tail and wings flailed through the air, striking other mountainsides and creating a wind that buffeted the smaller proto-dragons even as far away as where they were.

Galakrond's hacking and choking reached epic proportions.

To the shock of Kalec and his host, Galakrond struck his head against one peak in what was evidently a more desperate attempt to dislodge the rock. Malygos feared that he would succeed, but all that happened was that Galakrond shook his head again as if to clear it.

As he did that, his furious gaze fell upon Malygos.

Galakrond rose into the air, the icy-blue male his target. Malygos had no choice but to turn and flee. And hope.

Yet barely had he done so when a tremendous thud made him look back. Rather than pursuing Malygos, Galakrond had abruptly banked to the south. He crashed into the top of a mountain and tumbled over it.

Malygos considered continuing his flight, but Galakrond's next action put an end to such thoughts. Galakrond managed to rise into the air, but his path turned more erratic. Twice he dropped on top of peaks, destroying their crowns, before he succeeded in staying aloft. Yet it seemed as if Galakrond no longer even noticed Malygos and the others. He moved on to the south, past the mountains to the bleak stretches beyond, as if some key to his struggle for breath could be found there.

Fearful that such might be the case, Malygos finally dared to pursue the behemoth. Neltharion and the rest joined him. They all knew that if Galakrond was free to breathe, their own deaths would very likely soon follow.

Galakrond fluttered over the wasteland, his path meandering. His body was aglow again, but now as if aflame. Several of the extraneous appendages shriveled. From a distance, Galakrond almost looked like a true proto-dragon once more, albeit a huge one.

And then he simply dropped.

The land below shook with his collision, the shock wave expanding for miles. Crevasses spread all around where Galakrond

hit, cracks that looked like lightning bolts coursing along the ground.

No sooner had he hit than Galakrond shoved skyward once more. He managed to rise as high as one of the lower mountains in the distance, then fell again. While his crash did not reverberate as much as the last one had, it was no less dramatic, for it was quickly followed by the leviathan's manic flailing on the ground.

All the while, Galakrond coughed and hacked. His eyes stared but no longer appeared to see. He pushed himself up, beating his wings harder. Somehow Galakrond managed to keep going until, at last, he hovered higher than ever—

His wings ceased flapping. The coughing also stopped, but only because Galakrond was no longer trying to breathe.

To Kalec and his host, it appeared that Galakrond remained frozen in the air. The gigantic proto-dragon hung before them, wings spread to their full length.

The illusion faded as Galakrond dropped like a stone, his massive body spiraling tail-first.

When he struck this time, the force threw up a cloud of snow and dust that briefly obscured everything. Malygos managed to make out the silhouette as Galakrond's head swung down after the rest of his body had hit. The great head smashed into the empty landscape so forcefully that the neck snapped and the skull tilted at an odd angle, at which point the lower jawbone also broke off.

And only then, only as the dust cleared enough for the five to see and when it no longer mattered for Galakrond, the rock and the grisly remains tumbled free through the ruined jaws. They came to rest several yards away, insignificant in size compared with the creature they had helped bring down.

Galakrond was dead.

FIVE
PAST, PRESENT, FUTURE

Jaina understood. She knew why the artifact had been created, and she knew why it was acting as it was.

She also knew that it threatened to take Kalec from her. However, now the archmage had the key to reaching him.

Jaina only prayed she still had time.

They hovered there at first, unable to believe what they saw. It was Neltharion who finally did the unthinkable, testing whether Galakrond was dead by landing right on top of the heavy torso. Neltharion hit hard enough that the body trembled . . . but Galakrond did not stir.

Malygos landed before the huge head, marveling at what they had wrought. In retrospect, he knew that he had not expected that they would live, much less triumph. The immensity of their victory only now registered with him, and the proto-dragon shook.

Alexstrasza and her sister joined him. Nozdormu circled the great corpse once, then descended. Neltharion abandoned his perch atop the torso to fly next to the brown proto-dragon as they headed toward the other three.

Neltharion dropped next to Malygos. "We have won! We are powerful!"

"We are lucky," Malygos murmured in turn.

The charcoal-gray male cocked his head, then nodded. "Lucky, too . . . yes."

But this was more than luck, just as Neltharion indicated, an increasingly disjointed Kalec decided. *We won because we fought as one.*

He no longer thought of himself as ever having been a separate entity born in a time long after this. Kalec knew that he had always been a hidden part of Malygos. He assumed the other proto-dragons had similar secondary personalities, but that point was not very important to him. What mattered was that he and Malygos—along with the others—had managed to bring down Galakrond. The world was safe.

"He was right. . . . He insisted he was right," a feminine voice declared from behind them.

"We should've listened better," agreed a masculine one that sounded to Malygos and Kalec like none other than Tyr.

As one, the proto-dragons whirled around. Teeth and claws readied for the possibility of attack.

But instead, they confronted two cloaked and hooded forms with shadowed faces. One stood as tall and as broad as Tyr had when he and Kalec's host had first met; the other was slightly shorter and slimmer. Malygos judged the smaller to be the female and was proved correct when the figure spoke again.

"Hail to you, victors. We and this world owe you a debt."

"Where is Tyr?" Malygos asked impatiently. "You took him?"

"We did take him," the male responded. "His injury would have proved fatal otherwise. He's well but not recovered."

The more the male talked, the more Malygos noted something familiar. "Heard you in my head! You told us the way through mountains!"

"There were things you needed to know, such as Galakrond devouring both the undead and the living. We also sought to give you a few moments' necessary respite."

But Malygos was still not satisfied. Aware now that Tyr's kind had been observing and acting surreptitiously, he needed to know

one other thing. "Tyr fought! Tyr fought and almost died! You could have fought! You could have won!"

"Power does not mean victory," the female answered solemnly. "We might have won, or, more likely, we would have made things worse. Tyr had a point there, too, when last he tried to urge us to a course of action. We were beyond caring, though, indifferent to everything once our suggestions to him were found to be without merit."

"We let our duty in this world slip away," her companion continued bluntly. "We were unfit to protect it . . . unlike you." For the first time, he moved, raising a hand identical to Tyr's toward Malygos and the other four. "Tyr was correct in many things but most of all in this. He was right in what he found in the five of you. He asked of us—no, properly *demanded* of us—to set matters right so that no Galakrond, no other threat, may ever bring Azeroth to extinction."

The five proto-dragons glanced at one another, not understanding at all what the two-legged creatures meant. Kalec had some glimmer of the truth, but the haze that had gradually been enveloping him made those thoughts fade again.

"Guardians are needed, guardians representing the five essential Aspects that have helped mold this world and will continue to," the female started. Now she, too, raised a hand toward Malygos and the rest. "You will literally *be* those Aspects, using them in whatever manner necessary."

"Stronger." Malygos finally comprehended. "You want to make us stronger."

"More than just that. You will be something different, something *grander*." For the first time, the female hesitated. "But only if you *choose* to take on the roles of protectors. Tyr was also adamant about that. You chose to fight for your world once; will you now make it the purpose of your existence?"

The words were big ones, but Malygos found he understood

better than he would have expected. There was much he grasped that even a season ago he would have believed impossible to decipher.

And in understanding that, his decision was easy.

"I will do this." He looked to his companions. Alexstrasza was already nodding her agreement. Ysera was not far behind. Nozdormu appeared to mull over the offer for a moment and then, with a hiss, added his nod.

Only Neltharion had not answered yet. Indeed, Malygos found his friend staring off toward the mountains, as if he were listening to something.

Malygos let out a low, short hiss that brought Neltharion's attention back to the gathering. With what seemed almost impatience, the charcoal-gray proto-dragon blurted, "Yes . . . yesss."

"Then we shall begin now," the male announced to the proto-dragons and to the air itself.

And all at once, Kalec stirred from his fog. He realized what was about to take place. The female figure—who, like her partner and Tyr, radiated a presence much more astounding than what could at the moment be visibly seen—had even used the key word. *"Aspects," she said,* Kalec recalled. *This is how Malygos and the others became the Aspects!*

The actual event had been enshrouded in mystery even for the other dragons. Kalec suddenly remembered that, when he was much younger, he had sometimes wondered how the five had come to be the world's defenders.

And with those memories returned others, so many others. Kalec knew again who he had been and what had happened that had drawn him into these visions—

"Kalec."

He jolted. No . . . Malygos jolted. Kalec shook his head, *Malygos's* head. For the first time, Kalec had control.

"Kalec, look at me."

"Jaina?" He gasped, turning. "Jaina—"

But it was not Jaina he faced. Rather, Alexstrasza looked intently at him.

"Kalec," the fire-orange proto-dragon murmured. "Look at me."

Near them, two more hooded figures materialized. Kalec found himself caught between wanting to see what was happening and wanting to finally escape to his own existence. He wanted his life more than he had in many months, whether or not he was no longer an Aspect.

"Concentrate, Kalec. The artifact is trying to do what Tyr tasked it with, but the foulness that was Galakrond tainted it over the millennia, distorting its function even as it still sought to serve Tyr and the Aspects."

Kalec tried to seize on her words, but at the same time, the newcomers raised their hands. He also suddenly sensed that there was another, *greater* presence acting through the keepers, that presence being the true force bringing about the proto-dragons' coming transformations.

The titans.

It is happening! the blue dragon thought. *The titans are the ones overseeing the transformation, the creation of the Aspects!*

As they raised their hands, the figures also changed. They began to grow. Their hoods and cloaks fell away, revealing four giants akin in appearance to Tyr when he had fought Galakrond. The keepers continued to swell in size, and their bodies glowed with tremendous power.

"Kalec!" Alexstrasza called more sharply. "Look at me!"

Only she could have drawn him from this moment. Kalec at last concentrated fully on Alexstrasza, seeing in those reptilian eyes *human* ones.

The world began to turn on its head. Everything except the eyes

into which Kalec stared now appeared as if he were looking through water.

Kalec felt his bond with Malygos fade and, with it, the grip the visions had on him.

Darkness enveloped the blue dragon. Only the eyes, Jaina's eyes, brought any illumination. Kalec held her gaze because he understood that to lose that hold would mean his doom—and also because those eyes were *hers*.

With a gasp, Kalec at last truly woke up.

He felt the floor beneath him. He detected the scents of the Nexus—the traces of generations of blue dragons and the inherent smells that he associated with so much magic.

But most important, he saw not only the eyes of Jaina Proudmoore but also her face. Her human scent, so unique among her own kind and so enticing to him, lingered in his nostrils.

Kalec tried to speak, to say her name, but it came out as a croak.

"Hush," Jaina murmured, her hand gently touching his cheek. "Hush . . . give it a second."

He was too impatient, though. "J-Jaina . . . you brought . . . you brought me back."

"Nothing will take you away from me. Ever."

Her tone was blunt. He knew she meant what she said, and he felt the same. Reaching up a hand—a hand without scales or claws—Kalec touched her cheek in turn.

Then he recalled the bane of his existence. He looked to the side and saw that despite what he would have assumed, Jaina had not destroyed the artifact. It sat nearby, its glow very slight but still there.

With an angry hiss, Kalec started a spell—

"No, Kalec." Using both hands, the archmage brought his eyes back to her own. "The artifact means no harm. Remember what I said to you in the vision?"

"You said . . ." He did not go on, instead asking, "How do you know?"

"I was given the key, I think by a keeper. Or maybe a part of the relic with its own purpose. I'm not certain. I only know that she wasn't a taunka."

"Buniq?" Neither possibility concerning the taunka surprised him.

She summoned a flagon of wine from the air, then gently set the edge to his lips. While he sipped, Jaina explained further. "Tyr—the artifact made all this clear—always planned ahead. His only mistake was not foreseeing what Galakrond would become, as if anyone could have! He tried to make up for it by finding those champions who not only could defeat Galakrond but would also be willing to sacrifice themselves and their lives forever for the sake of Azeroth."

"He found them. He found the five," Kalec whispered. "Malygos. Alexstrasza. Ysera. Nozdormu. Nelth-Neltharion. They were heroes even before they were the Aspects. Azeroth wouldn't have reached the time of the dragons without their willingness to do what they had to do."

"They saved the world without all the powers they gained as the Aspects." She paused, her eyes widening. "Kalec! Did you see it?"

"No . . . and I don't think I would have. I think the vision was almost finished. I think I might have returned to the beginning, living it over and over and over." Kalec imagined the last few moments. "The artifact. Tyr tied it to the five. That's what he was doing when he pointed it at us—them. Imprinting the five on it. I think it drew from each but especially from Malygos, the first. Tyr didn't know that it would end up inside Galakrond."

"The key enabled me to delve into its core," the archmage said. "I saw some of what he intended it to tell you about its function. Tyr suspected—or knew—that someday there would come a time

when the five would have great doubts about themselves, when they might believe they were no longer worthy of their roles as protectors."

This was sounding all too familiar to Kalec. "At Wyrmrest, it came to a head. That's when they decided just that, because they no longer had the powers of the Aspects. They'd grown too accustomed to depending on those." He frowned. "And *that's* when the artifact awoke. It sensed that what Tyr feared had happened, if not quite as he calculated, and tried to act as he wanted. The only problems were the great amount of time and Galakrond's taint infiltrating its magical matrix."

Kalec tried to stand. With Jaina's arm around him, he finally managed. On somewhat unsteady legs, he walked to the relic. It no longer disturbed him, now that he knew what it had been meant for.

Tyr wanted them to be reminded of what they once were and how much they had accomplished even then.

To Jaina's shock, Kalec picked up the artifact.

"What are you planning to do with that?"

He thought of all he had lived through in the visions and what he had seen of young Malygos and the other four. There was only one course he could take after that.

"I'm going to call a convocation."

He waited quietly in the chamber, hoping that he was not waiting in vain. He had arrived at Wyrmrest more than four hours earlier, wanting to reach it before the others.

Kalec still sensed nothing beyond the temple's walls. The others should have been there by now. It was already well past the hour on which they had all agreed.

With a grimace, Kalec recalled how, in truth, the three had only said that they would fly to Wyrmrest after he had pestered them

over and over. It would not surprise him if they had changed their minds.

For the moment, he remained in his humanoid form, preferring it now for a variety of reasons. One was that he could better handle the artifact as he desired.

The relic currently sat in the very center of the chamber, a few feet ahead of Kalec on the platform. It pulsated quietly, its functioning having been corrected by Kalec and Jaina. Galakrond's taint had also been expunged, at least as far as either could tell.

If they do not come, I will have to bring it to each of them. Even that might not solve the situation; the other three could very well refuse to see him.

"Well, Kalec. Can you tell us now for what reason you insisted we return here?"

He could not help jumping. Alexstrasza—her form *humanoid*—strode into the chamber, looking every bit as radiant as when he had seen her in the forest. There was no sign of Ysera or Nozdormu, but Kalec suddenly sensed their nearby presence.

"You've been here for a while," he muttered.

"We needed to . . . discuss some things first. Now we are ready to hear you, if you still wish to call this gathering."

In response, Kalec took a few steps back from his position and transformed into his draconic form. He peered down at Alexstrasza. "I do."

"Very well." She started toward her usual place, changing as she moved. By the time Alexstrasza halted, she, too, was no longer humanoid in appearance.

Barely had she finished changing when Nozdormu and Ysera also entered. Unlike Alexstrasza, they did so in their draconic shapes and not in humanoid ones. They said nothing as they positioned themselves.

"Thank you for doing this," the blue dragon quietly said.

"Just what *are* we doing?" Ysera interrupted. "Best tell us quickly. You said it had to do with that thing, which I know I have seen somewhere before—"

Kalec immediately concentrated on the relic.

Nozdormu hissed. "Jussst what are you—"

Tyr's creation glowed brightly.

The three other dragons' gazes became locked on the relic. Kalec let out a deep breath. As it had done with him, so the artifact now did with the others, only in not so haphazard a way. All relived their past, from their first meeting with one another to the epic struggle.

But whereas Kalec had been caught up in the vision for days, the three others were only entranced for a minute, maybe two. In that short time, though, their reptilian countenances displayed a series of emotions, none of which, unfortunately, told Kalec how they were taking this sudden journey.

The artifact's glow all but faded. As Kalec expected, Alexstrasza and the others stirred.

"I was . . ." Ysera hesitated.

Nozdormu stared at the relic. "That thing . . ."

Alexstrasza looked put out. "Kalecgos, you should not have done this without our permission!"

"Would you have given it?"

"Of course not!" Ysera snapped. Then, sounding surprisingly softer, Alexstrasza's sister added, "But we would have been wrong."

Nozdormu turned his baleful gaze from Tyr's creation to Kalec. "Explain thisss . . . and yourself."

Kalec did, telling them what he had gone through and the things he had experienced in the vision. He told them everything except Jaina's part in it, as she had requested.

And when he was done, even Nozdormu looked astounded.

"I wondered for some time after why he had brought forth that thing," the former Aspect of Time muttered. "What a foolish notion to think that he could change what has happened by reminding us of this incident."

"It was hardly just an incident, though," the red dragon pointed out to him. "And your own tone betrays you, Nozdormu. You lived it again, just as my sister and I did. You remember how you felt then. How we all felt."

"What does that matter?" Ysera blurted.

Kalec seized control again. "What matters is what Tyr wanted you to see. What you have to see. When we gave up our powers to save Azeroth, you three, who'd wielded them for so long, willingly did a great and noble thing. Throughout the millennia, as Aspects, you more than once proved yourselves willing to sacrifice your lives." He looked at each of them, daring someone to deny what he said. "But Tyr knew—and I understand—that you were granted such fantastic powers in the first place not just because you were there but because you had already proved yourselves worthy several times over. Proved yourselves worthy as proto-dragons, nothing more."

Nozdormu grunted. "We nearly *died* several times over."

"But you did not."

"No . . . we did." Alexstrasza exhaled. "Not literally, but we did die. We forgot what we once were. How we originally were. We *did* exist before we became Aspects." She set herself before Ysera and Nozdormu. "We *existed*, and we fought thinking not of ourselves but of everything!"

Kalec pulled back again. Alexstrasza understood, but did the others?

"You fought very well for a runt," Nozdormu remarked to Ysera. "I thought you mad at timesss . . . but admirable."

"I had her to keep up with," Alexstrasza's sibling replied with a nod toward the crimson dragon. "And you were always there to lend your strength at the right moment, Nozdormu. You know that."

"We all fought very well that day," Alexstrasza agreed. "Even . . . even Malygos and Neltharion."

The three were silent for several seconds; then, as one, they turned to face the youngest of their party. Kalec remained perfectly still, aware that anything could alter the moment.

Alexstrasza shook her head. "You should never have done this, Kalec."

"It was ill-advised," Nozdormu added.

"Risky," Ysera concluded.

"But it has reminded us of much," her sister went on. "Reminded us most of all of who we were and still are." Alexstrasza again glanced at the other two. "We have far more to think about. Would you not agree?"

"Much," the bronze dragon answered.

Ysera nodded.

Something that had been bothering Kalec finally demanded attention. "I have to ask one thing. We all know Galakrond as Father of Dragons, but . . ."

"It did not begin that way," Alexstrasza murmured. "The first dragons to come after us knew only of the great skeleton already long lying in the Dragonblight. We made certain that the truth about Galakrond would remain secret, for fear that some other might decide to follow his insidious path. Because of his immense size, many could not fathom him as anything else but a true dragon."

"We chose to encourage the misunderstanding," Nozdormu interjected. "And in his perverse way, Galakrond did cause the rise of dragonsss. A 'father' in some sense, if not exactly as we led all othersss to believe."

"And we shall continue to leave it that way," the red dragon quietly declared. Then, before a startled Kalec could react, Alexstrasza turned and scooped up the artifact. "I will tend to this. Its work—Tyr's work—is done. We may not be Aspects anymore, but we are still ourselves. I, for one, think that perhaps there is some more I can offer the world after all. We can only wait and see."

"I understand," Kalec finally dared reply.

"The next convocation had better be for more urgent mattersss," Nozdormu commented as he spread his wings and started from the platform. "Promise that."

"I—promise."

"You're a stubborn one," Ysera murmured as she followed Nozdormu. "I can appreciate that."

Kalec was left with Alexstrasza. She tightened her grip on the relic. "Should I ever find that Tyr lives, I will thank him for reminding us. As I do not know if I will have that chance, I thank you in his place, Kalec."

"There's no need—"

"Yes, there is. You still remembered life before assuming the mantle. You remembered enough to make certain that Tyr's hopes rekindled our own drive. So I thank you for that and much else." She left the dais but, before reaching the exit, briefly turned back. "Oh . . . and thank *her* for us also."

Alexstrasza departed before Kalec could regain his composure. He immediately whirled toward a distant column half in the shadows. "You heard her?"

A part of the column separated from the bulk. As it did, it became Jaina Proudmoore. "I shouldn't have come with you! I'm sorry! What will she do?"

He shrugged. "Nothing. Maybe find a way to thank you again. I should have known that she, of all three, might sense you."

He shrank down into his humanoid form. Unperturbed by what

she had just witnessed, Jaina gladly fell into his arms. For several seconds, they did not speak.

Then Jaina said, "Did it work, Kalec? Will they rejoin the world? Azeroth needs them!"

Azeroth needs them. Three simple words, but Kalec thought about how much those words covered. The three elder dragons carried among them such knowledge, such experience, courage, and wisdom alone, that to lose even those things would leave the world sorely lacking. That, Kalec knew, could not be allowed to happen.

"I think they will," he finally answered. "They've always been true to themselves. They'll see the truth more than ever now. They just . . . forgot for a while."

Without warning, she kissed him. He replied in kind.

When they separated, Jaina whispered, "I'm so very proud of you, Kalec."

"I don't know why—"

"There are many reasons. Most of all, for not forgetting yourself, either. You still have a role in this world, too. Several, in fact, I'd say."

They had discussed some of this while he had been preparing for the convocation. After living through the visions, Kalec was now reconsidering his decision to let the other blue dragons choose their individual paths. He still had much to mull over and might yet decide to keep matters as they were, but there were factors favoring restoring the blue dragonflight. Not only for the sake of Azeroth but for the sake of his own kind. He had shirked his duties just as the others had done, but he would make up for that now.

And there were other roles. Roles that he had yet to completely figure out except that Jaina insisted she would be there to assist him. Their powers combined would be potent enough, but both believed that their *hearts* combined might in some ways help guide Azeroth yet more for the better.

Kalec thought it would be interesting to find out.

"We should leave," he told Jaina.

She nodded, then stepped back. As she did, Kalec transformed again. He lowered one wing so that she could climb up.

"Are you ready?" Kalec asked.

"Yes."

The blue dragon wended his way out of the temple. Night was just beginning to fall, allowing some details in the distance still to be noticed in the gloom.

Kalec spread his wings and leapt into the air. He looked back to make certain that Jaina was safe, then ascended higher.

On a whim, Kalec circled Wyrmrest once. As he did, out of the corner of his eye, the blue dragon beheld the bones of Galakrond.

A brief glint made him look closer.

"What is it?" Jaina called.

"Nothing . . . nothing."

Kalec banked, for Jaina's sake heading toward Dalaran before he returned to the Nexus to ascertain whether there were any lingering aftereffects from the artifact's presence. There was no reason he could not have told Jaina what he thought he'd seen below except that it had probably been his imagination. She might have understood, but this was one secret he decided to keep from her.

In the growing shadows of the great ribs, Kalec thought he had seen a figure, a figure small and cloaked but at the same time seeming as tall and as powerful as a dragon.

And whether the image of Tyr had been real for that brief time or, most likely, conjured by his mind, Kalec silently thanked the keeper for Alexstrasza, Ysera, Nozdormu . . . and himself.

NOTES

The story you've just read is based in part on characters, situations, and locations from Blizzard Entertainment's computer game *World of Warcraft*, an online role-playing experience set in the award-winning Warcraft universe. In *World of Warcraft*, players create their own heroes and explore, adventure in, and quest across a vast world shared with thousands of other players. This rich and expansive game also allows them to interact with and fight against (or alongside) many of the powerful and intriguing characters featured in this serial novella.

Since launching in November 2004, *World of Warcraft* has become the world's most popular subscription-based massively multiplayer online role-playing game. The latest expansion, *Mists of Pandaria*, takes players to a thrilling and never-before-seen corner of Azeroth: the mysterious continent of Pandaria. More information about *Mists of Pandaria* and previous expansions can be found on WorldofWarcraft.com.

FURTHER READING

If you'd like to read more about the characters, situations, and locations featured in this complete volume, the sources listed below offer additional information.

* Kalecgos—also known as Kalec—has been involved in many influential events in Azeroth's recent history. His heroics are chronicled in *World of Warcraft: Jaina Proudmoore: Tides of War* and *World of Warcraft: Thrall: Twilight of the Aspects* by Christie Golden; *World of Warcraft: Night of the Dragon* by Richard A. Knaak; and *Warcraft: The Sunwell Trilogy* and *World of Warcraft: Shadow Wing*, volume 2, *Nexus Point* by Richard A. Knaak and Jae-Hwan Kim.

* Details of Jaina Proudmoore's life, including her relationship with Kalecgos, are depicted in *Jaina Proudmoore: Tides of War*, *World of Warcraft: The Shattering: Prelude to Cataclysm*, and *World of Warcraft: Arthas: Rise of the Lich King* by Christie Golden; the monthly *World of Warcraft* comic book by Walter and Louise Simonson, Ludo Lullabi, Jon Buran, Mike Bowden, Sandra Hope, and Tony Washington; *World of Warcraft: Cycle of Hatred* by Keith

R. A. DeCandido; and *Warcraft: Legends*, volume 5, "Nightmares" by Richard A. Knaak and Rob Ten Pas.

* You can find more information about Alexstrasza, Ysera, Nozdormu, Malygos, and their respective dragonflights in *World of Warcraft: Thrall: Twilight of the Aspects* by Christie Golden and in *Warcraft: War of the Ancients Trilogy*, *Warcraft: Day of the Dragon*, *World of Warcraft: Night of the Dragon*, and *World of Warcraft: Stormrage* by Richard A. Knaak.

* Deathwing nearly destroyed Azeroth during the great Cataclysm. His long history of betrayal and brutality is featured in *Thrall: Twilight of the Aspects* by Christie Golden; the *Shadow Wing* series by Richard A. Knaak and Jae-Hwan Kim; the *War of the Ancients Trilogy*, *Night of the Dragon*, and *Day of the Dragon* by Richard A. Knaak; and *World of Warcraft: Beyond the Dark Portal* by Aaron Rosenberg and Christie Golden.

* Thrall's exciting background is revealed in *Warcraft: Lord of the Clans* by Christie Golden. Other tales about his past are portrayed in *Jaina Proudmoore: Tides of War*, *Thrall: Twilight of the Aspects*, *The Shattering: Prelude to Cataclysm*, and *World of Warcraft: Rise of the Horde* by Christie Golden; *World of Warcraft: Cycle of Hatred* by Keith R. A. DeCandido; Sarah Pine's short story "Garrosh Hellscream: Heart of War" (on www.WorldofWarcraft.com); *Warcraft: Legends*, volume 2, "Fear" by Richard A. Knaak and Jae-Hwan Kim; and issues #15–20 of the monthly *World of Warcraft* comic book by Walter and Louise Simonson, Jon Buran, Mike Bowden, Phil Moy, Walden Wong, and Pop Mhan.

THE BATTLE RAGES ON

The Cataclysm changed Azeroth and its myriad peoples in many ways. *Dawn of the Aspects* depicts the uncertainty that now plagues the ancient dragons. But what lies ahead for the world's other races?

In *World of Warcraft*'s fourth expansion, *Mists of Pandaria*, you can help shape this next chapter in Azeroth's history. Become one of the first members of the Horde or the Alliance to explore the mysterious and exotic continent of Pandaria. Or take on the role of a noble pandaren (*WoW*'s latest playable race) and join the Horde or the Alliance, depending on which faction aligns more with your ideals. Regardless of the side you choose, your adventures will impact Azeroth in the years to come.

With the dragons forging new destinies for themselves, the task of safeguarding the world from evil has fallen to mortal hands—*your* hands. Will you rise to the challenge?

To discover the ever-expanding realm that has entertained millions around the globe, go to WorldofWarcraft.com and download the free trial version. Live the story.

ABOUT THE AUTHORS

Richard A. Knaak is the *New York Times* and *USA Today* bestselling author of nearly four dozen novels and two dozen shorter pieces, including the *World of Warcraft* books *Wolfheart* and *Stormrage*, *The Legend of Huma* for *Dragonlance*, and his own *Dragonrealm* series. He has also scripted numerous manga and written background material for games. His novels have been published worldwide.

In addition to *Dawn of the Aspects*, his most recent releases include *Shade*—the latest novel in *Legends of the Dragonrealm*. He is currently at work on other projects. More can be found out at his website: www.richardaknaak.com. Please also join him on Facebook and Twitter.

Matt Burns is an associate story developer on Blizzard Entertainment's Creative Development team. A graduate of Chapman University's film and television program, Matt enjoys writing screenplays, gaming, and drawing. During his time in Creative Development, he has helped create licensed and ancillary fiction for *World of Warcraft*, *StarCraft*, and *Diablo*. His most recent project was developing and writing the *Diablo III: Book of Tyrael* illustrated guide.